CATHEDRALS

ALSO BY SIMON JENKINS

CATHEDRALS

MASTERPIECES OF ARCHITECTURE, FEATS OF ENGINEERING, ICONS OF FAITH

SIMON JENKINS

RIZZOLI
NEW YORK

New York · Paris · London · Milan

First published in the United States of America in 2022 by
Rizzoli International Publications, Inc.
300 Park Avenue South
New York, NY 10010
www.rizzoliusa.com

Originally published as *Europe's 100 Best Cathedrals*
in 2021 by Viking,
an imprint of Penguin Random House UK.

Design by Claire Mason

ISBN-13: 978-0-8478-7140-7
Library of Congress Catalog Control Number: 2021940594

2021 2022 2023 2024 / 10 9 8 7 6 5 4 3 2 1

Color origination by Altaimage, London
Printed and bound in Italy by Printer Trento

Visit us online:
Facebook.com/RizzoliNewYork
Twitter: @Rizzoli_Books
Instagram.com/RizzoliBooks
Pinterest.com/RizzoliBooks
Youtube.com/user/RizzoliNY
Issuu.com/Rizzoli

www.greenpenguin.co.uk

Penguin Random House is committed to a
sustainable future for our business, our readers
and our planet. This book is made from Forest
Stewardship Council® certified paper.

To Hannah

CONTENTS

INTRODUCTION

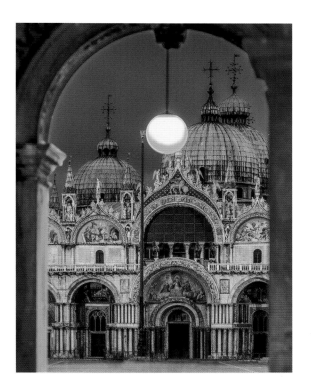

Europe's cathedrals are its finest works of art. They are testaments to its Christian faith but also to its architecture, engineering and craftsmanship. Eight centuries after most of them were built, they still stride across the continent, towering over cities from Cologne to Palermo and from Moscow to Barcelona. As a group, nothing equals them in splendour. At the height of their ambition the canons of Seville promised 'to build such a church that men will think us mad'.

A cathedral is defined as the seat of a bishop, the premier territorial priest in the church hierarchy. There are of course hundreds of cathedrals in Europe and the ones I have chosen are those I found most beautiful and appealing. Some are no longer official cathedrals, and a few I have included as being of equivalent quality and with particular local significance, such as St Peter's Rome or London's Westminster Abbey. Where Catholic, these are often termed basilicas by the Vatican. I have not included monastic or collegiate churches, which are a category of their own.

Most cathedrals are grand. No other places of Christain worship on earth remotely equal them in scale. While they are overwhelming today, it is hard to imagine the effect they must have had on people in the Middle Ages as they soared into the sky . France had nothing on the scale of 13th-century Amiens until Louis XIV's Versailles four centuries later.

Cathedrals appeal to people of every faith and none. All can marvel at the crossing at Ely, at the shadows darting through Toledo's Transparente or at the evening sun tracing across the façade of

← Medieval landscape with cathedrals
↗ Sunset on St Mark's Venice

St Mark's in Venice. These are wonders of the world, manufactured of brick, stone, wood and glass but elevated by a sense of mystery. That mystery may seem obscure to those not versed in the Christian story and liturgy yet it somehow transcends both. Cathedrals are what the French writer André Malraux called 'museums of the imagination'.

Like a majority of modern Europeans, I was born into a Christian society, the child of practising Christian parents. As an atheist I did not follow my parents' faith, but a love of architecture has always left me intrigued by how religious belief could fashion such material places of worship. I wondered at the magnificence of these buildings and how it relates to their intended purpose. I could see why the *philosophes* of the French Enlightenment called them 'embarrassments to reason'.

Churches were built in homage to the Christian God. To this end their sponsors brought together all the arts known to architecture as well as scholarship and often a fierce intellectual discipline. The

American writer Henry Adams devoted much of his life to the French cathedral of Chartres and to comparing it with the abbey of Mont-Saint-Michel, the one as religion looking outwards, the other as if looking inwards. He saw the appeal of the medieval cathedral as lying in 'the attraction of power in a future life'. It glorified the act of worshipping a God whose indescribability spawned the metaphor of a worldly monarch, rich in thrones, saintly attendants and palatial residences. These residences were what France's Abbot Suger, creator of the Gothic style, called 'the light of heaven received in splendour' on earth. Or as Napoleon crisply remarked on seeing Chartres, 'This is no place for an atheist.'

To Adams, cathedrals also supplied a more specific service crucial to understanding much of what we see inside a cathedral. This is the Christian and especially the Roman Catholic concept of intercession, of negotiating between man and God to secure everlasting happiness. When these churches were built, a belief in that eternity was what made the hardships of life on earth tolerable – in many cases it was the only thing.

Thus from earliest times that belief was supplemented by a hope that, as friends pray for us on earth, so martyrs and saints could pray for us perhaps with greater effectiveness in heaven. This especially applied to the Virgin Mary. With pain and violence a feature of everyday medieval life, Mary symbolized peace, purity and love. She stood against the fearsome images of punishment and hell with which Christians adorned their churches. I shall not forget the old lady I saw kneeling in Kraków cathedral before a candlelit Mary, tears of devotion streaming down her face. It was a cathedral working.

Saints feature prominently in the intercessory role of cathedrals. Hence the proliferation of shrines to house saintly relics, suggesting that saints were simultaneously present on earth and in heaven. By the early 12th century the papacy had given Catholicism exclusive rights of canonization, effectively monopolizing powers of redemption in this life and in the life to come. Its followers had only to

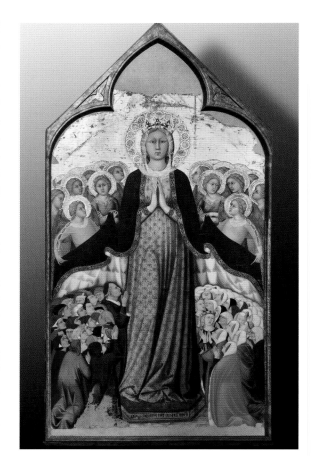

pray – and pay. Millions went on crusades and pilgrimages in this cause. Great deeds were done in the service of saints, and sometimes appalling crimes committed. Their shrines were of immense commercial value to cathedrals even where any link to a particular place was fanciful, such as James the Great to Spain's Santiago de Compostela. Cathedrals were so appealing that people travelled great distances to visit them. They always were and still are Europe's great tourist attractions.

Cathedrals have stood pre-eminent in the intellectual life of Europe. Modern secularism downplays the role of Christianity in the evolution of what are now termed liberal values. But as the historian Tom

↑ Mary: cult of peace, purity and love
↗ Canterbury with pilgrims

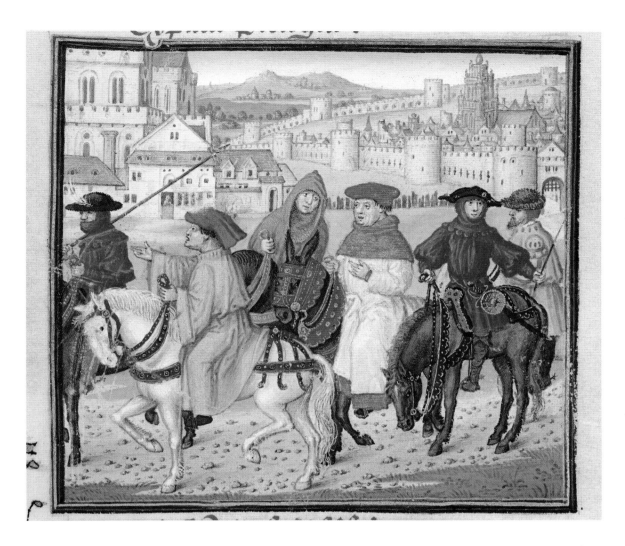

Holland has vigorously reminded us, while church doctrine has often seemed opposed to reason, dissent and tolerance, it has never wholly detached itself from Europe's philosophical discourse. The courts of Charlemagne (r.768–814) and/or 12th-century Paris, and monasteries and universities everywhere regarded themselves as heirs to Greece and Rome. They tested Classical doctrines against those of Christianity and its 'fathers', Paul, Augustine, Gregory the Great and Thomas Aquinas.

This sense of intellectual challenge was a defining feature of Christianity compared with other world religions. Throughout history it led to argument, schism and bloody wars. It began with the Great Schism in 1054 of the eastern and western churches. From the 16th century it was carried on by Luther and Calvin, plunging Europe into its most bloodthirsty conflict prior to the 20th century, the Thirty Years War of 1618–48. Division continued through the Enlightenment of the 18th century and the theological disputes of the 19th and 20th centuries. Dogmatic and conservative as it was, the Christian church was no stranger to individualism, human equality, forgiveness and charity. Though many revolutions have surged through its cathedrals, their most remarkable feature is that almost all that were built are still standing, when castles and palaces have crumbled and passed away.

There remains for me the capacity of a cathedral to inspire awe. The aesthetician of religion, Bishop

Richard Harries, argues that this is a sign of the beauty of God. I have no means of verifying this, beyond the incontrovertible fact of that beauty, the walls that encompass it, the windows that light it and the music that fills its air. If a link in the chain of my appreciation is missing, then I accept that I am the poorer for it. All I know is that many Christians hold to a faith that has led them to generous, noble and uplifting deeds. Where these include erecting buildings of such loveliness I see no 'embarrassment to reason'. I take comfort in our shared humanity and say a profound thank you.

THE CULTURE OF THE ROMANESQUE

The early church was a persecuted but a proselytizing sect. From the days of St Paul it had local leaders, known as presbyters and then bishops, claiming spiritual descent from the apostles. After the Emperor Constantine's decision in AD 313 to lift the ban on Christianity throughout the Roman Empire, these officials came into the open and acquired the civic status of magistrates. They conducted services in a hall known as a basilica, with a raised dais at one end on which stood a magisterial *cathedra* or throne. As such, from earliest times bishops were set apart from the laity and clergy, as if on a par with princes.

Within a year of his decision, Constantine summoned a council of bishops to Arles in 314, including three from Britain's London, Lincoln and York. This indicated a church whose hierarchical system had already reached the outer limits of the Roman Empire. These bishops were a source of strength but also of argument. Even Paul had written to the Corinthians, 'I beseech you, brethren, that you all speak the same thing and that there be no divisions among you.' Yet in 325, just a decade after the Council of Arles, Constantine had to summon another council to Nicaea to declare as heresy the creed of Arianism, which held that Jesus was a creation of God and therefore subordinate, denying the Trinity of Father, Son and Holy Spirit. Originating with

Arius, a 4th-century presbyter in Egypt's Alexandria, Arianism was to sweep across northern Europe and come close to dominating the western empire.

Thus from earliest times bishops were of immense significance to the church. They were its territorial governors and the sole means by which Christianity could maintain authority. Yet gradually these governors put down ever deeper roots in their native countries. From Rome's dissident Pope Gregory the Great (r.590–604) down to the Great Schism of Catholic and Eastern Orthodoxy in 1054, Christianity began to fragment. Muslim incursions in the 7th and 8th centuries narrowed its footprint in the eastern Mediterranean. The Christian Roman Empire in Africa and Asia, supposedly under Constantinople's leadership, disappeared and half of Christendom was lost with it. From this moment onwards, Europe as a peninsular continent was born.

Charlemagne's Holy Roman Empire, initiated in Rome in 800 but mostly consisting of present-day Germany, the Low Countries and France, lost political coherence soon after his death. Its constituent rulers were in conflict with each other and with the papacy, leaving local bishops with divided loyalties. France defected. Seismic disputes, such as Germany's Henry IV with the pope in 1076 and England's Henry II with Thomas Becket in 1170, were essentially about papal authority. Throughout this period, it was not the empire but the church that stood as an institution of emotional force, arousing widespread popular support. It spoke one doctrine in one language, Latin, and obeyed one leadership, that of Rome.

This church and its bishops acquired wealth beyond that of any secular power, on some estimates owning a quarter of the productive land of Europe. Its patronage was unequalled. Though the pope had no armies, he could call on armies of others loyal to him, notably for crusades to the Holy Land, the first of which departed in 1096. These ventures became expensive, fruitless and, in the fourth crusade of 1204, outrageous, when Venetian mercenaries diverted from Jerusalem to sack Constantinople. Yet

crusades were the first collective and truly European enterprise, significantly conducted under the initiative of the church.

Bishops were now powers in every land. They numbered among the Holy Roman Empire's electors. A statue on the wall of Mainz cathedral shows a bishop crowning two clearly diminutive emperors. The church had styled itself custodian of the collective conscience of Europe, and for a while Europe did not dissent. The claim to authority in the afterlife – to atonement, redemption and salvation – reduced monarchs and subjects alike to submission. Bishops, abbots, clergy and scholars maintained fraternities across Europe, aided by the ever-expanding monastic movement. Dogma enforceable by ecclesiastical courts was formulated under the edicts of assertive popes such as Gregory VII (r.1073–85) and Innocent III (r.1198–1216). In 1088 a faculty of law was founded in Bologna to set out what was called canon or church law. The church had become truly an empire of faith.

This supremacy did not last. By the 12th century the peoples of Europe were forming recognizable states under powerful dynasties. To France's Capetians and Germany's Ottonians were added England's Plantagenets and Spain's Castilian Jiménez and later dynasties. Rural feudalism was diluted by the growth of commerce. War and pilgrimage made populations more mobile.

Above all cities developed, led by Paris, Ypres, Cologne, Milan and Palermo. Their merchants prospered. So did their bishops, 'princes of the church', their loyalty straying ever further from a distant and increasingly corrupt papacy. Archbishops ranked second in seniority to monarchs. Bishops became entwined with the aristocracy, often because they were its sons and nephews. The church supplied kings with chancellors and officials. Nowhere was this growing status more manifest than in its physical manifestations. Bishops' houses, even in England, became known as palaces, their seats thrones and their churches ever mightier cathedrals.

The earliest such cathedrals were merely large churches, of which in the early Middle Ages the largest tended to be in monastic abbeys and pilgrimage stopping points. I have included two of the latter at Vézelay and Toulouse. The layout of these churches evolved either from the Greek cross – a cross of equal arms – or from the Roman hall or basilica, a term not to be confused with the Vatican word for an important non-cathedral church. Very few ancient basilican cathedrals survive, though I have included such early examples as Bologna's San Stefano and Venice's Torcello. Their plans and decoration hark back to Roman architecture, with features such as the apse, the semicircular arch and the acanthus-leaved capital. Where the basilica developed aisles and transepts to become cruciform, attention tended to focus on the crossing. The sanctuary, usually in the eastern arm, was reserved for the clergy, with lay worshippers in the longer nave opposite, named for its shape of an upturned ship. West fronts were often elaborately carved, notably the tympanum panel over the door, with admonitory Bible stories such as the Day of Judgement, and the Wise and Foolish Virgins.

This basic Romanesque style was a continuation of the Classical building tradition. It was carried across the continent by bishops and rulers eager to emulate each other and by masons in their train. Crusaders brought back variations of arches and capitals from the Levant. Muslim motifs survived in Sicily and Spain. But the basic form was similar everywhere, from the Ottonian Rhine to Spanish Santiago and from Norman Durham to Sicily. Interiors had been much influenced by one man, Bishop Chrodegang of Metz (r.742–66). He introduced such monastic practices as enclosed choirs where the clergy performed the daily liturgy, often invisible to the laity. Chrodegang's reforms influenced Roman Catholic architecture into the 20th century.

The Ottonian Holy Roman emperors (r.919–1024) sponsored large cathedrals at Magdeburg, Mainz, Worms and Speyer. These were distinctive in having apses at both ends, usually dedicated to the Virgin

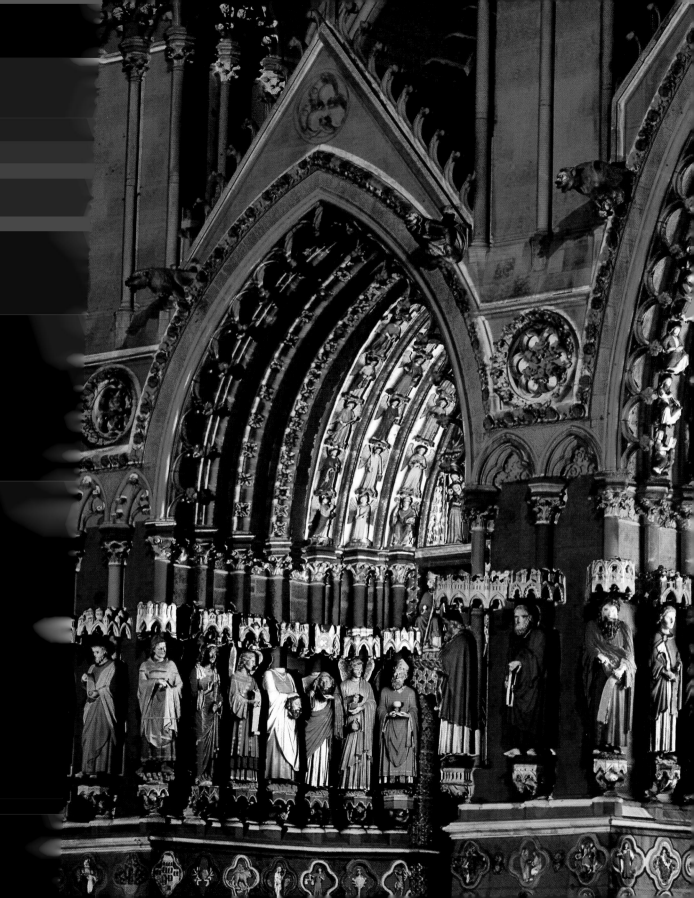

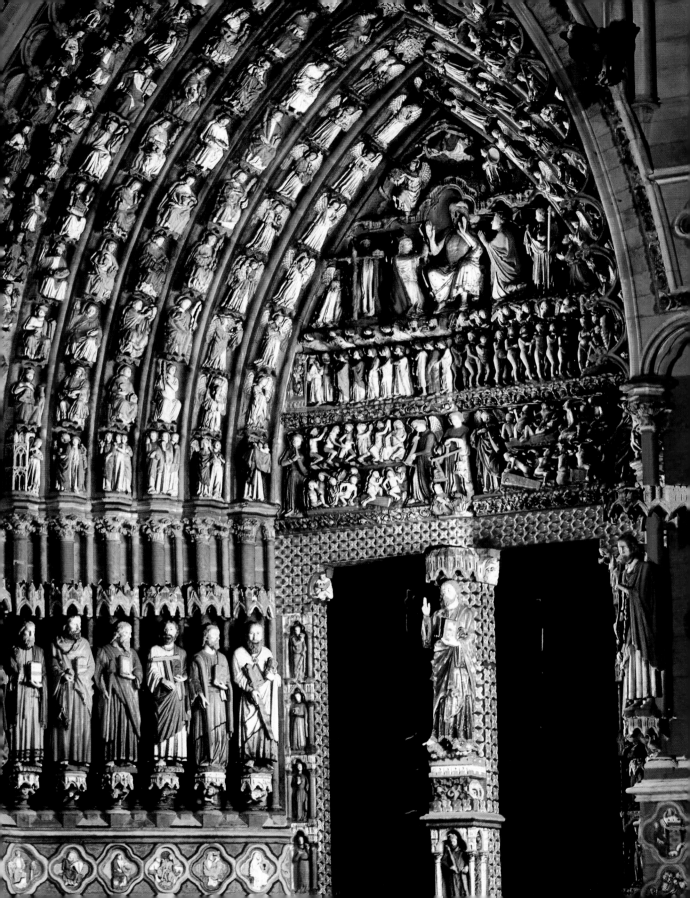

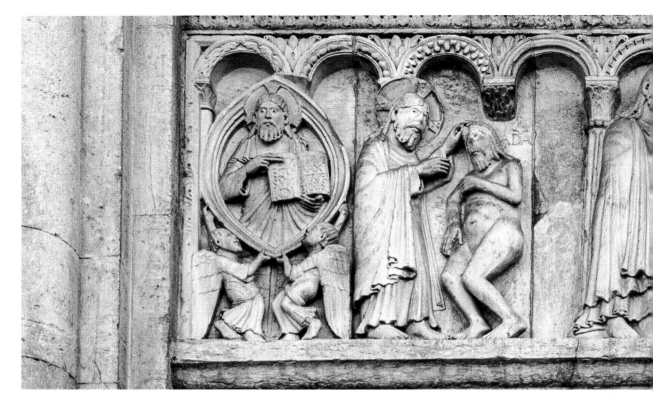

Mary and a local saint. But nothing did more to celebrate the Romanesque than William of Normandy's conquest of England in 1066. The Normans asserted their supremacy by rebuilding virtually all of England's cathedrals, abbeys and churches in the French Romanesque style, duly dubbed Norman. Winchester and St Paul's London had the longest naves in Europe, Norwich among the highest towers, Durham possibly the first pointed rib vault, later to become an essential ingredient of the Gothic style.

Yet Romanesque never escaped the confines of its engineering. Roofs could climb high but their weight was carried directly on thick walls and piers. Cathedral interiors were dark, their roofs mostly of lightweight wood. Towers rose solidly, stage upon stage. Other than in scale, Romanesque never truly evolved. To a modern eye its finest feature is its sculpture, especially on west fronts and nave capitals. The Pórtico de la Gloria at Santiago, the Gislebertus tympanum at Autun and Wiligelmo's

panels at Modena are outstanding works of art in any culture but are strangely static. At Arles I noticed that the faces on a 4th-century Roman sarcophagus were uncannily similar to those in the 12th-century cloister outside. It was as if the mason's chisel had been in the same groove for eight hundred years.

THE GOTHIC AGE

Despite the building frenzy of Norman England, it was France that was in the stylistic vanguard of Europe. Under the Capetian kings from 987, the Île-de-France region round Paris was prosperous and mostly at peace. Its population of some 100,000 was surpassed in Europe only by that of Constantinople. Its university overtook Bologna in distinction, its students colonizing the Seine's left bank as the academic *quartier Latin*, after the language in which they conversed. Here arose what historians have dubbed the 12th-century renaissance, reviving Latin poetry,

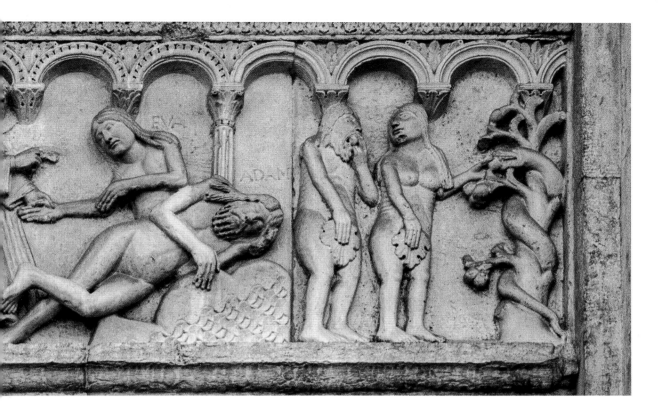

Roman law and the writings of Plato and Aristotle.

Students flocked to hear the charismatic philosopher Peter Abelard (1079–1142), reputedly addressing audiences of thousands as well as falling in love with the beautiful Héloïse. Abelard asserted, 'By doubting, we come to inquiry, and by inquiry we perceive truth.' Mankind would achieve faith by reason and the words of the Bible, not by obedience to the authority of the church. His ideas were taken up by a later Paris philosopher, Thomas Aquinas (1225–74), and became the cry of church reformation down the ages.

The impact of this scholarship on church architecture was profound. Even as Abelard preached one revolution, his contemporary Abbot Suger (1081–1151) of the abbey of Saint-Denis outside Paris was preaching another. If Abelard took reason as his guiding theme, Suger took light, and sought an architecture appropriate to it. The style that later generations called Gothic was more than

engineering applied to theology. It created a new aesthetic. Worship or access to God was to be signified by the exhilaration of an ascending line. In a Romanesque church worshippers bowed their heads in obedience to a dark mystery. In a Gothic church their eyes should rise to a supposed heavenly source of light. In the words of Abelard's biographer, Roger Lloyd, 'the curtain now rose upon the most vivid and satisfying century in Christian history', what lovers of cathedrals might call the Glorious Twelfth.

Gothic broke down a boundary in medieval engineering. It replaced statics with dynamics, leading the viewer on an adventure through space. As Chesterton wrote, 'Giants lift up their heads to wonder / How high the hands of man could go.' The answer in the Île-de-France was high indeed, higher than any structure

← Laser-lit Amiens as of old
↑ Modena frieze: the poor man's Bible
→ Notre-Dame and the Gothic dawn

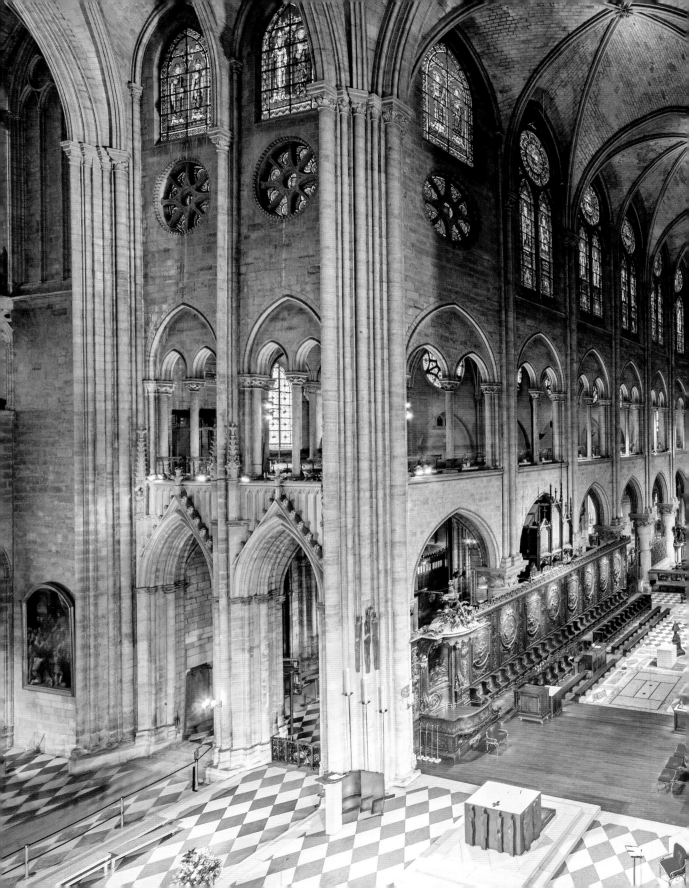

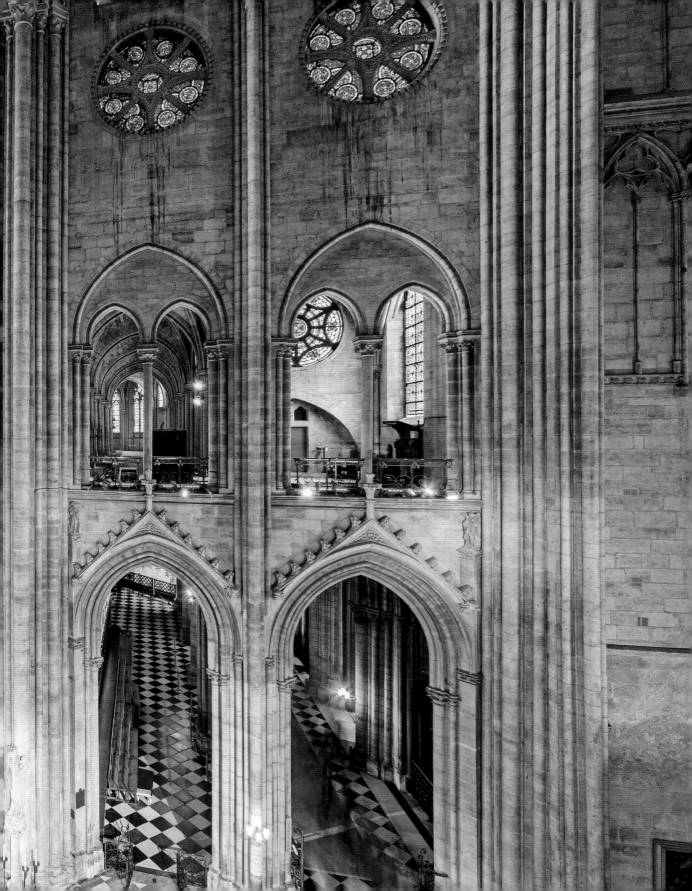

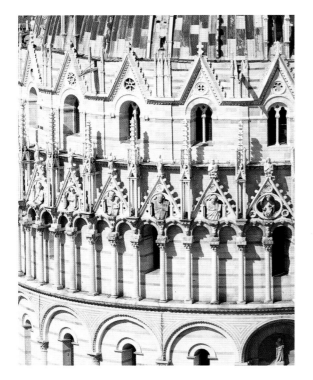

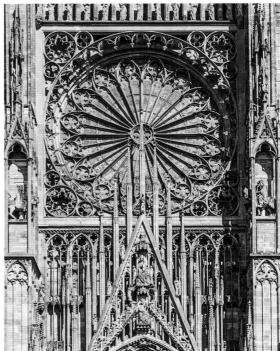

other than the pyramids. Gothic struck a chord in the imagination that was never to disappear. Even today it retains a hold on designers, from fairyland castles to horror movies, from 'goth' fashion to backdrops for hobbits and Hogwarts. Its steeples, gables and turrets have never been crushed by the right-angles of modernism or the doodles of 'starchitects'.

Suger was not without his detractors. The Cistercian conservative St Bernard of Clairvaux (1090–1153) deplored a church that 'clothes her stones with gold but lets her sons go naked'. He 'deemed as dung whatever shines with beauty, charms the ear, delights through fragrance, flatters the tongue', and felt the same about 'enormous height, extravagant length and unnecessary width'. To him a church, or at least a monastery, should be austere, dark and numinous. But Suger was more than a match for him. He was a worldly abbot, senior counsellor to two kings of France, Louis VI (r.1108–37) and his son Louis VII (r.1137–80). The new style – dubbed *le style français* or *opus*

francigenum – became not just popular but the official architecture of France. It spread rapidly to England, Germany and Spain. A specific category called Transitional was invented by art historians for churches which felt obliged to switch from Romanesque to Gothic mid-project. They included Chartres, Notre-Dame and Strasbourg.

Gothic spread along the pilgrim routes to northern Spain and Santiago, carried by eager bishops and French master masons. The masons of Bourges were in particular demand, with Burgos and León rebuilt in the 1220s by Frenchmen. The style crossed the Channel to see Canterbury rebuilt after a fire in 1174 by William of Sens. Gothic took its own peculiarly English manner in Bishop Hugh's rebuilding of Lincoln in 1186, later to be called Early English or – as I prefer – Early Gothic. This was the style of the new Salisbury cathedral, begun in 1220. Its

↖ Pisa: Gothic Decorative
↗ Strasbourg: Gothic Flamboyant
→ Canterbury: Gothic Perpendicular

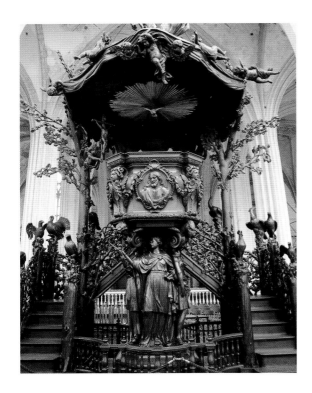

By the mid-13th century lancet windows had sprouted bar tracery known as Rayonnant. Vaults and piers acquired ever more shafts, tympanums became crowded, gables and parapets pierced. By the 14th century Rayonnant evolved into Flamboyant, its extravagant ribs and tracery spreading from France to Spain and Germany. England in the 14th century went in an opposite direction, to what was to be called Perpendicular. This plainer style devoted more window space to stained glass but added overhead the most elaborate of Gothic vaults, that of the fan and pendant.

By now the Roman Catholic church was showing signs of fissure. In the 14th century the papacy divided, with a dissident pope in Avignon (1309–76) under the protection of the French crown. The England of the Hundred Years War was becoming increasingly distinctive. In the 1370s criticism of Catholicism emerged under John Wycliffe and the English Lollards, to be taken up by Jan Hus in Bohemia, culminating in the latter's burning by a papal conclave in 1415. The Roman church was not deaf to calls for reform. The Avignon schism was eventually ended and a determined effort made for peace with the Byzantine Orthodox church. But this was no sooner achieved in 1443 than within a decade Constantinople fell to the Ottomans of Suleiman the Magnificent. Eventually Eastern Orthodoxy was saved largely by its adoption by Russia.

Gothic was now in a final flurry of invention. French tracery seemed to go wild, as in the transepts of Beauvais and Rouen and the west front at Troyes. The 15th century was an age of giant towers. Some were glorious, such as Freiburg, Canterbury and Gloucester. Many – Cologne and Ulm – proved so challenging they were not actually built until the 19th century.

The great age reached a sort of climax in the first decade of the 16th century. Gothic sculpture saw

relative modesty compares with Amiens' pyrotechnics, started in the same year.

Germany proved more dilatory, though the canons of Strasbourg switched their half-built Romanesque cathedral to Gothic in 1225. Cologne was begun in 1248 and Regensburg in 1273. Only Italy was resistant. There Romanesque continued in use throughout the Middle Ages, with Gothic mostly confined to decoration, as on the gables and window tracery of Pisa and Florence. Indeed Italy's resistance to the revolution was a fascinating sidetrack in the cathedral story. I can only assume some residual loyalty in this homeland of the mother church to the style of its Roman antecedents.

Above all Gothic seemed to release its architects to innovate and compete. Initially the lead was given by the French masonic lodges – as peripatetic families and groups of masons were known – but gradually Germans took command, notably the Parler family of Cologne and the Steinbachs of Strasbourg. Their names crop up at one cathedral after another.

↖ Antwerp: Baroque steps forward into light
↗ Gothic revived: Cologne's 19th-century completion

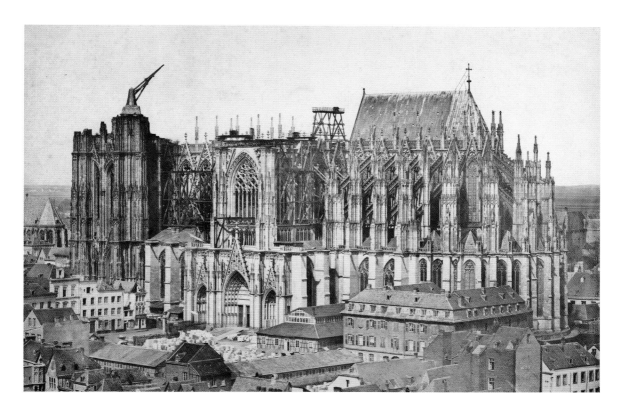

apotheosis in Vienna cathedral's two masterpieces, the imperial Habsburg tomb and Anton Pilgram's pulpit. Flamboyant tracery erupted across the west front of Rouen, later mesmerizing Monet. A mammoth reredos rose over Seville's high altar and a forest of pendants dripped from the ceiling of Henry VII's Chapel in Westminster. All were splendid but all had about them what seems an excess of effort, almost of megalomania. All left a question: what next?

THE MODERN AGE

In October 1517 Martin Luther marched to Wittenberg church and, so legend has it, nailed his ninety-five theses to its door. It was a punctuation mark in the history of the Catholic church – and of its cathedrals. Luther's Reformation took hold across northern Germany and spread in various guises to the Netherlands, Scandinavia, Switzerland, Huguenot France and eventually England. Just as the

11th-century schism was part geographical, so too was that of the 16th century, now north Europe against south. At the Diet of Worms in 1521 neither Luther nor the Holy Roman Emperor, Charles V, could find any point of agreement. Fearing for his life, Luther fled to Saxony.

Catholicism reeled but did not succumb. The Council of Trent in 1563 condemned Protestantism as heresy and reasserted traditional Catholic doctrine in conservative terms. It signalled the start of a Counter-Reformation. This in turn unlocked cathedral rebuilding in Catholic Italy, as well as an effusion of altarpieces and devotional paraphernalia everywhere Protestantism was not in the ascendant. Spain, then at the height of its imperial power, continued richly to adorn its cathedrals. Here the transition from Gothic to new Renaissance motifs coming out of Italy was signalled by the Plateresque, a delicate ornamental style originating in silverware. Meanwhile in Florence Brunelleschi took a full-blooded Renaissance from

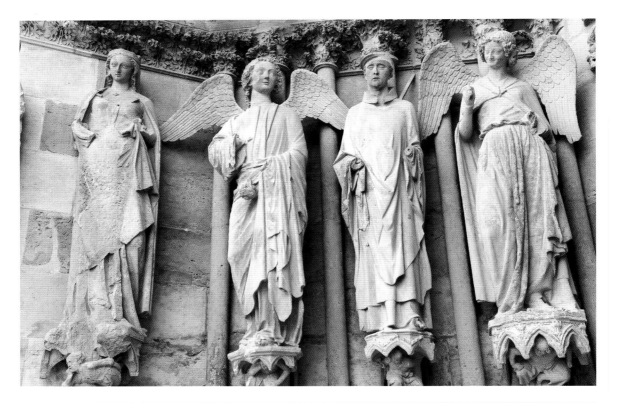

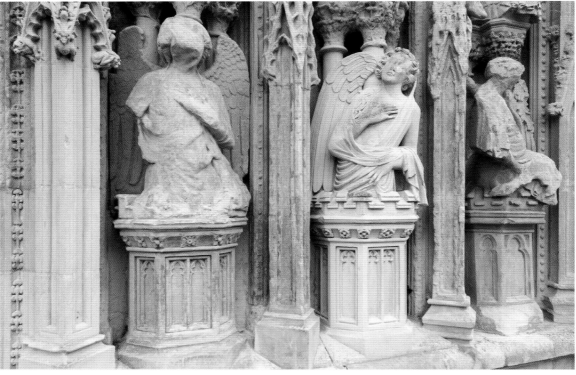

the Duomo to the church of San Lorenzo, while in Rome Michelangelo gave St Peter's a dome.

The 17th century was one of horror. The renewed schism of Christendom plunged Europe into the wars of religion, culminating in the devastating Thirty Years War (1618–48). At its final settlement in the Peace of Westphalia, religious autonomy was guaranteed to Protestant states. Nothing so indicated the decline in Rome's status as the pope not even being represented at the treaty negotiations. When he later objected to its tolerance he was ignored.

The calmer 18th century saw a return of self-confidence to cathedral architecture at least in Catholic lands, though a fine Protestant cathedral did arise in London after the Great Fire. Italy again was distinctive, with many older cathedrals demolished, gutted or replaced by Baroque substitutes. The Gothic lights went down and the Baroque stepped forward to illuminate the liturgical stage.

The prevalence of Neo-Classicism in all its forms in the 18th century left Gothic cathedrals unfashionable and at risk of anachronism. Many were neglected and threatened by the rise of Protestantism. England's Salisbury was gutted and its glass destroyed by James Wyatt. In 1772 the young Goethe visited Gothic Strasbourg and declared himself deeply moved by this 'wide-spreading tree of God', but few of the poet's contemporaries agreed. The revolutionary spirit of the early 19th century was firmly Classicist, so much so that Paris's semi-derelict Notre-Dame was in the 1820s threatened with demolition. Salvation came only with the popularity of Victor Hugo's novel about its legendary hunchback.

Fashions change in all things. By the mid-19th century a Gothic revival was in train across Europe. In Napoleon III's France, Eugène Viollet-le-Duc (1814–79), a young medievalist scholar and architect, was commissioned to restore old cathedrals nationwide. In Britain Gothic returned in full force

from the 1830s onwards. Sir George Gilbert Scott imitated Viollet-le-Duc, restoring almost all the country's cathedrals. Ludwig of Bavaria led a Neo-Gothic 'purification' movement, to eradicate all traces of Baroque. The medieval spirit twitched to life in the completion of the steeples of Cologne and Ulm to their original designs.

Partly due to the robustness of their construction, most cathedrals managed to survive the 20th century's two world wars, though not unscathed. Westphalians became symbols of resistance and peace to people on both sides. What did emerge from the rubble of 1918 and 1945 was a renewal of questions that had taxed 19th-century restorers. How far should the damage of age, pollution and war be repaired, and in what guise? What was authentic and what was reproduction or fake?

The reality was that by the 20th century precious little of the visible fabric of medieval cathedrals was medieval. Stonework had of necessity been replaced over the centuries and carvings retooled. Today's Speyer cathedral looks almost new. So does Denmark's Roskilde. The statues of Reims and Notre-Dame are suspiciously crisp. Ely's choir screen might as well be medieval as rebuilt from fragments by Scott. Most cathedrals treated the ravages of time as reparable, using modern craftsmanship to honour the inspiration of the original masters. The wonder of the Autun tympanum is one of restoration as much as of original sculpture.

Britain in the 20th century largely took another path. By the 1960s the doctrine of 'conserve as found' allowed no repair or reinstatement to eroded medieval carvings. Statues on the west fronts of Wells and Exeter remain in a state of unrecognizable decay, rather than being removed, as in Italy or France, to a museum and replaced with replicas. As will become apparent, I disagree with this policy.

In addition, to me colour was the very essence of the Gothic style. It can be seen in the restored frescoes of Assisi and Orvieto, in the doorway statues of Freiburg and in the ghostly tints of the portico

at Santiago. In Britain it can be enjoyed in the mid-20th-century reinstatement of colour in the east end of Exeter cathedral. But the nearest we can get to imagining a complete medieval façade is through the technology of nocturnal laser projection (see pp. xiv–xv). I have seen both Amiens and Westminster Abbey illuminated so precisely as to replicate the colours of human skin and clothing. Such images can look garish to the modern eye, but that is how they were. We censor history and deceive ourselves by denying this central feature of their creators' vision. I can only hope that one day Gothic cathedrals will be repainted inside and out.

Colour aside, today's medieval buildings are virtually all restored. None of those I have selected appears in a poor or dangerous state and most have been cleaned of soot and the detritus of age. The marble exteriors of Italy look as if new. The sandstone walls of Spain glow and shimmer.

To me the surroundings of a cathedral are its stage set. They inevitably affect my appreciation. This explains how often I remark on how good the entries in this book appear at dusk or at night. Floodlighting is a cathedral's finest cosmetic.

Unlike parish churches, cathedrals rarely envelop themselves with gardens, fields or graveyards but opt rather for piazzas and closes. Most are very much part of their towns, unless like Constable's Salisbury they nestle in a cradle of trees. But a cathedral returns the compliment. It spreads its protection like a penumbra over its environs, thus securing some of the finest ancient townscapes in Europe from insensitive development. As many cities face uncertain futures, nothing can confer on them so valued an elixir as the possession of a great cathedral. I like to think of its legacy as life everlasting.

A CHALLENGE TO REASON

A phenomenon occurred at the turn of the 21st century. While Christian church attendance for almost all denominations had been falling for decades,

cathedrals began to attract new congregations. In Britain while parochial worship fell by a third in the first decade after 2000, cathedral worship moved in the opposite direction. It rose by a third.

As I discuss in my earlier book, *England's Cathedrals*, this appears to be due to a combination of factors. They include the appeal today of any historic building in a town or city, given the losses to modern development. Cathedrals offer the embrace of antiquity without the intellectual demands of a museum or gallery. They are places of uncomplicated beauty. Another factor has been the growth in what is termed secular spirituality. The cathedral presents a retreat from the modern world, from crowds, noise and pressure, into a realm of meditation and private thought. People are comfortable sitting alone in a cathedral. A parish church often comes with identification and a hovering sense of commitment. A cathedral confers that most treasured aid to solitude – anonymity.

The sociologist of religion Grace Davie has long been intrigued by this semi-detachment, variously called 'vicarious religion', 'fuzzy fidelity' and 'believing without belonging'. In her *Religion in Britain Since 1945*, she points out that adherence to the sacred, to superstition and to the rituals of marriage and death persists 'in contemporary society despite the undeniable decline in churchgoing'. In this respect the cathedral occupies 'a border between the religious and the secular'.

Casual visitors, tourists and worshippers alike can be left to find what they want in a cathedral. They can seek soaring proportion and the play of light on stone and wood. They can seek music, with evensong an ever more popular service. Cathedrals now play an increasingly active role in the cultural life of their communities. They have shops, cafés, libraries, crèches, clubs and classes and were used in 2021 for vaccinations during the coronavirus pandemic. They are reverting to what they were in the

→ The cathedral in context: York minster from Petergate

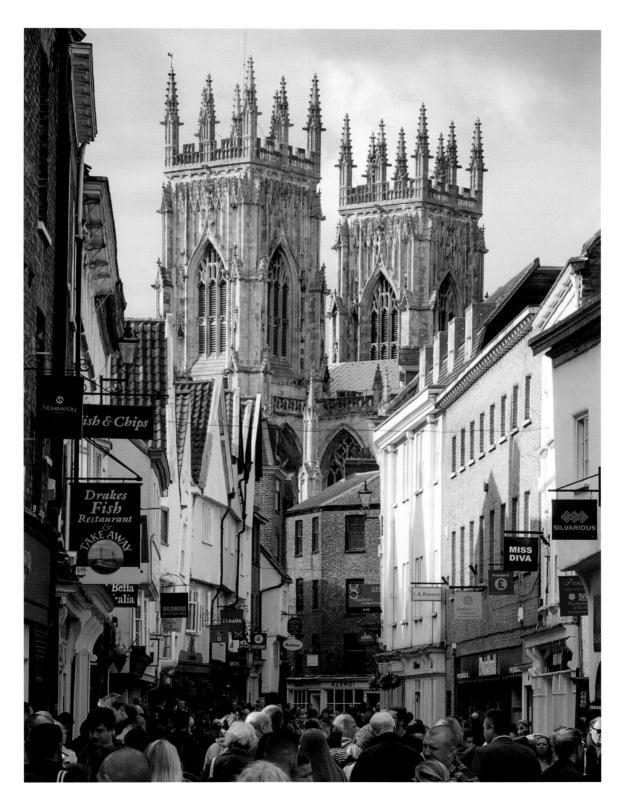

Middle Ages, places both part of local society and yet of withdrawal from it.

In this book I approach these buildings primarily as works of art, the products of architects, craftsmen and artists. Like all works of art, cathedrals have always been victims of taste. As the critic John Berger wrote, 'The way we see things is affected by what we know or what we believe.' It is also a function of what we choose to look at. I am aware that my taste is that of a moment in time and may not be that of others or of other times, not least those for whom a cathedral serves a different purpose from mine. Thus in Segovia's Chapel of the Recumbent Christ is one of the most gruesome statues I have ever seen. It depicts Jesus as a grown man lying naked on a slab with just a patch of cloth over his genitals, eyes open and with blood draining from open wounds. I reacted likewise to Milan's statue of the flayed St Bartholomew, standing with his organs showing and his skin thrown over his shoulder like a shawl. I can only assume others do not turn away in disgust.

Yet even my taste changes over time. I used to find Romanesque static and rather dull. I now find it dignified and peaceful, its sculpture as moving as any Gothic work. I always found Gothic stimulating and exhilarating, infused with John Ruskin's 'life and liberty of every workman who struck the stone'. I still feel that, but as Gothic careered through the 15th century I now see it straining towards vulgarity, as at Tours and Rouen, only to be revived four centuries later by Gaudí's wonderful Sagrada Família.

Having associated Gothic with individualism and freedom, I next associated its successor, Classicism, with order and authority. At first I did not warm to episcopal Baroque, to cohorts of Spanish Madonnas, angels and cherubs before skylines of crucifixions and tortured saints. I was therefore surprised to enjoy the theatrics of the High Baroque, Toledo's astonishing high altar and the Rococo of Passau's ceiling. I was almost disappointed in Germany to find that Ludwig of Bavaria's 'purifiers' had arrived before me. That said, my favourite

works of art in a cathedral were usually its humblest, its naturalistic pier capitals and its choir stalls, especially when offering scenes of local secular and domestic life.

In sum I see these buildings as manifestations of Europe's collective past. They represent its most embedded institution, Christianity, in all its finery. They are that faith at its most ethereal, yet also its most challenging. To Henry Adams in discussing Chartres, the essence of a Gothic cathedral was tension, architecture holding together walls, roofs, piers, arches and towers. To him, 'danger lurks in every stone . . . the restless vault, the vagrant buttress, the uncertainty of logic'. A cathedral thus became a living thing, 'the delight of aspiration flung up into the sky, the pathos of its self-distrust, the anguish of its doubt'.

Even today no other buildings on earth can compare with these structures. They are history and geography, art and science, mind and body in one. I am happy that they still leave me perplexed, a question mark hovering far above my head.

→ Vienna's Anton Pilgram: the artist surveys his work

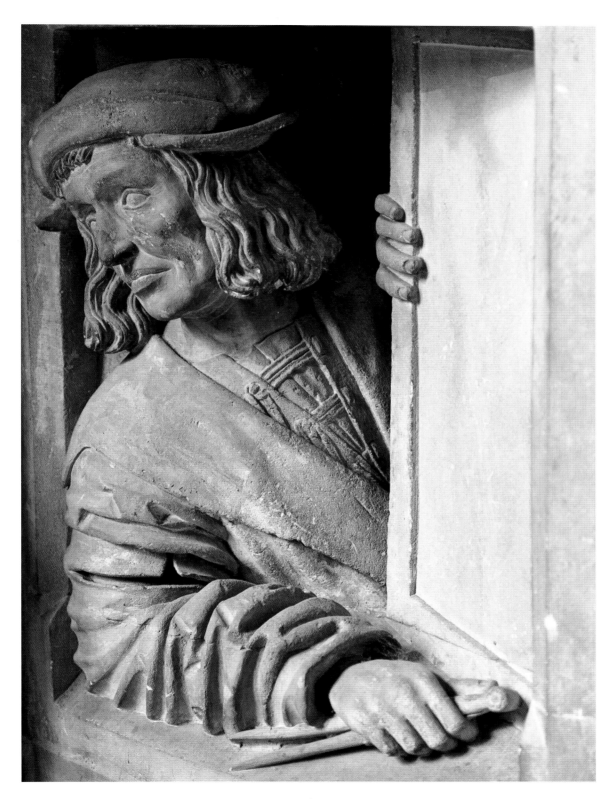

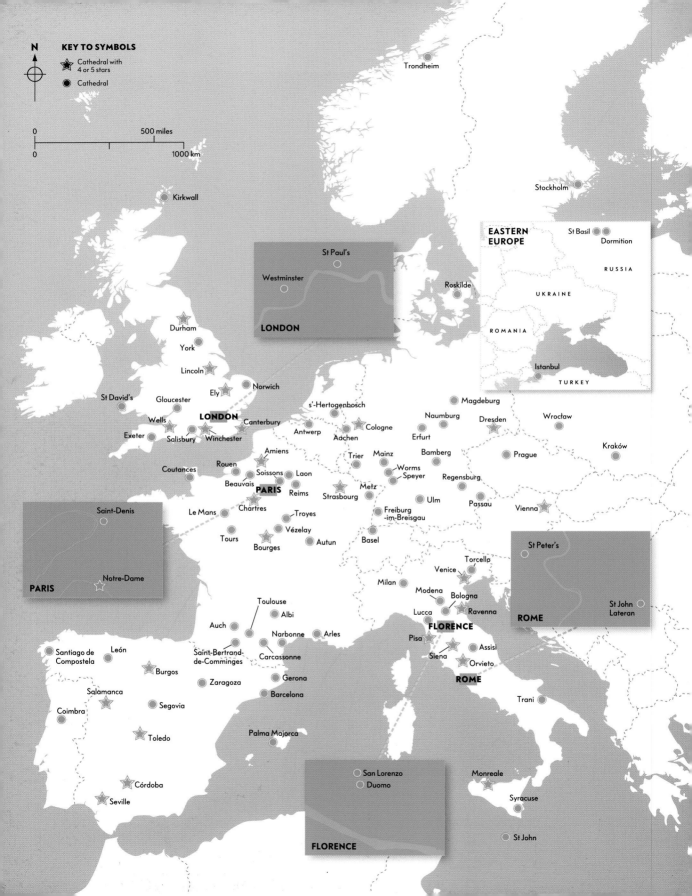

N

KEY TO SYMBOLS
⭐ Cathedral with 4 or 5 stars
⬤ Cathedral

0 500 miles
0 1000 km

Kirkwall

LONDON

St Paul's
Westminster

EASTERN EUROPE

St Basil
Dormition

RUSSIA

Roskilde

UKRAINE

ROMANIA

Istanbul

TURKEY

Trondheim

Stockholm

Durham
York
Lincoln
Ely
Norwich
St David's
Gloucester
Wells
LONDON
Canterbury
Exeter
Salisbury
Winchester

s'-Hertogenbosch
Antwerp
Cologne
Aachen
Magdeburg
Naumburg
Dresden
Wrocław
Erfurt
Prague
Kraków

Amiens
Rouen
Soissons
Laon
Beauvais
PARIS
Reims
Coutances
Chartres
Le Mans
Troyes
Saint-Denis
Vézelay
Notre-Dame
Tours
Bourges
Autun

Trier
Mainz
Worms
Speyer
Metz
Strasbourg
Ulm
Freiburg -im-Breisgau
Basel
Bamberg
Regensburg
Passau
Vienna

PARIS

Milan
Torcello
Venice
Modena
Bologna
Lucca
Ravenna
FLORENCE
Pisa
Siena
Assisi
Orvieto
ROME
Trani

St Peter's
St John Lateran
ROME

Toulouse
Albi
Auch
Narbonne
Arles
Saint-Bertrand -de-Comminges
Carcassonne

Santiago de Compostela
León
Burgos
Salamanca
Zaragoza
Gerona
Coimbra
Segovia
Barcelona
Toledo
Palma Majorca

Córdoba
Seville

San Lorenzo
Duomo

FLORENCE

Monreale
Syracuse
St John

THE TWENTY-FIVE BEST

✛ ✛ ✛ ✛ ✛

AMIENS

BOURGES

CHARTRES

SEVILLE

TOLEDO

VENICE, ST MARK'S

WELLS

✛ ✛ ✛ ✛

BURGOS

CANTERBURY

COLOGNE

CÓRDOBA

DRESDEN

DURHAM

ELY

LINCOLN

MONREALE

ORVIETO

PARIS, NOTRE-DAME

PISA

RAVENNA, SAN VITALE

SALAMANCA

SIENA

STRASBOURG

VIENNA

WINCHESTER

FRANCE

ALBI +++; AMIENS ++++++; ARLES ++;
AUCH +; AUTUN +; BEAUVAIS +++;
BOURGES ++++++; CARCASSONNE +;
CHARTRES +++++; COUTANCES +; LAON +++;
LE MANS +++; METZ ++; NARBONNE +;
PARIS, NOTRE-DAME ++++;
PARIS, SAINT-DENIS +; REIMS +++; ROUEN +++;
SAINT-BERTRAND-DE-COMMINGES ++;
SOISSONS +; STRASBOURG +++++;
TOULOUSE, SAINT-SERNIN ++; TOURS ++;
TROYES +++; VÉZELAY +

The cathedrals of France were the foundation stones of the Gothic age. Their origin lay in the division of Charlemagne's empire after his death in 814. West Francia and its capital of Paris were left surrounded by autonomous provinces, notably Normandy, Aquitaine and Burgundy but the city at the hub of trade routes across western Europe prospered and grew. In 987 Hugh Capet came to power as founder of the Capetian, Valois and eventually Bourbon dynasties, a family that was to rule France until the revolutionary republic was instituted in 1789. Under Capet and his successors over the 11th and 12th centuries this small area gave birth to one of Europe's most coherent and powerful states.

The growth of France coincided with three developments in European Christianity. The first was of monasteries, loyal to the papacy but outside the authority of local governments and the official church. Most influential was the house of Cluny founded in Burgundy in 910, over which towered the grandest of all Romanesque churches, now mostly gone. The second was the campaign for crusades to the Holy Land, the first and only successful one leaving France in 1096. The third was the cult of pilgrimage, primarily from France into northwest Spain and the shrine of St James at Santiago de Compostela.

Paris and its surrounding region were able to divert their wealth from the extravagances of war to those of civic and religious splendour. Towns sought to outdo each other in the scale of their rebuilt cathedrals, often oversize for their small settlements. Sens was constructed in the early 1140s, Noyon in the late 1140s, Senlis in the early 1150s and Soissons in the 1180s. Their builders were guided by the Gothic innovations under Abbot Suger at Saint-Denis in the reigns of Louis VI and VII. Suger declared light to be God's presence on earth and a church to be a shrine of that light. 'The dull mind', said Suger, 'rises to truth through that which is material.' By that he meant architecture so fashioned as to admit a maximum of light into the sanctuary and on to the altar. To this end a new style of church was required.

By the 1140s Suger had initiated the age of Gothic. Features such as the pointed arch, the ribbed vault and the flying buttress were not unknown at the time. They had been recorded by returning crusaders on churches and mosques in the Levant and were already used in Burgundy and in Sens cathedral south of Paris. A pointed arch transfers more weight directly downwards while a flying arch distributes it outwards, enabling vaults to be higher and windows bigger. As wall space shrank, stained glass replaced murals and mosaics. Altars became the focus of light, dramatically visible from the nave. Stimulated in part by the growth of the university of Paris and associated colleges at Laon and Chartres, the Paris region saw a building boom to match that of William the Conqueror in England a century before.

The true transformation came with the long reign of Philip Augustus (1180–1223), emboldened by his ejection of England's King John from Normandy in 1204 and his defeat of the Holy Roman Empire's army at the Battle of Bouvines in 1214. In Paris Philip built a new city wall and a citadel where now stands the Louvre. Cathedrals emerged into the High Gothic age with soaring vaults, ostentatious west fronts and spectacular rose windows.

The age saw a new nave at Chartres begun in 1194 followed by starts on Bourges (1195), Troyes (1200) and Reims (1211). Competition to erect ever higher vaults became manic. Where Chartres had been 37m, Amiens (1220) was 42m and Beauvais (1225) a record 48m. Flying buttresses flew ever higher. Gables over west portals erupted with carved leaves and pinnacles. The capacity of these churches vastly exceeded their local populations. They were works of both civic and episcopal vanity.

By the 14th century, French Gothic had grown ever more elaborate and, to later critics, overly lavish. Rayonnant evolved into Flamboyant, named for the sinuous form of a flame. Transepts rivalled each other in the span of their rose windows. Nemesis

was reached in 1284 when the vault of Beauvais choir fell under its own weight. This did not stop the chapter two centuries later erecting what was briefly the world's tallest tower, which also collapsed.

Within a generation the great age had passed. France's resources were diverted into the Hundred Years War with England, then weakened by the Black Death and conflict with Burgundy over the royal succession. French cathedrals saw a mild resurgence in the 16th century during the glittering reign of Francis I (1515–47). For a while, Gothic design cohabited with Early Renaissance, manifest in the exotic carving of choir stalls and altarpieces and in the Flamboyant façades of Martin Chambiges at Beauvais and Troyes.

In the 17th century's wars of religion, France sided with Rome. It saw Protestant uprisings from its Huguenot population. Cathedrals were widely vandalized and monasteries went into decline. This was aggravated by the secularization of the 18th-century Enlightenment. By the time of the French Revolution, the church could muster few defences against militant atheism. Cathedrals became 'temples of reason', though unlike monasteries few were actually demolished. Statues were less lucky. Almost all Notre-Dame's carvings were smashed, and church interiors acquired a nakedness that remains to this day. Even when the fury passed there was pressure to demolish seemingly derelict buildings, including Notre-Dame itself. Gothic architecture, France's glory, had few supporters.

Not until the long reign of Napoleon III (1848–70) did the French cathedral recover its panache. This was largely through the efforts of two men, a government inspector of historic monuments, Prosper Mérimée (1803–70), and a Gothic Revival scholar-architect, Eugène Viollet-le-Duc (1814–79). In 1838 the latter, aged just twenty-four, was commissioned by Merimée to begin what grew into a nationwide programme of church recovery and restoration. Though criticized for excessive zeal in his reconstructions Viollet-le-Duc rescued from almost certain loss Saint-Denis, Laon, Strasbourg, Vézelay, Carcassonne and Paris's Notre-Dame. France owes an incalculable debt to these two men.

Viollet-le-Duc's spirit lived on in the extensive salvage of cathedrals after the two world wars of the 20th century. Restoration tended to be more radical than in Britain, repair being seen as a creative act. The labour of Henri Deneux (1874–1969) in rescuing Reims did more than freeze ruins in time, it revived and put on view the design talents of the medieval masons and artists. Deneux's approach was replicated in the rebuilding of Notre-Dame after its terrible fire in 2019. France remains true to its noble inheritance.

ALBI
✣ ✣ ✣

Albi is a most unFrench cathedral, indeed from the outside a most uncathedral cathedral. The reason is simple. Its fortress-like appearance reflects the paranoia of the Catholic church in its conflict with Albigensian Cathars in the 13th century. In 1208 a crusade – better called a pogrom – against the Cathars was ordered by Pope Innocent III to suppress their heresy of dualism. This creed held there to have been two gods in contention, one evil and the other good, thus resolving the Christian 'problem' of the existence of evil. The Cathar crusade was in reality cover for the seizure of the Languedoc region by Philip Augustus in Paris. It was led by a ruthless warlord, Simon de Montfort (1175–1218), father of his English parliamentary namesake (1208–65), and lasted some twenty years.

The war and its resulting horrors would still have been in living memory when the new cathedral was begun in 1272 in the heart of Cathar country. Nothing was left to chance. From the outside, Albi is the medieval equivalent of a nuclear bunker, a silo of solid walls in places 3.5 metres thick, with only the

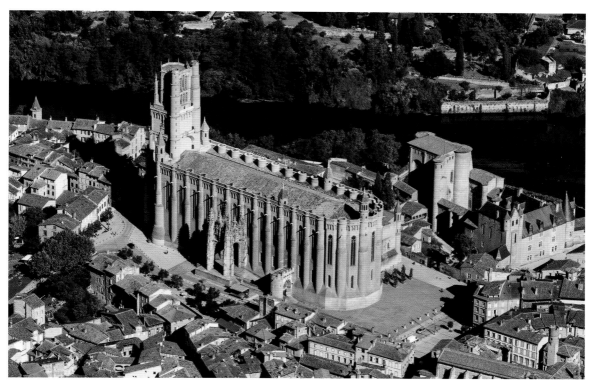

Albi: fortress in an alien land

narrowest slits for windows. The sole visual relief lies in the building being a soft pink colour.

Most extraordinary is the base of the walls, which slope outwards in what is called battering. This meant that projectiles dropped from battlements above would bounce outwards at attackers. Buttresses were also rounded to impede undermining by sappers. There are no transepts and no ornamental west front. This is effectively a military keep.

Entry today is into the south side, where between battlemented turrets is an almost apologetic Flamboyant porch, encrusted with filigree stonework. This was inserted in the 15th century in more peaceful times. Its doorway rises to a fishbone-patterned tympanum beneath a swirling roof. Only this portal and a picturesque octagon on the roof suggest a more civilized purpose.

The interior of Albi is no less unusual. An imposing nave is flanked by cavernous recesses,

twenty-nine in all, created by the walls' internal buttressing. Each contains a chapel beneath a continuous gallery under deep-set lancet windows. What might be a grim space is enlivened by polychrome murals executed by Italian artists in the early 16th century. The vault above is even more colourful, with gilded ribs and pictures of saints and zodiac signs in between. What could be grim is almost fairground jolly.

Albi's glory is its furnishings. The enclosed choir at the east end is virtually a church within a church, as if the clergy needed a final line of defence against invading Cathars. The chamber is bounded by delicate screens complete with a rood loft and rood figures, all dating from 1480. The figures in niches round the outside are of intense expressiveness, helped by retaining their medieval colouring.

The choir's 120 stalls form a dazzling ensemble, ranking among the finest in France. Carved arm rests

FRANCE

5

are backed by wooden panels beneath pinnacled canopies. Angels take the place of uprights. Beyond the choir is the sanctuary, another enclosed chamber also bounded by screens. Their openings are decorated with Flamboyant tracery that performs a wild Albigensian dance of curling shapes, attended by apostles in turbulent garb.

At the west end of the cathedral is yet more drama. The nave seats turn their backs on the choir and face two bulging internal walls, those of the two western tower piers. On them are the remains of a magnificent Day of Judgement by Flemish artists, still in good condition. It depicts one of the most horrific of hells. The terror on the face of one unfortunate woman writhing among devils might be funny today, but cannot have eased the souls of worshipping locals – which may have been the point. The mural was cut into by a colossal organ in the 18th century, its console raised on the figures of two muscle-bound giants.

Albi's aisle-less scale and sense of drama was said to be the inspiration for capacity-hungry architects of England's Victorian high church movement, giving rise to such churches as St Augustine Pendlebury and St Bartholomew Brighton, England's tallest nave. Next to the cathedral rises the equally fortified archbishop's palace. Albi was truly a church militant.

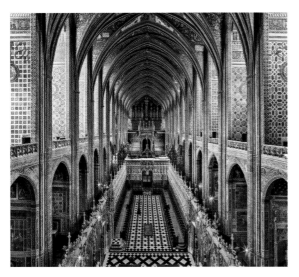

AMIENS

✥ ✥ ✥ ✥ ✥

Amiens cathedral is the supreme expression of France's golden age. I first approached it early one evening from the east. The light was dying and its massive outline was drifting into silhouette. Verticality was all, from the buttress pinnacles to the towers and the soaring flèche over the crossing. It was very dramatic and might have been the launch pad for a moon rocket, alone in the desert.

The cathedral, blessed owner of the head of John the Baptist, began rebuilding towards the end of the Early Gothic boom in the 1220s at the same time as England's Salisbury. Its architect, Robert de Luzarches, was bidden to outdo Chartres, Reims and indeed anywhere else. He created a vault higher than any in France at the time, and with a greater internal volume. The historian Émile Mâle said that, while Chartres, Reims and Amiens were together 'three moments of a single thought', it was Amiens that 'reached that point beyond which only the impossible lies'. To Ruskin it was 'the flower of Picardy'.

The exterior of the chevet is a summation of all that Gothic could offer in homage to height. Each buttress, with its panels, turrets and flyers, seems an independent work of art, though most are products of later reinforcements. Gothic engineering was here straining at the leash, and extra flyers were required to combat settlement. The buttresses are interspersed with crouching chapels.

The south transept has two buttresses flanking a lacy composition of Flamboyant rose window (c.1500) and an elaborate gable. In the portal stands a copy of Amiens' most precious work, a statue of the Golden Virgin. Here Mary twists her body while holding her baby on her hip, a stance that would

← Albi's fairground jollity
→ Amiens west front: faultless imbalance

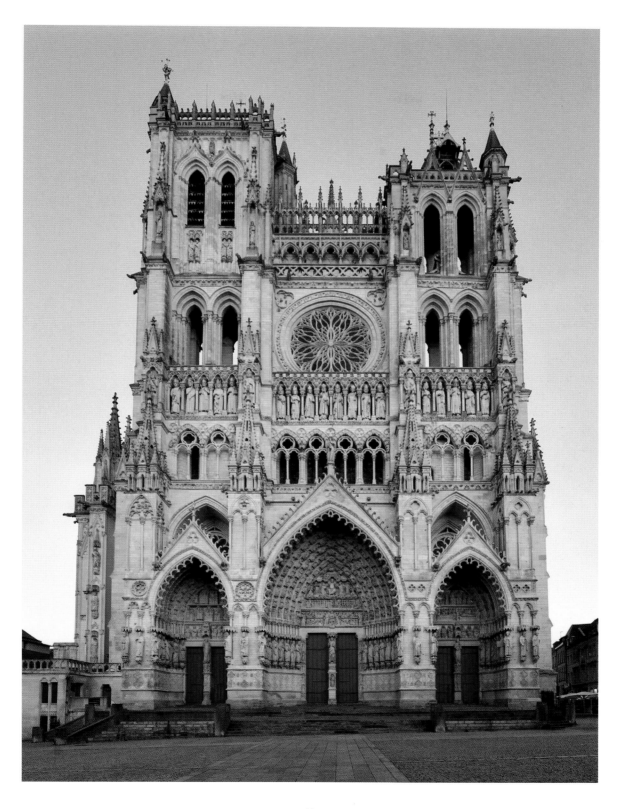

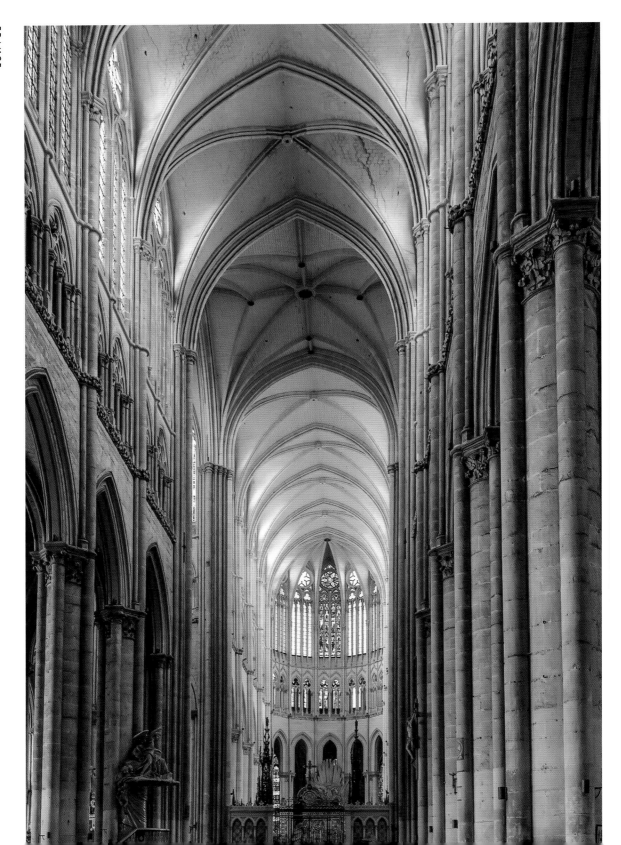

be copied across France at the time. The original is inside next to a pillar.

The west front is Amiens' masterpiece, the balance of its components faultless. Begun in 1220, the lower stage comprises the customary three doorways, their canopies projecting outwards, their bases crowded with statues. Four buttresses rise through a triforium arcade to a gallery of twenty-two life-sized kings. Above sits a later rose window of Flamboyant tenderness, like the petals of a flower. Such supremely original compositions make us realize how much scope Gothic designers had compared with their Early Renaissance successors, who had only to look at a pattern book and pick up where Classicism had left off.

The first impression of Amiens' interior ranks with Bourges in excitement. Height is stressed by a single shaft on each pier, rising uninterrupted from floor to vault, as if carrying a line of energy from the earth to the gates of heaven. The effect is enhanced by the scale of the nave clerestory, its windows filling the interior with light. We are watching France's 'Perpendicular' moment when Gothic walls start to disappear into windows. Yet, to give horizontality a lingering presence, Luzarches fashioned a garland of carved foliage to run above the arcade round the entire interior. I think of it as Abelard's line of reason.

As we move east, the crossing comes into view with a rise in spatial tempo. The transepts are so high they are like a second cathedral laid at right angles to the first. The clerestory slices light from every angle, while rose windows and their attendant lancets fill the end walls. In the crossing stands a Baroque pulpit, supported on effigies of faith, hope and charity. Cherubs draw back a curtain as if to reveal the preacher to the world. He would have to compete with the gesticulating angel overhead.

The apse has a central lancet window of singular narrowness, the only window still filled with coloured rather than clear glass. The absence of stained glass in most of Amiens is sad, though with a compensatory blessing of light. The choir itself is surrounded by a 16th-century screen with medieval tableaux of the lives of St Firmin and St John the Baptist. They retain their medieval colour.

A greater treat is the choir interior with oak stalls carved in the 1500s and offering an extensive narrative of Bible stories from the Creation to Christ, charmingly mixed with scenes of daily life in Picardy. Here are farmers, milkmaids, butchers, weddings, wives beating husbands, even the carvers themselves, apparently an astonishing 4,000 or so panels in all. The medieval church saw itself and its message as belonging to its community.

I was last in Amiens during its annual son et lumière, the most spectacular I have witnessed. Lasers lit up each element of the façade – arches, gables, niches, statues – and proceeded to play with them (see pp. xiv–xv). It brought out the geometric forces of the building, distorting them, collapsing them, rebuilding them, turning them inside out. Arches lurched forward and receded. The rose window exploded in a Catherine wheel of movement. As a crowning gesture we were shown the west front bathed in light, with the tiniest detail given its original colouring. This was Gothic architecture revitalized and galvanized, the apotheosis of one of the greatest cathedrals.

← The nave 'beyond which only the impossible lies'

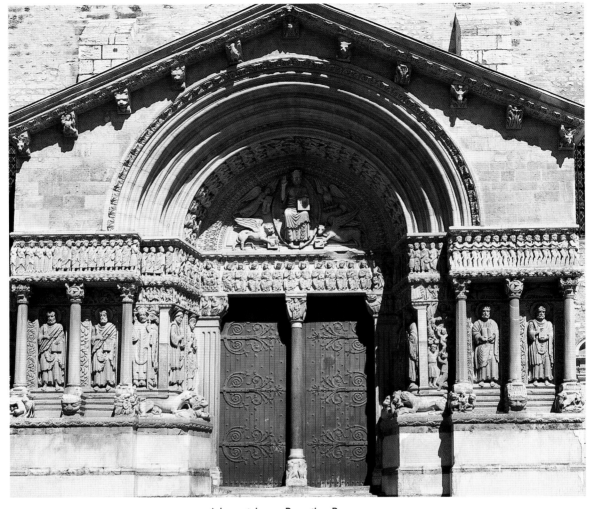

Arles portal: more Rome than Romanesque

ARLES

❖ ❖

Arles was the departure point for southern France's pilgrims to Santiago via Toulouse. Centuries later it saw another pilgrimage, by the artist Van Gogh, to create a Studio of the South in a city famed for the beauty of its women, where he was briefly joined by Gauguin. The first pilgrimage was to last four centuries at least, the second just fourteen months, reputedly because its women failed to meet expectations. Both yielded great works of art.

Arles is a rarity among French cathedrals in being discreet and unassuming. It sits in the town square and is overshadowed by a town hall on one side and the ruins of a Roman amphitheatre up the street behind. Its most intriguing feature is its west façade. Dated around 1100 but apparently adapted from an early basilica, it is a Romanesque design that looks truly Roman. It is in the form of a triumphal arch, decorated with animal corbels, a pediment and a

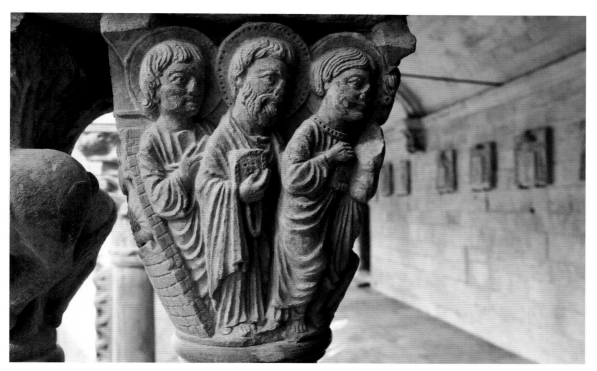
Cloistered apostles

hemispherical door arch. In the tympanum is Christ in majesty, flanked by the four evangelists with twelve apostles below. A frieze round the entire work shows queues of the blessed to the left and the damned to the right, heading for their respective fates. They are attended by elongated statues of saints, Romanesque in their stiff but moving tranquillity. Most rest on lions. The composition is heavily restored.

The white stone interior is a surprise. A high but narrow nave rises on square piers with exceptionally small side aisles barely 1.5 metres across. Above is a barrel vault. The lofty effect is exaggerated by the transept arch covering half the height of the nave and carrying a large 17th-century painting of the martyrdom of St Stephen. The choir beyond in the same white stone is much later, 15th-century Gothic. The walls throughout are warmed by Aubusson tapestries of the life of the Virgin.

Among the cathedral treasures are three Roman sarcophagi in the north aisle and transept, the earliest I have seen in any church. One apparently of the 4th century shows the crossing of the Red Sea with the water rising to impede the pursuing soldiers. Another has a gallery of Roman characters in togas and sandals. The Chapel of the Holy Sepulchre houses a 5th-century relief of a local Roman governor, pledging obedience to a Roman-looking Christ. The Chapel of the Relics contains a collection of pilgrimage trinkets reminiscent of London's Portobello Road market.

Arles' cloister is second only to Moissac's as a gallery of Romanesque sculpture. It lies surrounded by an episcopal enclave of chapter house, refectory and dormitory, with a roof terrace from which the town's red-tiled rooftops can be admired. The cloister itself dates from the 12th century, its sides composed of double-columned openings, whose capitals and side panels are a cornucopia of carvings.

Religious and mythical themes include a menagerie of wild beasts, luxuriant vegetation and

abstract patterns. Biblical themes embrace a medieval encyclopaedia of kings, angels, Last Suppers, Palm Sundays, stoned martyrs and slaughtered innocents. My favourite is a capital of the Three Magi packed tight in a bed, receiving instructions from the Angel Gabriel on how to get to Bethlehem. The guide points out that many of the cloister images are Roman survivals. This is a magical place. I confess I spent longer in the cloister of Arles than in the nave of Chartres.

AUCH

✣

The cathedral rises proud over its hilltop town, looking out over the Gers valley west of Toulouse. It was the site of a Roman church and later a stop on one of the pilgrimage trails to Spain. Auch was mostly built in the Late Gothic style in 1489 on the threshold of the Renaissance, but the west front of 1685 is a Classical composition fit for a church in Rome. It is composed of two square towers facing the central square in the form of Classical pavilions with pilasters and attached columns.

The Gothic nave is reminiscent of English Perpendicular. The aisles are doubled, containing evenly spaced Baroque chapels round the entire interior, each with an identical retable as if from a production line. The Chapel of Compassion is panelled with nine relief depictions of the passion of Christ in marble Renaissance settings. Most charming are the clerestory windows with 17th-century glass. One of them celebrates the local fruit, the Auch pear.

Auch has two treasures. The first is a set of eighteen windows in the choir chapels designed between 1507 and 1513. They show the Bible story from Adam to the Resurrection in colourful detail set against local buildings and landscapes. Christ's gaze on Mary Magdalene at the moment of *noli me tangere* is of remarkable intimacy. It is a joy to find such masterpieces buried in the French countryside.

Equally remarkable are the choir stalls by an anonymous master and on a par with those of Albi. They are dated to the mid-16th century with 113 stalls over two tiers totalling a reputed 1,500 scenes. Most are Christian or mythological though some depict domestic scenes beloved of medieval carvers. One shows a woman with her head on an anvil being hammered by blacksmiths. Elsewhere semi-naked women are shown contorting in agony or perhaps ecstasy. Adam and Eve look faintly Polynesian, while Noah is splendidly dressed in his ark. The choir is enclosed by a sumptuous Baroque screen, a stylistic banquet worthy of a Venetian palace.

↑ Garden of Renaissance Eden
→ Auch: illusions of Roman grandeur

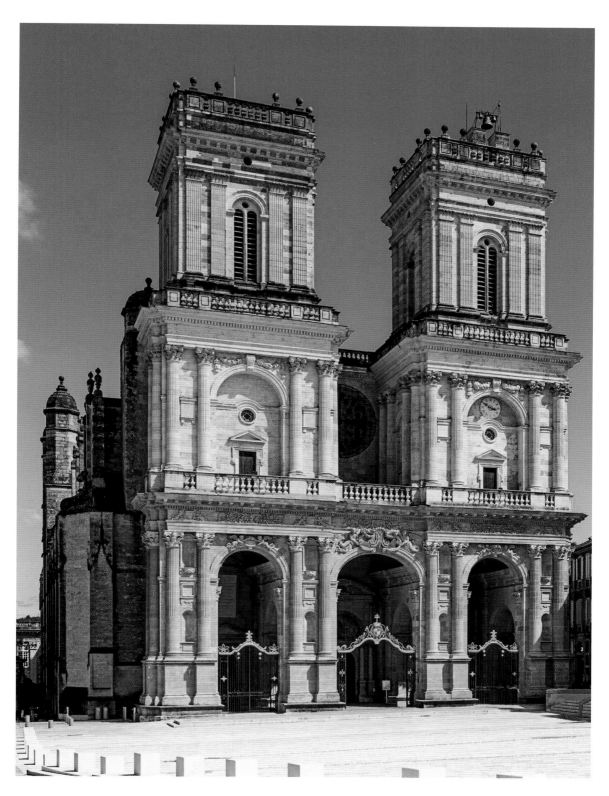

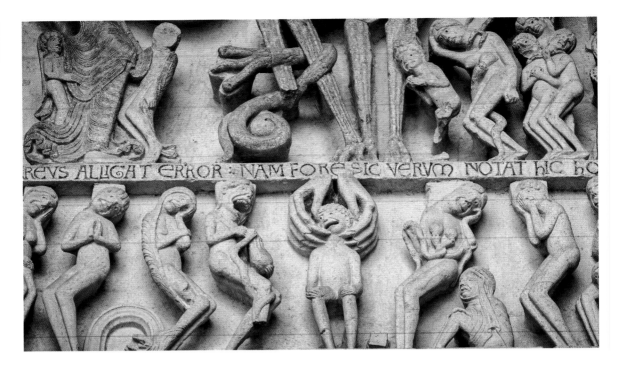

REVS ALLIGAT ERROR · NAM FORE SIC VERVM NOTAT HIC HO

AUTUN

✣

The town of Autun lies hidden in the Burgundian hills of Morvan. It seems to have fallen asleep. Roman ruins litter the fields. Roads are empty. Yet here in the 12th century worked a sculptor with a talent out of his time named Gislebertus, probably from neighbouring Vézelay. It is sad to know so little of these great artists, Gislebertus here identified only by his signature. He is one of those medieval figures I would love to meet.

Autun, the first stop on the pilgrimage route from Vézelay, was begun c.1120 and completed by 1146. Its exterior is unremarkable, though it has a pretty 14th-century tower with a crocketed spire. Attention is focused on the west doorway. This displays none of the pyrotechnics of celebrity west fronts. Steps rise to a door of no distinction other than its famous tympanum of the Last Judgement.

This work by Gislebertus of the 1130s is clearly the product of an individual, almost surreal imagination,

a foretaste of Hieronymus Bosch. St Michael weighs souls while devils try to fiddle the scales in favour of damnation. St Peter has trouble keeping crowds out of heaven. The damned are outlandish, etiolated figures holding their heads in their hands, lined up like an agonized corps de ballet. Impurity has her breasts seized by serpents. Avarice is being strangled by his sack of gold. One figure has giant hands seizing him by his throat as if to stop him talking.

The nakedness of some figures was considered so rude that in 1766 the Autun canons had the tympanum plastered over. Other than damaging Christ's face this preserved the composition until it was uncovered in 1837. The three surrounding arches carry signs of the zodiac interspersed with such labours of the month as threshing corn and treading grapes, a calendar of the working year. All medieval life is in this carving.

The interior of the cathedral, its stone recently restored to a gleaming white, appears to have been inspired by local Roman remains. The fluted pilasters

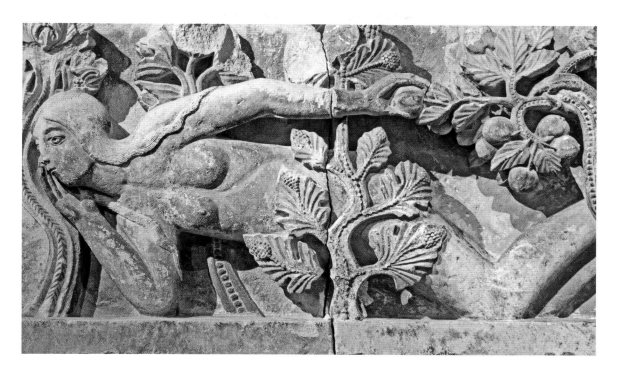

and the triforium arcade are those of a Classical temple. The piers are squared rather than round. Only the upper level of the eastern apse is of the Gothic period, serene and hardly out of key with the nave.

Once again, our attention turns to the carvings, this time on the nave capitals and apparently also by Gislebertus. They are if anything even more gruesome than the western tympanum. Each illustrates a Bible story, myth or sin. One shows a character called Simon the Magician trying to fly to heaven but crashing to the ground in front of St Peter, an eye bursting from its socket. A cackling devil looks on. Another shows Noah's ark on Mount Ararat, another depicts the antics of the 'fourth tone of music', allegedly that of sadness.

A number of the capitals have been removed to the chapter house off the south-east corner of the nave. They include the popular carvings of the Flight into Egypt, a ghoulish hanging of Judas, and Three Magi in bed with an angel. In the Rolin museum across the square is a panel depicting the Temptation of Eve, found in a local house after being sold as building material. With her sinuous body and flowing locks, she was the first known nude of the post-Classical era. Her partner Adam is lost but reproduced in a pair of alabasters surviving in Japan, remarkable in their eroticism. She puts Gislebertus in the first rank of European sculptors and later as an icon of the Art Nouveau movement.

The French statesman Talleyrand (1754–1838) began his career as modest bishop of Autun. He spent just three weeks in the town before moving on to higher things. As he paraded the palaces of Paris, London and Vienna I like to think of him being received in state back in simple Autun.

↖ Damnation Romanesque style
↑ An Eve for all time

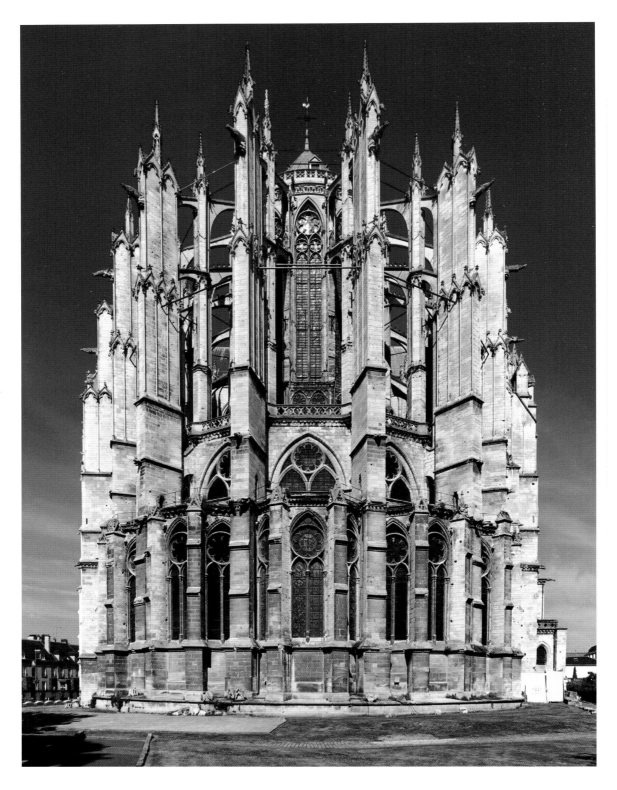

BEAUVAIS

✛ ✛ ✛

The vaults that rose over the churches of France in the 13th century had one aim, to be higher than any others. As France's towns grew in size and wealth their bishops were princes in a competitive world. One bishop of Beauvais, a noted warrior, personally felled England's Earl of Salisbury at the Battle of Bouvines in 1214. Three years later his successor Milon de Nanteuil decided to build from his own resources a cathedral higher than any in Europe.

The choir was begun in 1225 and at 48m was taller even than Amiens (42m), and twice the vault height of England's contemporary Salisbury cathedral. The choir without a nave was completed in 1272 and stood massive and alone, towering over the Picardy countryside. Twelve years later part of the vault failed, precipitating a crisis among French masons. Had they reached the limit of what Gothic engineering could sustain? No one attempted to outdo Beauvais, but a century later the ruined vault was rebuilt and a century after that in 1548 a crossing and transepts were erected to designs by the Flamboyant master Martin Chambiges of Paris (1460–1532).

Canonical ambition remained unsated. Later in the 16th century, Beauvais' chapter decided that rather than build a nave they would once more outdo Christendom, this time with a tallest tower. Topped out at 145m in 1569 it was probably the tallest structure in the world. Four years later the piers gave way and the tower fell, just after a congregation had left the building. The entire town shook. So dangerous was the ruin that a condemned man was invited, instead of facing execution, to complete the demolition. He narrowly avoided death in a further collapse.

The tower was not rebuilt, and when a start was

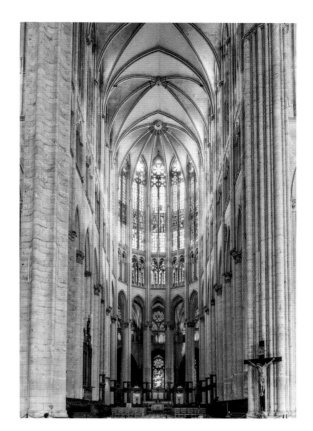

finally made on a new nave, that too collapsed. To many observers, God was telling Beauvais enough was enough. An earlier Romanesque cathedral dating back to 991 and reusing Roman bricks still stands defiant on a site next door. It cowers beneath the abandoned west wall, pointing a moral to architectural arrogance.

Beauvais has ever since been a laboratory for students of Gothic engineering. Rods were inserted to hold it together and then hurriedly removed for making the structure too rigid. The interior is a jungle of beams, braces and girders, rushing everywhere to lend support as if in an architectural A&E department. New York's Columbia University has taken on the task of monitoring every shifting centimetre.

For all that, the cathedral is an astonishing sight. The exterior displays what we might call a desperation of buttresses, crowding round the choir from

← Beauvais: a desperation of buttresses
↗ The choir: height at any price

every angle and rendering it near invisible. They are an extraordinary sight, well illustrating Ruskin's contention that in a Gothic cathedral the exterior is on 'the wrong side of the stuff'. Such was the fear of further collapse that no other building has been erected within a hundred metres of it. Chambiges' later south transept is magnificent, a riot of Flamboyant decoration. The doors carry Early Renaissance reliefs of the lives of St Peter and St Paul.

The interior is both a shock and a sensation. There is just a transept and apsidal choir, the latter a stupendous essay in Gothic height. Its ground-floor arcades are elongated upwards, with behind them an ambulatory and circuit of chapels, mostly later insertions to add strength where needed. Above the arcade rises an elongated triforium and clerestory, the latter like a tent floating on air. The composition is undeniably beautiful. Beauvais has fine stained glass, from the 13th century in the choir to the 16th century in the transepts.

Fragments of the old episcopal town survive round about, including the chapter house and cloister next to the remains of the 991 church. Two towers across the square belong to the old bishop's palace, erected to defend it against a mob which rose up to decry the incumbent's extravagance in 1305.

Beauvais has always evoked mixed emotions. To Viollet-le-Duc it was 'the Parthenon of French gothic'. To the cathedral historian Francis Bumpus it was 'defective and unpleasing … like a head and arms flung out in despair, an appeal for ever ignored by heaven'. To me, Beauvais is the ultimate in Gothic audacity, the cathedral as a monument of worldly splendour, felled by hubris. Nothing of such a height was ever attempted again until the 19th century, also an age of grandiose ambition.

→ Ambulatory: a pattern of diving arches
↓ Bourges west front: architecture as theatre

BOURGES
✤ ✤ ✤ ✤ ✤

Bourges challenges Amiens for primacy among the cathedrals of northern France. The archbishop of Bourges in 1183, Henri de Sully, was brother of the bishop of Notre-Dame in Paris, begun thirty years earlier. Given the identical height of the two churches and the fact that both lack transepts, it is hard not to see Bourges as an imitator of Paris. But where Notre-Dame was still plodding the path out of Romanesque, Bourges is Gothic at full throttle. To Balzac, 'All Paris is not worth the cathedral at Bourges.' From its inception in the 1180s, thus probably predating Chartres, cathedral builders across Europe sent emissaries to learn its techniques and borrow – or poach – its masons.

Whether to approach from the west or the east is a fine debate. I prefer the west for decoration, the east for engineering. The latter view from the old bishops' garden displays the curious rhythm of the paired buttresses. Twenty-eight in number, they seem to leap playfully over their chapel roofs. It has been calculated that each is less than half the weight of those of Notre-Dame de Paris, yet for a higher vault.

Like Paris, Bourges is a single chamber with two western towers and no projecting transepts. Its lancet windows show Early Gothic tending towards Rayonnant as they progress west along the nave wall. The south doorway is a surviving fragment of a Romanesque predecessor, round-arched and with simple sculptures of Christ accompanied by evangelists, apostles, prophets and kings.

Bourges' grandiloquent west front has been criticized for failing to discipline its massive buttresses. Six of them frame the five doorways, as if reaching out to seize passing worshippers. They are beautifully proportioned, throwing the doors and window recesses into deep relief. Lit at night, the front presents a dynamic eruption of cliffs and canyons, one of medieval architecture's great set pieces.

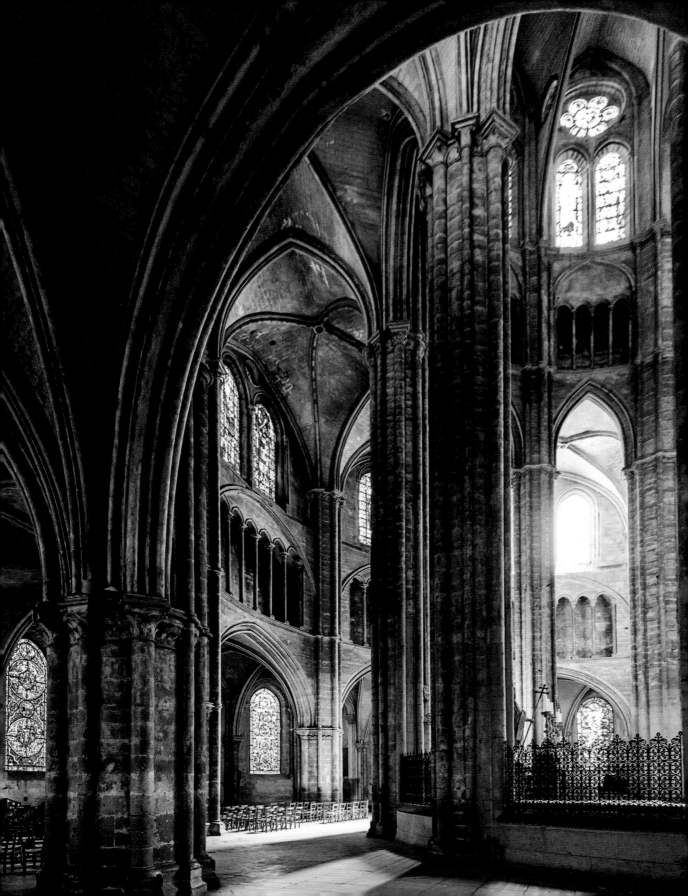

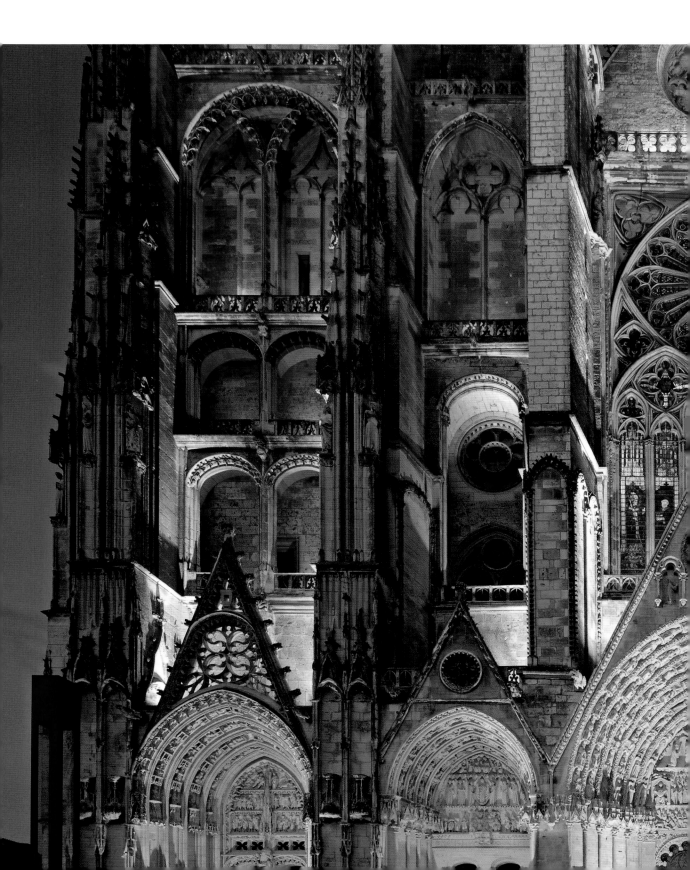

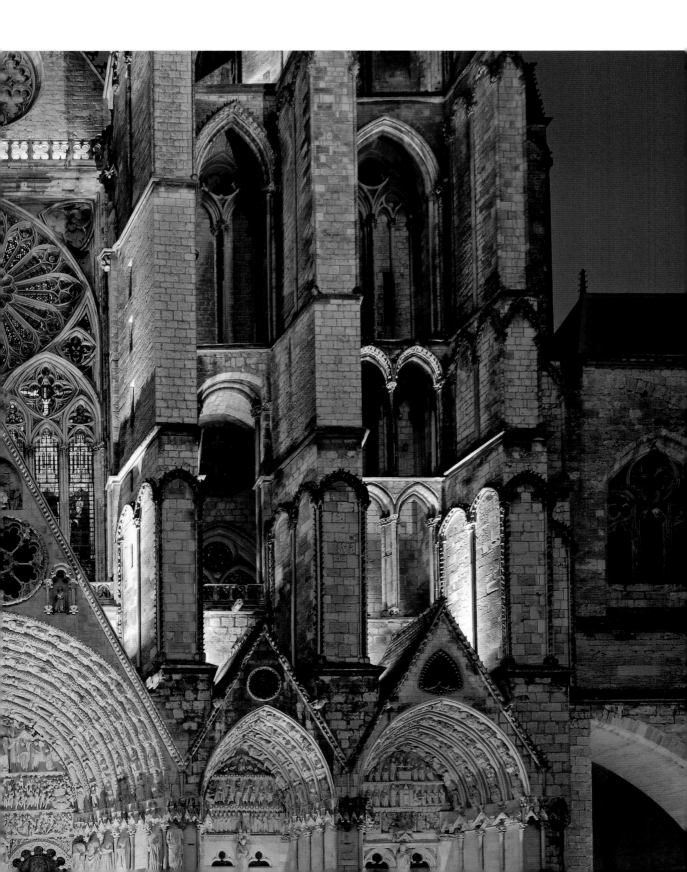

The iconography of the portals is familiar. The side doors are devoted to the Virgin, St Stephen and two local saints, Ursin and William. They contrast with the earlier stilted formality of Chartres. The figuring is vital and explicit. The Day of Judgement message is crude: obey the church and you win a bevy of smiling virgins, disobey and you boil in a vat of oil. St Michael magnanimously snatches an infant back from a devil carrying it off to hell.

Below is a strip cartoon of the Resurrection, its theological relationship to the Day of Judgement above unclear. All the figures even of the saved are naked, except for a bishop whose dignity required him to keep on his cope and mitre. At Bourges as elsewhere I crave to see these extraordinary tableaux in the colours intended by their creators.

The interior of Bourges is an uncluttered masterpiece of French Gothic. Comparing it with its contemporary at Chartres, the Gothicist Jean Bony goes conceptual: 'The master of Chartres was concerned for the structure of his solids, that of Bourges for the relationship of his spaces.' The absence of transepts gives the interior a spatial unity. The nave arcades, among the tallest in France, are composed of uninterrupted piers soaring from ground to vault attended by tubular shafts rising in elongated fronds. As they rise they reveal two rows of flanking aisles, each high enough to have its own clerestory as if a miniature nave. Their vaults are likened by Bony to billowing sails.

The nave progresses magnificently towards the distant choir. The lancet windows, as yet without tracery, seem clean and serene. It is hard to exaggerate the visual delight and ingenuity of this work. The stained glass is superb throughout, dating from the 13th to the 17th centuries.

The finest is in the ambulatory, where we stand enveloped in medieval colour. The Good Samaritan window has the parable down the centre, with its theological interpretation down either side, a sermon in glass. Later windows are in the side chapels, including a lovely Annunciation, sponsored by a 15th-century merchant, Jacques Coeur. Much

pleasure can be had by searching the lower panes for symbols of these donors, such as weavers, carpenters, wheelwrights and others. Beneath lies a fine Romanesque crypt surviving from the earlier church.

By the 17th century, the windows towards the west end of the nave are more like Renaissance paintings, single compositions with landscape backgrounds rather than kaleidoscopic vignettes. The west rose window was earlier, donated by Burgundy's most celebrated aristocrat and artistic patron, Jean Duc de Berry (1340–1416). His manuscript volume, the *Très Riches Heures*, includes an illustration of Bourges and even its patron's window, depicting a period when, despite the Hundred Years War with England, France seemed bathed in prosperity and order.

CARCASSONNE
⁘

I enjoy Carcassonne, but admit to finding it somewhat eerie. The town is not so much a restoration of a medieval predecessor as a 19th-century creation of a new one by the ubiquitous Viollet-le-Duc, imagining how such a town might have looked. He rebuilt a semi-derelict ruin in 1853 after a period when France had indulged in an orgy of destroying its past. He wanted to remind his countrymen of what they were losing. Those who cannot see Carcassonne without mentioning Disneyland merely show how accurate both were in appreciating the public's enthusiasm for the antique.

The modern cathedral is in the newer town and the old one described here is now called the Basilica of Saint-Nazaire. Like its neighbour Albi, it has characteristics of a fortress deep in Cathar territory. The exterior displays two building periods. The earlier west end was built into the wall of the old town and is a windowless façade of stone. The 11th-century Romanesque nave has minimal windows and an entrance in the north wall devoid of decoration.

At the east end 13th-century Gothic takes over with

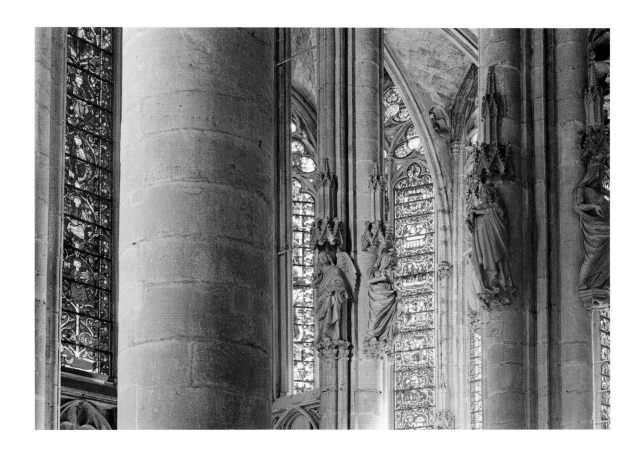

a complex plan of two transepts, choir and side chapels. Here the exterior walls are filled with generous Rayonnant windows, supported by buttresses and adorned with gargoyles. The interior vividly reflects the separate periods of construction. The nave is cool Romanesque with piers rising to capitals of animals and plants beneath simple arches and a barrel vault. There is no clerestory. A change of key comes with the later crossing. The location of chapels in the angles of the transepts and choir has a dramatic effect, with walls seeming to dart in all directions. The shallow apse of almost continuous windows gives the cathedral a pleasant sense of intimacy.

Carcassonne is rich in glass and sculpture. The apse glass is regarded as the finest in the south of France, of the 14th and 15th centuries depicting the life of Christ and of St Peter and St Paul. The sculptures on many of the piers are remarkable in being carved directly into the columns themselves. In the north transept is a polychrome *pietà*, with Christ's body dominating the figure of Mary.

More striking is a 16th-century sculptor's depiction of the Trinity. It shows God as an old man, with Christ on the Cross between his knees and a dove coming out of his mouth. Against the wall in the south transept stands a monument to the warlord Simon de Montfort, scourge of the Cathars in this region during the Albigensian crusade of the 13th century. It is surprisingly intact.

↑ Sculpted columns at Carcassonne

CHARTRES

✣ ✣ ✣ ✣ ✣

Chartres is the celebrity capital of the Gothic age. The worship of the Virgin Mary may have dated back to Hagia Sophia and Eastern Orthodoxy, but it found its most intense upsurge in 12th-century France. The mother of Jesus served as an antidote to a world fixated on military valour, cruelty and war. Henry Adams, in his comparative essay on Mont-Saint-Michel and Chartres, called her cult the 'greatest force the western world has ever felt' since the advent of Christianity itself.

Within easy reach of Paris, Chartres was already home to a precious Marian relic, the chemise worn by the Virgin at the time of the Annunciation. Its bishop Geoffrey of Lèves (d.1149) was a leading player in France's 12th-century intellectual revival, when theology was married to the liberal arts and the study of the classics. The three great portals of Chartres, west, north and south, are symbols of this early French renaissance.

So many medieval churches were born of fires

it was sometimes said they were God's way of expediting home-renewal. A fire at Chartres in 1134, which the Virgin's chemise miraculously survived, destroyed the cathedral's west front and Geoffrey duly reconstructed it in the still-prevailing Romanesque. A second fire in 1194 left only this front standing, by which time the Gothic revolution was in full cry. Chartres thus records the transition between these two great languages of medieval architecture.

This is first signified in the two western steeples. That on the south-west corner begun in 1145 is severe Early Gothic emerging from a Romanesque base. The north-west steeple is a contrast, with the Romanesque base of 1134 giving way to a Flamboyant Gothic steeple of 1513. Though standing at opposing ends of the Gothic period, the two towers still contrive to speak to each other.

Between them stands Chartres' centrepiece, its west façade, essentially a work of 12th-century

pre-fire Romanesque. The central tympanum depicts Christ familiarly attended by evangelists and apostles. The tympanum to the right depicts His life on earth with scenes from the Bible. The arch contains images depicting the liberal arts of scholastic Chartres, the trivium of rhetoric, grammar and logic and the quadrivium of astronomy, arithmetic, geometry and music. Music chimes its bells, grammar wields a book and a birch, Euclid traces his geometry and Aristotle – or some say Pythagoras – bends over a desk. The doorway to the left depicts Christ's Ascension, here surrounded by the labours of the earth and seasons of the year.

These three doorways thus celebrating Christ, scholarship and labour are flanked by elongated and distorted New Testament figures rising up the columns. These icons of Romanesque art remain in the stiff formalized style of the pre-Gothic era, yet I see them as bidding us remember the old guard as we progress inside to the wonders of the new.

The rest of the post-1194 exterior of Chartres seems determined to compensate for the relative plainness of the west front. Both north and south transepts are still transitional, repeating the west front's tripartite doorways but in a richer and livelier decorative tradition. The themes are mostly familiar, though the south doorway carries an extraordinary sequence of admonitory carvings depicting demons tempting decent Christians to sin.

The interior of Chartres is 1190s High Gothic in all its glory. The nave elevations are liberated from Romanesque solidity. Piers soar from floor to roof, aided by clinging shafts drawing the eye upwards to Chartres' defining masterpiece, the clerestory windows. Here is the triumph of Suger's space and light over mere materials, especially evident as we move forward down the nave to reach the crossing in an explosion of light. The multiple shafts of the transept piers seem to quiver as they rise.

The apse is beautifully proportioned, serenity everywhere sustained. Here early in the day we can follow the sun's movement over the shifting volumes

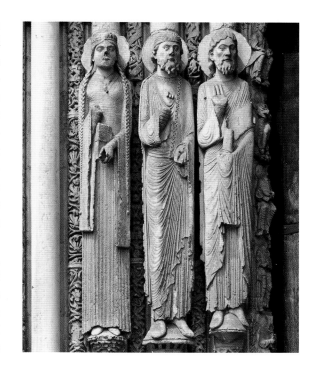

of the interior, an effect enhanced by the simplicity of the lancet windows. The final glory is the screen round the choir, begun by the same hand, Jean de Beauce, as the Flamboyant north-west tower. It depicts some two hundred figures in full relief and took more than two centuries to complete. The final carvings are in full Renaissance costumes. The sculptor Rodin remarked that, each time he saw the screen, 'I set myself to study it as if I were seeing it for the first time.'

Perhaps Chartres' greatest treasure is its surviving glass. The mostly medieval vignettes require a guidebook in themselves to take us through this illuminated missal in the sky. While their subject matter can be hard for the casual visitor to discern – at least without a biblical encyclopaedia – their overall effect is extraordinary. They suffuse the whole interior with shades of blue, radiant, dignified, sombre, perhaps even sad. Chartres is a rare building that is said to reduce pilgrims to tears.

↖ Rodin's inspiration: the Flamboyant choir screen
↑ The old guard: elongated Romanesque

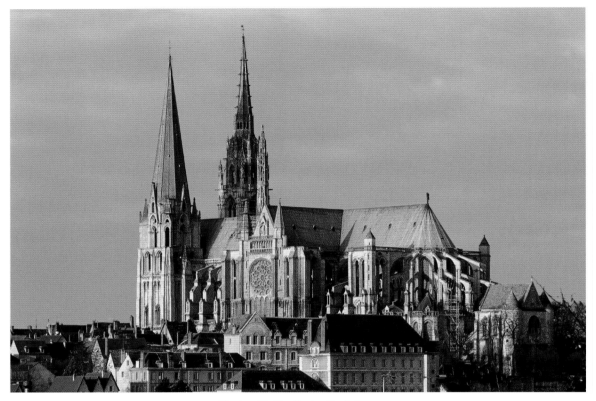

Chartres: Gothic afloat on the skyline

The 173 surviving windows were donated by over forty guilds, as well as assorted merchants of the town. At the foot of the windows can be discerned the emblems of drapers, cobblers and stonemasons. Outstanding subjects include the Blue Virgin in the south ambulatory, the Charlemagne window in the north and the early Jesse window in the west front. The transept rose windows are described by the writer and lover of French cathedrals Ian Dunlop in his essay on Chartres as having 'the loveliness of a water opal and the complexity of a snowflake'.

The cathedral's 2019 interior restoration was and remains controversial, rendering its nave walls in white while leaving the transepts smoky dark. In the process the so-called 'black Madonna' emerged not as black at all but white. To critics this creation of a contrast between parts of the interior was incorrect and unfortunate. But this is a minor complaint.

Chartres ranks with Amiens and Bourges as a signature experience of European culture.

COUTANCES

❖

Students of France's history know never to treat it as one country, least of all when in Normandy. Coutances became 'French' only with the loss of Normandy by King John of England in 1204. My mother was a child of Guernsey, so I felt strangely at home when told I could see the Channel Islands from the tower of Coutances cathedral. They are nearer than any French city and once even shared a diocese. It remains one of my favourite corners of Europe, those that are on the way to nowhere.

Lady Chapel: polychrome restored

A new cathedral was begun in 1220 in a style dutifully deferential to its new rulers in Paris. Its three towers are overpowering for a town of its size. It reminds me vaguely of Don Quixote on his steed looking for a windmill to attack. Viollet-le-Duc was also impressed, remarking that a central tower (as was common in England) was rare in France. The cathedral was lucky to survive the Normandy landings in 1944 which flattened virtually the entire town.

The view from the east is of chevet roofs with three tiers of flying buttresses. The central tower now deprived of its spire is heavy and the exterior unadorned but for the two west towers. Their spires are visible for miles around, coated in blind arcading. The west front is austere, its doorway topped with a screen of gables pierced by trefoils and quatrefoils.

Coutances' impressive interior suggests an alien culture eager to make a point. The nave is a Gothic overlay of a Romanesque predecessor with composite piers that seem too bulky for their purpose. Double aisles permit shafts of light from large windows to penetrate the nave from all angles. At the crossing the piers become manic bundles of shafts, straining to support the octagonal tower overhead. The transepts have no rose windows – perhaps the town lacked rich sponsors – and are illuminated by simple

lancets. The view inside the octagon lantern is superb, rising to a lofty gallery under a sixteen-ribbed vault, apparently supported by nothing but its windows.

The choir is contemporary with that of Le Mans, a simple hemisphere of round columns with the vault pierced by clerestory windows. Below is a double ambulatory, the 13th-century mastery of space at its loveliest, while the Lady Chapel retains its original colouring, a rare example of a Gothic interior as its designers intended. The most distinctive memorial is a chapel off the north transept dedicated to Thomas Becket. It was erected by the builder of the cathedral, Bishop Hugh de Morville, whose uncle of the same name was one of Becket's murderers. It is said de Morville died 'giving proof of a deep repentance'. A stained-glass window helpfully depicts the murder.

LAON

✣ ✣ ✣

Laon at first sight is a bruiser of a cathedral. Its five towers sit pugnacious on a limestone ridge overlooking the plains of Champagne, site of an early Frankish city before the rise of Paris. The building was mostly the creation of one man, Gauthier de Mortagne, a champion of France's 12th-centry renaissance and bishop of Laon from 1155 to 1174. Building commenced on his arrival, and was completed to his plan by 1220. Its west façade evokes the climax of Romanesque architecture at the dawn of the Gothic age.

The west front is a confident composition. The ground floor is occupied entirely by three giant portals under round arches projecting forcefully from

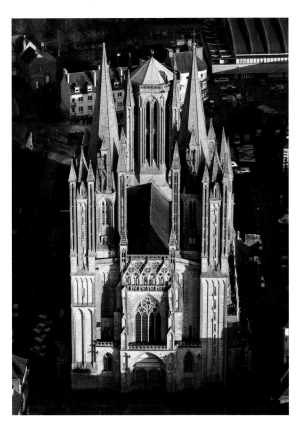

Coutances: Don Quixote on his steed

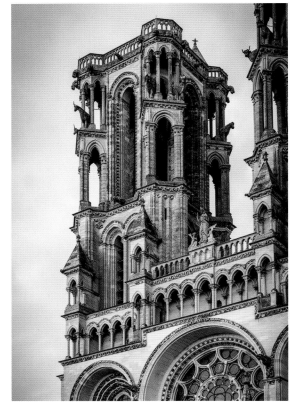

Laon's mystic oxen on display

the façade. In a bright light these form welcoming canopies, in a dark one ominous caves. Above each of the bays is a corresponding window, their arches crowded with human and animal faces.

The two west towers rise like elegant cake-stands. Each tier has an open portico on its corners rendering them Classical in appearance. On each corner is a statue of an ox. This honours the beasts that are said to have emerged from nowhere to haul the stones uphill for the start of the building and then vanished. Two similarly decorated towers crown the transepts. Most distinctive is the way Laon's towers all seem to project and retreat depending on the angle from which they are seen. It is a most curious cathedral, as if Romanesque was striving after the Baroque before its time.

This could not be less true of the interior, built now in the transitional Gothic. The nave arcades rest on rounded piers above which clustered shafts rise to a rib vault. An unusually spacious gallery allows a perambulation round the interior at first-floor level, a walk through a glade of columns, capitals and vaults all flooded with light. These galleries would have housed choirs on ceremonial occasions.

The transepts are clear of ornament and harmonious in style, lit by large rose windows. The chancel beyond is most unusual for France in extending for a full ten bays but with no culminating apse. The cathedral's east end is flat with a rose window set above three lancets. Where the eye expects a receding apse is only a squared wall. We are so used to French apses that this is almost an anticlimax.

Laon was stripped of its furnishings in the Revolution and appears even emptier than most French cathedrals. This makes the surviving glass

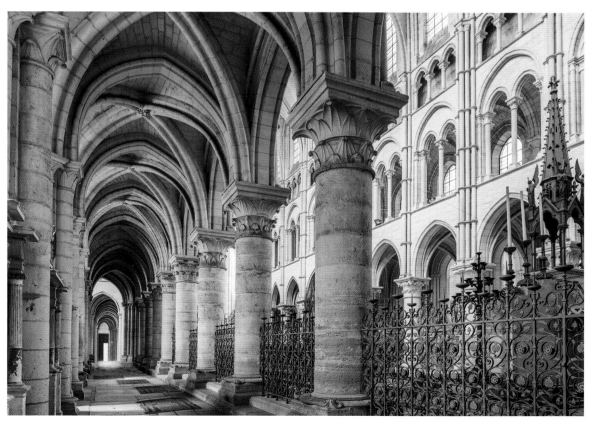

The nave: muscular transitional

the more prominent, chiefly in the rose windows and lancets. The rose in the north transept recalls Laon's scholastic tradition in the 12th century, depicting the same liberal arts as are celebrated at Chartres. They are arranged in a circle, round the central figure of philosophy. One curiosity is that here grammar is depicted as a lady gently showing a pupil a book, whereas at Chartres she is thrashing him with a birch. I would have sent my offspring to Laon. The choir screen is of exceptional 18th-century metalwork.

The cathedral lies atop a hill that retains many of its medieval church buildings, including a cloister, chapter house and the oldest hospital in France, now a tourist office. They commemorate a moment in Europe's history when this corner of France was briefly a citadel of learning.

LE MANS

✥ ✥ ✥

To most people, Le Mans is a motor race. To me it is a choir. The 11th-century town lay in the province of Maine which was then part of Normandy. In the 1080s it is recorded that William the Conqueror (of England) objected to an earlier cathedral overlooking his chateau. It was the first case of nimbyism and, as so often, his protest was overruled by the developers, here the church.

The town was later the birthplace of Henry II of England, son of Geoffrey of Anjou and Matilda. The cathedral was rebuilt following a fire in 1134, its nave still in the Romanesque style we should here (as in England) call Norman. Following the loss of Normandy by King John in 1204 a new cathedral was ordered and in the 'French style'. This was begun in 1217 and completed in 1254, creating one of the loveliest east ends in France. New transepts followed in the 14th and 15th centuries. Le Mans is thus three distinct cathedrals in one, a catalogue of styles and a delight to the eye.

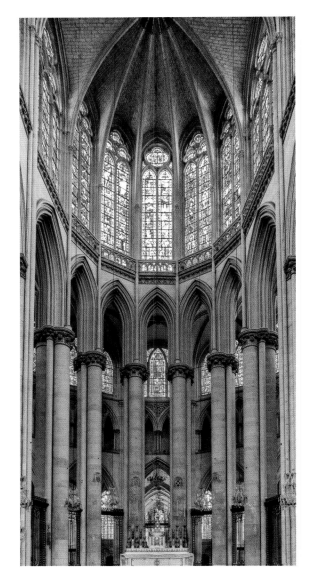

The Romanesque west front is unimpressive. An entrance in the south wall of the nave has a porch and Chartres-like statues of saints. The nave interior is late Romanesque with capitals portraying human faces and birds, notably owls, peeping out from behind acanthus leaves. The windows retain some 12th-century stained glass.

↑ Le Mans choir: Gothic with a height complex
↗ Metz: High Gothic Chagall

The builders of the new choir in 1217 seem determined to outshine those now rising round Paris. The buttresses are almost desperately numerous, so that the chevet appears embattled by a cohort of pikemen, their spear-like pinnacles waving in all directions. A semicircle of thirteen uniform chapels each with its own roof and miniature apse peer out from between the legs of the buttresses.

The transepts and south tower proved a crippling expense and were not finished until the turn of the 15th century. By now Gothic walls were largely in the hands of glaziers. As a result the interior of the crossing at Le Mans is as if levitated. The old nave to the west is like a dark tunnel while overhead soars a crystal palace of windows supported by the slenderest of stone piers. Here also we are reminded that France too had its 'Perpendicular' style.

The choir–apse interior, completed in 1254, displays a clear intention to go for height. The bays are stretched upwards in the most elongated arches imaginable. Not until 1908 was it noticed that to exaggerate the perspective the walls were given a deliberate outward splay similar to the bulging 'entasis' of a Classical column.

Such is the enveloping lightness of the ambulatory that the choir is like a theatre-in-the-round. The 13th-century clerestory glass is dominated by reds, as that of Chartres is by blues, lending it a blazing vitality. To Ian Dunlop this chamber is 'the most perfect realisation of all that gothic architecture sought to express, a cage of coloured glass upheld by a slender scaffolding of stone'.

The cathedral's setting could not be bettered. The best view is from the east, presenting the chevet at the top of a flight of steps that further exaggerates its height. The south, west and north façades are enclosed by the buildings of the old town as if huddling to protect the old Norman end of the church from its French interloper. Against a corner of the west front leans an even older talisman, a stone menhir. Such stones were objects of devotion long before Christianity. A wise community clearly leaves them in peace.

METz

⁘ ⁘

Metz cathedral is a colossus. It sits pinned to a hillside overlooking the River Moselle as prominent in its landscape as is Laon. The city was capital of the contested region of Lorraine and an episcopal seat from earliest times, claiming its first bishop, St Clement, in 280. By the 8th century the bishop of Metz, St Chrodegang (or Godegrand), initiated a reform to the liturgy and layout of worship that spread Europe-wide. This included the practice of isolating the clergy from the laity in an enclosed choir. Chrodegang's innovations have dictated Catholic church design to this day.

Metz's episcopal enclave was a city within a city. It once comprised six churches, a cloister, a bishop's palace and numerous hospices and

schools. The Carolingian cathedral was followed by a Romanesque one, but further growth was obstructed by an adjacent church of Notre-Dame-la-Ronde which lay across the site of the proposed nave. Rather than demolish it the cathedral incorporated it as the nave's three western bays. Since these were aligned at right angles, its old apse now bulges from the cathedral's south wall, one of the most bizarre cathedral amalgams I have encountered.

Lorraine's political instability delayed the rebuilding for over two centuries, the bulk of the work being completed in the 13th-century Rayonnant style. The north side is encased in buttresses to stop it sliding downhill and is dominated by a north transept window visible for miles around. The south side faces what was the old cloister and is now an open square. As for the west front, it has undergone a life of changes. It was rebuilt in the 18th century with a Classical entrance, then rebuilt as Neo-Gothic at the end of the 19th. Metz is solid rather than graceful.

The interior with its large clerestory has an overpowering verticality. Except on the brightest of days the nave is not a cheery place but the gloom is offset by the cathedral's principal treasure, its medieval glass. Like many cathedrals, this claims to be 'the world's largest expanse of glass'. Certainly to wander the nave and transept is to be lost in the pages of an ancient manuscript. Half an hour in Metz can induce a crick in the neck.

The western rose window created in the 1380s by Hermann of Münster spins outwards from its hub in a kaleidoscope of soft colouring. Moving east we pass the rounded piers of the old Notre-Dame church to reach the Chapel of the Blessed Sacrament, its coloured glass garishly modern. The tempo rises at the crossing. Here the glass in the north transept is late Gothic of 1504, depicting saints in various stages of martyrdom. Each panel is framed by a forest of Gothic pinnacles. On the left is a beautiful counterpoint, one of the cathedral's three windows by Marc Chagall (1887–1985), here depicting the Creation and Adam and Eve.

The south transept offers a striking contrast. Here the stained glass dates from just twenty years after the north transept, but the shift into the Renaissance is dramatic. We are now in the hands of a 16th-century master, Valentin Bousch (c.1490–1541), originally from Strasbourg. He replaced Gothic formalism with portraits and landscapes in sunny reds and yellows, all in Classical settings. One such is of St Apolline, a martyred virgin whose torture was to have her teeth wrenched from her jaw. She duly became the patron saint of dentists and is shown holding a tooth.

Since the window openings remain Gothic, to study Bousch's glass in the south transept of Metz is like peering through the Middle Ages into the light of the Renaissance. This is one of France's great windows at a turning point in the history of European style.

Metz's apse, completed in the 16th century, has more windows by Bousch and two more by Chagall in the northern arm. On the altar platform is the original throne of the cathedral's founder, St Clement, simply carved from an old Roman column. Metz's treasury is rich in medieval sculpture, including a copy of the Louvre statue of Charlemagne on horseback.

NARBONNE

⁙

There is sadness to Narbonne cathedral, despite its status as the Beauvais of the south. It is a choir without a nave and its west wall is raw and incomplete, a façade of gaunt buttresses looming over stray cats and parked cars. The solitary choir soars over the town, looking from a distance like a tanker washed up on a beach.

The town of Narbonne was once of great importance. All of Gaul was Gallia Narbonensis in the days of Rome and it hosted the western empire's first official church in 313, the year Constantine legitimized

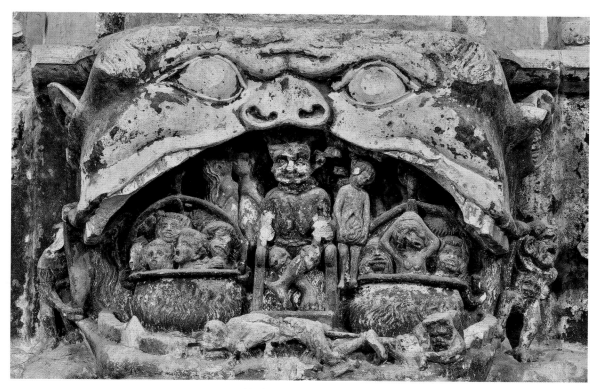

Narbonne: the jaws of hell

the Christian faith. The present structure dates from a decision in 1268 of a local boy made good, Pope Clement IV, that his home town should rival the glories of the Île-de-France. He even sent a foundation stone from Rome.

Building of the choir began in 1272 just two decades after Beauvais and before the latter's collapse. The design is possibly from the workshop of a Picard, Jean Deschamps, who worked on Carcassonne. It was completed in 1332 but apart from two square towers to the west no further work was attempted. A nave would have involved the demolition of the town wall, and in south-west France in those days that was considered unwise. Narbonne is therefore just a choir, but a fine one.

The exterior is a tangle of flying buttresses in two decks and two rows, like athletes doing exercises against a wall. The windows are the last word in Flamboyant tracery. Inside, the choir vault is exceeded in height only by Beauvais and Amiens. Given its narrowness it is almost more of a tower. The clerestory windows are of extreme elongation, some of its uncrowded stained glass original. This must be the work of masons familiar with Gothic engineering in northern France and practised in competitive elevation.

Beneath the windows in the apsidal Chapel of Our Lady is the relic of an altar retable vandalized in the Revolution but still magnificent. It is composed of frescoes and sculptures in deep relief, including characters of the Day of Judgement in vivid detail. In the centre stands an exquisite alabaster Virgin with Child with a 14th-century hairstyle. At her feet opens a monstrous mouth indicating that those who disobey her will be swallowed alive. Forgiveness cuts no ice in Narbonne. Opposite is an Early Renaissance tomb of a local cardinal with mourners round its base.

Narbonne choir is filled with 18th-century stalls and an altarpiece designed in 1694 by the master of French Baroque, Jules Hardouin-Mansart. On my visit it was host to a delightful festival of local guilds being entertained to a Bach flute recital. Afterwards the guild members formed a colourful parade of farmers, wine growers, cheese makers, pig producers and even snail merchants, all in medieval costumes and each with its ceremonial banner. They marched round the town in an evocation of medieval Languedoc.

Narbonne may lack a nave but it has fine archiepiscopal buildings. The cloister is a muscular contrast to that of neighbouring Arles, compact, heavily buttressed and with no adornment but the leering spouts of giant gargoyles. In the treasury below is a superb 16th-century Flemish tapestry of the Creation, woven in silk and golden thread.

PARIS
NOTRE-DAME

✣ ✣ ✣ ✣

Notre-Dame rivals St Peter's Rome among the citadels of Christendom. For me its personality is elusive. It has the aura not of Parisian romance but rather the opposite, of a stern great-aunt with not a hair out of place. In a lifetime of visiting Paris I always felt her watching me through her pince-nez, ready to disapprove should I misbehave.

That said, Notre-Dame's place in public affection was beyond doubt when a fire broke out in her nave in April 2019. Not just a nation but the world looked on aghast. The disaster showed the hold these cathedrals have on people's imagination, with or without Christian affinity. Notre-Dame was France and everyone mourned. As it turned out the damage was largely confined to the nave roof, destroying a 19th-century flèche that had in turn replaced one destroyed in the French Revolution as 'contrary to equality'. All could be remade.

The Île-de-la-Cité in the Seine had boasted a church since the 6th century when Clovis moved his capital here from Laon. In 1163 its scholar-bishop, Maurice de Sully, began a rebuilding in the new Gothic style of the abbey of Saint-Denis outside the city. Work was expedited under Philip Augustus (1180–1223), it being unthinkable that Paris should not have the finest cathedral in France. At 35m the

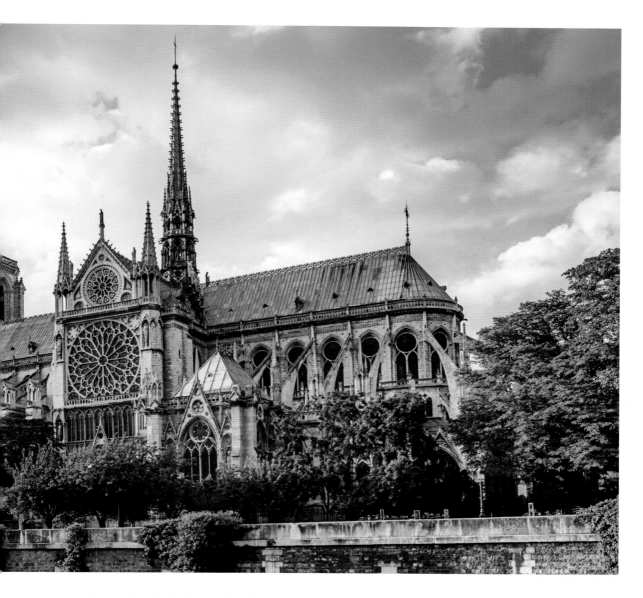

nave vault was to be the highest yet built, apparently based on the former Romanesque plan (see p. xvii).

The sequence of construction saw the new choir rise in the 1160s to be consecrated in 1182, with the nave following in the 1190s. It was therefore like Chartres, a creation of the transition from Romanesque to Gothic. The west front with its towers followed in the 1220s, with Rayonnant transepts being added later in the 13th century. The nave was later altered to increase the size of the clerestory, while the choir was encased in chapels between the buttresses.

Notre-Dame suffered grievously from Paris's turbulent history. It was desecrated in the French Revolution and afterwards fell into dereliction, so neglected that its demolition was debated. Salvation came from an unusual quarter. In 1831, Victor Hugo's novel *Notre-Dame de Paris*, published in

↑ Notre-Dame: Gothic elegance on the Seine

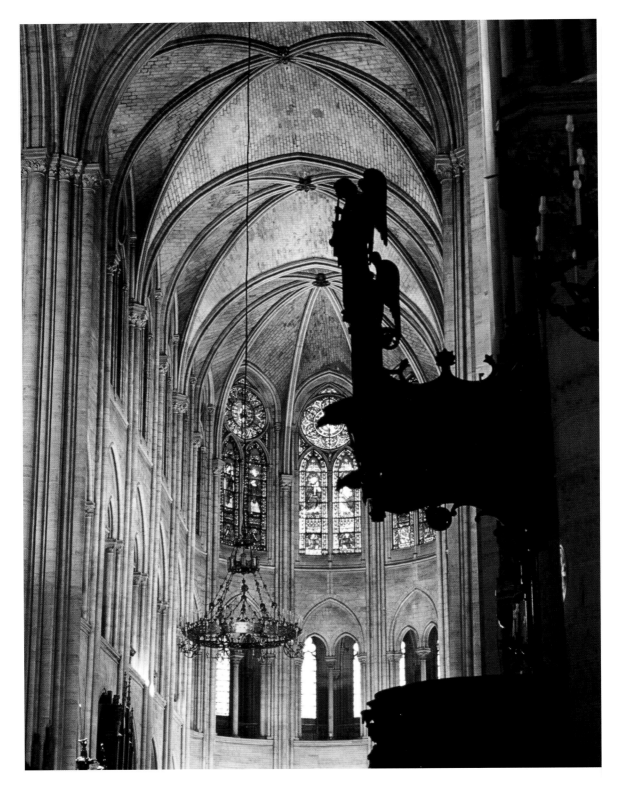

English as *The Hunchback of Notre-Dame*, told the story of the doomed love of twenty-year-old bell-ringer Quasimodo for the sixteen-year-old gypsy Esmeralda. The cathedral was virtually a character in the story. The novel's popularity spurred a campaign to restore it, initiated by Viollet-le-Duc and Jean-Baptiste Lassus in 1844. Those who ridicule saviours of today's old buildings should remember what we owe to saviours past.

The cathedral today is so familiar that its diverse stages are easily neglected. The west front and western sections retain the solidity of the Romanesque, whereas seen from the east the Gothic exterior rises like a galleon moored to the river bank encircled by the masts and spars of its buttresses. Viollet-le-Duc's prominent flèche over the crossing contributed a masterly balance. After its loss in the 2019 fire and proposals for a modernist replacement, the National Assembly wisely voted for its facsimile.

For millions who have never ventured inside, Notre-Dame is its west front. It has been described as 'the tomb of the Romanesque and the cradle of gothic'. It has none of the upward thrust of the pointed arch, deriving its verticality solely from the massing of rounded arches. Its two towers stand guard over an elegant rose window above three ground-floor portals, all in golden limestone. These portals are similar but not the same, composed of multiple arches encasing tympanums each marginally distinct, one being triangular.

The right-hand portal devoted to St Anne is the earliest, reconstructed from the older church and with sculpture stiffer and more stylized. The tympanum of the centre portal depicts an unsensational Last Judgement. The damned are clothed and form an orderly queue, though this may be the work of Viollet-le-Duc's restorers. The figures in the Resurrection lintel also look more Art Nouveau than 12th century, as do some of the niche statues. So much the better for variety.

Over the portals a second stage comprises a frieze of the kings of Judah, restored after beheading by revolutionaries for merely being kings of anywhere. The rose window is beautifully traceried with allegedly the smallest amount of masonry in proportion to glass in any church. It is flanked by double windows beneath pointed arches. Each tower is a simple pavilion with two open lancets on each side, coated with what the English call ballflower decoration. For all its subsequent restoration, this west façade has an impeccable harmony.

If the exterior of Notre-Dame is one of balance, says the writer Stan Parry, 'the interior is one of noise and confusion . . . the impression of an ancient theme park'. The nave is gloomy and rather narrow. The Romanesque columns trudge towards the crossing with Corinthian capitals and triforium bays forming a strong horizontal line. The later clerestory struggles to relieve the gloom as it unfurls into the transepts and their Rayonnant windows. Here Notre-Dame emerges into the light, the southern transept rose window a spinning wheel of blues and reds.

The cathedral does indeed have the clutter of a theme park, the theme being mostly the Virgin Mary. But the clutter is of a high quality. The 14th-century panels in the choir are superb, including a moving *noli me tangere* of Christ and Mary Magdalene. The altar is formed of egotistical sculptures installed by Louis XIV in 1699, portraying himself and his father Louis XIII in extravagant poses paying court to Mary swooning over the body of Christ.

The cathedral is enjoyably crowded with works of art, including thirteen painted altarpieces donated annually in the 17th century by the Paris goldsmiths' guild. They formed what was said to be Europe's first public art gallery. This tradition should resume when the cathedral reopens, expedited as in the Middle Ages by the conspicuous generosity of the merchant princes of Paris.

← Nave interior with pulpit

FRANCE

PARIS
SAINT-DENIS
⁘

Given its role in the history of European architecture Saint-Denis is a lost soul. It gazes over a characterless square in a rundown Paris suburb, its west front recently restored and its tower possibly to be rebuilt. Since it was also extensively altered soon after its construction in the Middle Ages, an effort of imagination is required to revive the conception of its progenitor, Abbot Suger.

The site goes back to 465 and the earliest days of Christianity in France, when French monarchs made what became the abbey of Saint-Denis their resting place. The abbey owed its ascendancy to Suger, abbot from 1122 to 1151. He was the son of a peasant, entered the church and rose to be regent of France under his friend Louis VI (r.1108–37). A master administrator, he restored the royal and episcopal coffers and made Saint-Denis the spiritual headquarters of the Capetian dynasty, though it did not become a cathedral until 1966. With the nearby Notre-Dame, Chartres and Laon, the abbey also played a part in France's 12th-century renaissance.

The church that Suger re-erected at Saint-Denis did not invent the Gothic style. He would have known of the pointed arches of Burgundy and of reports of vaulted churches brought back from the Levant. Also in the 1130s, the cathedral at Sens was being rebuilt with Gothic features. What Suger's masons did was form these elements into a coherent project. A Romanesque wall was inert, with each stone transmitting weight to the stone beneath. A Gothic vault would transmit weight laterally to buttresses, eventually to flying ones. Hence the wall need not carry the entire weight of the vault and much of it could be replaced by windows. This allowed the greater penetration of light into an interior, eventually on a spectacular scale.

Suger began his new church in 1135 with a west front designed as 'a gateway to heaven', composed of three portals and a surmounting rose window. It was essentially Romanesque with round arches and a tympanum depicting the Last Judgement. Towers on either side arrived later, the northern one with a steeple that was dismantled in the 19th century. There is a project to rebuild it.

Suger's attention next turned to the choir and apse, completed in just three years. The choir was consecrated in June 1144 in a ceremony attended by the king with bishops and dignitaries from across Capetian France. Ever the showman, Suger announced that his church had already been blessed secretly and in person by Jesus and a celestial choir who had appeared to a leper the day before in the churchyard. He had the leper's discarded skin to prove it. He also acquired a nail of the True Cross and part at least of the Crown of Thorns (a whole one is also in a Notre-Dame safe). This appeal was enhanced with a lucrative annual fair called Lendit.

The exact appearance of Suger's choir is unclear, since his innovative vault was raised and given a lofty clerestory just a century later when Louis IX decided to make Saint-Denis a royal necropolis. As a result what we see today has mostly the appearance of a High Gothic church of the 1230s, begun by local masons but later worked on by the celebrated Pierre de Montreuil, active in Paris in the mid-13th century. All we have of Suger's choir are the surviving ambulatory, chapels and lower windows. These windows are a copy of his original stained glass, what he called his 'poor man's Bible'.

Possibly under Montreuil the nave and choir were united in an all-enveloping circuit of clerestory light. The irony is that Suger saw his choir as a visual climax to a dark nave, a celestial burst over the sanctuary. Today the light streams over the nave while the altered sanctuary is relatively dark. The most evocative part of Suger's church to survive is

→ Saint-Denis: monarchs in a suburb

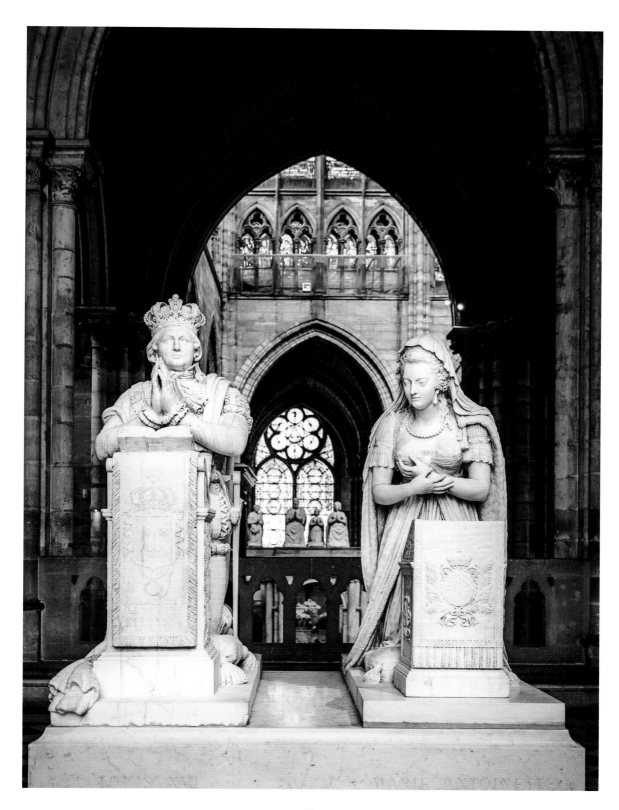

his earlier crypt. It embraces a fragment of a confessional wall and window dating from Charlemagne's time. The choir stalls are something of a relief from the gloom. I particularly like the Sybil acting as the Oracle of Delphi.

All but three of France's pre-revolutionary monarchs are or were buried in Saint-Denis, though many of the tombs vanished during the Revolution. The tablets, floor plates and memorials are gathered in such numbers that corners look like royal emergency wards. Notable are those of Louis XII, Catherine de' Medici, Louis XVI and Marie Antoinette. The treasury includes Charlemagne's crown.

REIMS

✥ ✥ ✥

Reims cathedral is most famous for surviving. It was targeted by German artillery in 1914 in an attempt to destroy local morale, a counter-productive crime pursued by many armies in time of war. The interior was left a gutted ruin, with walls, stonework, statues, stained glass and fittings reduced to piles of rubble.

What England would have regarded as a picturesque ruin and have stabilized 'as found', an architect, Henri Deneux (1874–1969), saw as a lifetime project. He arrived in 1918, moved into an adjacent flat and set about a complete restoration. Money came from the Rockefeller family in America and labour from German prisoners of war. Assistants collected all the fragments of glass and stone they could find and pieced them together. Deneux's only concession to modernity was to rebuild the roof with reinforced concrete instead of unavailable wood.

No sooner was Deneux's restoration finished in 1938 than the cathedral was again battered in the Second World War. Damage this time was less

← Reims: tapestry in stone
↗ Virgin and Child: the swaying Madonna

considerable, and in 1962 the re-restored west front was used as backdrop for a reconciliation between France's General de Gaulle and the German chancellor Konrad Adenauer. Today as the patina of time descends on Deneux's work it is hard to tell where the 13th century ends and the 20th begins. Reims remains a medieval masterpiece.

The cathedral was known as the Parthenon of France. It was the coronation site of French kings from the 12th to the 19th centuries. At the turn of the 13th its archbishop was eager to emulate what were then eight cathedrals under construction or reconstruction in the Paris region. A fire in the old building in 1210 gave him his opportunity – there were even rumours he started it himself. The new cathedral took up the baton of High Gothic where Notre-Dame de Paris and Chartres left off, though it took until the 15th century for the building to be completed.

The much restored west front is divided into the customary three stages, with the portals dominant. These are flanked by replica statues – some originals are in the cathedral museum – including a beautiful Virgin and Child dividing the central doors. It was called by Rodin, 'la vraie femme française … la plus belle plante de notre jardin'. The portal arches are crowned with strong gables, the pierced central one breaking free of the wall and intruding on the upper stage. Here it frames a sculpted group of the Coronation of the Virgin.

The second-stage gable now takes its turn to intrude on the third, its pinnacles pushing up into a gallery of kings. This gallery was in honour of the cathedral's royal status and is the most accomplished of any French cathedral. It extends round the entire building and even the chevet buttresses. Reims' twin towers were not finally built until the 15th century with a Flamboyant richness, their lancet openings liberally decorated with ballflower, crockets and pinnacles.

The remainder of the exterior is a homage to the flying buttress. Each buttress pinnacle is crowned by a statue, one of reputedly 2,000 on Reims' exterior, including 211 giants more than 3m tall. Angels seem to flap their wings and rise from their plinths; the chevet is a bestiary of weird animals. Many if not most of these statues are clearly – and inevitably – of modern replication.

The interior of Reims is initially austere. The rhythm of the 1220s nave is that of Early Gothic piers rising to rich leaf capitals, the bays articulated by thickly clustered shafts. Dark aisles have geometrical tracery in the windows. Such architecture is heavily dependent on the play of light from windows, and Reims' replacement opaque glass does no favours to grey stone. A little medieval glass survives in the apse. There is one moving intrusion, three windows in the ambulatory by Marc Chagall of 1974.

As a child I was read the Victorian poem 'The Jackdaw of Rheims' by R. H. Barham. It satirizes the Catholic clergy of the Middle Ages when a jackdaw upstages the cathedral canons and steals a cardinal's ring. The canons are terrified of retribution and have the bird made a saint. The poem echoes through the dark recesses of this magnificent church, which I regard as much a memorial to Deneux as to his medieval forerunners. Our admiration for the Gothic masters is enhanced when the beauty they created lends itself so well to the art of restoration.

ROUEN

✥ ✥ ✥

The west front of Rouen has fascinated artists down the ages, from Turner and Ruskin to the American Roy Lichtenstein. None was more mesmerized than Claude Monet. In 1892 he rented a studio facing the building and set about trying to capture the varying moods that weather and the seasons projected on to the façade. He found the exercise mentally exhausting and had nightmares of the stone as coloured pink, blue and yellow. 'Each day,' he said, 'I discover something I hadn't seen the day before … I am trying to do the impossible.' He eventually painted thirty versions of Rouen, choosing twenty for exhibition. Though attempts were made to keep them as a set they are now dispersed to galleries round the world.

What did these artists see? Gothic never strayed further from the sober days of Chartres and Notre-Dame than at Rouen. It is the architecture of exuberance. It reflects the same stylistic extroversion that later drove Classicism to the excesses of High Baroque. Going over the top is the whole point, and this cathedral does that.

Rouen was the ancient capital of Normandy and its cathedral was yet another child of fire in 1200. The new building was erected piecemeal over three centuries, culminating in a final burst of Flamboyant Gothic in the 15th century. The central spire is a steel

→ Monet's Rouen: 'trying to do the impossible'

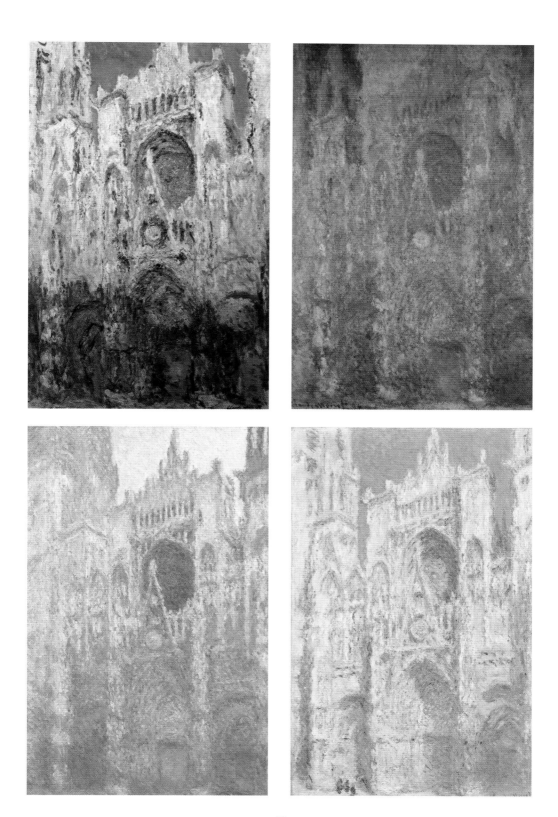

19th-century rebuild which, when completed in 1876, was briefly the tallest structure in the world. Like many such Neo-Gothic creations it was spectacular rather than beautiful and was severely damaged by the Allies after D-Day in 1944. Flaubert in *Madame Bovary* called it 'the dream of a delirious tinker'.

The west front is Rouen's – and Monet's – *coup de théâtre*. It has three sections of two asymmetrical towers flanking a central façade. These towers are different in period and style. That on the north is the austere Tour Saint-Romain, dating from the pre-fire building and with a Romanesque base. That on the south, taller and stouter, is the Tour de Beurre or butter tower. It is so called for being financed from indulgences (pardons in the afterlife) bought by citizens who wished to continue eating butter during Lent, surely the most light-hearted of fund-raising gimmicks. The two towers stand detached from the central façade like two disapproving chaperones guarding a flirtatious teenager.

The portals are unconventional in their subject matter. That in the centre is a majestic Tree of Jesse showing the supposed lineage not of Jesus but of the Virgin Mary. The left-hand portal includes a much reproduced scene of Salomé dancing on her hands before Herod. The athleticism has given rise to a number of balletic imitations.

The west front is rivalled by that of the north transept, reached down an alley off the city's medieval enclave. It is named the Booksellers' Portal or Portail des Libraires after the adjacent neighbourhood. The façade is an elaborate Flamboyant composition, its tympanum of two tiers depicting the Last Judgement at its most graphic. Heaven and hell are packed solid while the Resurrection below looks like a crowded publishers' party. I was delighted to find books still sold in the alleyway, presumably as they have been for centuries.

Rouen's interior displays piers obsessively shafted, like pipes in a ship's engine room. In the south aisle they are clustered into bunches, their capitals sprouting leaves and faces, nature in stone. In the north transept inside the Booksellers' Portal stands a charming medieval staircase leading to the cathedral library. Off the south transept is the Chapel of Joan of Arc, who in 1431 was burned to death by the English in the town towards the end of the Hundred Years War. Joan is celebrated in a modern window by Max Ingrand (1908–69) – like John Piper in England, the designer of choice for windows across Europe.

The apse and choir date from the initial rebuilding in the 1220s, the chapels round its ambulatory rich in original glass. On the north side is the window of St Julian, his story embellished with portrayals of its sponsors, the Fishmongers' guild. At the apex of the apse is a Lady Chapel dating from 1302, a serene space with windows stretching virtually from floor to vault. Here lie the memorial effigies of two cardinals, uncle and nephew, marking the transition from Gothic to Early Renaissance. The two look oddly placed since the nephew had his uncle shifted to one side to give himself more prominence.

SAINT-BERTRAND-DE-COMMINGES
❖ ❖

For a wandering pilgrim lost in the Pyrenees this tiny one-time cathedral would have been a glimpse of paradise. Its location is charming enough, but its cloister is exceptional. Most cloisters are four-sided and inward-looking. Here one side opens to a view across a deep valley to forested hills and snow-capped mountains. The valley is magical, green and quiet. There are no roads, no buildings, no people, just the tinkle of cow bells and the cooing of a dove. I cannot believe it has changed in a millennium.

The cloister's other three sides are flanked by diminutive arcades of 11th-century columns, their capitals carved into faces, monsters and vegetation. One column is a statue of four eroded evangelists

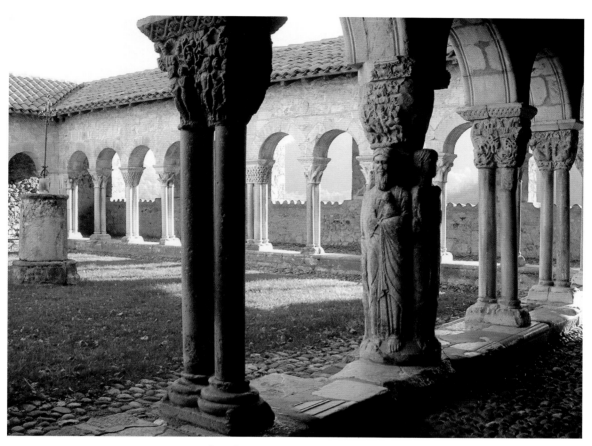

Saint-Bertrand cloister: glimpse of paradise

standing guard. 'The stones are silent,' says an evocative notice in English, 'but a watchful eye, an open heart and an appropriate welcome make the stones talk.'

The hill on which Saint-Bertrand sits overlooks the headwaters of the Garonne, where stood a Roman town of some 30,000 people founded by Caesar's rival Pompey. The cathedral and associated monastery were begun in 1073 by a local nobleman and canon of Toulouse, Bertrand de l'Isle. He became a saint and thus his tomb qualified as a pilgrim destination. Of his church, the tower, entrance and two internal bays survive.

In 1305 the local bishop Bertrand de Got became the first Avignon pope, Clement V, and duly improved his old home church with a grander east end. Given the limited site there was room only for a single chamber without aisles or chancel. This was completed in 1350 by another bishop, Hugh of Châtillon. A third bishop, Jean de Mauléon, transformed the interior in the 16th century by filling it almost completely with an exaggerated oak choir leaving hardly any room for local worshippers.

The entrance is reached across a pretty village square under a Romanesque tower with a weather-boarded crown. It looks no bigger than a parish church. A simple arch over the door covers a tympanum of the Adoration of the Magi, primitively carved and overseen by St Bertrand in person. Below is a row of apostles, all severely eroded.

The interior is a surprise. De Mauléon's grandiloquent choir of 1535 is surrounded by high screens,

FRANCE

leaving room for only a narrow ambulatory round its perimeter. At the west end is a short 'nave' of a few metres known as a pronaos where lay people might have attended while the canons chanted inside the choir. A century later a small altar was installed for them against the nave south wall. Hanging above it is a stuffed crocodile, supposedly slain by St Bertrand but probably a trophy of a Levantine pilgrimage. The pronaos does at least have an impressive pulpit and organ, also provided by de Mauléon.

As for the choir, it is clear that de Mauléon wanted nothing but the best for this isolated spot, importing French and Italian craftsmen to create it. The screens are covered in oak carvings, some free standing, some in marquetry. The last are rated among the finest in France. Three of the panels on the west screen are polychrome, one depicting St Sebastian but with its arrows missing their target. The sixty-six stalls are outstanding, juxtaposing biblical and domestic scenes. The domestic ones border on the indecent, the carver having a fascination with female breasts. A fine Poseidon rides a mermaid.

Behind the altar is the shrine of St Bertrand complete with a reliquary. Paintings depicting the saint's miracles cover the screen. Off the north ambulatory is Hugh of Châtillon's tomb, a marvel of High Gothic carving. The cathedral museum overlooks the south ambulatory. Apart from the usual liturgical silverware it houses two copes of biblical scenes embroidered in England in the 14th century. At this time so-called *opus anglicanum* (English work) produced in London was among the most valued in Europe. The Passion Cope is particularly fine.

Entry to the cathedral is free, but the cloister and choir costs two euros, and rightly so. The cathedral is a curiosity, the cloister a place of the most exquisite beauty. I was therefore somewhat surprised to find it the setting for one of the ghost-writer M. R. James's most gripping horror stories, 'Canon Alberic's Scrap-Book' (1894), whose plot I dare not reveal.

SOISSONS
⁘

Of the lesser cathedrals erected in the Île-de-France from the mid-12th to the mid-13th centuries I find Soissons the loveliest. It embodies French Gothic in its climactic period. Others such as Sens, Noyon and Senlis have their admirers. But for me Soissons brought so-called High Gothic nearest to its ideal. In the 20th century it was also a triumph of the French genius for restoration.

In 1918 as German artillery retreated across the plains of Picardy in the final phase of the Great War it pulverized Soissons in an orgy of pure destruction. The town fell and the cathedral was reduced to a partly roofed shell of rubble, which lay 6 metres high in the crossing. A post-war guide to the battlefields declared the building beyond saving. Yet saved it was, in an operation of reinstatement on a par with that of Reims and Dresden's Frauenkirche (see p. 70). This operation is related in an exhibition in the nave.

The exterior of Soissons is not special. The west front lacks its northern tower, which was never built, and the south is undistinguished. The façade is out-gunned by the twin towers of the ruined abbey of Saint-Jean-des-Vignes on the outskirts of the town. The east end is supported with two-tier flying buttresses with generous Early Gothic windows and a chevet surrounded with identical chapels. The walls are heavily pitted with shell shrapnel wherever a fragment lived to tell its tale.

Inside, Soissons comes into its own. The cruciform plan is of a seven-bay nave and four-bay chancel plus apse, with north and south transepts. Seen from the west, the arcades are of rounded piers with lightly floriated capitals, above which bundles of colonettes rise through the triforium to a high clerestory and vault. Only at the transept crossing do the piers break step. Here are multi-shafted

→ Soissons: variations on a theme of windows

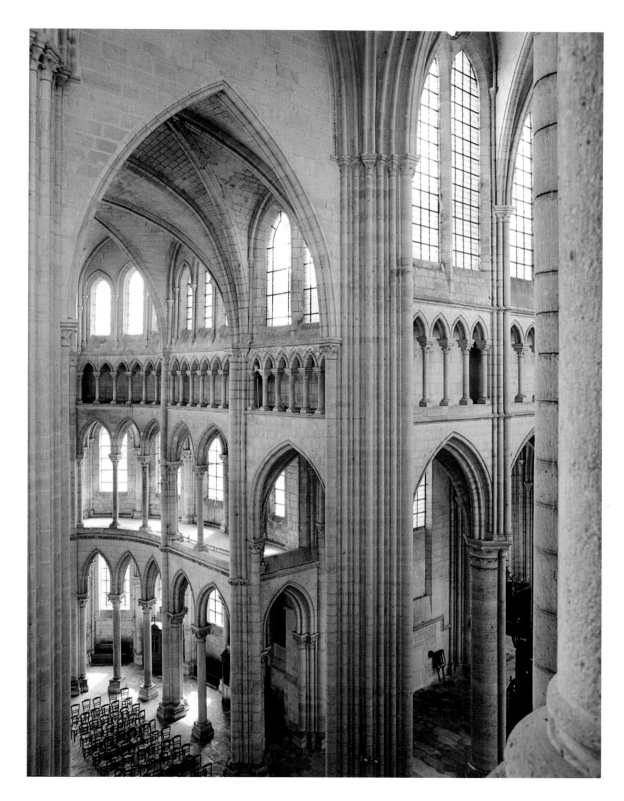

rather than rounded piers, soaring the full height of the church. The effect, especially when soft sunlight warms the creamy texture of the stone, is one of rhythm, proportion and balance.

The eye is diverted by the pulpit, candelabra and high altar, and the view closed by the distant reds and blues of the stained glass in the apse. This surely is what Abbot Suger of Saint-Denis meant by a church representing 'the light of heaven received in splendour'. Soissons is the language of Gothic in song.

The cathedral has one hidden delight. As we move forward from the west into the crossing, the usual spectacle would be of rose windows filling the north and south transept end walls. Here the north transept is indeed closed by two tiers of Rayonnant windows and a giant rose. But the south transept is a surprise. It is not rectangular but apsidal. We seem to have lost our bearings and feel as if we are looking into an east end not a south transept.

This transept apse has four beautiful stages of arches, three of them fenestrated. They evoke what Stan Parry calls 'emotions of lightness, playfulness, harmony, sureness and gracious symmetry'. A charming chapel opens from the transept's east wall. When we realize this was the earliest surviving section of the cathedral to be built in 1177, we can see the whole of Soissons as a variation on the theme of this apse.

While much of the glass is 20th century, it is clearly intended to respect the style of the medieval portions that were removed for safe keeping before the war. Medieval blues and reds are dominant, yet in the north-transept lancets we can detect a few delightful touches of 1920s Art Deco.

STRASBOURG
✢ ✢ ✢ ✢

Capital of the long-contested territory of Alsace-Lorraine, Strasbourg on the upper Rhine was torn between the peoples and the cultures of France and Germany. It was part of the Holy Roman Empire until Louis XIV took it for France in 1681. It was occupied by Germany in the Second World War and was doubly punished by being flattened by Allied bombs in August 1944. Post-war reconstruction of the old town was meticulous and triumphant and holds the key to its present attractiveness and wealth.

The much restored cathedral rivals Cologne as a glory of Rhenish High Gothic. Its great steeple gazes down on strolling members of the local European parliament, embracing them in European community. Strasbourg is a majestic city.

In 1176 a Romanesque cathedral was built on the site of a 5th-century Roman basilica and then in 1015 an Ottonian church, apparently by French masons. In 1225, however, fashion-conscious canons decided to rebuild in the new Gothic style, even demolishing much of what they had just built. Romanesque walls survive in the apse, south façade and porch. The refashioning of the nave and south transept was begun in earnest in the 1230s in a completely French style. In 1284 the German master Erwin von Steinbach arrived and his family soon acquired legendary status among the leading masonic lodges of Europe. The cathedral was notable, when viewed by the 23-year-old Goethe in 1772, in being the first modern expression of admiration for a Gothic cathedral. To Goethe it expressed the essence of the 'strong, rough German soul'. We can see why. The sandstone west front is the ultimate assertion of 'skyscraper' Gothic.

The façade rises in three distinct stages past a delicate rose window to culminate in a northern tower. Its southern twin was never built. The tower was completed at the turn of the 15th century and is at first sight uncomfortable, rendering the façade lopsided. Its architect was Ulrich von Ensingen, designer also of Europe's tallest tower in Ulm in Germany which was not completed until the 19th century. Ensingen died at Strasbourg in 1419, but the spire was not finished

→ Strasbourg's gap-tooth Gothic

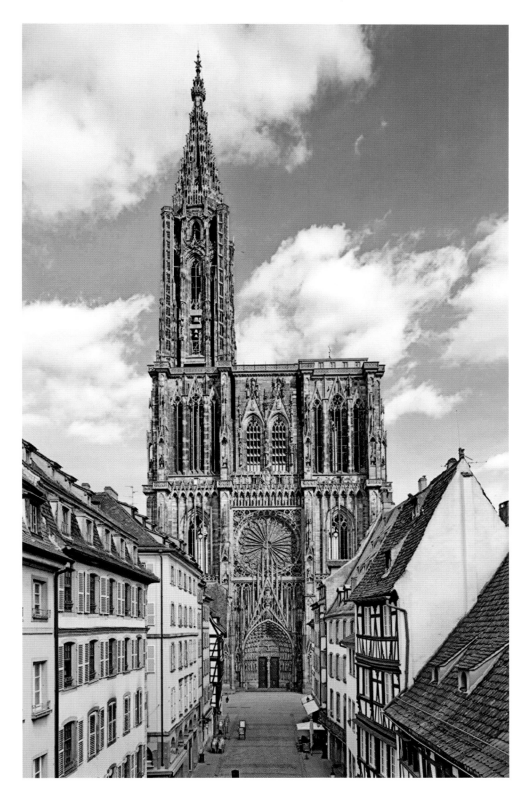

FRANCE

Ultimate time-keeper meets Day of Judgement

celebrating the life of the Virgin. The north-side portal is a complete contrast, late Flamboyant and dedicated to St Lawrence, its canopy a ghoulish depiction of the saint being roasted on a gridiron.

Strasbourg cathedral's interior is a hall of clustered piers and pointed arcades, majestic High Gothic with windows that fill the nave aisles and clerestory with light. There seems barely a foot of solid wall anywhere. The more dramatic is the view of the surviving 12th-century apse to the east, a curved chamber of Romanesque design alive with wall paintings.

Much of Strasbourg's glass is medieval, having been stored in a salt mine during the Second World War. The north side contains the so-called Emperor Windows depicting nineteen Holy Roman emperors dating from the 12th century. A modern window in the choir is by the French artist Max Ingrand, a gift in 1956 of the Council of Europe, located in the city prior to the European parliament. It is medieval in spirit despite its rather cartoonish Madonna.

The cathedral's outstanding possession is its 16th-century clock. Located in the south transept and made in 1547, it was designed by local craftsmen listed as watchmakers, mathematicians, architects and painters. Rebuilt three centuries later in 1842, it original working parts are mostly in the cathedral museum but mechanical figures still emerge periodically from their niches to mark the hours, months, seasons and phases of the moon. They are represented by a procession of apostles, the ages of man, a crowing cock and Christ chasing Death. Among its features is a solar system charting the equinoxes, including a wheel said by engineers to take 25,806 years to rotate. I wonder who is counting.

In front of the clock stands Strasbourg's Angel Pillar, composed of three tiers of statues clearly influenced by those at Chartres and depicting the Last Judgement. Equally fine carvings adorn the pulpit. The Gothic organ case on the nave wall is decorated with characters that once moved mechanically in time to the organ music.

until 1439. It is 142m high, deferring only to Cologne's 156m and Ulm's 161m. It is conspicuously transparent, coated in tiny Gothic pinnacles like flames and flanked by four staircase turrets open to the elements. To the historian William Lethaby this was 'electrical gothic, as if the stone had leapt into a spray of flame'.

The façade below is divided by ornamented buttresses, framing a composite gallery of sculpture. Each of the three bays has a portal telling a different biblical tale by a different school of carvers. The central tympanum is a Passion of Christ, with a Madonna and Child below. The right tympanum is a Last Judgement and the left a childhood of Christ. We also have a full turnout of wise and foolish virgins. The façade carries a reputed total of a thousand sculptures and is a testament to the restorer's art.

Along the south side of the cathedral we find the old Romanesque south entrance still in place. Its original double door is crowned by statues

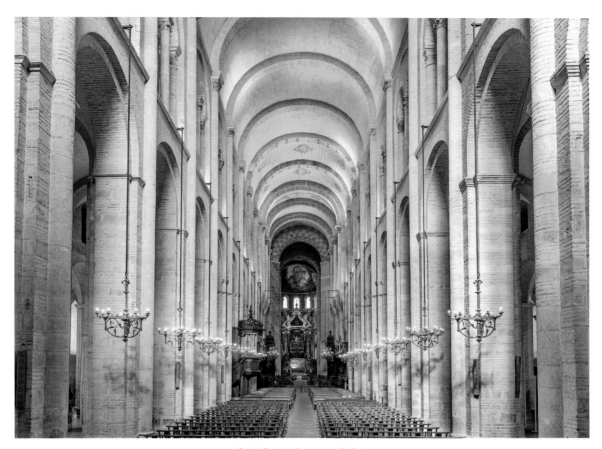

Saint-Sernin: the pomp of pilgrimage

TOULOUSE
SAINT-SERNIN

✥ ✥

The Basilica of Saint-Sernin dominated the pilgrim trail from Arles to Spain. Dating from the 1080s it was and is colossal, a transit camp for the pilgrim masses and the second largest Romanesque church in Europe after Germany's Speyer. Its 21m vault rebuts the idea that only Gothic engineers could raise a giant roof, though unlike its contemporary Durham it is still barrel-vaulted rather than ribbed. Toulouse's official cathedral of Saint-Etienne is elsewhere. Saint-Sernin is the city's dominant church.

Finished swiftly in 1120, the building is cruciform and almost entirely of brick. The exterior presents two contrasting faces. The west front is built out as a narthex, looking from the side like a castle keep. Its façade has two simple arched doors, unadorned, with above them a row of slit windows.

On the south side is Saint-Sernin's prize, the celebrated portal, the Porte Miègeville. Its carvings (c.1115) of biblical and mythological scenes are among the strangest in the Romanesque canon. The angels, kings and Old Testament figures are curiously oriental, fat-cheeked, voluptuous and full of life, their headdresses unlike any elsewhere in France. King David plays a viol, the Annunciation is charming, almost casual, Adam and Eve leave the

FRANCE

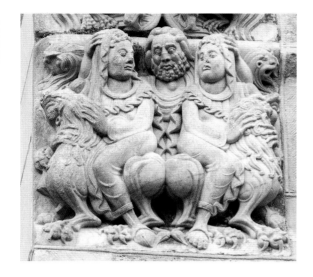

chapels and corners. The pier capitals – reputedly 268 in the whole church – are an art gallery in themselves, the more enjoyable for many being viewable at shoulder height. We must imagine this space crammed with pilgrims, a Babel of languages spoken, priests chanting and much money changing hands for purposes devious and devotional. There is nothing new in Europe's tourist economy.

TOURS

❖ ❖

England's sorriest monarch, King John, lost his lands of Anjou and Touraine to France in 1204 and with them the cathedrals of Le Mans and Tours. Since 1170 a new cathedral at Tours had begun to rise from the ruins of a fire-damaged predecessor. Little progress was made until 1236 and the coming of age of Louis IX, for whom Tours was 'my second Paris'.

First to be completed was the spectacular choir in Rayonnant Gothic, regarded as an inspiration for Louis' Sainte-Chapelle begun two years later. The rest of the cathedral took over three centuries, yielding a local phrase for extreme delay as 'when the cathedral is finished'. Tours was not obsessed with height like Amiens and Beauvais, attentive rather to proportion, duly winning plaudits from Viollet-le-Duc to whom the choir at Tours was 'the work of a well-balanced mind, in full possession of his art'.

That said, there is a sense of abandon to Tours' exterior. The west front is spectacular, featuring two telescopic towers not completed until the 16th century. They are a catalogue of French architecture from Romanesque to Renaissance composed of twelve diminishing stages, piled one on another with increasing enrichment and topped by small cupolas. They suggest two madcap entertainers

Garden of Eden as if off on holiday. The central panel portrays the Ascension with two angels hoisting Christ to heaven by his waist. Most extraordinary is Montanus, a priest of the Cybele cult holding by their heads two acolytes mounted on lions. The women are named Priscilla and Maximilla. They represent unconquered death.

The interior of Saint-Sernin is spacious, the nave 100m long with double aisles culminating in an apsidal choir. All appears to have been built at the same time. The brick-built piers are squared with cylindrical shafts attached. Everything about the progression eastwards contributes to a sense of expectation, as of pilgrim crowds gathering to await a moment of revelation. Pilgrimage was an exercise in sustained drama.

Saint-Sernin's east end was clearly designed as a climax to this drama, with an ambulatory and display area for shrines, altars and relics. The style of 'pilgrimage Romanesque' is rather spoiled by the later insertion of a Baroque choir. This is overly theatrical, a massive blast of 17th-century stalls and Rococo altar canopy. The walls, vaults and dome above are coated in vivid murals.

With the apse the church mutates into a museum. Its wares are laid out round an ambulatory over a three-tiered crypt, a maze of stairs, platforms and display cases. Statues of saints and pilgrims litter

↖ The Porte Miègeville: priest with happy disciples
→ Tours: the telescopic west front

poking fun at the world round them – hard to take seriously. Beneath the towers the central gable rises to a rose window whose tracery is so riotous it might be called 'terminal' Gothic.

The nave interior was completed in the 14th century in the highest of Gothic, indicated by an emphasis on the clerestory as focus of attention. Two short transepts – one still with Romanesque fragments – are uplifted by tremendous rose windows, that in the south transept with an organ silhouetted before it.

The choir sets Tours apart. The arcades appear as mere supports for the triforium and clerestory above. Here the glass depicting scenes from the Bible is some of the best preserved in France, installed later than that of the Sainte-Chapelle and widely regarded as superior. Especially fine are the windows in the axial chapel, of the childhood and passion of Christ.

At the south entrance to the ambulatory is the 16th-century tomb of the children of Charles VIII who died in infancy. It is an emotional work, reminding me of Francis Chantrey's *The Sleeping Children* (1817) in Lichfield cathedral. Sculptors of these scenes were expected to induce tears in those who looked on them, like television reporters from another era.

TROYES

✣ ✣ ✣

Troyes may be a lesser star in the Île-de-France galaxy but its quiet beauty set among timbered houses off the beaten track makes it a delight to visit. The west façade is from the hand of the Flamboyant master Martin Chambiges, creator of Beauvais' south front, not begun until 1506. His three portal gables drip with scrolls and pendants like icing. The swirling tracery of the rose window is framed by a decorative gable that points to a parapet where Chambiges seems to hint at the Renaissance. A sad loss is that of all three tympanums, victims of revolutionary fury. Only gargoyles

were left untouched by the devil's disciples.

Troyes' interior is earlier than these façades, of the 13th century and forming a harmonious vista of nave and choir. Double aisles are lit by clear windows producing shafts of light that seem to dance free through a forest of columns. The nave capitals are composed of deeply undercut foliage in which scholars have found oaks, roses, thistles and even snails. Troyes is Gothic at the limit of inventiveness. Walls have become little more than a stone frame on which is hung a coronet of clerestory glass running round the entire building.

This glass is the glory of Troyes. It is mostly 13th-century in the choir and 16th-century in the nave. The latter is in the form of compositions that occupy entire windows rather than separate vignettes. One series depicts the story of Job. Another has Pharaoh dreaming of fat and lean years, apparently languishing in the local Champagne countryside. A chapel in the south aisle has a curious Classical screen, as if the masons were showing off the latest Renaissance motifs from Italy.

The choir is darker, its lower stages Early Gothic with solid walls, lancet windows and glancing views from the arcades into surrounding chapels. Windows here have no tracery and the stained glass is divided into medallions, one a spectacular Tree of Jesse. Above and just thirty years later is the Rayonnant clerestory of c.1230. Here all is blazing light, with familiar biblical themes in dominant blues and reds.

There is a calmness to Troyes, especially as the sun dips and penetrates the glass, bathing the limestone in colour. If Chambiges' exteriors are a memorial to the last phase of the Gothic era, Troyes' interiors are a reminder of an earlier, less cluttered period, a place to meditate in peace.

→ Troyes: Pharoah in Champagne country

PHARAO

VÉZELAY

✣

The abbey of Vézelay, a basilica rather than a cathedral, is the grand old lady of French pilgrim architecture. I once walked uphill past medieval cottages to the modest square at the top and sensed the feet of millions who must have made this climb over the centuries before setting out on the long journey to Santiago. The memory is one of heat, sore feet and the beckoning cool of an ancient church.

The site was of a Roman villa turned convent turned abbey. In 1050 a group of enterprising monks claimed to have found bones of Mary Magdalene, acquired from the Holy Land or possibly from a church in Provence. It was like striking oil. As pilgrims made their way across northern France, a new church was needed in their honour, consecrated in 1104. The requisite local taxes were so high that the abbot was killed in a riot, but by 1132 a new narthex and west front had been constructed.

Such was Vézelay's rise to prominence that it was here that Bernard of Clairvaux launched the second crusade in 1146. Here too Thomas Becket of Canterbury resided in exile in 1166 and here the kings of France and England assembled for the third crusade in 1190. Then in 1279 disaster struck. The monks of Saint-Maximin in Provence claimed they still had Mary Magdalene's body, and had miracles to prove it. Vézelay had no answer to this and went into decline. Its own alleged relics were destroyed by Huguenots in the 16th century and the old church came close to collapse in 1834, when Mérimée and Viollet-le-Duc arrived to save it. Vézelay has rested in peace ever since, rescued as a destination for those latter-day pilgrims, Burgundian tourists.

The west front is a precursor of the tripartite façades familiar on most French cathedrals. There are three portals, the central one rising to five lancet windows and a gable with a small tower on the northern side. The west front is barely decorated.

Such adornment as it has is thanks to Viollet-le-Duc, including a Neo-Romanesque central tympanum. The church exterior shows heavy buttressing and diminutive windows.

A more dramatic tympanum is inside the narthex over the door into the nave. This is attributed to the 12th-century sculptor Gislebertus, reputed native of Vézelay and master at Autun cathedral. It is almost unique among tympanums in depicting not a Last Judgement or similar theological scene but rather the politics of its time.

Here Christ is seen dispatching the apostles as crusaders to the Holy Land to confront the heathen.

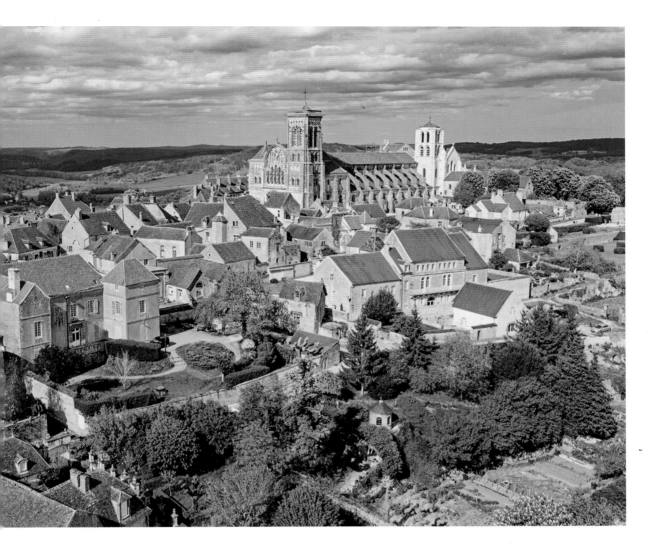

The figures are contorted and expressive, their garments swirling round their limbs, with heathens in various stages of presumed deformity. One has a pig's head, another is a pygmy trying to climb a horse with a ladder. The surrounding panels are of the crusader nations with vignettes of such miracles as lepers examining their healed limbs. The Vézelay narthex is a foretaste of the Pórtico de la Gloria of Santiago at the other end of the pilgrimage.

The basilica's interior dates from a rebuild in 1165 and is impressive but simple, a view down a barrel-vaulted tunnel to a distant apse. The arcades are round-arched with vivid black and white banding, the latter contributed in the 19th century. The piers are squared and shafted, with ornate carved capitals again reminiscent of Autun. At the choir end Early Gothic takes over with pointed arcades and a ribbed vault. The walls are bare, the altar simple, the glass plain.

To the south of the nave lie the remains of a pretty cloister with carved columns framing its openings. Vézelay has recently been restored and cleaned and is immaculate, a serene place appropriate to departure on a long journey.

↑ Vézelay's hilltop point of departure

FRANCE

GERMANY, AUSTRIA AND SWITZERLAND

AACHEN ✣; BAMBERG ✣✣; COLOGNE ✣✣✣✣;
DRESDEN, FRAUENKIRCHE ✣✣✣✣;
ERFURT ✣; FREIBURG IM BREISGAU ✣✣✣;
MAGDEBURG ✣; MAINZ ✣✣; NAUMBURG ✣✣✣;
PASSAU ✣✣✣; REGENSBURG ✣✣; SPEYER ✣✣;
TRIER ✣✣; ULM MINSTER ✣; WORMS ✣;
VIENNA ✣✣✣✣; BASEL MINSTER ✣

The year 800 was widely taken to mark the advent of a new Europe under the Frankish leadership of Charlemagne (r.768–814). That year he was crowned Emperor of the Romans by Pope Leo III four centuries after the demise of the last such empire. Charlemagne pronounced himself the 'new Augustus'. The title was changed to Holy Roman Emperor by Otto I, later the Great, in 962. It was a fanciful and unstable concept enjoying a tentative sovereignty over little more than the German-speaking regions of central Europe, yet it remained in existence for a millennium until abolished by Napoleon, and later recreated as the Prussian Empire by Bismarck.

Charlemagne's faith was the Christianity of Rome not of Byzantium, though he did make determined overtures to Constantinople and fashioned his church at Aachen after the Byzantine church of San Vitale in Ravenna. Charlemagne took his adopted inheritance seriously. He treated his capital at Aachen as a new Rome, and welcomed churchmen and scholars to what has tentatively been called Europe's 'Carolingian renaissance'.

This empire disintegrated half a century later in 842 and was divided between Charlemagne's descendants. In its place were territories covered roughly by today's France, Germany, the Low Countries and Switzerland. While France gradually combined as one nation, the Germanic core of the Holy Roman Empire did not, despite acquiring the subtitle 'of the German nation'. As Voltaire said, it was not holy nor Roman nor an empire. Its internal loyalties and external borders were to be disputed into the 19th century, as was its interpretation of the Christian faith.

In 919 this Germany came under the Ottonian dynasty of the three Ottos, starting with Otto the Great (r.936–73). His signal achievement was to drive back the invading Magyars at the Battle of Lechfeld in 955, carrying in his hand the spear that had allegedly stabbed Christ on the Cross. The Ottonians were followed by the Salians

(1024–1125) and the emergence of a distinctive German language and culture. Otto's headquarters had been at Magdeburg on the Elbe, Germany's eastern frontier. But no city ruled Germany, and others were soon bidding for royal and ecclesiastical supremacy, notably Mainz, Worms and Speyer. A remarkable number of their cathedrals survive in the Romanesque style. This was universal across Europe from the 10th to the 12th centuries, but in Germany it had the distinctive feature of double apses and usually choirs, east and west, often crowned with a profusion of towers.

By the turn of the 13th century prosperity permitted some church rebuilding, and here Germany, like Spain, found itself following in France's stead. It was Gothic masons who arrived in the great trading centres of the Rhine and Danube. Cologne, Strasbourg (see p. 48), Prague and Vienna saw Gothic vaults, choirs and towers to rival those of the Île-de-France. Germany soon developed its own mason-architects, the Parlers of Cologne and the Steinbachs of Strasbourg. Their creations were filled with sculptures fit to rival those of central Italy, from the 13th century's Master of Naumburg to Nikolaus Gerhaert, Tilman Riemenschneider and Anton Pilgram in the 15th.

Throughout this period, the Roman Catholic church served as a unifying force in German life. It grew immensely rich from land and inheritances, and thus exercised widespread patronage over Germany's political and intellectual elite. It also enjoyed a stable hierarchy not constantly vulnerable to death in battle, in marked contrast to the ever shifting allegiances of Holy Roman emperors and their subordinate kings and princes.

The result was a rising tension between Germany's many statelets and the church in Rome. First sign of an open breach came with the radical teaching of Jan Hus (1372–1415) in the Bohemian capital of Prague. The resulting Hussite rebellions against papal corruption were the first tremors of Reformation. A century later the advent of a Medici

pope and the flagrant sale of indulgences (pardons in the afterlife) to pay for the rebuilding of St Peter's Rome and other extravagances were the final catalyst for Martin Luther's revolt.

In 1517 Luther published his ninety-five theses in Wittenberg, challenging indulgences and the status of the pope as exclusive intermediary between mankind and God. Forgiveness, he said, emanated from God alone and was validated by faith. He wrote to the archbishop of Mainz ridiculing the idea that as people 'cast their contributions into the money-box, souls fly to heaven out of purgatory'. Luther's message spread rapidly across a northern Europe which already felt little loyalty to Rome.

The Roman church had one powerful ally. The then Holy Roman Emperor Charles V was no German but a Dutch-born Habsburg married to a Spaniard, ruling a dynastic domain from the Polish border to the Atlantic. In 1521 he summoned Luther to a meeting or 'diet' at Worms and accused him of 'defying the faith held by all Christians for a thousand years'. Luther is said to have replied, 'Hier stehe ich. Ich kann nicht anders' — Here I stand, I can do no other. Aware that Hus a century earlier had been burned at the stake for less, Luther fled and found refuge with the ruler of a sympathetic Saxony.

As the states of north Europe took sides, the schism saw its climax in the Thirty Years War (1618–48), the bloodiest and most destructive European conflict prior to the 20th century. Initiated by the Holy Roman Empire to stamp out Protestantism, it returned Germany and its neighbours to medieval anarchy. By the time of the Peace of Westphalia in 1648 Germany lay devastated, its religious loyalties divided between a mostly Protestant north and a Catholic south.

Cathedral building did not resume until the 18th century, but refurnishing of Catholic churches flourished under the influence of the Counter-Reformation. Just as Gothic had evolved into Flamboyant three centuries before, so the 16th-century Renaissance evolved into ever 'higher'

Baroque. While Protestant Naumburg and Magdeburg were stripped to a spare austerity, Catholic churches saw their sanctuaries, aisles and chapels fill with extravagant altars and images. Catholic Passau, rebuilt in the 1660s after a fire, was in the most elaborate Italian Rococo. It makes an intriguing contrast with the sobriety of London's Protestant St Paul's built at the same time.

By the 19th century what turned out to be a widespread and deep-seated reaction had set in across Europe, a harking back to the Gothic Middle Ages. Even the German Classicist Karl Friedrich Schinkel (1781–1841) moved to Gothic later in his career. A movement for Neo-Gothic church 'purification' was led vigorously by King Ludwig of Bavaria (r.1864–86), his influence extending well beyond his own domain. The shift was fuelled after the 1870s by the drive for German nationalism under Bismarck, manifest in widespread church restoration. Its most dramatic symbol was the completion of towers planned in the Middle Ages at Cologne, Regensburg and Ulm.

The 20th century came close to ending the story of the German cathedral. It is hard to exaggerate the devastation of Allied bombing of German towns and cities in the closing months of the Second World War. It was a militarily useless strategy. However, unlike in less afflicted Britain, most German towns immediately set about rebuilding, often facsimile, what the bombs had destroyed. Nothing so symbolized that country's economic resilience as the restoration of its ancient towns and their cathedrals. The effort reached a climax in the long-delayed reconstruction of Dresden's Frauenkirche in 2005.

AACHEN

❖

Towards the end of his belligerent reign, Charlemagne (768–814) turned from warmongering to build a 'Rome of the north' at Aachen, to be the new capital of the great empire to which he claimed succession. There in 793 he began a palace and chapel that is now the oldest cathedral in northern Europe. He summoned clergy and scholars from across Europe. From York in England came the scholar-poet Alcuin, who in 782 became one of his closest advisers and later bishop of Tours. For the last ten years of his life Charlemagne hardly left Aachen. As for the chapel across the courtyard, he modelled it on the Byzantine church of San Vitale in Ravenna, in honour of the broadmindedness of his new domain. The chapel became a cathedral in 1801.

Aachen and its chapel never achieved its patron's ambitions. The cathedral today is hard to appreciate from the outside. It is surrounded and obscured by later accretions, including a large Gothic choir and Baroque roof and porch. The original chapel survives at its core with an entrance through an atrium still with its original bronze doors. These are flanked by statues of a pine cone and a vixen. The interior is in the form of an octagonal hall originally under a domed roof that was once the tallest north of the Alps. This dome was later replaced by a higher Baroque version, inevitably distorting the proportions of the church as a whole.

The church is on two floors, the upper ambulatory being where the royal court assembled for worship, processing by a bridge from the palace opposite. A number of the columns were said to have come from Italy, though modern dating doubts this. The walls would have been covered in murals and mosaics as in Ravenna.

The church today lacks the antique authenticity of its Italian parent. This is due to a drastic 19th-century makeover when the wall surfaces were re-covered with gilding, marbling and mosaics. New tiles were laid on the floor and frescoes painted on the ceiling in a Neo-Byzantine style. Only the bronze trelliswork and gates of the balcony balustrade are original, together with the Barbarossa chandelier, donated by that emperor in Charlemagne's memory c.1165. The chandelier is 4 metres in diameter with a circumference portraying the walls of Jerusalem. Its forty-eight candles are still lit on special occasions, when the interior must take on a more original character. More impressive is Charlemagne's throne in the upper gallery. The seat is simple and austere, four slabs of marble with steps leading up to it but sitting isolated and out of context. For some time it was thought to be a later work, but science has since confirmed it as of Carolingian date c.800.

The much later choir begun in 1355 lies off the old chapel with an apse of tall stained-glass windows apparently modelled on Sainte-Chapelle in Paris. Here stands Charlemagne's shrine which became the focus of mass pilgrimage after his beatification in 1165. The casket is similar to that of the Three Kings in Cologne, a chest of wood, metal and precious stones of c.1200. Panels of free-standing sculptures depict not the usual biblical figures but Carolingian kings and dignitaries. Charlemagne is shown next to God and almost on equal terms.

The casket was opened in 1861 and revealed bones judged to be almost certainly those of the emperor, a mature man of the right period and almost 6ft tall. The coffin sits on an altar whose fascia is a superb panel of gold reliefs. Round the shrine are faded survivals of the original frescoes. The choir also treasures relics of the Virgin Mary, including her cloak, Christ's birth swaddling clothes and his loincloth worn when hanging on the Cross. The Aachen treasury contains a collection of early medieval statues, reliquaries and liturgical objects.

The apse windows were destroyed by bombing in the war and modern replacements have restored the chancel's deep-blue colours and atmosphere.

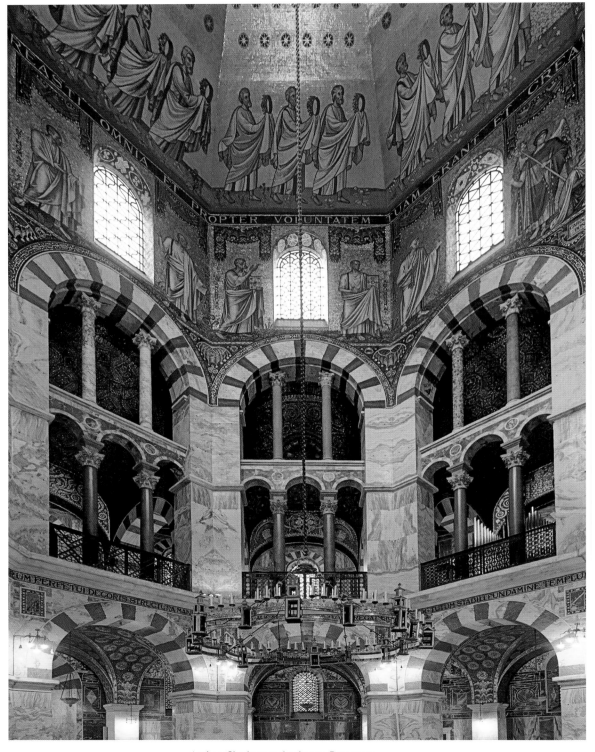

Aachen: Charlemagne's tribute to Byzantium

BAMBERG

✥ ✥

Bamberg is among the finest historic towns in Europe. Narrow lanes and gabled houses, immaculately preserved, line the banks of the River Regnitz. That so modern an industrial nation should be able to save unsullied such treasures of its past is much to Germany's credit. On a hill overlooking the town rises its cathedral, regal and aloof with four corner towers topped by conical spires. They stand like black-hooded wardens watching the streets below as if ready to pounce on any misbehaviour.

The cathedral was rebuilt at the start of the 13th century in a mix of Romanesque and Early Gothic. It has the characteristic German double choir, Romanesque at the east end and Gothic at the west. Windows and portals are round-arched, the effect solid and dull rather than soaring. Bamberg's interior was 'Baroqued' in the 17th century and then 'purified' by Ludwig of Bavaria in the 19th, restoring its medieval appearance in a slightly frigid manner. The earlier eastern end is elevated over a beautiful crypt and is used as a concert platform. This is clearly not the business end of the church, as the nave pews

face west to what is now the choir, with carved stalls and elaborate altars.

Bamberg's principal attraction lies in its location and its art. Of the latter, pride of place is the tomb of the German king and later Holy Roman Emperor Henry II (r.1002–24), founder of the first cathedral in 1002. A Bavarian and last of the Ottonian dynasty, Henry lies with his wife Cunigunde, with whom he also appears on the façade at Basel cathedral (see below). Designed in the 1490s by Tilman Riemenschneider (1460–1531), the tomb shows the royal couple lying alongside each other while round the base are scenes from their respective lives. The queen is depicted walking on flaming ploughshares, apparently to prove herself innocent of adultery. We assume she was acquitted, as both she and her husband were later canonized.

Riemenschneider was a successful and productive sculptor in the city of Würzburg. He ranks with Austria's Anton Pilgram as one of the masters of Late Gothic carving, northern successors to Italy's Ghiberti and Donatello as the Gothic style passed

into the Renaissance. He is known above all for the emotion of his groupings and the intensity of his facial expressions. Bamberg also exhibits his exquisite altarpiece. Seeking out works by Riemenschneider is a delight of German church-visiting.

On an adjacent column is the so-called Bamberg rider, a striking statue of a king on horseback carved shortly before the cathedral's consecration in 1237. The image was adopted by German nationalists of all stripes as symbolizing German enterprise, facing east for new worlds to conquer. Though anonymous, it is now thought to represent King Stephen of Hungary (975–1038).

Bamberg has three carved portals. The Adam doorway is flanked by a naked Adam and Eve while the northern Fürstenportal suffers a common problem for carvers of medieval Last Judgements. They tend to make hell look more enjoyable than heaven. The cathedral is surrounded by episcopal buildings dating from the Middle Ages to the 18th century. They include not just old and new bishops' palaces but hostels, stables and a complete medieval service courtyard. The enclave is a remarkable survival even in this lovely town.

COLOGNE

✥ ✥ ✥ ✥

As I drove across the featureless country of the lower Rhine, I glimpsed what seemed like two dragons' teeth on the horizon, as if warning of impending doom. Nearer to hand, Cologne's famous steeples are scarcely jollier. This greatest of German churches was black when I first saw it in the 1970s and black it still seems other than in the brightest weather. But grimness soon turns to glory. This great cliff of a church is architecture at its most potent.

Cologne was a Roman frontier town and site of early Christian worship. A baptistery is dated to the 7th century and a Carolingian church was consecrated in 818, reputedly one of the largest in Europe. It was built with the customary German sanctuaries at both ends, its early walls still visible in the basement car park. The cathedral's fortunes were transformed by the 1164 donation of relics of the Three Kings by the emperor Frederick Barbarossa. They became a lucrative pilgrimage attraction.

A rebuilt cathedral was begun in 1248 by a Master Gerhard with the new French cathedrals of Amiens and Beauvais in mind. In his stead came the celebrated Parler family of masons, originating in Cologne but soon migrating to cathedral projects across the German-speaking world, both as architect-engineers and as sculptors.

Work on Cologne began at the east end round the shrine of the Magi where an outburst of flying buttresses almost hides the apse walls. Progress was slow and the transepts, nave and west end had not been completed by the 16th century when political instability brought cathedral building to a halt. A print of Cologne in 1531 shows no transepts and only the stump of a western tower. Three centuries later prints show the addition of only a crane and scaffolding (see p. xxiii). Not until a visit in 1842 by the Prussian king Frederick William was the project galvanized, fuelled later by Bismarck's drive to unify Germany and Prussia. The west front and towers of Cologne cathedral were built in the 1870s as symbols of a new Prussian-led German empire.

The new builders were lucky to discover seven surviving 14th-century designs of the towers which they meticulously followed. Only the transepts had to be designed afresh, while seven hundred new sculptures were carved by a local artist, Peter Fuchs. On its completion in 1880 Cologne was the tallest man-made structure in the world until overtaken by the Washington Monument four years later.

Cologne is thus a cathedral designed in the 14th century and largely built in the 19th. Its walls survived the wartime flattening of the surrounding city

→ Cologne: High Gothic Prussian-style

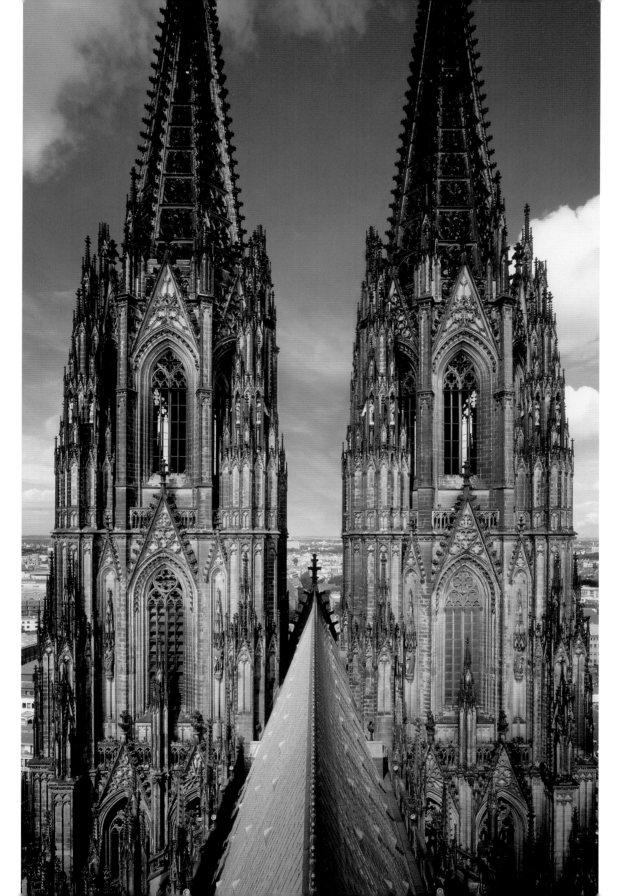

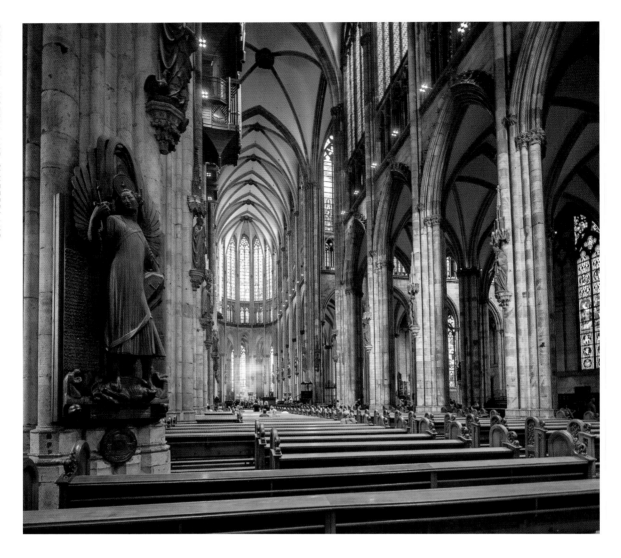

despite being hit by eighteen bombs and losing its roof and flèche. The latter was replaced by a successful modern design of fish-scale tiles.

Entering Cologne cathedral is like wandering into a forest of giant redwoods. Dark columns soar on all sides as the nave merges into its double aisles. Clerestory windows turn the enveloping space a subaqueous blue. The view east past the crossing is almost surreal. The choir beyond appears to be squeezing its arches upwards to exaggerate their height – Gothic at its most French.

Cologne's fittings have been carefully protected from the dangers of history. The 12th-century Three Kings shrine is in the form of a metal casket set on an altar. It displays gold kings presenting their gifts, joined for good measure by the king of Germany. The characters are seated and animated, set in pearls, enamels and 1,000 precious stones. The composition is one of those medieval treasures I long to see dismantled so that each piece could be studied on its own. The front is removed at Epiphany each year to reveal the three crowned skulls inside.

On the ambulatory wall is the much revered Gero Crucifix of c.970, 187cm tall. It is said to be

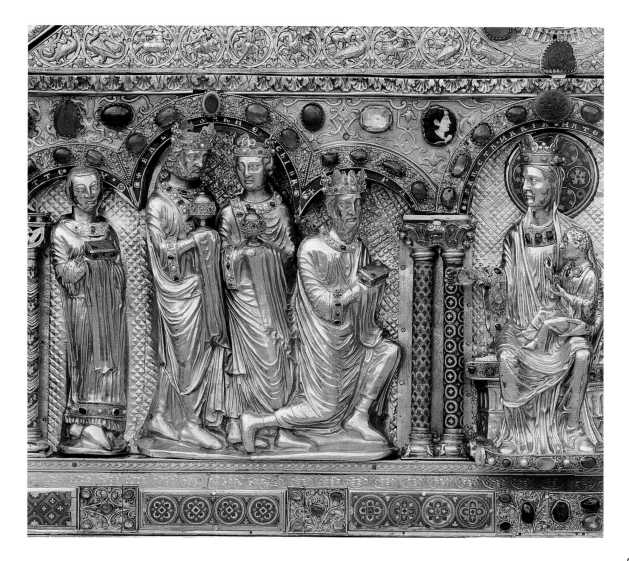

the oldest monumental sculpture of the post-Classical era in northern Europe. The twist of Christ's head and limbs in agony contrasts with later icons tending to show Him almost at peace. Cologne kept its medieval glass out of bombs' way and now displays it in the choir. The more vivid 19th-century glass in the nave was donated by the ubiquitous Ludwig of Bavaria in 1842. In contrast the south-transept window is an abstract design of

2007 by a 'computer-controlled random generator'. I prefer the work of human hands.

Standing in the nave is the Dombild altarpiece of the Three Kings with the Madonna and Child, painted by Stephan Lochner c.1445. The attendant Cologne citizens look barely out of their teens and rather pleased to be in such distinguished company. In the north transept stands the eerie Jewellery Madonna, her costume covered in pilgrim trinkets left like lovers' tokens on a Paris bridge. Cologne may be in north Germany but it is very much a Catholic cathedral.

↖ Cologne: nave as avenue of redwoods
↑ Reliquary of the Three Kings

DRESDEN
FRAUENKIRCHE

✤ ✤ ✤ ✤

The name of Dresden should be painful to British ears. On the night of 13 February 1945 with the war nearing its end the RAF sought to obliterate with fire-bombs the heart of the historic capital of Saxony. It was Britain's inexplicable Hiroshima. The walls of the Protestant Frauenkirche, among the finest Baroque churches in Europe, withstood the first attack only to implode later from the sheer heat of the fire.

After the war the 18th-century city centre was largely rebuilt by the communist government. Context, scale and materials were respected. The city's Catholic cathedral was restored and stands near the bank of the Elbe but it was decided to leave the rubble of the Frauenkirche as a war memorial. I recall the site as a lingering eyesore especially when surrounded by such carefully restored architecture.

In 1985 a still-communist Dresden changed its mind and decided the church should be rebuilt after all. This was confirmed after reunification in 1989 and three years later an international fund-raising campaign led to the start of construction. The Dresden-born American scientist Günter Blobel donated his entire $1m Nobel prize to the fund.

Photographs and other descriptions of every feature of the building were collected. Wedding photographs taken outside the main portal proved most useful. Existing stones were reused where possible in their original locations. The gold cross on the top of the dome was replicated by an English craftsman whose father had been a pilot during the bombing. The church was consecrated on Reformation Day in October 2005.

The Frauenkirche had been designed in 1726 for the Elector (or king) of Saxony Augustus the Strong (r.1697–1733) on the site of a former Catholic church. Saxony was at the peak of its revival in the aftermath of the Thirty Years War. Augustus was a German Louis XIV, eager to rebuild his capital in the Italian style as a monument to himself. Though a Protestant, when he was offered the Polish throne if he converted to Catholicism he duly did so. He then reassured his Lutheran subjects by rebuilding the Frauenkirche as their new principal church, though it was never a cathedral. I include it here as a tribute to its reconstruction. Luther's statue still stands guard in the square outside.

The church was designed by the city architect, a former carpenter called George Bähr (1666–1738), and was and is a masterpiece of Baroque architecture. The base is an octagonal plinth above which rises a

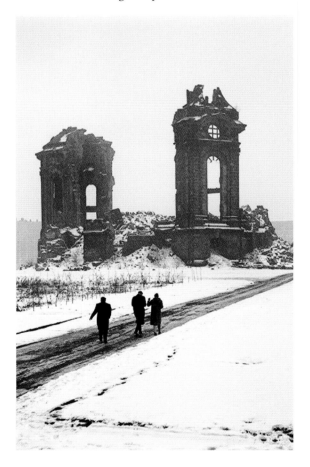

↑ Frauenkirche as post-war ruin
→ Dresden renascent

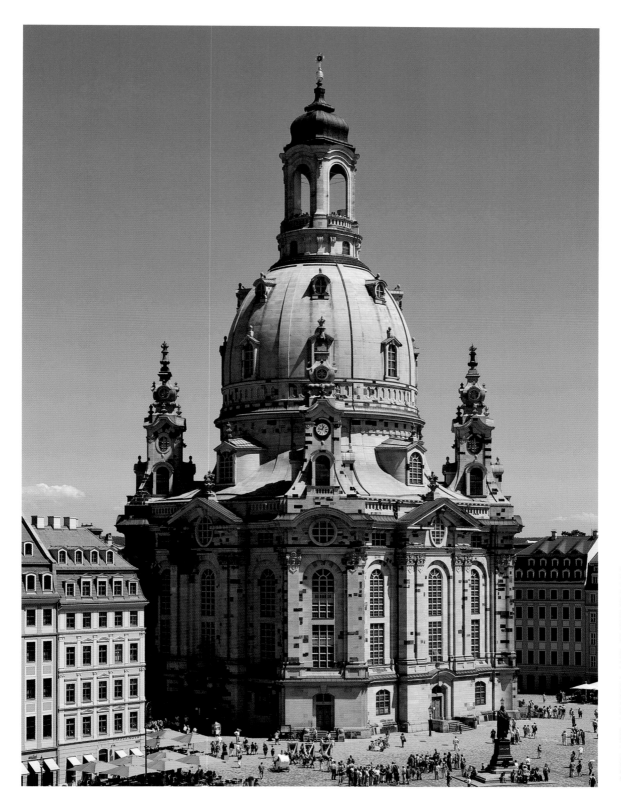

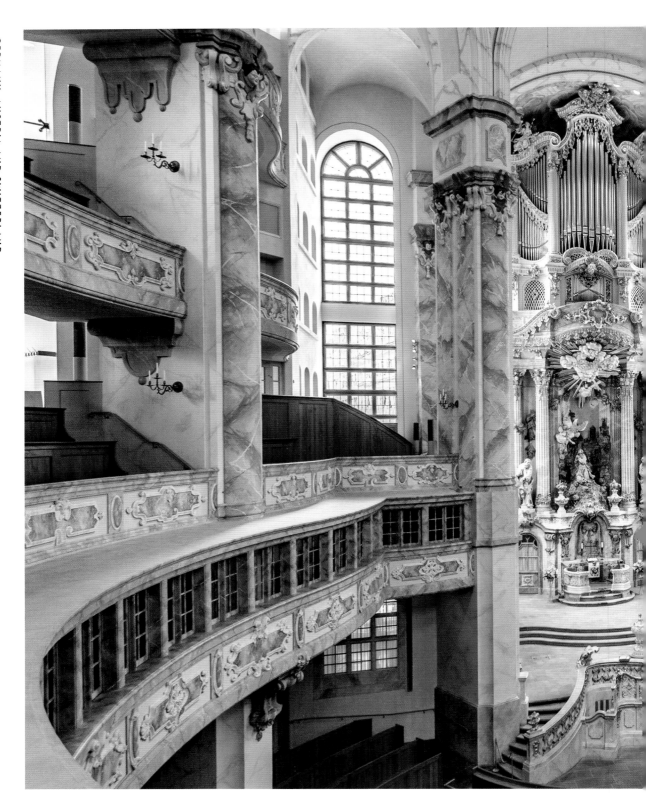

piano nobile of rusticated windows. The crowning dome is surrounded by four turrets ornamented with the features of the Classical canon, pediments, arches, cornices and cupolas. Proportion, line and silhouette are in perfect balance.

The interior is a theatrical auditorium round which are arranged stalls and three tiers of galleries. The lowest gallery is composed of enclosed rooms each with its own screened window on to the church. They are like a row of directors' boxes in a football stadium. The plasterwork is in warm pastel shades, gilded and with replicas of the statues originally carved by Italian sculptors.

The focus of the auditorium is an altar bay whose reredos rises the full height of the interior. The altar itself is High Baroque placed against the back wall of the bay so that it is lit by the side windows. The reredos features Jesus on the Mount of Olives. The topmost stage is filled with the organ, the only feature of the church not restored exactly as before. Its white plasterwork drips with gold.

The church's Protestantism expresses itself by separating the altar from the body of the church with an elaborate balustrade in front of which is a grand pulpit. Hence the preacher is given priority. That said, I have never seen a Protestant church designed in such spectacularly Catholic style.

There was much concern when the rebuilt church opened over whether it would ever have a congregation, misunderstanding the popular appeal of these buildings in modern cities. The inherent beauty of the Frauenkirche and its music programme are happily attracting visitors in their thousands.

← Dresden interior: theatrical Protestantism

ERFURT

⁜

The tourist office may call this the Romanesque Road but Erfurt cathedral on its bluff overlooking the old Thuringian capital is Gothic through and through. It stands with its neighbouring church of St Severus like an elderly couple gazing down at the Domplatz below. On my visit this was heaving with the most dazzling Christmas market even Germany can supply.

The cathedral is two quite different entities, a 14th-century Gothic choir and behind it a later 15th-century hall church. The exterior is dominated by three towers with spires, the centre one housing the biggest medieval bell in the world, known as Gloriosa. Rung only on special occasions, its sonorous boom can allegedly reduce the people of Erfurt to tears.

Entry to the cathedral is up a long flight of stairs from the square. The doorway is framed by an unusual triangular porch with two portals. Here the customary cathedral best-behaviour warning – a Day of Judgement frieze – is substituted by a 14th-century parade of biblical wise and foolish virgins. They are depicted as happy and sad, though as so often with this theme the sad ones look like a group of girls recovering from no more than a good night out.

The nave comprises three aisles of equal height flooded with light from tall side windows. It is chiefly notable for its wall memorials and sculptures. In the north aisle is a much-admired – and puzzling – bronze statue of a man named Wolfram dating from the 11th century. He stands with his arms outstretched holding candles, his symbolism a mystery to this day.

Nearby a funeral slab depicts a crusader Count Ernst of Gleichen flanked by two women, apparently his wife and mother. Legend has a different story, that he had been captured in the Holy Land by the Saracens and rescued by a local girl whom he married in gratitude. When he brought her back to Germany

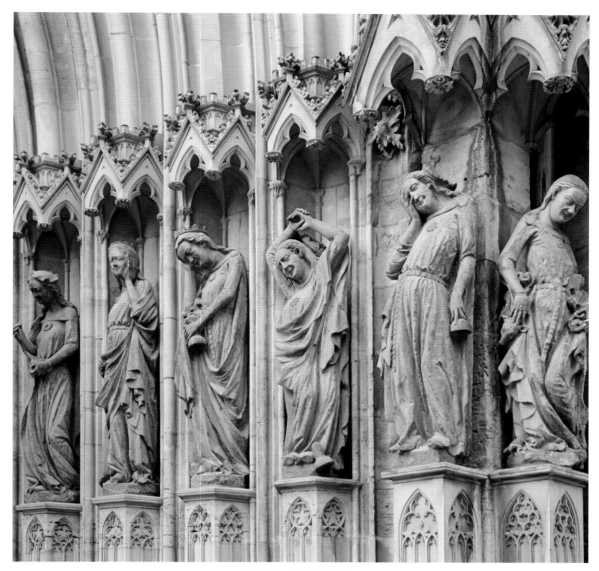

Erfurt's (very) foolish virgins

his first wife was so happy to see him she accepted the girl as second wife. Faced with such magnanimity a papal blessing was secured for the bigamy.

A narrow passage leads from the nave to the choir, a shift in style from German to French. The windows are mostly filled with medieval glass and reach from floor to vault in an uninterrupted leap. Handsome stalls lead to a sanctuary over which rises an elaborate Baroque reredos. Two paintings of the Madonna are framed by giant broken pediments on barley-sugar columns. Saints, candlesticks, cherubs and flowers are encrusted with gilding as if the craftsmen had a fear of empty space.

It was in this choir that the young Martin Luther was admitted to the Catholic church in 1507. Despite this distinction Erfurt went on to defy Luther's Reformation and remained firmly Catholic. Perhaps this reredos is its revenge on its miscreant son.

FREIBURG IM BREISGAU

✣ ✣ ✣

To the historian Jacob Burckhardt, Freiburg's steeple 'will forever remain the most beautiful spire on earth'. Its minster–cathedral survived appalling wartime bombing that obliterated the ancient town and should not be confused with differently spelled cathedrals at Freiberg in Saxony and Fribourg in Switzerland. It has been restored as a jewel of a church.

The exterior has a south transept that survives from the earlier Romanesque building, but the remainder was rebuilt in the 13th century and later. Its Late Gothic profile is enhanced by multiple buttresses prettily decorated with statues set in pavilions. Both Germany's leading mason families appear in records of its construction, the Parlers and the Steinbachs.

The essence of the celebrated west tower lies in the delicate tapering of its stages. It is not grand and has room for just a single doorway at its base. Pinnacled buttresses rise to the bell chamber encased in Gothic panelling with tall openings. The chamber contains nineteen bells, one of the largest chimes in Germany, including one dated 1258.

From here the spire soars upwards as a graceful openwork octagon, a web of tracery pierced with daylight like lattice. It was built to 116m and finished in 1330, reputedly the model for the later, higher towers at Strasbourg and Ulm. The tracery was recently found to be strengthened with iron anchors embedded in lead, a feature that probably saved it from the bombs.

The entrance porch is alive with murals and carvings, including a rare sight of Gothic statuary with its original colour conserved. The tympanum

is like a child's scrapbook of biblical events, from Mary in a sumptuous bed to a customary blood-and-guts Day of Judgement. Round the walls stand richly clothed sculptures, among them a full cast of wise and foolish virgins and a Prince of the World, the mythical seducer with his victim. Freiburg was clearly in need of discipline.

Fronting the Romanesque south transept is a curious Renaissance porch of 1620. It seems strangely out of place, as if brought back by the local bishop from a Tuscan vacation. The choir exterior is extravagant Late Gothic finished in 1515. Even by medieval standards the Parlers' gargoyles are outlandish, including a very rude posterior.

Freiburg's interior is a picture of Late Gothic perfection. Narrow arcades are divided by an avenue of thickly clustered columns all in a warm grey-pink stone. Every line points upwards to where the eye is gently led from nave to choir where a cobweb of

← Freiburg's 'most beautiful spire on earth'
↗ Masonic patronage: the pretzel window

intersecting ribs might be the work of a busy spider. In the side aisles rise windows of medieval glass, carefully stored during the war. Their sponsoring guilds are indicated by symbols of bakers, shoemakers, tailors and miners at the foot of each window. It is a catalogue of life in a medieval town. The bakers' windows of Bible stories proudly rest on pretzels.

The choir rises over a light-filled ambulatory, an ethereal chamber centred on an altar triptych by Dürer's pupil Hans Baldung (1485–1545). A frieze at the entrance to the St Nicholas Chapel forms another cartoon of fables and Bible stories. In the north aisle the Last Supper Chapel contains a sculpted portrayal of the meal's participants in a state of high animation.

Freiburg was an ancient university town and its cathedral has a university chapel, with an altarpiece by Hans Holbein the Younger of 1525. The rarity of such an academic presence in the cathedrals of Europe has always been a mystery to me, given the closeness of the clergy to many university institutions. Freiburg makes amends.

MAGDEBURG

⁜

Magdeburg was once a prince among German cities. As headquarters of Otto the Great (r.936–73), first Holy Roman Emperor of the Ottonian dynasty, it stood on the banks of the Elbe at what was then the eastern limit of Christendom. Beyond lay pagan Slavs and threatening Magyars, Otto's relentless foes.

The church's sponsor was Otto's English wife, Edith. She had been sent with her sister Eadgifu by their half-brother Athelstan, first 'king of all England', to forge an alliance with Germany. Otto was invited to choose whichever sister he preferred, Edith scoring with her 'pure noble countenance, graceful character and truly royal appearance'. Both she and Otto were buried in the cathedral, which was rebuilt after a fire two centuries later in 1209. The rejected Eadgifu went on to marry the king of France, Charles the Simple.

Magdeburg later grew to be a 'free city' under the Holy Roman Empire. It was to its archbishop Albrecht von Brandenburg that Luther addressed his 1517 theses protesting against indulgences. Later, in 1631, it was the scene of the massacre of almost all its 20,000 inhabitants, probably the greatest horror of the Thirty Years War. The city was rebuilt and the cathedral heavily restored in the 19th century. Wartime bombing was followed by a bleak exercise in East German town planning. Through all this the cathedral survived, though it is hard to tell how much of the stone is medieval.

The cathedral stands grey and austere overlooking the Elbe. The historian Simon Winder describes it as 'tremendous [and] gnarled . . . one of the great symbols of Christian colonization and arrogance'. It is Romanesque in style with a massive west front flanked by twin towers. These rise as if aspiring to great height but lose heart and become octagonal lanterns with cones. The west doorway completed in the 15th century is covered in Gothic panelling.

Magdeburg's interior is an airy space, vast and imposing. Aisles are wide, glass is clear and barely pointed arcades rise from squared columns to a generous clerestory. Considering its punishing history Magdeburg is rich in surviving monuments and sculpture. Inside the west front is a 1498 iron grille to the tomb of Archbishop Ernst of Savoy. The tomb is in the form of a bronze sarcophagus of 1513 by Peter Vischer, member of the productive Vischer family of Nuremberg sculptors. The bishop lies on his back surrounded by saints, regarded as a masterpiece of Late Gothic if not Early Renaissance art.

Moving down the nave we pass a miniature chapel empty but for two statues of a king and queen. They were once (but are no longer) believed to be Otto and Edith. Next door rises a pulpit of 1595 coated

→ Magdeburg's richly carved Renaissance pulpit

with alabaster carvings and justly described in the guidebook as 'one of the most beautiful works of late Renaissance in Germany'. It sits rich and warm in this severe setting. The choir is guarded by a 15th-century rood screen, a rarity in a Protestant cathedral. Beyond lies the simple sarcophagus of Otto the Great beneath a slab reputedly of Roman origin. The lofty apse is supported by four great columns, again of a possibly Roman date.

The rest of Magdeburg is a museum of medieval carving. The statue of St Maurice in the sanctuary is a rare medieval depiction of an African face, that of Magdeburg's Egyptian patron saint, a Roman soldier martyred for refusing to kill Christians. The ambulatory capitals dating from the early 1200s are of great variety and originality. One is composed of leaves and tendrils, another of human faces.

In the north ambulatory is a tiny carving of a man removing a thorn from his foot, believed to be a metaphor for the conversion of pagans, a relevant issue along the valley of the Elbe at the frontier of Christian Germany. In the north aisle stands a 1929 memorial by Ernst Barlach to the First World War of grim-faced German soldiers standing round a cross. As a reflection on war at a crucial juncture in German history it is of great poignancy. The Nazis had it removed but it was hidden and restored in 1955.

The cathedral's most celebrated work stands in the 14th-century Paradise Porch in the north transept. This is perhaps the most accomplished version of the familiar subject, the Bible's wise and foolish virgins, carved c.1250. The joy bordering on smugness of the wise virgins contrasts with the dismay of the foolish ones. The theme of sin, rather as in the Day of Judgement, seems to have freed medieval carvers from biblical stereotypes and enabled them to express a range of human emotions. The hand gestures, the lined faces, the smiles and tears seem wholly modern, sculpture reaching across the centuries.

The cloister survives from the earlier 12th-century cathedral. Its simple columns and arches seem quietly domestic after the soaring dimensions of the interior. Off the north side is the Tonsure Chapel with Christ's horrifically realistic corpse hanging free on a tree, by the German sculptor Jürgen Weber (1989).

MAINZ

⊹ ⊹

Mainz stands with Worms and Speyer in the triumvirate of Rhineland *Kaiserdome* or imperial cathedrals. Since Holy Roman emperors lived in perpetual motion, a capital meant little more than a place of coronation and burial. Archbishops were different, secure in their tenure, enjoying wealth and patronage and exercising quasi-magisterial authority. Mainz was for a time the base of Archbishop Willigis, arch-chancellor to Holy Roman emperors from 975 to 1011. He had ambitions similar to Charlemagne's, seeing his city as fit to be 'a second Rome'. Mainz had some way to go.

Willigis rebuilt the old cathedral soon after his arrival and this building with additions is the one we see today. It is a friendly place in the centre of the town, its blood-red walls looming over the houses crowding round it. The plan has the familiar Ottonian nave chancels east and west. Entry is down an inconspicuous passage into the north side from the market place, sandwiched next to a local art gallery. To the right of this entrance stands the later Godehard Chapel of 1137, built to link the cathedral to an episcopal palace that once stood next door.

The two-chancel form creates a confusing orientation since each end has three towers, with the middle one rising over a crossing with transepts. The building is like two ships sailing in opposite directions. Beyond the eastern towers and dating from the 11th century is a triconch or three-chapel apse. The western crossing tower was crowned in the 18th century with an octagon by Franz Neumann, son of the Baroque master Balthasar Neumann. The whole

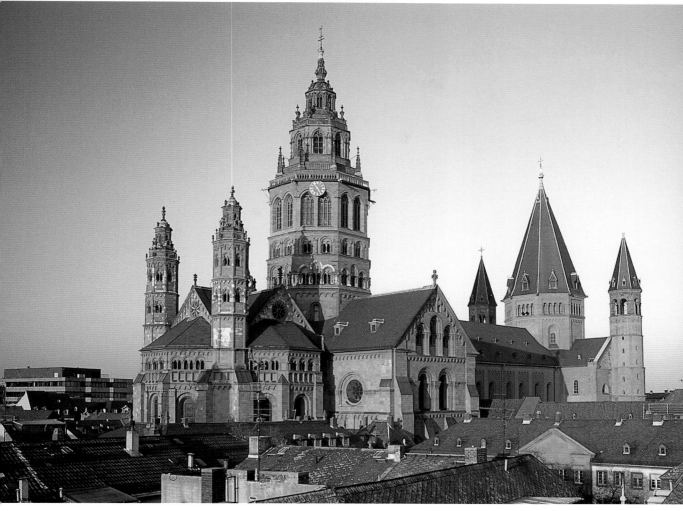

Mainz: Disneyland Ottonian

building was roofed in steep slates in the 19th century, giving it a flavour of a Hollywood fantasy palace.

Mainz's interior reflects its medieval importance. Eleventh-century piers rise to cushion capitals under shallow arches. Their simplicity is elaborated by a later ribbed vault of c.1200, with Gothic windows to the aisles. A triforium stage is filled with modern frescoes of biblical scenes as at Speyer. In the east end lies the earlier apse, with beneath it a crypt rebuilt in the 1870s. The west end contains the proper choir surrounded by chapels. Given its architectural solemnity, it is a relief to see Rococo choir

stalls and a throne inserted c.1800 with flamboyant carvings as if to jolly the place up. The stalls seem to be hugging each other close for comfort.

Otherwise Mainz is a display of memorials. Columns and walls are lined with bishops, chapels and tombs, supplemented in the 17th century by donors. A significant carving outside the east choir depicts an archbishop, Siegfried von Eppstein (d.1249), who is shown larger than life placing crowns on two diminutive emperors. It drives home Mainz's primacy in the matter of coronation and episcopal power.

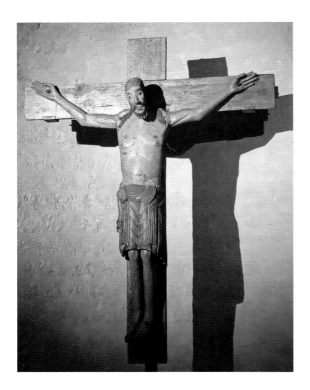

NAUMBURG

✢ ✢ ✢

Of all German cathedrals, Naumburg is the one I long to revisit. From a distance it is impressive, with a profile typical of Ottonian churches of four towers rising over the trees. Within the town it forms a modest enclave off the main square more parochial than episcopal, with a cloister and the Three Kings Chapel with its steeply gabled roof. Naumburg was an ancient bishopric and its cathedral was mostly rebuilt in the early 13th century. It was to be the first in Saxony to espouse the Protestant cause. Today it belongs not to any church but to a local trust.

The plan takes the earlier Ottonian enthusiasm for twin chancels to an extreme in that the elevated east and west choirs are so generous as to leave little space for a nave between them. They might be the forecastle and poop deck of a Spanish galleon. The church is entered through a spectacular Romanesque doorway from the cloister. The interior suffered from Ludwig of Bavaria's purification in the 1870s which stripped out all post-medieval fittings. As a result what exists of a nave looks stark and new.

All Naumburg is in its choirs. The east choir is a church in itself. It overlooks the nave with a heavy stone screen with oval paintings in the balustrade. The choir above is reached by stairs with banisters composed of brass animals and birds, supposedly blocking the way to paradise and presided over by St Francis. They look medieval but were made by modern artist Heinrich Apel in 1972. The choir itself retains medieval stalls with canopies, old lecterns and a life-sized statue of a monk reading a book. He looks as if he was dropped in by Madame Tussaud, a touch of humanity welcome but all too rare in a church these days. A pier capital depicts two monkeys playing chess. Beyond in the apse is a Renaissance reredos framing an altar table backed by 15th-century stained glass. Beneath this choir a

The interior of the Godehard Chapel might be the atrium of a Roman villa, Christian architecture in a line of descent from Rome. The atrium arches support an upper gallery that would have been used by the bishop and his staff entering from the adjacent palace. This has smart rounded pillars and cushion capitals, a sign of luxury. The beautiful Udenheimer Crucifix of 1070 hangs over the altar.

Mainz's cloisters were rebuilt after wartime bombing and look uncannily like those of an Oxford college. They lead to the cathedral museum, a substantial collection of medieval art. It includes 16th-century paintings by Luther's contemporary and Reformation ally Lucas Cranach the Elder and a tapestry of fabulous animals.

↑ Mainz: the Udenheimer Crucifix
→ Saxon verticals at Naumburg

side door leads into the crypt, a triple-aisled feast of curving vaults and carved capitals.

The west choir is quite different. Built in the 13th century, its screen is pierced by a double arch with Christ on the Cross and Mary and John on either side. The balustrade panels depict scenes of the passion of Christ in deep relief. They include a Last Supper with room for just six diners, who look rather lonely.

The choir above presents a gallery of statues of great importance, the work of the unnamed Naumburg Master in the 1250s. The expressive style and retention of original colour has given this collection a special place in European art. The subjects are unusual for their period in being not saints or bishops but civilians, portrayed larger than life size. It is assumed they were given this honour as a sign of Naumburg's civic status.

Most remarkable are the statues of a local ruler or margrave, Eckard II, and his wife Uta, carved fully two centuries after their deaths, his being in 1046. Seen from the west they appear as astonishingly

lifelike actors in a costume drama, gazing across time. Attention has long focused on the statue of Uta. The refinement of her face is more 21st century than 13th. The Italian novelist Umberto Eco declared her 'the most desirable date' in European art. She was allegedly the model for the Evil Queen in the Hollywood cartoon of Snow White. An annual Uta Festival is staged in her honour, attended by namesakes from round the world. I am not sure what on earth they discuss but their website is most active. By the same hand is the facing statue of Uta's sister-in-law Regelinda (d.1014), Polish-born margravine of Meissen. Her jolly expression contrasts with Uta's serene aloofness, such that it is impossible not to see them as portraits of real people. Yet the sculptor cannot have seen his subjects, nor was this an age of portraits handed down by families. So who were the models for Saxon Uta and Polish Regelinda, so different yet so compelling?

↖ ↑ Homely Regelinda meets Stylish Uta

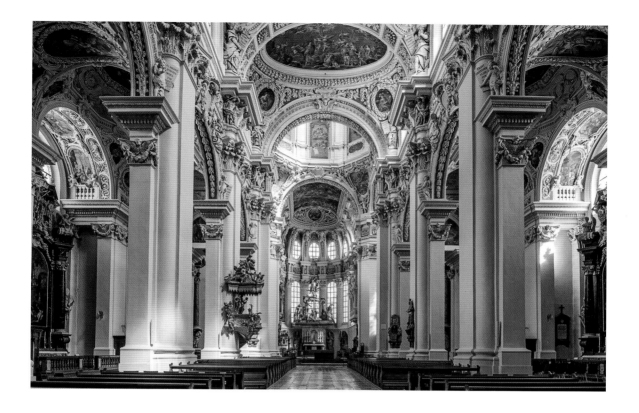

PASSAU

✤ ✤ ✤

For anyone tiring of episcopal Gothic, Passau cathedral on its Wagnerian rock overlooking the Danube is the antidote. I came to it downriver from the stern towers of Regensburg and it was like crossing a boundary between austere north and light-hearted south. Climbing the hill I almost expected to see a parade of Passau citizens come dancing round the square singing Bach. In 2015 Passau played reluctant host to thousands of Syrian refugees after their tortuous escape from Greece across the adjacent Austrian border. To them it must have seemed like paradise.

This was never a big town. The cathedral was founded in 739 by an English missionary, St Boniface, seeking to convert pagan tribes along the German border. It became the centre of what was for a time one of the largest dioceses in the Holy Roman Empire. In 1662 the town was consumed by a devastating fire, after which the cathedral was rebuilt by an Italian architect, Carlo Lurago. Famed for its swordsmiths, Passau remained an independent prince-bishopric into the 19th century.

The church is Baroque in style, dominated by twin towers crowned with octagons and green cupolas. Its stucco west front forms the focus of a *Domplatz* of 17th-century façades. Everything is white and cheerful. The water in the river far below might be the warm Mediterranean rather than the chilly Danube.

Passau's opulent interior fulfils the Baroque mission of uplift and exhilaration. The lower stages of the

↑ Passau: an exhilaration of Baroque

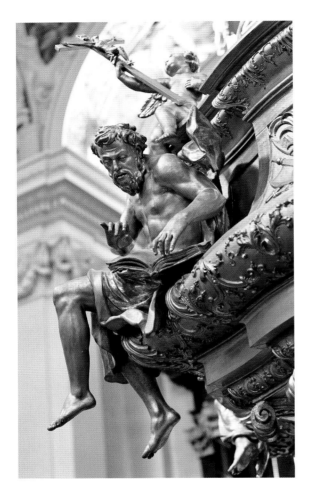

lavish decapitations and martyrdoms. The impact of the church is largely that of an integrated work of art.

Passau possesses what is claimed as the largest church organ outside America. It is splendidly arrayed across the west end and so drips in gold it is a wonder any sound can emerge. Not completed in its present form until the 20th century, the organ has 17,774 pipes with five linked manual consoles. Not surprisingly it is much sought after by enthusiasts.

REGENSBURG

✣ ✣

Perhaps I was there on a dull day but Regensburg's cathedral is a solemn place. The ancient city is genial on its bank overlooking the Danube, but the dominant Gothic church might suggest the Saxons came south to teach the light-hearted Bavarians the seriousness of their faith. A 12th-century bridge still straddles the river, its tolls long the source of Regensburg's wealth. Thronging with tourists from cruise ships, narrow streets wind uphill to the Domplatz.

The city was a Danube border fort of the Roman Empire and still boasts fragments of Roman walls and gates. In the Middle Ages this was the capital of Bavaria and a home to the assembly of the Holy Roman Empire from 1663 to 1806. A Romanesque cathedral burned down in 1273 and a new one was begun in the Rayonnant style now ubiquitous in Germany. The resulting choir, nave, flying buttresses and windows are emphatically French in feel. The cathedral was finally consecrated in 1520.

The bulk of the west front was built under the direction of a German family of masons, the Roriczers. One of their number, Matthew Roriczer, was famous or infamous for publishing the 'mysteries' of his craft at a time when they were supposedly oral and secret.

nave are plain but the arcade piers rise to an explosion of Rococo detail, like trees supporting a canopy of heavenly delights. The arches seem playgrounds for cherubs and angels. The ceiling vaults are frescoed with celestial scenes by the charmingly named Carpoforo Tencalla (1623–85). I try to imagine him and his fellow artists running riot over these spaces, delighted by the commission. The stuccowork grows even richer as it progresses towards the crossing.

The notable feature of the nave is the astonishing pulpit of 1726 made of linden wood and covered in gold leaf. Such is its profusion of musicians and other figures that any preacher must have to fight for the congregation's attention. The chancel and side aisles are lined with Baroque altars crowded with

↖ Pulpit hangers-on
→ Regensburg: a silver altar glows beneath medieval glass

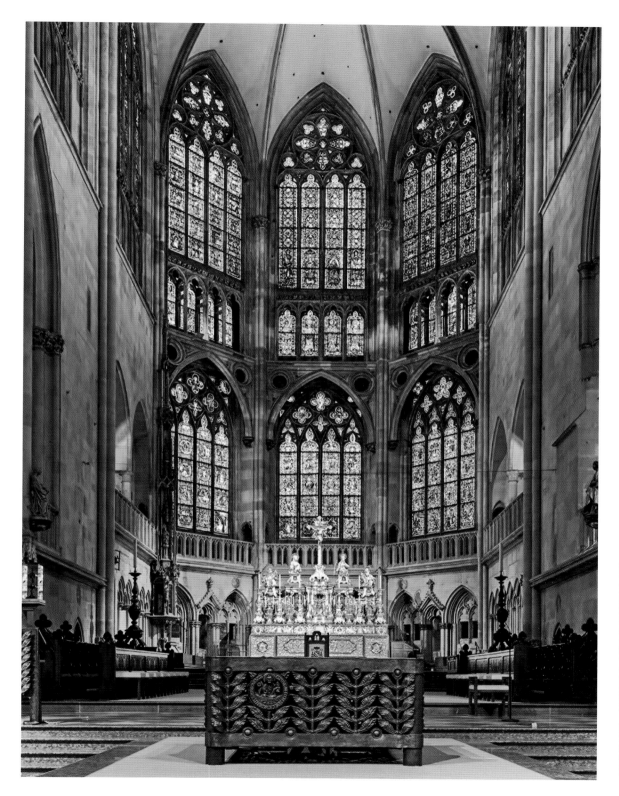

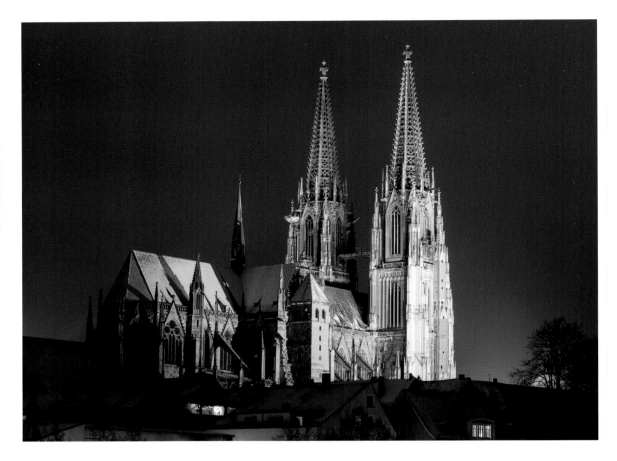

A curiosity of the drawn-out construction is the survival of its medieval *Eselsturm* or donkey tower, an ancient turret built against the north wall and used for hauling building materials to the roof. The turret was never dismantled and is still in use.

Regensburg's two western towers look as if they were trying to outsoar Cologne, though like those of most German cathedrals they were not completed until the 19th-century 'purification' by Ludwig of Bavaria. This involved the removal of post-Gothic features, including a Baroque cupola over the central crossing. The west front rises above a beautiful triangular porch projecting over the doorway, but the façade is a curious clutter of Gothic motifs, its dignity saved by the spires of openwork tracery.

Regensburg's interior is that of a conventional Late Gothic church with high nave. Only the ghost of a transept marks the join of nave and choir. The result is a sense of spaciousness, with an uninterrupted view west to east. The wide arches and aisles require heavy piers whose stone can seem grey on a gloomy day. I sometimes wonder what these vast interiors would be like if painted a dazzling white, as are some in Scandinavia.

Star of the interior is the 18th-century altar, which seems to have survived Ludwig of Bavaria's censorship. Made of silver it radiates down the length of the church and forms the backdrop to the cathedral's boys' choir, the *Domspatzen* or cathedral sparrows. These singers claim to be the oldest choir in the world, founded in 975 and still going strong.

Regensburg's detached Romanesque cloister lies to its north-east. Here tucked into a corner is the battered but idyllic All Saints Chapel of 1140. It is like

an old retainer left outside in the cold. The chapel contains a complete set of pre-Gothic frescoes still with their colour intact and with much medieval glass. It makes a secluded contrast with the great cathedral next door. No less contrasting is a building hidden on the other side of the square, Regensburg's 18th-century Alte Kapelle. This is a jewel of ecclesiastical Rococo, its decorative plasterwork on a par with that of Passau. To find these examples of the three ages of Christian architecture within a few paces of each other is a Bavarian delight.

SPEYER

✤ ✤

Speyer stands alone in a park on the edge of its town as if abandoned by the tide of German history. With Mainz and Worms it was the grandest of the three 'imperial' cities of the Salian dynasty. Buried here were Holy Roman emperors galore, including the one who completed it in 1106, Henry IV (r.1084–1106). He was the first emperor to test the authority of the German state against the Roman church. Though the issue was arcane – who had the right to appoint clergy – the so-called Investiture Controversy of 1076 led to a war between Germany and Rome and a dispute that was to continue in one form or another to the Reformation.

Speyer is architecture as power. At 134m in length, it is the largest purely Romanesque church still standing. It was begun in the 1030s and built over the following century, its appeal lying in the purity of its Romanesque form and decoration. Since its star had waned as early as the 12th century it was saved from the customary Gothic updating. A giant of red sandstone, its nave culminates in transepts at both ends, each crowned with three towers. There are no pointed arches, Gothic vaults or Renaissance capitals, just Classical pediments to the transepts.

In the 17th century Louis XIV's soldiers set the cathedral ablaze, and its west end was demolished and rebuilt in 1748–72. Invading French troops again wrecked it in 1792 but failed in their ambition in 1806 to replace it with a park in Napoleon's honour. In the 19th century the west end was again rebuilt in a Neo-Romanesque style. Much of the interior was covered in wall paintings at the time. Speyer has more than a touch of pastiche, the inevitable peril of restoration.

The interior is largely bare. The nave arcades are a sequence of squared piers with stone shafts and arches that change colour from silver grey to soft pink depending on the light. These tones form a pleasing contrast with the white limewash of the plaster. A later barrel vault replaced what would have been a simple wooden roof. Speyer's transepts can be compared with those being built at the same time in the 1070s, for instance at England's Winchester cathedral. I find these the more elegant. To the east, steps rise to the choir and apse under an arcade of elongated arches.

This apse covers Speyer's most important treasure, its crypt and royal mausoleum. Twenty columns sustain forty-two vaults, some of them 7 metres high. Almost all have cushion capitals dating from the earliest period of Speyer's construction. This part of the cathedral was not extensively rebuilt. Next to the crypt are imperial tombs of Salian emperors including the controversial Henry IV, as well as later Hohenstaufens and even Habsburgs.

Back in the nave St Catherine's Chapel is on two levels, with a baptistery below. The upper columns have formal Corinthian capitals presumably in honour of the dignitaries who would have occupied it. On the lower level are so-called free capitals, where it would appear the carvers allowed their imagination to roam at will. Only in the later sacristy does Speyer's stylistic guard drop, with the insertion of a renegade Gothic arch. It is as startling as a glass pyramid in a Louvre courtyard.

↖ Stern Gothic over light-hearted Regensburg
→ Romanesque crypt at Speyer

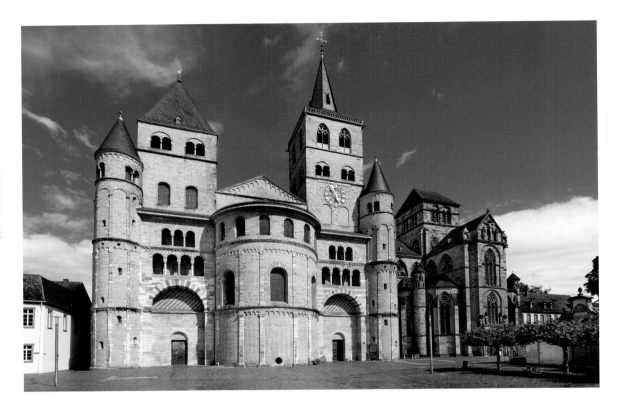

TRIER

❖ ❖

The emperor Constantine's mother Helen was the most gifted souvenir hunter of all time. She was the first official pilgrim to the Holy Land after her son's adoption of Christianity in 313, arriving in Jerusalem probably in 326. It is said that on her first day of sight-seeing she stumbled across the True Cross together with its nails and the 'seamless robe' or Holy Tunic worn by Christ on his walk to Calvary. Soon after-wards she came across a phial of Mary's breast milk, Christ's childhood swaddling clothes, the axe used to build the ark and the dish used in the feeding of the 5,000. Helen was later canonized – surely as patron saint of tourism.

Trier had been a major base for Diocletian's western empire in the third century and under Constantine (r.306–37) it retained that status.

Constantine murdered both his wife and his son for reasons that remain obscure, but he was deeply attached to his mother. Legend holds that she had a palace at Trier, hence presumably the cathedral's ownership today of Christ's tunic and crucifixion nail, although they were not 'discovered' until some eight centuries later.

Fragments of Roman brick wall can be seen in the exterior of the west front, but most of the present structure dates from the late 11th century with com-pletion in the 12th. Trier was in the form of a basilica with chancels at east and west ends, each with twin towers. The Romanesque west front is like a fortress, a wall of masonry beneath corner turrets rising above blind arches embracing a bulging semicircular apse.

The building is endearingly matched on its south

side by the startlingly different Liebfrauenkirche. This church was built c.1230 in a delicate Gothic style and could hardly look more contrasting. Romanesque Trier looks like a stout old man with a fashionable trophy wife on his arm.

The interior has been heavily restored and in a confusing jumble of styles. Some bays are round-arched and others pointed, while 18th-century furnishings are splashed about on all sides. The most startling insertion is the Baroque altarpiece in the east choir. Steps rise to an apse on which stands what appears to be a pile of rock framing an eerily illuminated altar within. Its sculpture is more geological than architectural.

At the other end of the church, the west choir is even more eccentric. It is decorated to look like an 18th-century drawing room panelled with figurative pilasters of caryatids apparently wrestling to support their capitals. Attached to the wall of the nave is an extraordinary 'swallow's nest' organ. Dated 1974 it is a welcome, and for once successful, modernist insertion into a medieval church interior.

Finally we reach the Holy Tunic. The garment was first recorded at Trier in the 11th century but it was found hidden inside an altar only when the emperor

↖ Fortress-like Trier
↑ Interior: a museum of styles

GERMANY, AUSTRIA AND SWITZERLAND

Maximilian I demanded to see it in 1513. It was then exhibited and attracted a reported 100,000 pilgrims, for whom a wooden gallery was erected on the west front so it could be shown to the crowds outside. The magnetism has never diminished. A 'showing' in 1996 attracted a million visitors, repeated in 2012. The tunic itself has been so manhandled, repaired and doused in rubber preservative as to be immune to scientific dating. The guidebook states deftly that its 'authenticity cannot be answered definitively: for the faithful, it is its symbolic value that is important'. Scottish visitors can take heart. Trier also possesses the sole of the sandal that was worn by their patron saint Andrew.

ULM MINSTER

✣

Having known Ulm as the tallest church in the world I was not sure how to approach it. Known as a *Münster* (or minster) but often referred to as a cathedral it is officially just a parish church. The tower rises from a square so close-packed that its size is hard to appreciate. Standing before it I felt the same giddiness as when looking up at Dubai's Burj Khalifa skyscraper. Both were built for no other purpose than to be higher than anywhere else. Like its rivals at Cologne (157m) and Rouen (151m), Ulm's 162m spire was not completed until the 19th century. Even then its scale must have seemed extraordinary.

The building was begun not by the church but by the town authorities in 1377 to replace an earlier one outside the city walls. The Cologne master Heinrich Parler was summoned to the task, but it was his son Michael who appears to have planned the tower. The church was estimated to have a capacity of 20,000 worshippers, though the population of Ulm was just 5,000. In 1392 the Parlers gave way to Ulrich Ensingen, who went on to design the tower of Strasbourg.

After Ulm had voted to follow Luther in 1530, work on the church came to a halt in 1543 with the tower at a height of just 100m. Construction was not resumed until 1817 when new flying buttresses were added. The spire was finally erected only in the 1880s, topped out in 1890 just half a century before it guided Allied bombers to the total obliteration of Ulm in a single night in December 1944. As with Ensingen's Strasbourg, the tower contrived to survive high explosives on all sides. The town's post-war reconstruction was carefully deferential to its setting. Even today the church is not wholly stable, its walls allegedly undermined by being used for centuries as a market urinal by Ulm's male citizens.

The minster is a display of obsessive verticality enveloped in flying buttresses struggling to keep it upright. The west front lacks the composure of a great French façade largely because each stage is straining to support the one above. The style might be termed elastic Gothic as if a giant hand had grabbed it from above and stretched it skywards. The tower openings are elongated beyond endurance and when the spire is finally reached it splinters into a filigree of openwork ribs. The top can be reached by climbing 768 steps which I fear I have not attempted.

The portal beneath is buried in a deep porch, the 14th-century tympanum a refreshing departure from the usual Day of Judgement. It is exceptionally decorative, depicting bosky scenes from the Book of Genesis, most of the figures appearing to enjoy themselves. The central column depicts Christ as the biblical Man of Sorrows. The gargoyles are suitably fierce.

Ulm's interior has two chambers. The nave, which was raised in the 15th century to support the tower, has double aisles and is of Late Gothic lightness. The stern furnishings look as if eager for Luther's seal of approval. Though the piers have statues of saints, the walls are covered in the civic shields and crests of local guilds and families. Ulm minster is a testament to the pride of its citizens rather than of its church.

→ Ulm Minster: Dubai of the Danube

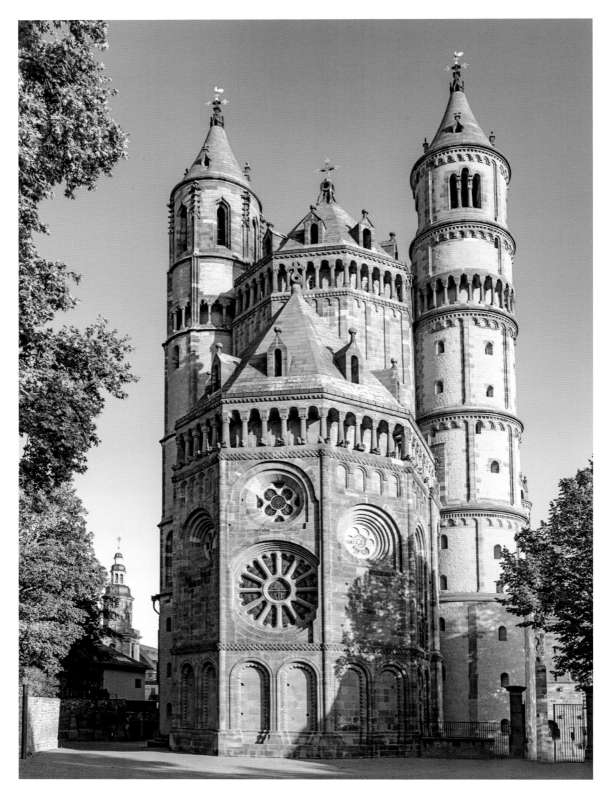

The earlier choir is smaller in scale. Here the walls are in a soft stone colour, the slender columns of the arcades rising to a vaulted roof alive with ribs darting from side to side. The canopy over the pulpit, decked in pinnacles, seems eager to emulate the vault above. The choir stalls come as a relief, 16th-century and backed by busts of saints and local characters. At the end of one of them is a bust believed to be of the carver Jörg Syrlina the Younger, portraying himself in the guise of Virgil. Ulm's organ is known to have been played by Mozart in 1763.

WORMS

✤

Every history student knows Worms for its 'diet', not a health regime but a church synod. As we saw in the opening of this chapter, it was here in 1521 that Luther was summoned for questioning by the Holy Roman Emperor Charles V and from here that he fled for refuge in the Elector of Saxony's castle at Wartburg, where he continued to promote the Reformation.

The cathedral was consecrated in 1181 on the site of a Christian church dating from Roman times. As one of the three *Kaiserdome* the cathedral's profile is not as elegant as Speyer's nor as sophisticated as Mainz's but somehow it exudes self-importance. The balancing choirs at the east and west ends carry the customary towers, each rising in seven telescopic stages. A feature of these German double choirs is the architectural elaboration added to them. At Worms the west towers are separated by what appears to be a double apse crowned with a blind arcade. The apse has no fewer than four rose windows. These Romanesque towers and windows are covered with carved animals, monsters and dwarfs as if in a child's story book. The real and the fantastical are all one to the medieval sculptor.

← Worms: architecture of busy-ness
↗ The Jesse Tree relief

Worms came through the Gothic revolution little altered apart from the south portal. This is 14th-century and framed by carvings of Bible scenes full of vitality and humour. Jonah emerges delighted from the mouth of his whale. The gable above has Mother Church riding on a bizarre animal composed of the four symbols of the evangelists, an angel, lion, ox and eagle. The resulting so-called tetramorph looks like a very sick camel.

Inside, the choirs at both ends present the familiar German confusion. It appears that even the pulpit does not know which way it should be facing. The choirs indicate that the east end is the answer. Here it appears that the canons in the 18th century were eager to cheer up what must have seemed a desperately old-fashioned place of worship. They duly filled the choir with Baroque furnishings including a Rococo baldachin rising over Balthasar Neumann's altar of 1742. The choir stalls are festive to the point of promiscuity, with gilded putti clambering over their canopies.

In the north transept stands a large 10m fresco of St Christopher bidding travellers a safe journey. An appropriate prayer as you leave the church is said to ward off evil spirits for one day on the road.

VIENNA

✤ ✤ ✤ ✤

My last visit to St Stephen's cathedral was in midwinter. The evening streets were empty of traffic and crowded with stalls and pavement entertainers. In the cold air, surrounded by caped and cloaked strollers, I could have been in the Middle Ages. As a backdrop was Vienna's monumental cathedral floodlit against a black sky, showing how splendid these churches can look at night with surrounding buildings invisible. Stone texture is softened and detail is thrown into relief.

Like many cathedrals of the Rhine and Danube, St Stephen's (Steffl to the Viennese) was rebuilt in the Gothic style after a fire. The choir was begun in 1304, the nave and steeple in the 15th century, initially by the German master Wenzel Parler, recently of Prague cathedral. The scale of the latter is similar. The roofs are extraordinarily steep, with tiles patterned as lozenges and depicting double-headed imperial eagles over the east end. Towers stand over the two transepts while two more guard the west end. Everything declares the confidence of the Austro-Hungarian Empire in its prime.

The great tower over the south transept was mostly designed by Parler around 1400, and was completed in 1433. Narrowing stages of gables and pinnacles rise to a spire coated in crockets. Its northern twin was never built, the stump supporting nothing more than an onion dome. The lower portions of the two west-front towers survive from an earlier Romanesque cathedral, as does the plain Giant Gate between them. Strange early sculptures have been let into its wall and the gate contains remarkable 13th-century carvings of apostles and monsters. Otherwise the exterior of this imposing church is about mass and presence.

→ Vienna: Gothic most imperial

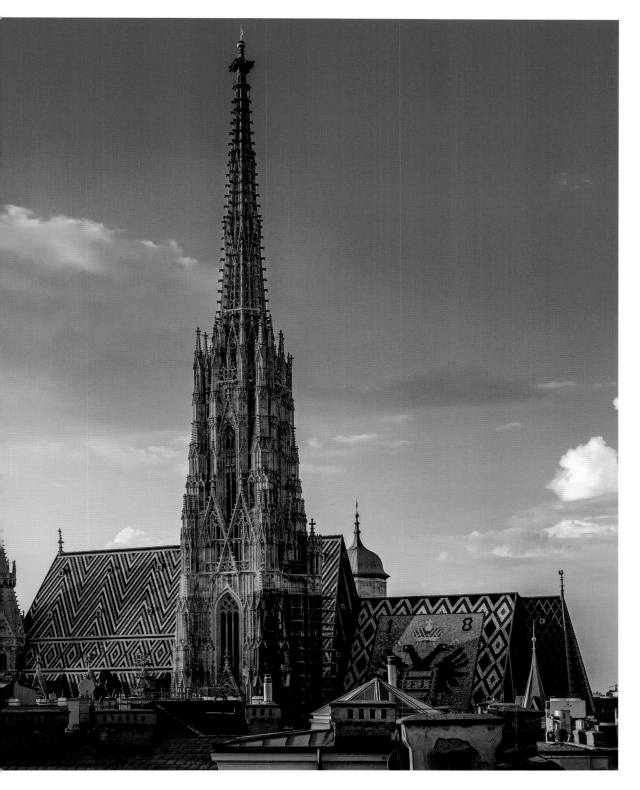

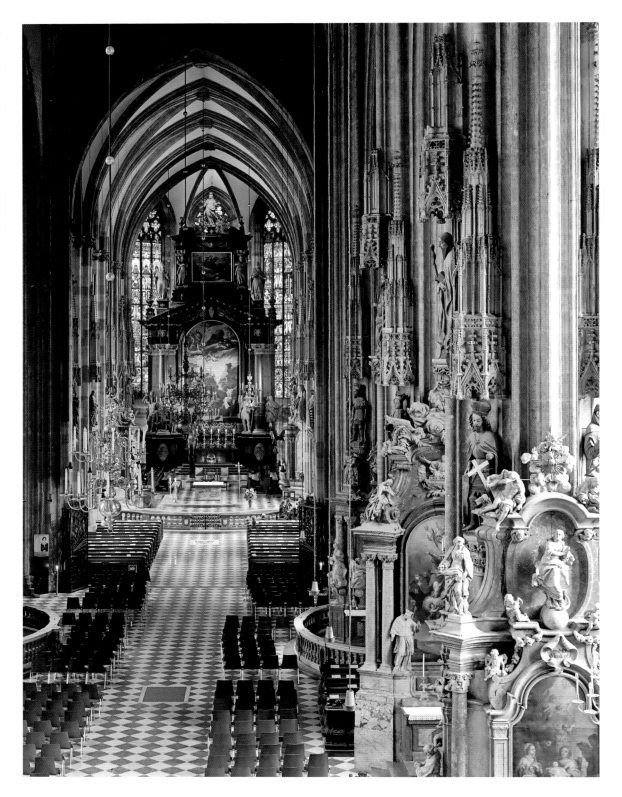

The power of St Stephen's lies in its gallery of ecclesiastical art, so splendid it could be an extension of Vienna's Kunsthistorisches Museum. Nave and aisles are divided by slender piers up which Baroque altarpieces clamber like reefs of stranded coral. Meanwhile the walls are festooned with chapels and shrines of all ages. The ensemble demonstrates how well Gothic and Baroque can sit next to each other in an appropriate setting.

The pride of this cathedral is one of the few pulpits to match those of Pisa. Dated 1514 on the threshold of the Renaissance, it stands at the west end of the nave covered in Late Gothic tracery. Round its base are niches containing busts of the church's four most celebrated theologians, Augustine, Jerome, Gregory and Ambrose. Their faces are said to express the 'four temperaments', sanguine, choleric, melancholic and phlegmatic.

The preacher would climb the pulpit with a handrail covered in toads. These represent evil being devoured by 'good' lizards while at the top a dog represents God. At the foot of the composition is a carved portrayal of presumably the sculptor himself peeping out of a half-open window. Doubt

← The nave: galvanized by Baroque
↑ The pulpit: two of four temperaments

surrounds his identity, but my most authoritative guide to Vienna agrees that he is the Late Gothic master Anton Pilgram (1460–1516) (see p. xxix), his is a face full of curiosity and humanity.

I find the Gothic works quieter and more moving than the Baroque ones. The icon of Mária Pócs (c.1676) is said to weep overnight during serious crises. Christ with a Toothache (1380) stands under the north tower offering comfort to sufferers. Constantine's mother St Helen has her True Cross, miraculously discovered on the first day of her pilgrimage to Jerusalem. Another sculpture of Pilgram with his mason's tools can be spotted on a corbel under the organ.

A series of reliefs of Christ's passion is displayed in the cathedral's north-west corner dated 1527. One shows a fat Martin Luther in the crowd before Pontius Pilate demanding Christ's death. This was at the height of Luther's vilification by the Catholic authorities. Next door is the Chapel of the Cross, burial place of Prince Eugene of Savoy (d.1736), co-victor with Marlborough at the Battle of Blenheim.

Most remarkable is the monument in the cathedral's south-east corner, the red marble tomb of the emperor Frederick III, the first Habsburg Holy Roman Emperor and also the longest ruling (1452–93). It appears to have been commissioned by Frederick during his lifetime as early as 1469 from Dutchman Nikolaus Gerhaert van Leyden (1420–73). The style is the highest of High Gothic. Round the casket are priests praying for Frederick's soul while beneath are turbulent people and animals allegedly depicting the emperor's sins during his life.

Austria's future imperial family, the Habsburgs, were thus being placed under an antique Gothic tomb as if to stress their links with Germany's past. At much the same time in London, it was the Tudors who were coming to power, equally eager to assert their royal credentials. But when Henry VII died in 1509 it was to the future that the Tudors looked. His tomb in Westminster Abbey is in the Renaissance style by an Italian, Pietro Torrigiano (see p. 142).

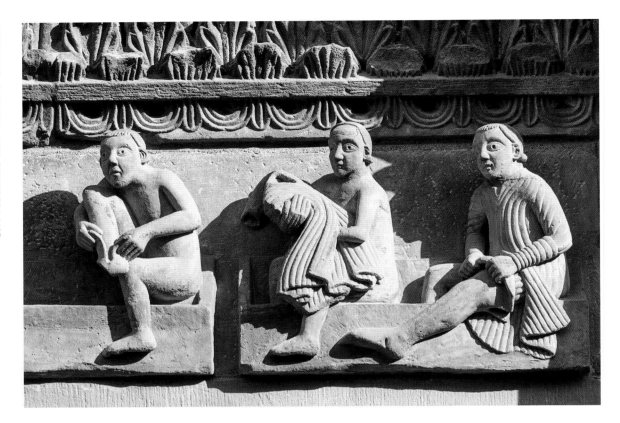

BASEL MINSTER

❖

Basel minster sits on a hill over the Rhine like a house on which someone started work and then added bits over time. The older parts and the crypt date from its rebuilding in 1019 under the last of the Ottonian Holy Roman emperors, Henry II (r.1014–24). Heavily damaged by a fire in 1185 and an earthquake in 1356 it was gradually updated until assuming its current state in 1500 shortly before the Reformation.

The cathedral's entrance façade has a curious appearance, as of a sandstone barn whose gabled roof extends almost to ground level on either side. Through this roof are thrust two assertive and not quite matching towers, restored after the earthquake and with the saintly names of Martin and George.

To the left of the doorway is a fine relief of St George sparring with his dragon across an expanse of wall. The 13th-century statues flanking the doorway are, on the left Henry II and his wife Cunigunde, and on the right a Prince of the World. This mythical seducer has a snake crawling up his back as his lady victim smiles while undressing. The roof tiles have a bold lozenge pattern.

The church interior has width at the expense of height. It is essentially a basilica with widely spaced arcades and double aisles on each side. The pleasant grey stone is lit by clerestory windows. At the crossing the piers are clustered and the transepts decorated with blind arcading. The north aisle displays a masterpiece of 12th-century carving, four relief panels of the life of St Vincent, the faces strongly expressive for so early a work.

The choir is clearly Protestant. Basel opted for the Reformation in 1529 during which a mob under the influence of the Swiss reformer Ulrich Zwingli (1484–1531) sacked the cathedral and destroyed its Catholic fittings. It became a Protestant Swiss Reformed church. The apse is accordingly empty and the altar table is backed by a simple row of seats for elders. It reminds me of a Welsh Nonconformist chapel. Only the swirling High Gothic pulpit offers an echo of a pre-Reformation past.

Beneath the choir is Basel's medieval crypt. Capitals and corbels carry inventive carvings inspired by legends of early Switzerland. Townspeople are fighting dragons when not gathering in the harvest. The church's treasure is the 12th-century St Gallus portal outside the north transept. It is framed by miniature Romanesque arches while the doorway itself is flanked by three pillars with free-style capitals. In the tympanum Christ sits in judgement on the wise and foolish virgins, clearly extending his blessing to the former.

Basel has two cloisters great and small with a graceful arcade between them filled with memorial plaques. The cloister openings carry bold Flamboyant tracery. The south transept overlooks them with a six-pointed window, a Star of David which was the emblem of a medieval masons' guild. Basel is worth visiting for this charming enclave alone, the architecture of shady cloister, sunny lawn and curvilinear tracery the epitome of a place of retreat and meditation. The Renaissance scholar Erasmus ended his days in Basel in 1536. Though a Catholic, this broadminded man was presumably content to be buried in a Protestant church.

↖ Basel: resurrected souls get dressed
↑ Cloister of retreat and meditation

GREAT BRITAIN

CANTERBURY ✤✤✤✤; DURHAM ✤✤✤✤;
ELY ✤✤✤✤; EXETER ✤✤✤; GLOUCESTER ✤✤✤;
KIRKWALL ✤; LINCOLN ✤✤✤✤✤;
LONDON, ST PAUL'S ✤✤✤;
LONDON, WESTMINSTER ABBEY ✤✤✤;
NORWICH ✤✤✤; ST DAVID'S ✤; SALISBURY ✤✤✤✤;
WELLS ✤✤✤✤✤✤; WINCHESTER ✤✤✤✤;
YORK MINSTER ✤✤✤

Under the aegis of the Roman Empire, Christianity spread to most corners of the British Isles. Three bishops from London, Lincoln and York attended the first Christian council at Arles in 314, indicating an established church hierarchy. Yet when the empire collapsed most of the country appeared to revert to paganism, with pockets of Christianity surviving chiefly in Ireland, Wales and Cornwall. By the 6th century these pockets were sending missionaries into Scotland and down the east coast of England, including an abbey at Lindisfarne. It is even possible that this so-called Celtic church might have become that of the British Isles as a whole.

As it was, in 596 Pope Gregory the Great sent Augustine to secure England for Rome; he landed in Kent and obtained the conversion of its pagan king, Ethelbert, whose French wife was already a Christian. By the start of the 7th century the Roman 'rite' was in open conflict with the Celtic one, both in Wales and in Northumbria. This led in 664 to the Synod of Whitby, which decided that the Christian church, at least in what became England, would opt for Rome. By the 730s this decision was well enough established for the Venerable Bede of Jarrow to write an *Ecclesiastical History of the English People*. This loyalty to Rome survived until the Reformation.

Gregory had intended London to be the English church's headquarters, with its St Paul's claiming foundation in 604. But when a dispute with the then ruler of Essex led to the eviction of Mellitus as London's first bishop in c.618 he retreated to Canterbury, which remained the seat of England's premier archbishop. This is a church that does not forget or forgive.

By the reign of Alfred the Great (871–99) and his victory over the Danes at Edington in 878, England outside the east-coast Danelaw was dominated by Wessex, supporting a network of Anglo-Saxon abbeys and cathedrals. But episcopal and monastic authority in the British Isles was notoriously lax. One reason the papacy supported William of Normandy's 1066 invasion of England was to restore the authority of Rome.

Nothing so visibly symbolized the Norman Conquest as the swift rebuilding of virtually all Saxon cathedrals, abbeys and most churches. Historians regard this building campaign over the half-century after the conquest as unprecedented in Europe. Bishops and clergy poured into England from Normandy, benefiting from the total expropriation of Saxon wealth. They stamped their authority on the country with an empire of stone.

The new cathedrals boasted the rounded arches, sculpted capitals and western wheel windows of the French Romanesque. England, if not yet Scotland, was to be emphatically an adjunct of Normandy. Norwich, Winchester and London competed to be the longest churches in the land and Durham's rib vault of 1133 may have preceded even those of the Île-de-France. A quarter of the forty richest dioceses in Europe were in England.

The next burst of building came with the boom in pilgrimage and the advent of the Gothic style in mid-12th-century France. In 1174 the French master William of Sens was chosen to rebuild Canterbury after its destruction by fire. At the same time pilgrimage to saints' shrines was requiring ambulatories to be replaced by retrochoirs to take ever larger numbers. As a result few English cathedrals retain rounded apses. There was also less emphasis than in France on spectacular west portals and tympanums.

In the mid-13th century French Rayonnant Gothic arrived with Henry III's rebuilding of Westminster Abbey, designed in 1245 by Henry of Reims and evolving into the later Gothic style known as Decorated. Its chief innovation was elaborate window tracery and pier decoration, as in York's west front and Lincoln's Angel Choir respectively. The half-century from 1290 to the Black Death in 1348 saw craftsmen such as Thomas Witney and William Joy join the ranks of the finest architects in English history.

The Hundred Years War with France brought to an end the dominance of French architectural

style in England. While continental cathedrals were erupting into Flamboyant Gothic, England evolved a more sober style to be known as Perpendicular. Arcades became plainer, arches shallower, windows bigger and rectilinear. Most prominent were the towers, magnificent at York, Gloucester and Canterbury. Perpendicular reached its climax in Henry VII's Chapel at Westminster at the start of the 16th century. Built half a century after Brunelleschi's Renaissance San Lorenzo in Florence, it suggests a confident culture reluctant to adopt the style of ancient Rome.

Henry VIII's Reformation brought almost all church building to a halt. Only St Paul's slipped through the net after the London fire of 1666. Over the 17th and 18th centuries many cathedrals suffered neglect and lost interior fabric and fittings. York minster once had fifty chantry chapels, almost all now gone. More English medieval glass disappeared through Georgian decay than through Reformation iconoclasm.

The Gothic revival of the 19th century did much to set this neglect to rights, in England as in France. This was largely due to one architect, Sir George Gilbert Scott, responsible for almost every cathedral restoration in the land. Like France's Viollet-le-Duc he was criticized for the radicalism of his reinstatements, but he was struggling with much desperate dereliction. A serious student of Gothic, he strove always to repair rather than reinvent. In the new screens at Ely and Winchester it is hard to tell what is Scott and what medieval.

In the 20th century, architectural respect mutated into timidity. Architectural historians opposed the restoration of eroded statues and façades, favouring mere 'stabilization'. Empty and decayed west fronts at Wells and Exeter mostly stayed that way (see p. xxv). While modern glass was considered acceptable, modern or replicated sculpture was rare. As for new buildings, post-war Coventry made a valiant bid for modernity and a few cathedrals contrived sensitive additions, as at Norwich, Wells and St David's,

but lack of resources and a fear of the new seemed to freeze ecclesiastical taste.

The revival of English cathedrals in the 21st century that I noted in the Introduction has been due partly to an enthusiasm for historic buildings generally, but also to the cathedrals' determination to refocus as centres of their communities. At a time when so many local institutions are failing, cathedrals are reasserting a musical, social and educational role. That their fabric is now largely in good order is a double blessing, though efforts to conserve their townscape settings are a constant battle against careless development.

CANTERBURY

✢ ✢ ✢ ✢

Canterbury may be England's archiepiscopal capital but it is a charmingly unpretentious place. From a distance its silvery towers rise over the green Kent valley, beckoning pilgrims to its bosom as they have done for centuries. Close to, ancient walls still guard the cathedral's privacy and protect its treasure house of medieval architecture and art.

In 580 the pagan King Ethelbert of Kent (r.589–616) married a French princess Bertha, descendant of Clovis, first true monarch of France. It was a political marriage and she insisted on retaining her Christian faith in her godless new home. In 596 this stirred Pope Gregory to dispatch Augustine to Kent, where he founded his first cathedral in Canterbury. This survived until the Normans demolished and replaced it soon after the conquest.

A century later Canterbury hosted an event that scandalized Europe. On 29 December 1170 the archbishop Thomas Becket was murdered at his altar by four supporters of the Plantagenet Henry II (r.1154–89). Within hours of his death townspeople were flocking to dip their garments in his blood. Miracles were instantaneous. It was said that 'the blind see, the

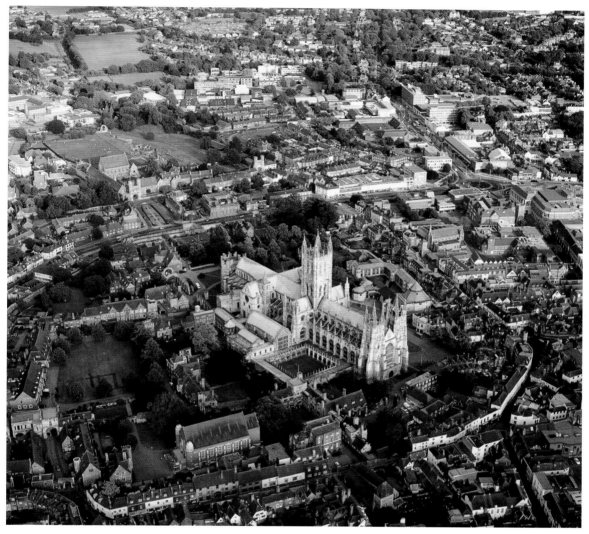

Canterbury with its medieval enclosure

dumb speak, the lame walk, the sick are made whole.' Pilgrims rushed to Canterbury. Four years later the east end of the cathedral was consumed in a fire, claimed by many as punishment for Becket's death. A monk named Gervase wrote that his colleagues 'howled rather than sang their matins and vespers'.

The monks soon turned grief to good account. Becket's shrine became third only to Rome and Santiago de Compostela as a European pilgrimage destination. Canterbury prospered mightily. The task of rebuilding the eastern arm of the cathedral

went in 1174 to the French master mason William of Sens. On his early death in 1180, the work was continued by William the Englishman, his name perhaps suggesting the rarity of English masons at the time.

The east end of the cathedral was duly designed in a Transitional Romanesque–Gothic style familiar in France, and completed in 1220. This style can seem overly heavy today, but to early pilgrims approaching from a then gloomy Norman nave the east-end interior would have seemed bathed in light. Becket's shrine would have come into view

in all its glory, piled with jewels and surrounded by devotees.

Today the shrine has gone and a visit to Canterbury must begin, to my mind unfortunately, not as it was for pilgrims through the transepts but through the later Perpendicular nave built in the 14th century and crowned by the three great towers. Of these the central one, 'Bell Harry', was built in 1498 by the Perpendicular master John Wastell and named after its donor Prior Henry. Of the western towers the southern was built in 1424 and is similar to Bell Harry and the northern was an imitation of it begun in 1832, so all are essentially by Wastell. They compose a magnificent trio.

The nave was constructed by the royal mason, Henry Yevele, in 1378. Nine bays of rolling piers soar upwards, each with a mere whisper of a capital before splaying outwards into a zigzag of vaults. The aisle and clerestory windows are mostly hidden behind an avenue of piers, but when shafts of sunlight burst through them they dance with refracted colour. I found myself here one summer morning during a choir rehearsal of Bach's B minor Mass. I have never known music so enhanced by light.

Above the crossing rises the vault of Bell Harry, its fan of ribs and panels spinning dervish-like in the air (see p. xxi). A pulpitum dating from the 1450s guards the older eastern arm beyond. Its parade of statues of kings from Ethelbert to Henry VI is a signal that Canterbury was emphatically an English church, if not yet the reformed Church of England.

The south transept, through which pilgrims originally entered, is the first display of Canterbury's medieval stained glass. Tiers of 15th-century figures and shields include what appears to be a rare contemporary portrait (c.1482) of Edward IV and Elizabeth Woodville. Below is some of the oldest glass extant in England, a wonder of medieval art of the late 12th century depicting Christ's ancestors, including an alert and expressive Methuselah. The north transept, which pilgrims reached through a tunnel from the south, is the reputed site of Becket's

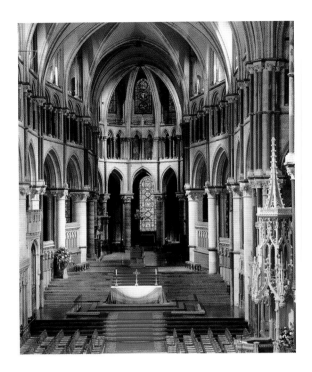

murder, the Martyrdom. The fatal altar is marked by a grim modern sculpture of jagged swords by Giles Blomfield (1986).

From the Martyrdom steps lead up to the choir and down to the crypt. The latter is one of the joys of Canterbury and the most extensive in England. The pier capitals are Romanesque masterpieces executed *in situ*, with some of them left unfinished. They portray flower patterns, jugglers, animal musicians, men fighting beasts and wyverns fighting dogs. Life is both violent and comical. To the historian T. S. R. Boase, they show that the snapping jaws of hell 'are never far behind men's heels … frail naked humanity is forever caught in its coils.' The chantry chapel of the Hundred Years War hero the Black Prince was intended for his tomb, but that lies near the Becket shrine in the cathedral above. The chapel was granted to Huguenots fleeing French persecution in the late 16th century.

The pilgrim route leads from the Martyrdom along the north choir aisle, forming the visual and emotional climax of the journey. Steps would have

been lined with chantries, monuments, murals and stained glass, attended by flickering candles, the smell of incense and the chanting of monks. Of the windows the 12th-century Bible sequences are like pages from a book. Lot's wife gazes back at Sodom's destruction and her fate. The progress is like a pilgrimage in miniature, faith as theatre.

As we have noted, the cathedral's eastern arm of c.1180 is Transitional Gothic. The arcading remains Romanesque in form, the capitals adorned with acanthus leaves, the pointed arches not yet soaring. The sanctuary below is flanked by a busy-ness of tombs, altars and chantries of a quality second only to Westminster Abbey. The finest is that of Archbishop Chichele (d.1443), in the form of a triumphal arch coloured and maintained by Chichele's foundation, All Souls College, Oxford.

Beyond the sanctuary we reach the site of Becket's shrine. The walls flanking the Trinity Chapel here bend in and out round the site, creating a faintly Baroque sensation. This was to avoid demolishing two earlier chapels on either side which survived the earlier fire. The location of the shrine itself is today an anticlimax. By 1538 when the 'Becket question' was abruptly resolved by Henry VIII, the object of veneration had become a heap of gold and silver, of trinkets and precious stones left by centuries of pilgrims. To the Venetian ambassador it was 'passing all belief'. Erasmus related that the prior 'pointed out each jewel, telling its name in French, its value and the name of its donor'.

Henry's commissioners were unimpressed. They bizarrely 'summoned Becket' to a kangaroo court on a charge of treason and when he failed to attend loaded the shrine on to twenty-six carts for the royal treasury in London. The site is now marked by a simple Protestant candle. Canterbury is thus *Hamlet* without its prince. I am sure Anglicanism could tolerate a recreation of its most famous relic.

↖ The choir: Gothic emergent
↗ Romanesque crypt capital

As it is, visitors must turn to thebecketstory.org.uk website to see how the shrine would have appeared, bejewelled and guarded with railings.

The site is overlooked by one of Canterbury's treasures, the tomb of Henry IV (d.1413) and his wife Joan of Navarre. They were buried here because Westminster Abbey was declared full, though it was also thought to be because he was a usurper. Their effigies are reputed likenesses carved in alabaster. Opposite lies the tomb of the Black Prince (d.1376), another supreme work of medieval sculpture. The chamber leads into the culminating Corona Chapel, bathed in blue light and believed to be the resting place of Becket's head.

Canterbury's medieval stained glass is now in full flow, much of it rearranged and infilled by masters of Victorian Neo-Gothic, Clayton & Bell. The windows in the Trinity Chapel portray the miracles of St Thomas, those in the Corona Chapel the events of the Crucifixion. The stained glass is complemented by medieval tiles, some brought back by crusaders from the Levant. These survive round the shrine in rich browns and yellows.

The cathedral close retains the ambience of a medieval enclave. Walls, gates and outbuildings of the old priory survive, including the Norman

cloister. The cloister's vault is composed of ribs with 850 bosses, another miniature sculpture gallery. In the north-east corner is a boss depicting Becket's murder but showing only two of the four murderers. Someone was being protected.

DURHAM

✣ ✣ ✣ ✣

Durham on its bluff over the River Wear boasts the finest cathedral location in Europe. It was intended as a citadel of the Norman Conquest and, like Albi in France, its purpose was to assert the presence and permanence of an alien power. Durham is a cathedral I find it hard to like, but it is undeniably awesome.

The present cathedral was begun within twenty years of William's 'harrowing of the north', a campaign of starvation and expropriation as punishment for the north's refusal to submit to Norman rule. At a time when most people would have been living in thatched huts the building must have seemed from another world. I once visited Durham shortly after returning from St Peter's Rome. Could they be temples to the same faith?

This was not the first church on the site. In 995 the monks of Lindisfarne were seeking safety from invading Danes with the body of their patron, St Cuthbert. Legend holds that a kindly cow led them to this rocky outcrop, though it cannot have needed a cow to see its defensive advantages. A church and monastery were duly founded. When the Normans arrived the local bishop was granted palatinate or absolute powers, allowing him to suppress rebellious Saxons or intrusive Danes without having to await orders from the king in the south. The new cathedral was begun in 1093. Durham on the northernmost frontier of Christendom was thus contemporary with Germany's Speyer. They make a telling Romanesque comparison of Norman robustness with Ottonian refinement.

The climb through Durham's old town winds upwards to a spacious close overlooking the encircling Wear gorge. The cathedral stands massive on the far side of the close, its brown stone needing a bright sun if it is to look remotely cheerful. Stylistically the exterior is confusing since much of what we see is post-Norman. The central tower and much of the fenestration are Perpendicular while the west towers carry fussy 19th-century battlements where once were stern Norman spires.

The exterior of Durham was also extensively restored and much of its detail removed in the 18th century. Its most celebrated fitting, a Romanesque bronze door knocker, is a replica of the original in the cathedral museum. A fugitive who grasped it was in theory allowed thirty-seven days of safety inside. He then had to escape or hope his pursuers' enthusiasm had cooled.

Durham's nave is among the most muscular works of Romanesque architecture. Its arcades form an avenue of towering columns alternately circular and shafted, their piers incised with diapers, spirals and chevrons. These incisions were once filled with metal and now look naked. It would be wonderful to see their former colouring restored. Monumental solidity was not the intention of their creators. If conservationists are allowed replica knockers why not replica pier fluting?

Durham's ceiling was built in the years following 1093 not as a customary timber structure but with a pointed rib vault. This may be the earliest such vault in Europe and must have been built by masons trained in Normandy. Every moulding of the nave is decorated with the design motif of the age, zigzag. This covers arcades, triforium and clerestory almost obsessively. The only other adornments are a few monsters peering down from corbels, as if to strike fear into the worshippers below. The side walls are lined with blind arcading again with zigzag, but otherwise the nave is bare. A line across it marks the point

→ Durham: architecture of power

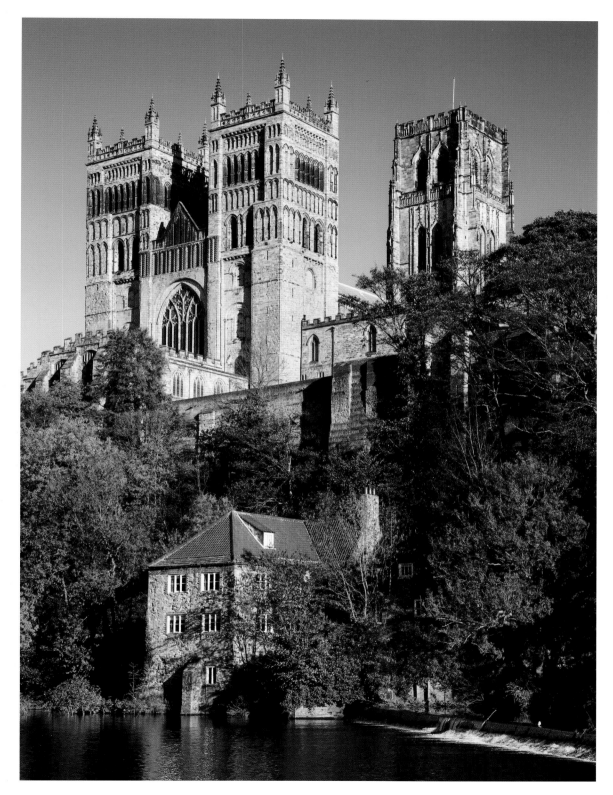

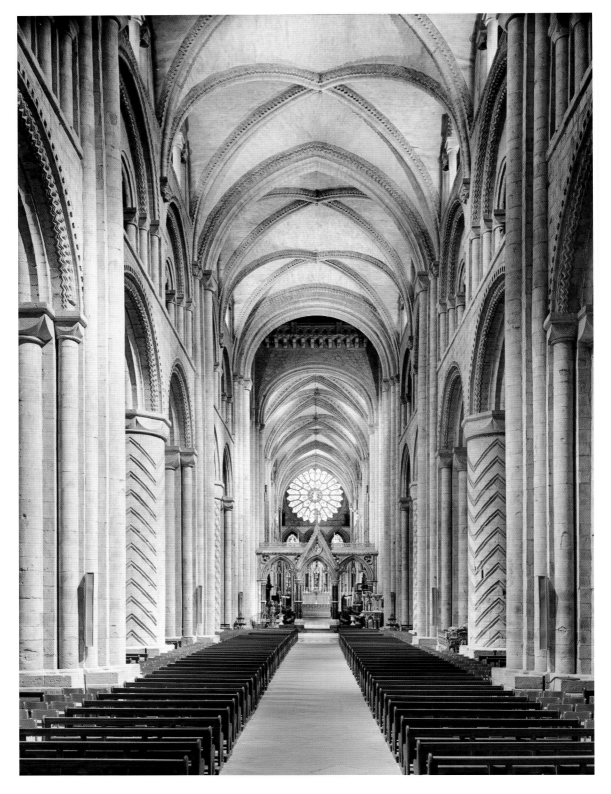

114

beyond which women were once banned from proceeding eastwards as the cathedral was officially also a monastic church. In the aisle a coal-black memorial of 1947 is to Durham miners who died in local pits.

A door in the west wall leads to the Galilee Chapel built jutting out from the cathedral towards the cliff edge. Designed at the end of the Romanesque era c.1175 its stylish delicacy contrasts with the massiveness of the nave. The patron was Durham's flamboyant bishop Hugh le Puiset (1153–95), who lived openly with a mistress and fathered many children. Round arches on spindly piers line up in rows, reminiscent of Córdoba cathedral. The chapel houses the tomb of the Venerable Bede (672–735), brought from Jarrow to Durham in the 11th century. Jarrow needs him and should surely get him back.

Back in the nave a climax is reached in the crossing and choir. Here the stalls were inserted in 1665 in the Gothic style by the royalist but Protestant Bishop Cosin, passionate enthusiast for what came to be called Gothic 'survival' as appropriate for high church worship. Beyond stands the throne erected for himself by Thomas Hatfield, bishop for thirty-six years until his death in 1381. The throne with Hatfield's tomb beneath is said to be taller even than the pope's in Rome. It reflects the status of the Durham bishops with their palatinate authority.

East of the throne stand the Neville screen and flanking sedilia. This exuberant work of Perpendicular art was donated to thank St Cuthbert for the English victory over the Scots at the Battle of Neville's Cross in 1346. Designed by Edward III's master mason Henry Yevele, it was shipped from London in kit form and soars upwards like a row of stalagmites. The screen niches were once filled with 107 alabaster statues and their absence after removal by iconoclasts is painful to see. It is like an art gallery of empty frames. They need filling.

Durham's Gothic eastwards extension was begun in the 13th century by Bishop Richard Poore, founder of Salisbury cathedral. He was sent north in 1228 to resolve a dispute within Durham's fractious

Benedictine community and decided to build a new shrine for St Cuthbert directly behind the high altar. This was dismantled at the Reformation, but when Henry VIII's commissioners opened the actual coffin in 1542 they were reportedly horrified to see Cuthbert's undecayed body, his beard fully grown. They grabbed his jewels and fled, referring the matter to the king. Cuthbert's remains were reburied.

Beyond the shrine rises the Chapel of Nine Altars, in effect a pilgrimage waiting chamber. The style echoes Poore's previous cathedral of Salisbury in its extensive use of dark 'Purbeck marble', in fact quarried locally at Frosterley. Lancet windows suffuse the space with a sombre light. On the north side rises the bizarre Jesse window with overlapping styles of geometric and intersecting tracery forming a sort of medieval double-glazing.

Beyond lie the cloisters and conventual buildings of the old monastery, among the most complete in England. They are now an extensive museum. It would be wonderful if they could be restored more accurately to represent the activities of these largely forgotten medieval institutions.

← The nave: epitome of the Romanesque
↑ The Galilee arcade

ELY

✤ ✤ ✤ ✤

The popular Ely image is of the cathedral floating in the distance on a sea of mist, a ghostly Fenland galleon. The original abbey was founded in the 7th century by England's first female saint, Etheldreda, a princess who rejected the consummation of not one but two arranged marriages. She duly died a virgin, an abbess and a saint, patron apparently of bad throats. Her abbey in this watery corner of East Anglia was reached by three secret causeways.

The church was seized and rebuilt by the Normans to reinforce their crushing of a Saxon revolt by Hereward the Wake in 1071. As with Durham, Lincoln and Norwich, its size reflects the Conquest's insecurity along England's east coast. Of the Norman church the west front and nave survive and convey its scale, but the press of pilgrims to Etheldreda's shrine in the 13th century required the rebuilding of the east end.

A century later in 1322 came disaster. The Norman crossing tower collapsed, taking with it the crossing and four bays of the choir. The architect Alan of Walsingham was said to have been left 'grieving vehemently and overcome with sorrow', possibly because the foundations of his new Lady Chapel were thought a cause of the collapse. He recovered to bless Ely with its most glorious feature, a great stone octagon and wooden lantern, the latter designed by a genius of a carpenter named William Hurley. I recommend the climb to Hurley's corona and the view out across the Fens in a setting sun.

From the west the cathedral is a mess. The northwest tower also collapsed in the 15th century but unlike the crossing was never rebuilt, giving the west façade an amputated look. The south-west tower survives and is adorned with circular shafts from top to bottom, looking like scaffolding. The south exterior has two superb Norman portals, the prior's door and the monks' door, each decorated with spiralling tendrils, figures and motifs. The tympanum above the prior's door has a Christ in Majesty attended by distorted angels with strangely huge hands and feet.

The nave can be seen through the open west door – indeed I was once able to stop my car outside and glimpse its entire length from the front seat. The nave arcades stretch into the distance, with no ornament, just a rhythmic alternation of rounded and shafted piers. Overhead is the original wooden ceiling redecorated by the Victorians in Pre-Raphaelite reds and greens.

Visitors walking down Ely's nave should prepare themselves for a surprise. The few steps leading from the nave aisle into the crossing offer a sudden spectacle on a par with the choir at Beauvais. The view leaps upwards into space as ribbed fan vaults dance attendance on Hurley's octagonal lantern. This lantern forms an upper chamber, vaulted and with windows. The view upwards into this space is as fine as any in an English cathedral.

The construction of the octagon began in 1322; the lower vault and the lantern are of wood, requiring twenty-four giant oaks to be transported from Bedfordshire and raised to a vast height. Ely is thus a phenomenon of engineering which continues to fascinate builders to this day. The view down into the crossing from the accessible octagon is almost as exhilarating as that up from below.

The east end of the cathedral is a different Ely. The 14th-century choir – originally under the crossing – is garlanded with stiff-leaf carving and studded with the ballflower, crockets and foliage of Decorated Gothic. In the 19th century this area was ruinous. Pugin reportedly burst into tears on seeing it, crying, 'O God, what has England done to deserve this?' The arrival in 1850 of George Gilbert Scott saved the day. His choir screen based on fragments surviving on site is one of his earliest, perfectly modulating the view between east and west of the interior. Nowhere is Scott's mastery of Gothic on finer display. His work sits well alongside Peter

→ The crossing: a starburst of light
↓ Ely: afloat on a fenland mist

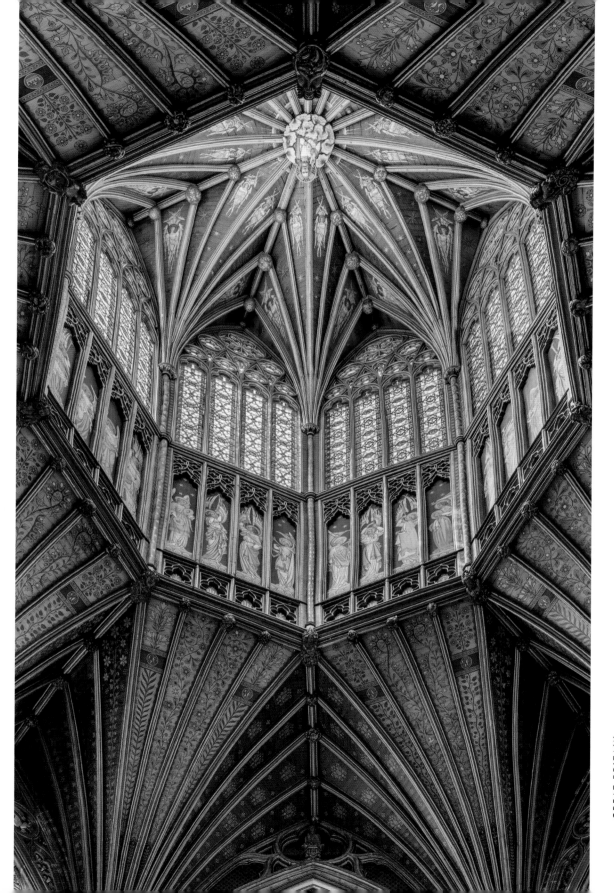

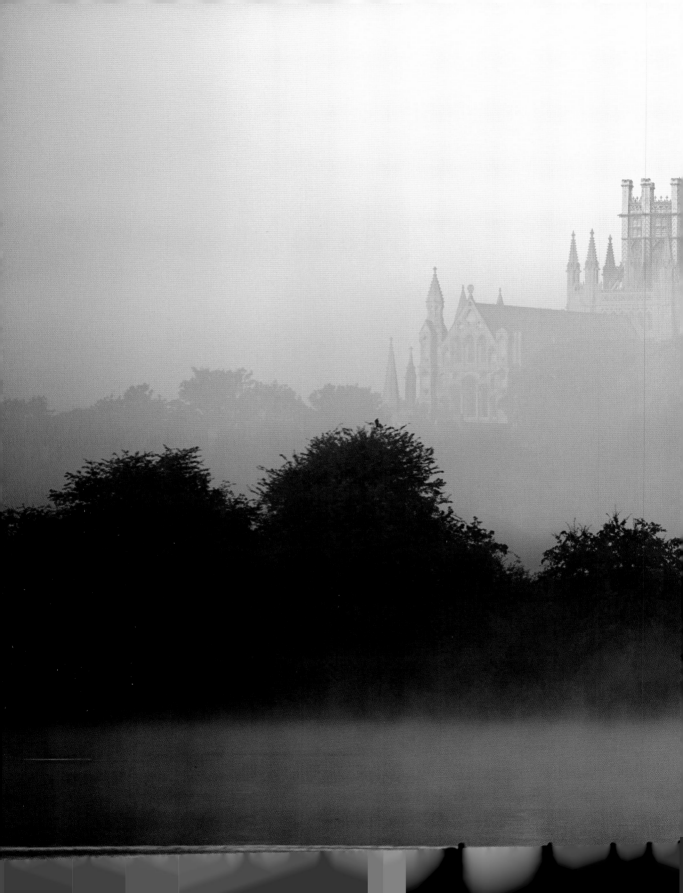

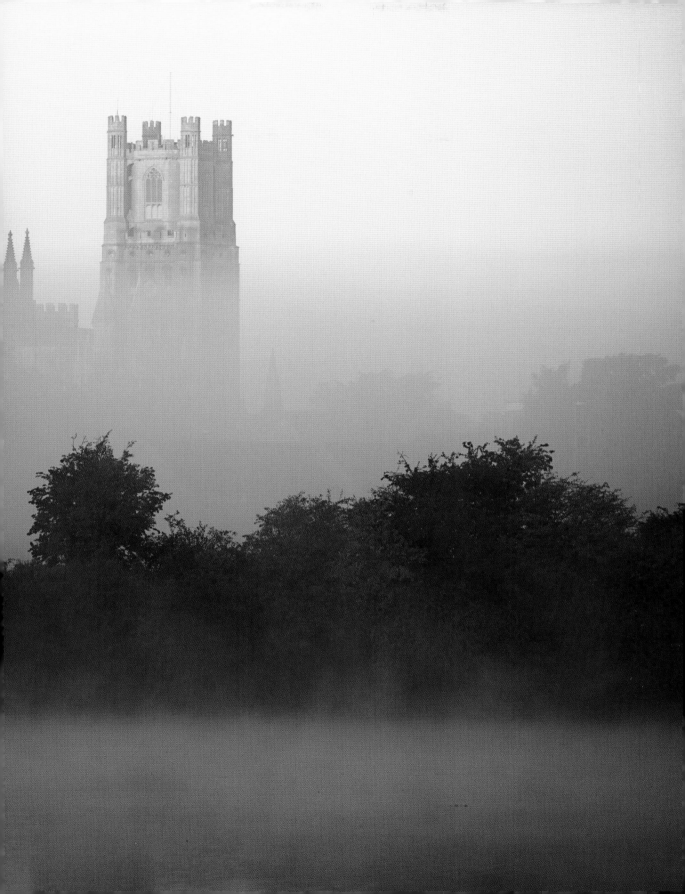

Eugene Ball's sculpture of Christus Rex (1999) over the nave pulpit.

Ely has no surviving cloister or chapter house. There is just a Lady Chapel built at the same time as the lantern but not finished until 1349, after the tower's collapse. It is a casket of Gothic delight. The east wall is almost entirely window, alive with interlaced tracery. The 14m vault is the widest of the period in England. The chapel's glory are the stone seats ranged along the side walls. Their canopies of ogival and triangular gables undulate in a flowing line, voluptuously covered in vegetation. The carving is so meticulous it might be the work of silversmiths, but the figures were defaced by iconoclasts in the 16th century and are a memorial to vandalism rather than medieval sculpture.

Ely lost its medieval glass mostly through 18th-century neglect, but following Gilbert Scott's arrival it became a gallery of the best of Victorian glazing. There are windows by Wailes, Clayton & Bell, Kempe, Hardman and William Morris, and modern glass by John Piper. In consequence, the nave triforium houses the National Stained Glass Museum, a corrective to all who find Victorian windows insipid.

EXETER

✥ ✥ ✥

Exeter cathedral is architecture as theatre. I first set eyes on it as an evening sun was fading to the west, illuminating each of its features in turn. The west front was like a music-hall turn with the two flanking towers as Norman pantomime dames, poking fun at the young goths playing at their feet.

Devon and Cornwall retained pockets of Celtic Christianity into the Dark Ages, but as Wessex spread its power westwards in the 9th century they came under the authority of Canterbury. Saxon Exeter cathedral was rebuilt by the Normans from 1112 and the two gnarled Romanesque towers remain Exeter's signature to this day. The rest of the cathedral was rebuilt after 1275 by two celebrated bishops, Walter Stapledon (r.1308–26) who was Edward II's treasurer and founder of Exeter College, Oxford, and the scholar bishop John Grandisson (r.1327–96).

Exeter was wealthy enough to engage the leading architect of the day Thomas Witney, who worked on the cathedral from 1313 until his death in 1342. These years spanned the Decorated climax of English Gothic. Under Witney Exeter became one of the most exciting cathedrals in England and is worth a visit for his work alone.

The aforementioned west front is an extraordinary façade, as if the result of a series of afterthoughts. Starting from the top the roof gable has barely time to show itself before being swamped by a battlemented wall supporting a large Decorated window. This in turn is upstaged by a lower screen of sculptures begun in 1338 by Grandisson, reputedly envious of Wells's screen. This frames three tiers of figurative statues probably designed by another 14th-century master, William Joy, who followed Witney at Exeter until the Black Death in 1348.

These sculptures do indeed match Wells as a spectacle of medieval carving, but they match it also in displaying the English preference for ruin against art (see p. xxv). The lowest tier of twenty-five angels is so eroded as to be shapeless stones. The higher tiers are of kings and knights, then saints and apostles. These figures retain some animation, their torsos apparently standing, sitting, turning and praying. Two are cross-legged and appear to be arguing with each other, but their faces are an archaeological blur.

Exeter's interior is English Decorated Gothic at its most polished. The arcades are a feast of clustered columns carrying the eye for a hundred metres down what is said to be the longest unbroken Gothic vault in existence. Each pier has sixteen shafts with eight

→ Exeter: a west front of afterthoughts

GREAT BRITAIN

mouldings to each arch. The piers of 'Purbeck marble' rise to vaults of creamy limestone.

Down the centre of the roof dance Exeter's celebrated bosses. In full restored colour they portray a cast of monarchs, Bible scenes and monsters. A particularly gruesome Becket martyrdom has a sword buried in the bishop's head. Wheeled table mirrors assist those tired of neck-craning.

Attached to the nave north wall is a gallery of the mid-14th century fronted by a frieze of painted angels playing musical instruments. These include a fiddle, a trumpet and a Jew's harp. The angels sway expressively, seeming to play their instruments with their bodies as good musicians should. In the north transept hangs a 15th-century clock; below it is a door with medieval cat flap. The cat was employed for a penny a week to combat the vermin.

The eastern arm of the cathedral is announced by a pulpitum screen. This is in the form of a vaulted gallery completed by Witney in 1324 as part of a suite of furnishings planned by him c.1312–25. It is of three arches topped by crockets and trefoils. These are glorious works stretched, almost tortured, to express their creator's Gothic vision. From every nook peers an animal or human face amid foliage so free-floating it might be ready to fall to the ground in autumn. Panels are replacements for those destroyed at the Reformation.

In the choir stands Witney's bishop's throne, begun in 1313. To Pevsner it is 'the most exquisite piece of woodwork of its date in England, perhaps in Europe'. Every feature strains upwards, multilobed arches, nodding ogees, crockets, balls, vine leaves, grapes and human and animal faces. The composition is crowned by enormous pinnacles, Gothic at its most glorious, but we yearn for the colour that must once have been its summation. The throne is celebrated in English history as being the rostrum from which William of Orange read out

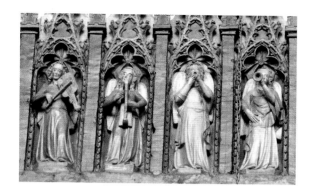

his 'declaration of peaceful intent' at the start of his invasion of Britain after landing at Brixham in 1688. It was most effective.

The sanctuary beyond displays Witney's three sedilia, each under a pinnacled canopy. The altar reredos has vanished and instead the sanctuary is enclosed to the east by two round arches through which we can see the intersecting vaults of the retrochoir. Above rises Exeter's Great East Window, most of it dated 1303. Saints and biblical figures such as Isaiah, Abraham and Moses are set in architectural surrounds, vividly alive. A corbel high on the wall facing it carries a rare sheela-na-gig, a portrayal of a woman exposing her genitalia. Whether this was to ward off evil or promote fertility is a matter of fruitless debate. I like to think the masons were mocking the chastity of the canons below.

Exeter's retrochoir was exceptionally fortunate in having its original colouring restored by Gilbert Scott and then by the 20th-century medievalist E. W. Tristram (1882–1952). Basing his work on surviving fragments of old paint, Tristram brought back colour to the retrochoir's walls, vaults and carvings, turning this part of the cathedral into a painted kaleidoscope, much as it would once have been.

The Lady Chapel contains an effigy of Lady Dodderidge (d.1614) in high Tudor fashion holding a skull and ablaze with colour. Its entrance is guarded by effigies of bishops Branscombe (d.1280) and Stafford (d.1419), the latter's alabaster covered in ancient graffiti. Both are shielded by filigree Perpendicular

← The choir, summation of Decorated Gothic
↗ Angel musicians on high

canopies. Here also is a lovely statue of a woman and child, *Unfolding Love*, by Janis Ridley (2006).

In the St John's Chapel the Carew tomb shows an Elizabethan knight and his lady lying in some state while their nephew is crammed uncomfortably on a shelf below, again all brightly painted. So too is the roof of the chapter house. Exeter in other words is a rare cathedral in conveying its atmosphere at the time of its construction. There is hardly a church in Europe where I do not mourn the brevity of Tristram's mission to restore to Gothic architecture the intention of its creators.

GLOUCESTER

✣ ✣ ✣

The Norman Conquest was one of church as well as state. When Abbot Serlo of Mont-Saint-Michel in France arrived at the old Benedictine monastery of Gloucester in 1072 he found it occupied by just two monks and a handful of novices. On Serlo's death thirty years later he left an active and prosperous base of Norman power in the Welsh Marches.

Even so, Gloucester's fate might have been that of most English abbeys but for its proximity to Berkeley Castle. Here in 1327 Edward II was murdered at the instigation of his wife Isabella and her lover Roger Mortimer. His body was brought to the nearest abbey at Gloucester where his seventeen-year-old son Edward III (r.1327–77) made it his father's burial place and intended shrine as a saint. Royal masons arrived from London to give the abbey church a new transept and choir in the latest all-English style of Perpendicular Gothic. Edward II was never made a saint but owing to the presence of a royal tomb Henry VIII did not dissolve the church along with the abbey; instead he raised it to cathedral status.

A new tower followed, to become a beacon for visitors descending from the Cotswolds or travelling up the Severn from Bristol. It rises like a stack of jewelled boxes with a crown formed of four lantern turrets. They are so sculpted that in a low sun their stonework might have been spun from gold. For all Canterbury's splendour and Salisbury's grace I find this the loveliest tower in England.

The contrast between Gloucester's original Norman bones and its 'Edwardian' flesh is clear inside. The nave is severely Norman, austere piers rising to the simplest of capitals and a plain Early Gothic vault. As we move past an obtrusive organ into the south transept we immediately see Edward's masons struggling to modernize. Perpendicular windows appear in shadowy Norman walls. Struts emerge at random as if desperate to prop up the tower.

In the choir the royal masons were able to show the new style to full effect. A high chamber has flat walls panelled in glass and stone with shafts rising from ground to roof. The crossing covers the choir, its stalls with ogival canopies and forty-six medieval misericords, one believed to be the earliest depiction of English football. The north transept has a lovely serpentine arch, apparently of no structural significance. In the sanctuary lies the source of Gloucester's survival, the tomb of Edward II, the design of which was allegedly supervised by Edward III in person. It shows no trace of the king's reputed effeteness.

The cathedral's east wall is virtually non-existent, being composed of reputedly the largest unbroken expanse of medieval glass anywhere. It is known as the Crécy window for being contemporary with Edward III's victory over the French in 1346, but this attribution is Victorian. The window is composed of rectilinear stone frames. In addition to religious themes it is celebratory and political, honouring barons at the bottom and rising through bishops, saints and apostles to Christ at the top, all in elaborate architectural settings. While Gloucester's misericords show football, the Crécy window has the first depiction of medieval golf – long before Scotland's claim to its invention.

→ Gloucester: tower of bejewelled boxes

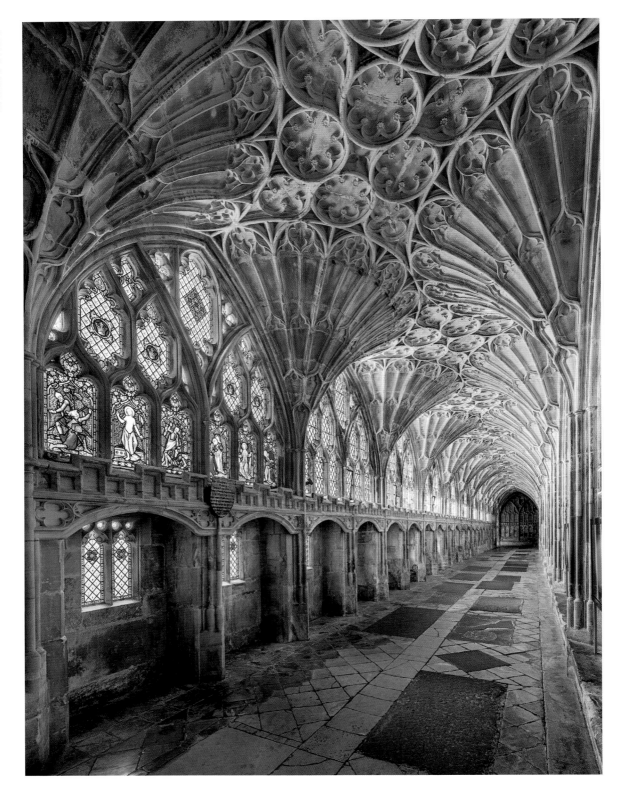

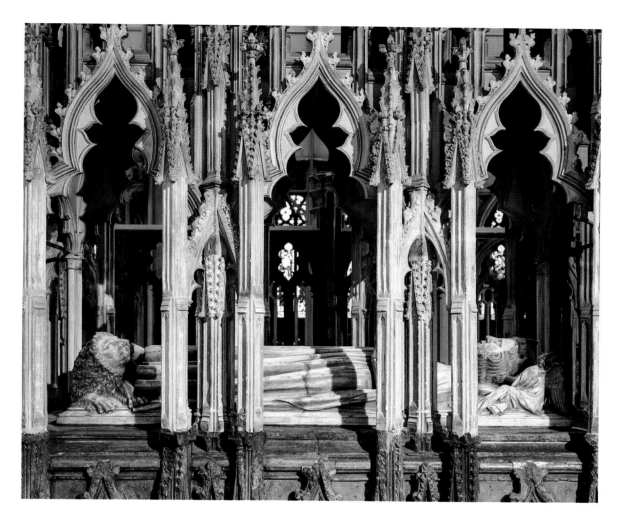

Beneath the window is the entrance to the Lady Chapel, virtually a separate church added c.1500 and a marvel of Perpendicular glazing. The side windows are modern, mostly by the Arts and Crafts artist Christopher Whall (1849–1924), and depict saints and Bible stories free of Victorian elaboration. Off the Lady Chapel are tiny chantry chapels with fan vaults and choir lofts, epitomes of English Gothic design.

Gloucester's cloisters were built from the 1350s onwards and are a virtuoso display of Perpendicular's first known fan vaults. In golden Cotswold limestone they are almost head height, supported by arcades on to the garden filled with stained glass. The effect is of a richly foliated canopy in some jungle glade, its colours deepening in the early-evening light.

The cloister still has the monks' *lavatorium* with a stone shelf for towels. One range also has small study carrels, each with its individual window on to the garden where a gentle fountain plays among the hedges. Here the monks would sit and write. I can think of nowhere more conducive to a contemplative life. As it is, the cloisters are crowded with children seeking what were locations for the film of Harry Potter's Hogwarts.

← The cloister: an avenue of fans
↑ Edward II's unsaintly tomb

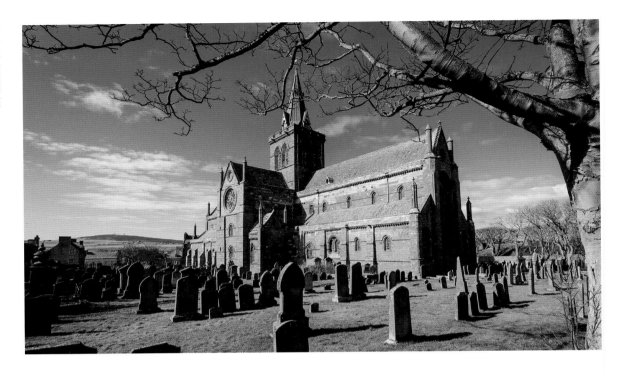

KIRKWALL

✛

The ancient cathedral of St Magnus on Orkney gets little passing trade. It rises over the small town of Kirkwall near the sweep of Scapa Flow with tree-less moorland on all sides. Winter here is harsh. Yet Orkney is filled with evidence of a busy prehistory not least at Skara Brae, one of the best-preserved Neolithic villages in Europe. I visited it on its sea-side dune and had it entirely to myself, a wonderful moment of communion with humanity's most distant past on these islands.

Orkney was still under Norwegian rule in the Middle Ages, the island being contested between Earls Magnus and Haakon. The latter murdered the former in 1118 in an act considered so shocking that Magnus was later canonized. His nephew Rognvald (c.1100–1158) built a cathedral for his relics, begun in 1129 under the archdiocese of Trondheim in Norway. He is thought to have recruited masons from

Durham – their marks are found on the stones – to create a church such that 'none was more magnifi-cent in the land.' Orkney passed to Scotland in 1468 as dowry for a Norwegian princess's marriage to a Scottish king, James III. Since then Orcadians have maintained a vigorous communal independence. The town of Kirkwall owns its cathedral.

The exterior is undistinguished apart from its stone, which is of a vivid pink strangely interspersed with grey, as if intended to be chequered. East and west ends are Transitional Gothic, but most of the exterior has small Norman windows. The crossing was given a fussy broach spire in the early 20th century.

The west front and south transept have elaborate 13th-century doorways so eroded by Orkney storms as to have lost all figurative meaning. According to the guidebook, 'this pleasing almost sculptural effect adds to the cathedral's charm.' But there is nothing

↑ Kirkwall: touch of Norway on a distant shore
↗ Romanesque doorway, much eroded

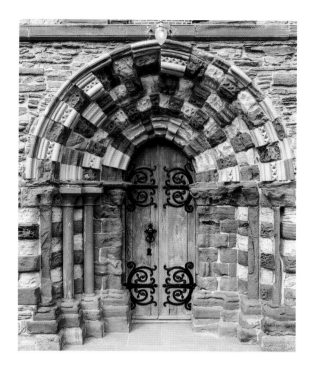

for the 'sculptures' to evoke, their indentations looking like works by Henry Moore.

The interior is indeed a miniature Durham. Cylinders of pink stone lead eastwards to the crossing and a distant rose window. Since the nave is narrow the effect is tall, almost corridor-like. It was once used for the prosaic purpose of drying ships' sails. The enveloping darkness is illuminated by careful spotlights, but I would love to see it candlelit. Most noticeable is the Norman blind arcading along the nave and transept walls, soft stone laid on rough ashlar, thickly decorated with zigzag. It is all like being enveloped in warm pink cushions.

The transepts are as high as the nave with four tiers of small windows. Stained glass depicts northern kings and saints. In the north transept hang the flags of Britain and Norway, the church's twin sovereigns. The choir is transitional Gothic with pier capitals of human heads, monsters, foliage and even a green man. On a south-west pier there is a fertility carving or sheela-na-gig (see Exeter, p.123).

The choir was once crammed with private pews owned by the local guilds of tailors, sailors, scholars and even magistrates. Today it is screened with woodwork dating from a 20th-century restoration by an Edinburgh architect, George Mackie Watson (1860–1948). His Gothic Revivalism suits the spirit of the place. Carved filigree screens overlook saints, kings and birds. The east wall was rededicated to Rognvald in 1965, with a modern statue of him holding a model of his cathedral above one of his longboat. It reminds us that this was very much a Viking church.

St Magnus has an enjoyable collection of memorials, almost all of them 17th century, lining the walls like sentinels. It was the most elegant period of church calligraphy. One panel shows the Rognvald family tree including his splendidly named relatives: Rolf the Ganger, Magnus Barelegs, Hall of Side and Thorfinn the Skullsplitter. I would not mix with them.

A monument in the south aisle is to Orkney's celebrated Arctic explorer John Rae (1813–93), discoverer of the fate of the 1848 Franklin expedition in search of a north-west passage round Canada. Rae is shown sleeping beside a gun and a book. He is overlooked by a plaque commemorating two 20th-century Orcadian poets, Edwin Muir and George Mackay Brown.

LINCOLN

✣ ✣ ✣ ✣

Saxon Lincoln stood on a hill at the frontier of the Danish territory of the Danelaw. In 1072 William the Conqueror ordered his bishops forward into such defensible outposts. Lincoln was another Durham, with a Benedictine monk named Remigius sent to build a castle and cathedral on its prominent site. The old Saxon diocese was huge, running from the Humber to the Thames at Dorchester-on-Thames and possibly the most extensive in England. Lincoln

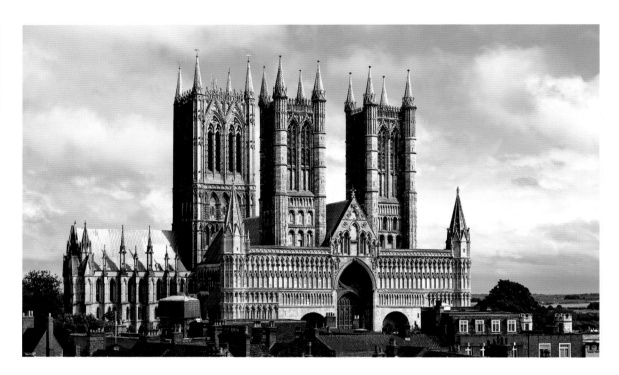

cathedral was architecture as power. Even as later rebuilt it towers over the town on the slopes below.

After the Norman structure had suffered fires and an earthquake in 1185, an eccentric Carthusian monk named Hugh of Burgundy arrived as bishop in 1186. Much as later bishops aspired to the House of Lords, medieval ones aspired to sainthood. Each night he gnawed a bone of Mary Magdalene's arm and, thus sanctified, set about a more lasting memorial, the rebuilding of his cathedral, leaving untouched only the lower stages of the west front.

Hugh died in 1200 and was duly canonized twenty years later. His shrine erected in 1230 deferred only to Canterbury in pilgrim appeal. The resulting revenues paid for a new eastern Angel Choir as well as a central tower built in 1307. Its spire was implausibly reputed to rise 160m, making Lincoln the tallest man-made structure in the world. But even at a more possible 150m it would have beaten short-lived Beauvais (145m) and even the Great Pyramid of Giza (139m). It collapsed in 1548 and was never replaced.

The surviving Norman west front has a lateral screen unique to Lincoln and apparently defensive in purpose. It is certainly impressive rather than beautiful. The centrepiece is five stepped portals within deep recesses like caverns hacked from a cliff. They represent gateways to heaven. The central doorway has beak-headed monsters chewing into the arch moulding and fragments of a Romanesque frieze, including a Last Supper, Noah building his ark and Daniel in the lion's den. The style has been traced to similar carvings at Saint-Denis in Paris. Some of the figures are now inside, hopefully to be replaced by replicas.

The best view of Lincoln's exterior is from the east where it is dominated by the 13th-century Angel Choir in Decorated Gothic style. It is enriched with arcades, gargoyles, foliage and ballflower. The east-window tracery is of circles spinning within circles. As we step backwards the mass of Hugh's earlier Gothic cathedral comes into view featuring lancet windows and blind arcading.

Lincoln's interior is of intense beauty. The Early Gothic nave has almost rounded arches, the Purbeck piers elegant and the windows as yet without tracery.

Pace quickens at the later crossing overlooked by two of England's finest rose windows in the Decorated style. The northern one is known as the Dean's Eye overlooking his (later) residence and still with its medieval glass. The southern Bishop's Eye was created in 1330 and is a masterpiece of curvilinear tracery, displaying two great ovals filled with hearts. Supporting the organ is a pulpitum of a sumptuousness, says Pevsner, 'that makes one understand how the Decorated style came to be called Decorated'. Eight tall niches flank a central portal. Gables are thick with leaves and animals as if all of nature were laid out on a quilt.

The eastern arm begins with Hugh's choir, constructed at the turn of the 13th century in a style consistent with the later nave. That is except in one respect, the so-called 'crazy' vault whose asymmetry is the oddest feature to be found in any medieval church. Like many, I think I can see a pattern but then promptly lose it. The ribs of each bay reach a central ridge where some jump into the next bay, others not, as if each had a will of its own. Pevsner's valiant attempt to describe this vault is incomprehensible; his conclusion was that it is 'overwhelmingly lopsided'.

I prefer a medieval explanation: that the vault is a bird that plants its feet on a column, 'stretches out her broad wings to fly . . . and soars to the clouds'. Either way the creation is so curious it might just be an error in the course of construction. A thicket of pinnacles over the choir stalls below appear to be pointing up to the vault as if in ridicule. The stalls have an astonishing ninety-two misericords. One is of a lovely mermaid and another of a unicorn hiding in a virgin's lap, but they take much bending double to find.

The final movement in Lincoln's symphony is the Angel Choir housing St Hugh's shrine, the latter now a chest of beheaded figures. The choir was begun in 1256 and the relocated shrine followed in 1280, the whole chamber a work of English Gothic at its most accomplished. Whorls of acanthus rise, dip and wave from capitals so undercut as seeming about to peel from their shafts. One capital depicts dogs hunting a hidden fox, another a man removing

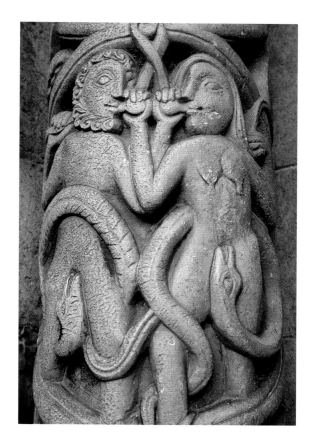

a thorn from his foot, possibly a metaphor for the conversion of the heathens. On a corbel Adam and Eve leave Eden with serpents gnawing at their genitals. Angels crowd the arcade spandrels and in the north arcade we see the Lincoln imp, a devil turned to stone for throwing rocks at one of them.

Off the choir is the ten-sided chapter house, precursor of that at Wells with a graceful palm vault. Next door is the cathedral library designed by Sir Christopher Wren (1632–1723). It overlooks a spacious cloister in which sits my favourite and most peaceful cathedral cafeteria. As John Ruskin said of Lincoln, 'it is worth any two other cathedrals we have.'

↖ Lincoln pride: fortress-like west front
↑ Adam and Eve with snakes
→ Lincoln: the Angel Choir

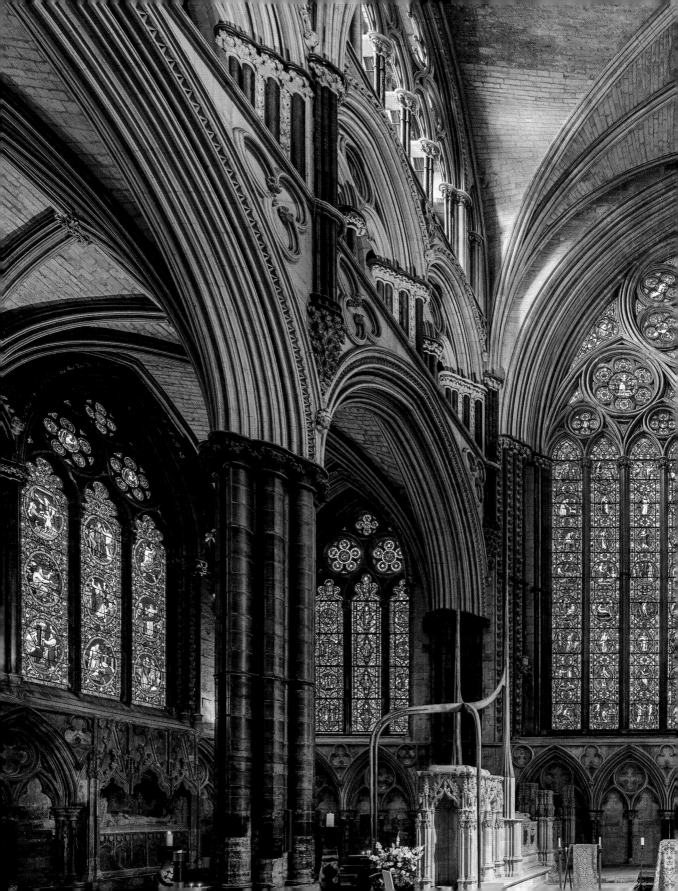

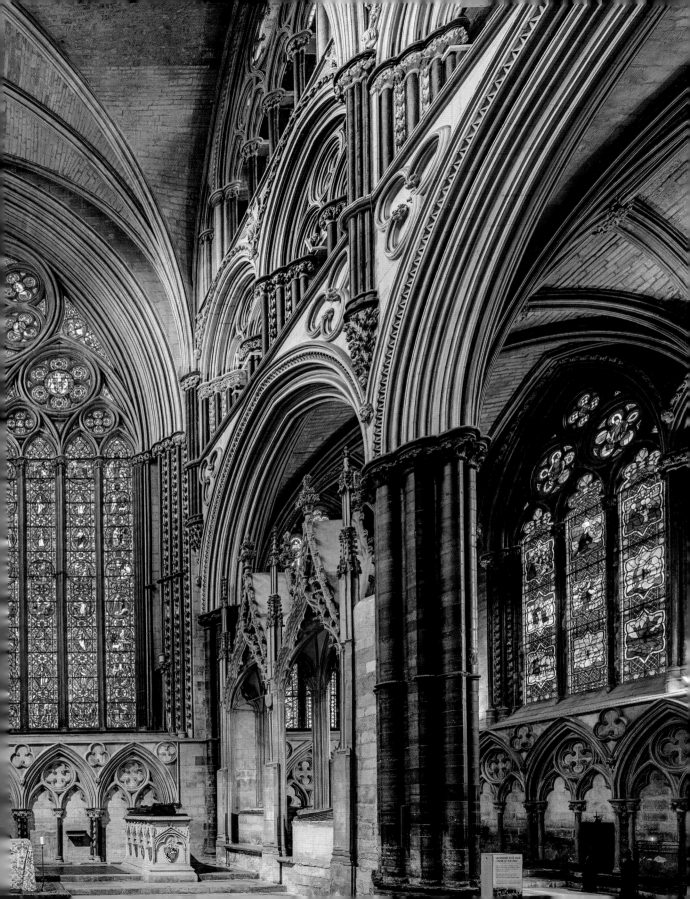

LONDON
ST PAUL'S

✤ ✤ ✤

St Paul's is the nation's principal temple, outranking Westminster Abbey in capacity and thus hosting such ceremonies as Churchill's funeral and the Charles and Diana wedding. It is also Britain's most visited cathedral, at 1.7m in 2019. But it suffers a new fate. From a distance it must cower beneath the office towers that form a jagged backdrop to north, east and south. Never would Paris, Rome or Cologne dare inflict such indignity on their greatest church. St Paul's grandeur survives only in views from the river below, but survive it does.

London has had a cathedral here since Augustine's missionaries arrived in 604. London was represented by a bishop recorded as Restitutus at the Arles council in 314, but when Londoners rejected Bishop Mellitus c.618 and Canterbury emerged supreme, St Paul's was left as the leading church of London but not of the nation. By virtue of Edward the Confessor being crowned at Westminster and his successors following suit, St Paul's could not even claim a coronation.

That said the Norman building was colossal, longer even than the present one. By the 17th century it was a tired and crumbling edifice, having lost its timber and lead spire, second in height only to Lincoln, in a storm in 1561. Inigo Jones created a new west front for it in 1630 and the royal surveyor Sir Christopher Wren proposed a new dome in 1666. That same year disaster struck when the Great Fire of London reduced the building to a blackened ruin. Cathedral building in Protestant England had been in abeyance for almost two centuries, but St Paul's had to be replaced. Wren seized the opportunity.

A debate promptly ensued as to whether the cathedral – and the spirit of Restoration England – should be reborn in Gothic or Classical guise. It was a foretaste of debates that consumed church architecture ever after. Wren had worked in both styles but was adamant for Classical with his adage that 'beauty is from geometry.' The eventual plan approved by Charles II was considered a compromise, a traditional cruciform with a nave, transepts and chancel but clothed in Wren's English Baroque. Work began in 1675 and was interminable, costing the equivalent of £1.6bn in modern money. Not until 1711 was it finished, when Wren at the age of seventy-nine was hoisted to the top in a basket by his son. Hence his famous epitaph *si monumentum requiris circumspice* – if you seek a monument look around you.

The church is in the restrained form of English Baroque sometimes dubbed Wrenaissance. The basic structure has a Classical west front with two tiers of Corinthian porticoes and similar transepts and eastern apse. Windows and doorways are linked by a frieze of Classical scenes and motifs, with panels above the arches designed by Grinling Gibbons (1648–1721) and his studio. Wren wanted white Portland stone for the exterior, annoying the Bath stone quarries who maintained that London should be a city of 'gold rather than silver'. When the cathedral was half coated in soot in the 1970s, the critic Ian Nairn pleaded for it not to be cleaned, leaving the exposed white contrasting with the more sheltered black. That effect is now visible only in old photographs.

Above the cornice line St Paul's shows a change of gear. The two western towers and the central drum look bigger-boned and more Baroque than the body of the cathedral below. We do not know if Wren meant the upper part of his cathedral to be seen floating on the skyline. Either way, from near and far the composition has a grandeur that delighted Canaletto in his London paintings (1746–56), though I notice that he reduced the prominence of the Baroque towers.

→ St Paul's: London's glimpse of Rome

134

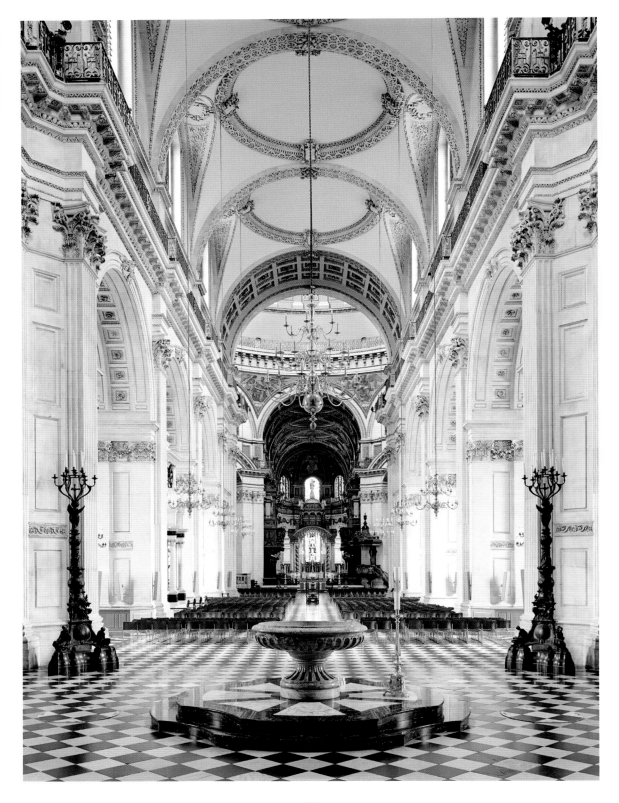

The first impression of St Paul's interior is that of a sumptuous Roman palace. It is on a scale unequalled in English architecture until the railway age. An arcade of four large bays with ceilings of saucer domes strides from the entrance to the crossing. The fittings are firmly Protestant, boasting no holy shrines and few private chapels or altars. The aim is clearly to cloak the nation's history in architectural glory.

The nave is lined with memorials. Saints and bishops play second fiddle to generals, admirals and politicians, with their attendant victories and magnificent deaths. Pre-eminent are the Duke of Wellington, Lord Kitchener and Gordon of Khartoum. At the crossing the aura of national mausoleum becomes overpowering. Dying soldiers are carried aloft in the arms of cherubs and nubile angels. This is the nearest the British Empire gets to a celebration. St Paul's is, as the writer Christopher Somerville remarks, 'a love-letter by the British establishment to itself'. In a brief moment of calm, a chapel in the north transept contains Holman Hunt's portrait of Jesus as the Light of the World. It was reputedly the 'most viewed' picture of all time on its global tour in 1905.

Above the crossing is St Paul's climactic dome. Ever the mathematician, Wren saw it as an overlap of circular and rectangular planes creating a contrast of darkness and light. Its swirling circles are echoed in the marble floor below. The ceiling carries restored murals by Sir James Thornhill (1675/6–1734) of the life of St Paul.

East of the crossing lies the panelled choir, a tour de force of carved wood screens and stalls by Grinling Gibbons. At the height of his fame he was paid a pound for each of the sixty-six cherub heads, a grand sum at the time. He contrived to combine the stateliness of a ceremonial space with the intimacy of a college chapel.

The vault above is covered in a Pre-Raphaelite mosaic by the artist William Blake Richmond,

← Wren's nave: stately Protestantism
↗ Donne's touch of the macabre

installed in 1900 after Queen Victoria had called this part of St Paul's 'dull, dingy and un-devotional'. Richmond's allegorical depictions were controversial, inserting what Wren's biographer Adrian Tinniswood called 'an air of popery about the gilded capitals, the heavy arches . . . unfamiliar, un-English'. Wren was reportedly keen on having mosaics like those in Hagia Sophia.

The choir leads to the hardly less popish baldachin which is by Stephen Dykes Bower in 1958, replacing a Victorian one destroyed by a bomb in the war. Flanking the sanctuary on the north aisle are iron gates of 1700 by the Frenchman Jean Tijou, a glorious tangle of Rococo ornament. Nearby in the Dean's Aisle is a free-standing sculpture by Henry Moore of a Mother and Child (1983).

In the south aisle stands a macabre shrouded statue of the poet and dean of St Paul's John Donne,

supposedly designed by himself and carved by Nicholas Stone in 1631, the year of Donne's death. It was the only monument to survive the Great Fire. More controversial, at the east end of the aisle is a no less macabre plasma screen by the artist Bill Viola of 2014. It depicts actors playing 'martyrs' being tortured by the elements of earth, air, fire and water. As in Spanish cathedrals, I find it hard to comprehend the yearning to depict pain in Christian worship.

St Paul's extensive crypt covers almost the same floor area as the cathedral above. Its centrepiece is a memorial to Nelson in a sarcophagus prepared for Cardinal Wolsey but left unused after his downfall. He is surrounded by celebrities including Florence Nightingale, Churchill and some welcome artists, Reynolds, Turner, Millais and William Blake.

The cathedral's environs are among the bleakest of any cathedral in this book. While Germany and France carefully reconstructed their cathedral settings, London invited modern architecture to do its worst. That said, two views are worth seeking out. One is a glimpse of the portico up Ludgate Hill, a relic of the City's medieval aversion to straight lines. The other is from the top floor of the Tate Modern across the river. Here the cathedral can be seen in its entirety side-on. It rides on the backbone of its city for once in unchallenged majesty.

LONDON WESTMINSTER ABBEY

✣ ✣ ✣

Hearing of my interest in large churches a London chorister demanded of me, Are you Westminster or St Paul's? To him, they might have been football teams. Ignorant of any such choral rivalry I replied Westminster. He punched the air, Yes!

London's two leading churches have long competed as national mausoleum and venue for state ceremonial. St Paul's is bigger, grander and marginally beats Westminster in paid visits, 1.7m to 1.6m in 2019. But Westminster has my vote for personality. I see St Paul's as a major-general covered in medals, overblown and slightly pompous. Westminster is an old bag lady fallen on hard times, rummaging through her belongings in search of a missing poem. It is to Westminster I would turn in an hour of need.

Reputedly the site of a 7th-century abbey, the marshy Thorney Island by the Thames was chosen in 1042 for a monastery and palace by England's Francophile king Edward the Confessor (r.1042–66). He wanted to live aloof from the rude Anglo-Saxons of the City of London crammed into their tenements and not speaking French. In time this 'west minster' grew in status to become London's second city. It was chosen as his coronation site by William the Conqueror, again for not being the Anglo-Saxon capital of Winchester and because his claim to the throne was through 'French' Edward.

The old abbey of St Peter disappeared in Henry VIII's 1539 Dissolution and its extensive landholdings were distributed round his Tudor courtiers. The king wanted to make the abbey's church a cathedral and it became one briefly under Mary I. This ended under Elizabeth, and the diversion of its revenues to St Paul's cathedral was known as 'robbing Peter to pay Paul'. As the place of coronation it became a Royal Peculiar.

Fragments of Edward's Norman monastery survive but all of what we see today was rebuilt after 1245 by Henry III (r.1216–72). He created it as a shrine to his predecessor and hero Edward the Confessor, who became patron saint of England until Edward III replaced him with the more glamorous St George. For the rebuilding the equally Francophile Henry sent for Henry of Reims, master of High Gothic Rayonnant, later dubbed English Decorated.

→ Henry VII's Chapel: perpendicular magnificence

138

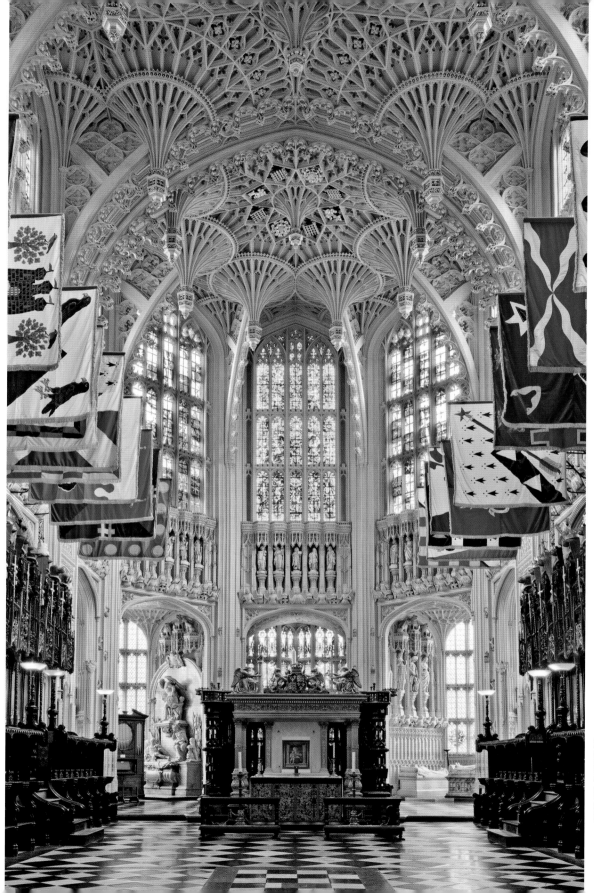

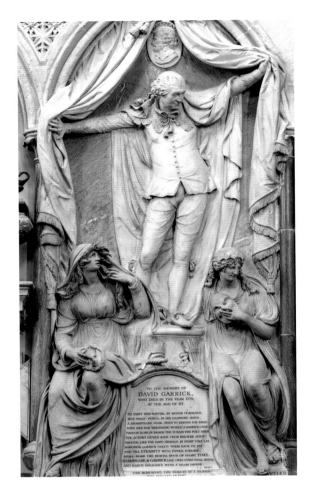

TO THE MEMORY OF
DAVID GARRICK,
WHO DIED IN THE YEAR 1779,
AT THE AGE OF 63.

church, above which is a Perpendicular façade begun by Wren but continued by Nicholas Hawksmoor after 1723. Hawksmoor intended his towers to be Gothic, which he considered appropriate for all 'antient, durable, publick buildings', regarded as a dig at St Paul's. Yet his Gothic outline embraced Classical features and Baroque openings, notably the clock. His Gothic and Classical dance arm in arm.

The north transept on to Parliament Square was extensively remodelled by Sir George Gilbert Scott in the 1860s and by J. L. Pearson in the 1880s to frame a new rose window. The result is that this façade is ungainly, with Victorian buttresses crouching over the square like a giant spider. To the east lies the most substantial later addition to the abbey, Henry VII's Perpendicular chapel begun in 1503. This chapel was crucial in the debate over the style for the adjacent Palace of Westminster after the old palace was destroyed in a fire in 1834. Had Henry's chapel been Early Renaissance rather than Gothic, Britain's parliament today would almost certainly be Classical.

The abbey interior comes in two parts. To the west is a high nave, narrow and lined with memorials. The view east is interrupted by a pulpitum screening the choir which was brought forward into the nave by Henry III to allow more space for the coronation rite in the crossing. This in turn left the nave hardly bigger than a parish church, which means none but the grandest VIPs are able to witness any ceremony held in the crossing. This is why big events must decamp to St Paul's.

At the crossing the abbey becomes part stage set and part mausoleum. The building boasts a reputed 3,300 memorials packed into every inch of space. Some lurk, some soar, some are demure, some merely showing off. Many Victorians agreed with Ruskin that they were an 'ignoble, incoherent filling of the aisles'. There have been various attempts to relocate them to a national Valhalla or Pantheon as in Paris. Yet to the visitor much of Westminster's appeal lies in precisely this aura of a timeless junk shop, a cross between Portobello

Westminster was to see the first arrival in England of a complete programme of window tracery.

The abbey exterior is embarrassed by the lack of a crossing tower despite frequent attempts to build one. They included an offer in the 1990s to pay for one by the composer Andrew Lloyd Webber over which negotiations foundered. The abbey thus has to rely for a profile on its two western towers, not erected until the 18th century. Even so for a church of national ceremony the formal entrance off Parliament Square is modest. There is no grand avenue or fine portal as with St Peter's or Notre-Dame, just a gate and a door.

The west front is so familiar that its stylistic oddity passes unnoticed. The bases survive from Henry's

The shrine's north side is overlooked by Henry III himself, serene, effete and with dress flowing free. The tomb of his warrior son Edward I carries no effigy, just a cold stone slab and the brazen title 'Hammer of the Scots'. The south side has Henry's grandson Edward III with a long beard, his troublesome offspring appearing as bronze weepers round the base. His queen Philippa has a surprisingly realistic middle-aged face. Finally comes the tomb of the deposed Richard II and his wife Anne of Bohemia. Their fine effigies evoke late-medieval beauty cushioned in royal wealth and attended by lions, harts, eagles and leopards.

Overlooking the whole chamber is the extraordinary chantry chapel of Henry V. As son of the usurper Henry IV (whose tomb was banished to Canterbury) Henry V shrewdly ensured his place in the abbey pantheon before departing for Agincourt in 1415. Since the only space was overhead he had to be fitted in sideways with a chantry altar in a gallery reached by spiral stairs. He lies immortalized in Perpendicular glory as if he were the grandest monarch of them all.

The ambulatory round the shrine is formed of chapels filled with those clamouring to be near royalty, like film stars jostling for a group photograph on Oscar night. Courtiers elbow aristocrats and generals. Some chapels are so cramped they look like a mason's yard with tombs stacked as if in storage. It is splendid chaos.

No such indignity afflicts the Lady Chapel, originally intended as a shrine to Henry VI until negotiations for his canonization fell through. It duly became the chantry chapel for Henry VII with a stipulation that 10,000 masses be said for his soul. Building commenced in 1503, the architect probably the royal mason William Vertue (d.1527).

The chapel is the final masterpiece of English Gothic before the onset of the Renaissance. The walls

Road and Highgate Cemetery, England at its most eccentrically unEnglish.

Only to the south of the crossing is some attempt made to order the chaos. Poets' Corner is a mass of sculptures by Le Sueur, Rysbrack, Scheemakers, Flaxman, Westmacott and others. Chaucer gets a modest medieval alcove, Shakespeare a fine Classical statue. As for today the place is full and the most a Dylan Thomas, Ted Hughes or Philip Larkin can expect is an inscription on the floor. Soon there will be space only for window engravings.

From this point eastwards the abbey becomes a chapel royal, the emotional heart of Henry III's church. The shrine of Edward the Confessor lies dark and claustrophobic, surrounded by the tombs of Plantagenet monarchs. They are like wagons drawn in a circle against any challenge to their right to the throne, a reminder that this church was French from the start.

ⓚ Mausoleum Baroque in Poets' Corner
↑ Urban oasis, the Little Cloister

are almost entirely of glass, supported by the thinnest of wall piers. Overhead are fluttering fans and pendants of golden stone, apparently defying gravity. Everywhere are banners, flags and coats of arms.

The chapel became the royal mausoleum for Henry's Tudor descendants, as Edward's shrine was for the Plantagenets. In the centre lies Henry himself alongside his wife, Elizabeth of York. Of English monarchs he barely merits this degree of splendour. But his marriage to Elizabeth marked the end of the Wars of the Roses, and thus a sort of climactic in English medieval history. It is therefore perhaps appropriate that the actual tomb should look not back to the Gothic age as does the surrounding chamber but forward into the age of European Renaissance. The tomb chest is actually Classical and designed by an Italian, Pietro Torrigiano, in 1517. It might just have arrived by boat from Florence. The chapel is flanked by Tudor burial chambers including the tombs of Mary I and Elizabeth I as well as later tombs of the Stuarts, Charles II, William and Mary, and Anne.

South of the abbey lies the old monastic enclave of Dean's Yard, the East Cloister, chapter house, Little Cloister and Jerusalem Chamber. It is a precious survival. In search of peace I used to retreat to the Little Cloister with its fountain, birdsong, monastic silence and oasis of calm. I loved it for being just a hundred metres from that bear pit of pandemonium, the Houses of Parliament. The chapter house of 1246 was the jewel of Henry III's abbey, model for others across the country, notably Salisbury's. Rebuilt facsimile by Gilbert Scott in the 19th century it retains its original floor, into which is inscribed the quiet claim, 'As the rose is the flower of flowers so this is the house of houses.'

→ Norwich: Norman grandeur, decorated refinement

NORWICH

⁘ ⁘ ⁘

After the Norman Conquest, Suffolk's St Edmundsbury abbey was declared headquarters of a new diocese of East Anglia. Yet the monks refused the honour, professing loyalty only to Rome and the king and not to any bishop. In 1095 the bishop Herbert de Losinga duly chose Norwich and initiated a fierce rivalry between the two great churches. At one point St Edmundsbury added an extra bay to its nave merely to be longer. That is now a ruin and Norwich at 133m is virtually the same length as Germany's Speyer as one of the longest Romanesque footprints in Europe.

Bishop Losinga had to flatten a quarter of Norwich for his church, including much of the market area leading down to the River Wensum. He laid the foundations in 1096 with stone imported from Caen in Normandy. Walls and gatehouses were erected to keep an often hostile town at bay. The cathedral was in part an act of atonement by Losinga for the sin of simony (bribery) by which he had secured his post. Such has been the redemption of dodgy philanthropists down the ages.

So big was Losinga's cathedral that it survived the Gothic age essentially at the size he left it. Only in the 15th century was it enhanced by a Gothic clerestory, stone vault and spire. Norwich retains what is a rarity in English cathedrals, a rounded apse with an east end that echoes a French chevet with flying buttresses.

The exterior is impressive if rather a mess. The nave wall that towers over the cloister presents five tiers of different periods of fenestration. The tower is coated in vertical shafts, intersecting arches and so-called porthole or circular tracery. The west front like so many in England lacks panache and is largely a frame for a Perpendicular window. Its doorways are flanked by modern statues by David Holgate, one of them of Julian of Norwich (1342–1416), the first woman to write a book in English, on Divine Love.

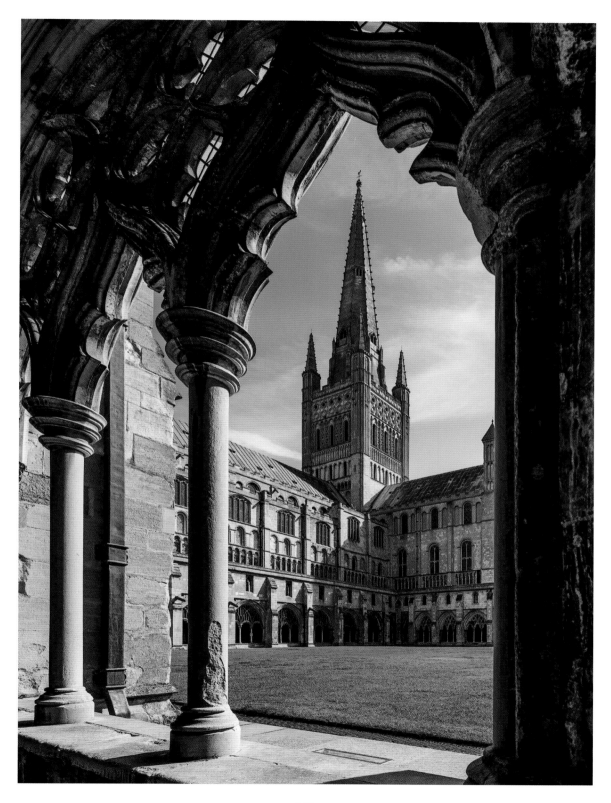

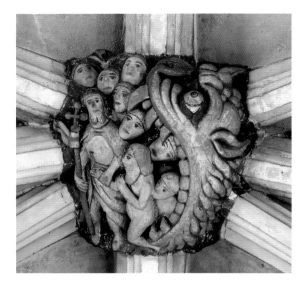

Norwich's interior is magnificent. The nave has fourteen bays of Romanesque limestone piers marching into the distance. Its later Perpendicular vault erected in the 1460s has fans of ribs decorated with vividly coloured bosses. These form a gallery of over a thousand carvings scattered across the cathedral's vaults, most of them frustratingly hard to see. They are believed to have been inspired by woodcuts in 15th-century German Bibles, full of imagination and humour. Noah's ark is regularly reproduced. In the nave below is a gleaming copper vat acting as a font. Once used for heating chocolate in the local Rowntree sweet factory, it is therefore of Quaker origins.

The west end saw the installation in 2019 of a giant illuminated helter-skelter allegedly intended to attract visitors and give a better view of the bosses. It was predictably controversial, with one church official complaining that 'to buy in sensory pleasure and distraction is to poison the very medicine it offers

the human soul.' The sentiment echoed Bernard of Clairvaux's objection to Suger's Saint-Denis (see p. xx). Given the centuries of sensory pleasure that is a cathedral, it seemed a bit hard.

The location of Norwich's organ and choir is unfortunate, intruding two bays into the nave. This bringing of the choir forward was common in monastic churches, as in the *coro* of a Spanish cathedral, but it interrupts what should be a dramatic view from nave to east end. The choir stalls are mostly 15th century, though three misericords are modern. In keeping with their domestic tradition, one shows a Norwich City footballer saving a goal. More such touches would bring cathedral iconography up to the present day.

The presbytery east of the crossing was in effect Losinga's throne room, the seat itself being positioned in the centre of the sanctuary behind the high altar. It is above a cupboard built for saints' relics. The eastern arm of the cathedral is a soaring structure, the bottom two storeys Romanesque and the upper one Perpendicular. The ambulatory is a medieval art gallery. The cathedral's greatest treasure is the Despenser altarpiece in St Luke's Chapel dating from the 14th century. It is of five wooden panels depicting the Crucifixion and Resurrection, commissioned by 'the fighting bishop' Henry le Despenser (r.1369–1406) to celebrate his suppression of a local Peasants' Revolt in 1381. The altarpiece was hidden from iconoclasts in the Civil War as the underside of a tabletop, to be rediscovered in 1847.

Norwich's cloister is England's only one of two storeys and the grandest after Salisbury. The openings are a pattern book of swirling Decorated and Perpendicular tracery, some looking almost oriental. The 394 bosses rival those of the nave. The cloister is home to the prior's door, Decorated Gothic of around 1310. Four shafts support an arch broken by seven radiating figures all in colourful animation. They are crowned by alternating triangular and ogee arches as though spinning in flames round a Catherine wheel. It reminds me of the helter-skelter.

Set into the west and south sides of the cloister and boldly visible across the close are Norwich's Hostry and Refectory, designed by the architect Sir Michael Hopkins in 2004–10. They sit well in context, medieval fragments retained to soften their relationship with the cathedral. Norwich's medieval close is still roughly the area delineated by Losinga, running from the Saxon market place down to the river. It is a blessed oasis in the centre of a busy city.

↖ All human life in a Norwich roof boss
↑ The Flagellation, the Despenser retable

ST DAVID'S

✥

More than any British cathedral St David's evokes the age of pilgrimage. It lies peaceful in a green defile protected from the storms and Vikings of the Irish Sea, reached by a path climbing from an unchanged shore. Along this path plodded pilgrims rich and poor, sick and dying, excited and exhausted as they neared their destination. Beside the path runs the Alun stream in whose water the reputedly tetchy misanthrope St David (c.500–c.589) stood freezing to purify his soul. Round about lie the same meadows and the same spindrift, gorse and bilberries, and overlooking them is the same open clifftop on which David's mother St Non supposedly gave birth to him. It is a rare cathedral to be so little changed by time.

The church was rebuilt by the Normans to assert their presence in this distant corner of their domain, and the Conqueror personally visited it in 1081. In 1123 diplomacy secured a papal privilege that awarded the new cathedral a rich accolade, declaring that 'two pilgrimages to St David's equal one to Rome and three equal one to Jerusalem.' This was gold dust for the cathedral's pilgrim revenue.

A new cathedral was duly begun in 1181, though it showed few signs of the Gothic style already introduced at Canterbury. Sitting as it does in a valley bottom, the building was always vulnerable to collapse. Even so the stone tower and clerestory windows are still Norman while the west front is Victorian Neo-Norman. All are in grey slate, unjoyous in the Pembrokeshire rain but a lovely silver in sunshine. The cathedral was comprehensively restored by Sir George Gilbert Scott in 1862–70.

The nave interior is a composition of late Norman arcades and clerestory with a multiplicity of fluted capitals and chevron arches. Experts have detected twenty-two different forms of chevron. A new wooden roof was inserted in 1530 with a magnificent Tudor ceiling with pendants.

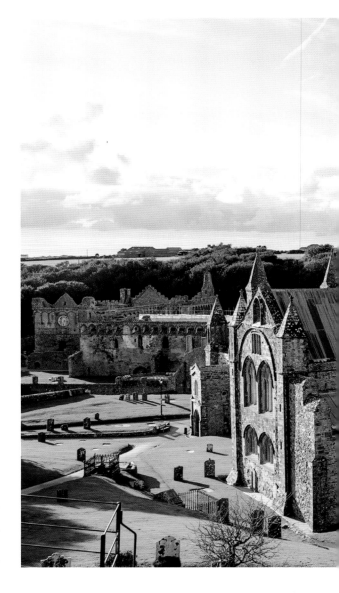

The nave is divided from the monastic east end by a pulpitum of c.1340 erected round the tomb of Bishop Henry de Gower. Sent from the chancellorship of Oxford University to this humble bishopric, he celebrated – or perhaps retaliated – by building himself a splendid palace that now lies in ruins next door. The pulpitum screen was restored with saints in niches by the Neo-Gothic architect William Butterfield in the 19th century. A new organ was installed in 2000.

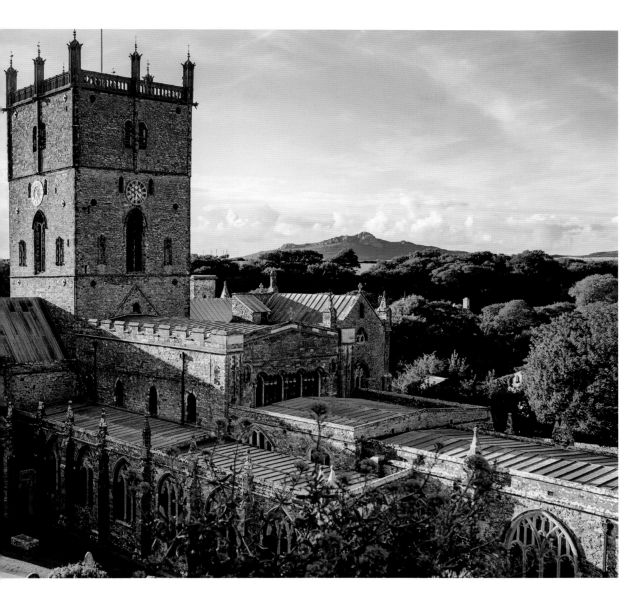

The cathedral's east end is a place of Gothic vaults and secluded chapels contrasting with the spaciousness of the nave. The Perpendicular choir has misericords portraying such familiar scenes as a pilgrim being sick over the side of a ship. St David's sanctuary and presbytery were saved by Scott from total dereliction, the restoration necessarily drastic. The saint's shrine is lodged in a wall. A grander tomb is that of Edmund Tudor (d.1456), father of Henry VII and founder of the Tudor dynasty. The

Holy Trinity chapel was built by Bishop Vaughan in the 1500s and is a Tudor tour de force with fan vault.

On its north side the cathedral has a small cloister with a visitor centre and café designed in 2004 by Peter Bird of Caroe and Partners. Medieval in proportion and mostly made of wood, it is a rare work of ecclesiastical architecture that is quietly respectful of its setting.

↑ St David's: pilgrim magnet

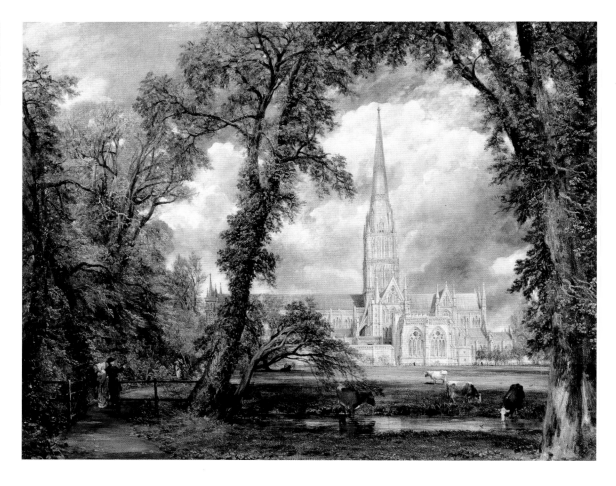

SALISBURY

❖ ❖ ❖

A waving elm, a sleepy river and a silvery 'needle in the sky' compose the English ideal of a cathedral. An Italian might envisage a portico and the French a west front, but ask a Briton to sum up the word cathedral and likely as not the imagination turns to Salisbury. Indeed it would probably be the Salisbury of John Constable, depicted by him in paintings and drawings some three hundred times. His vision of a spire framed by nature came to embody the Georgian picturesque. It was Salisbury usually from an angle, its walls, gables and roofs as triangles of light enveloped by grand and now sadly departed elms.

The cathedral's origins were unusual. Its Norman predecessor lay 3km to the north on Old Sarum hill. In 1217, with old Romanesque cathedrals being reconstructed across Europe, the bishop Richard Poore petitioned Rome to move his seat away from the crowded hilltop down to a gravel terrace by the Avon river. England had just emerged from King John's civil war into the hoped-for stability of Henry III, and Rome agreed. In the classiest of planning permissions it declared, 'Let us spread joyfully to the plains, where the valley abounds in corn, the fields are beautiful and there is freedom from oppression.' Things got better. The visiting Henry of Avranches declared the new site 'a second Eden this, where beasts forget their enmities and birds unite in song'.

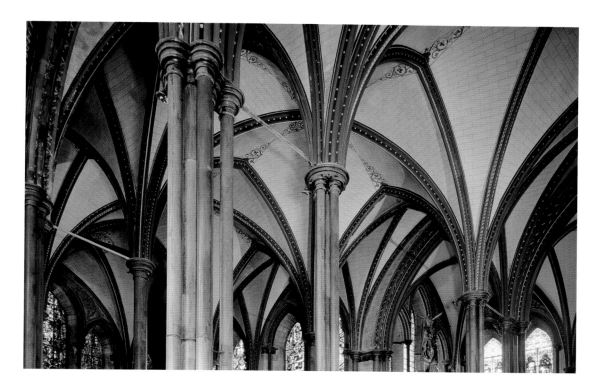

A site had already been selected and Salisbury's canons were invited to choose plots for their houses round what is the largest cathedral close in England. Two-thirds of the oaks for the church came from Ireland and Henry III gave a large ruby. Fifty members of the chapter were taxed at 23 per cent of income, and indulgences (pardons in the afterlife) were sold shamelessly. The cathedral was adjoined by one of England's few medieval planned towns. This was on a grid of squares and market gardens next to the river, an intriguing reversion to the Roman concept of a rectangular plan.

The first stone was laid in 1220, making Salisbury contemporary with Amiens. Its designer was Elias of Dereham (1167–1246), who became a Salisbury canon. The style was Early Gothic with lancet windows, some with simple plate tracery. The original building, not yet with its steeple, was not

exceptional. Salisbury has long troubled critics complaining that its exterior is unexciting and its west front lacks coherence. It was designed in a hurry and Pevsner found it 'a headache, perversely unbeautiful … stunted'.

This view was transformed by the building of a steeple in the first quarter of the 14th century, a recognized masterpiece of the English Decorated style. The tall base and lofty spire have none of the heavy engineering and buttressing of its German and French contemporaries. The spire emerges gently from the crossing until, as Constable wrote, 'it darts into the sky like a needle.'

The interior's ten bays of nave and ten of presbytery embrace two pairs of transepts. The architecture is graceful, enlivened by the lavish use of Purbeck marble in the triforium and clerestory, though the piers are devoid of ornamented capitals. We see few figurative sculptors at work, though much of Salisbury's reputation for coldness derives from a restoration by James Wyatt in the 1780s, intended

↖ Constable's *Salisbury Cathedral from the Bishop's Ground*
↑ Retrochoir: serenity amid woodland shades

to declutter the interior. He felt Gothic 'ought to be homogeneous in style and unencumbered by screens, monuments and other obtrusive relics of the past'.

Chantry chapels and stained glass were particular victims of 'the destroyer', as Wyatt was dubbed. Almost all the medieval glass was thrown into a ditch and a large window in the style of Michelangelo was inserted above the presbytery arch. Later windows are 19th-century additions by William Morris and Edward Burne-Jones. In the nave a large reflecting font by the modern sculptor William Pye offers probably the most photographed image in any English cathedral.

Salisbury makes amends in the three east chapels beyond the altar. Here slender columns are those of a forest glade while the vaults invite calm contemplation. They suffer only from a gloom caused by the 1980s insertion of deep-blue windows in the eastern Trinity Chapel. These depict 'prisoners of conscience' trapped in the dark, as if enduring eternal misery.

Some tombs survived Wyatt. The Perpendicular chantry chapel of Bishop Audley (d.1524) in the north choir is Salisbury's principal treasure. It is a doll's house of a Late Gothic chapel with a gilded fan vault, roses and pomegranates representing Henry VIII and Catherine of Aragon. The south-east transept has the tomb of Bishop Bridport of 1262, covered with stiff-leaf carving and scenes from the bishop's life. In the north-east transept is a much rubbed brass of Bishop Wyville (d.1375) looking out from a fantasy castle.

Salisbury's cloister is reputedly the largest in England and one of the finest. Its arcade built in the 1260s has tracery of large Decorated cinquefoils. Off the cloister is the chapter house, one of many to emerge towards the end of the 13th century and a close copy of Henry III's octagonal chapter house at Westminster. The windows are filled with elegant tracery, the central pier so slender Daniel Defoe claimed that it moved when he leaned on it. It does not.

Here in the chapter house Salisbury's masons seem released from the austerity of the main cathedral. Heads and relief panels over the canons' seats form a gallery of faces smiling and frowning, supposedly from the first two books of the Bible. Some are building the Tower of Babel, others merely having a chat. The faces look real, perhaps citizens of medieval Salisbury, albeit many of them admirably recarved in the 19th century.

WELLS

✣ ✣ ✣ ✣ ✣

Throughout the Saxon era, Wells abbey competed for primacy with its neighbours at Bath and Glastonbury. The Normans decided on Bath as the bishop's seat, but in 1176 Reginald de Bohun seized on Henry II's post-Becket building boom to start a new cathedral at Wells. Begun at the same time as the new Canterbury it was the first cathedral in England to be entirely in the Gothic style, pre-dating Salisbury by half a century. Building was slow but gathered pace under Reginald's successor Jocelin of Wells (d.1242) and in 1245 episcopal rivalry was settled by the pope's deciding on 'Bath and Wells' as the bishopric and Wells as the seat. Glastonbury vanished at the Dissolution.

The Wells chapter now consisted of fifty-four canons and by the turn of the 14th century they were ready to expand their cathedral. They commissioned the finest masons including Thomas Witney (1292–1342) and William Joy (fl.1329–48), followed by the Perpendicular master William Wynford (fl.1360–1405), architect of Winchester. The cost was enormous and the chapter was soon at odds with an increasingly hostile town. Protective walls were even erected round the close which remain to this day. A private street of lodgings, Vicars' Close, has an enclosed bridge into the cathedral to protect

→ Wells: a geometry of scissors
↓ Roseate Wells: the west front

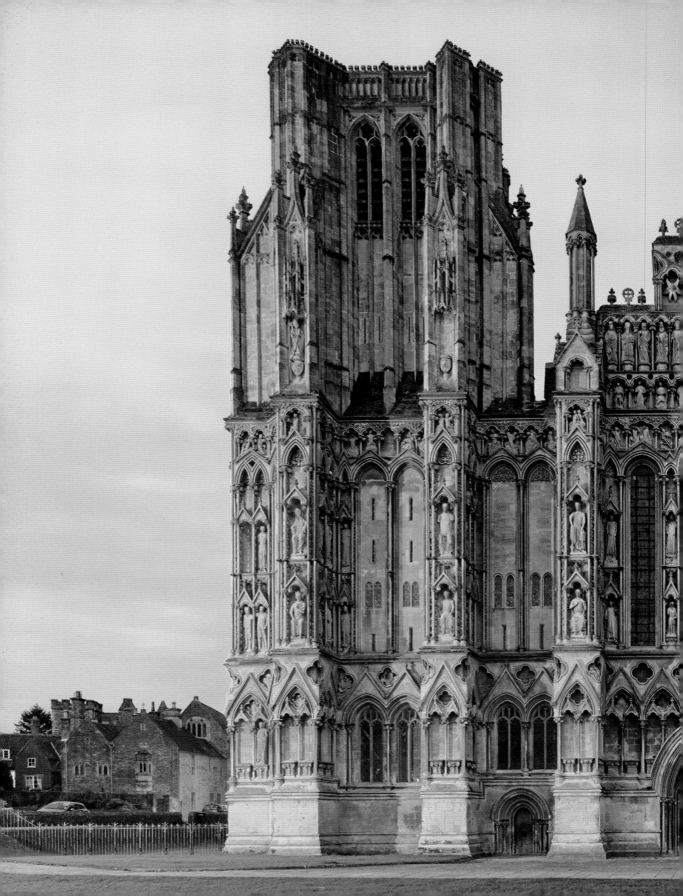

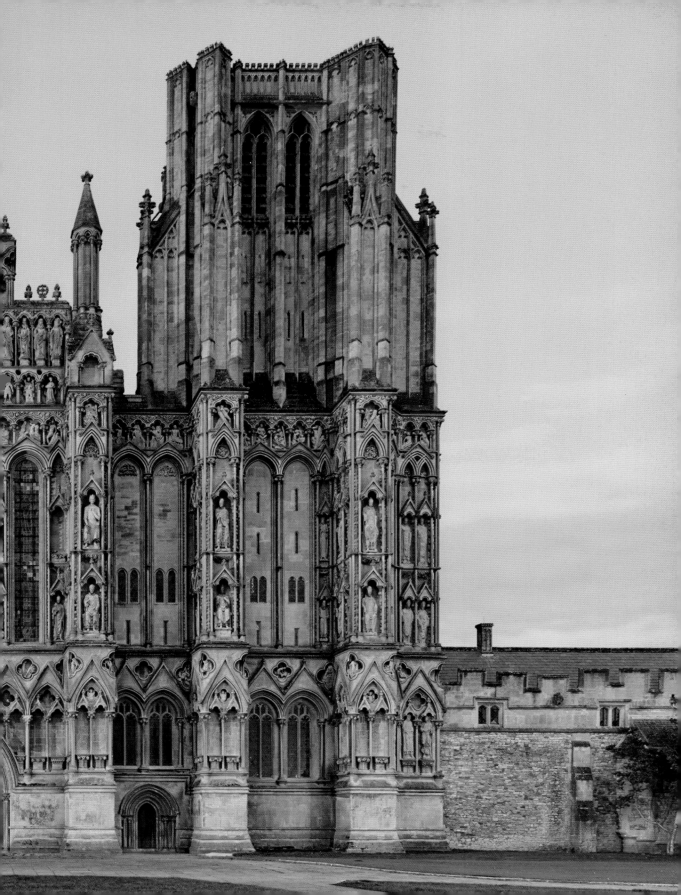

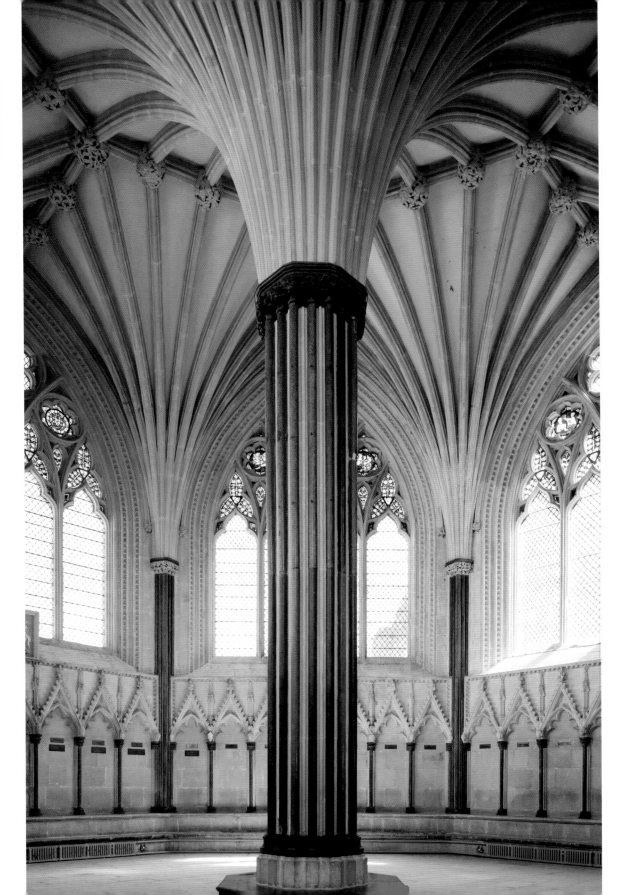

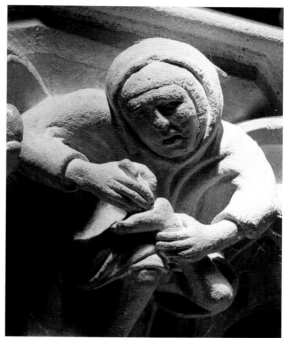

clergy from attack. Jocelin's palace was – and still is – surrounded by walls, gates and a moat. It has rebuffed recent attempts to turn it into a hotel.

The west front of Wells is England's most celebrated cathedral tableau. It was designed in the 13th century as a sculpture gallery with two ambitious towers. When Wynford came to build these towers in the 14th century the softness of the ground made it impossible. Six hefty buttresses were left with little to support. The front is thus an expanse of statuary in four tiers of niches, once with four hundred figures but now nearer three hundred.

These tiers have not been free of controversy. Most writers have eulogized a façade that, though oddly proportioned, is full of personality. But the statues are problematic. To the ever critical Pevsner they are ill-fitting and so eroded as to be either unrecognizable or 'weird and gaunt'. Barely a quarter are identifiable as biblical or secular figures.

← Chapter house: the palm vault
↑ The toothache and thorn capitals

When I climbed the scaffolding during Wells's last restoration I found it hard to see the point of not repairing or replacing them. Only on the sheltered north side do the 'four Marys' convey sculptural potency, as well as perhaps two dozen others.

On a continental cathedral these statues would have been removed to a museum and replaced by replicas or substitutes. In the 1980s the sculptor David Wynne made new figures for the empty niches at the top of the façade, but argument arose over whether to replace others. In the event they were left meaningless and merely 'stabilized'. That said, the façade of Wells is a scene of endearing loveliness. Caught in a late sun its cliff-face of Somerset limestone turns a radiant gold, rising from the surrounding grass as if by force of nature. Visitors wishing to glimpse its original splendour may catch the occasional nocturnal laser projection when it is transformed into brilliant colour in the style of Amiens (see pp. xiv–xv). It shows how taste changes over time.

Wells's interior opens with a shock. The nave is Early Gothic with piers of clustered shafts lacking

much sense of verticality. The triforium is horizontal. It is cut short at the crossing by extraordinary strainer (or scissor) arches inserted by William Joy in the late 1330s to strengthen the then sinking central tower. In the form of a curvilinear cross of St Andrew the arches rise from floor to ceiling without bases or capitals. Some people find them intrusive and some cannot even believe them medieval rather than 20th century. Yet the arches are a case of necessity turned to art. With their two eyes they are like a gigantic owl gazing down on the nave congregation in stern judgement.

Beneath these arches the crossing houses a treasury of late 12th-century carving. Some two hundred capitals are clustered eight to a pier, their carvers' chisels released from biblical duties to portray daily Somerset life. We see a farmer chasing a fox that has stolen his goose; a cobbler banging a shoe; and a man removing a thorn from his foot. To me these carvings are miracles of Gothic art, with a naturalism that seemed to disappear from church craftsmanship with the Gothic style. They fused religion with the daily lives of worshippers, here rendering the cathedral a calendar of the working and playing year.

All eyes now turn east. Towering over the sanctuary and choir is a magnificent Jesse east window chronicling the House of David. Long known as the 'golden window', it avoids the reds and blues of most medieval glass, stressing greens and yellows. The choir stalls below have a collection of original misericords, an inventory of medieval life as lively as the crossing capitals if less conspicuous.

Wells has no reredos behind the altar, just three elegant arches giving a glimpse of the retrochoir and Lady Chapel beyond. These were designed by Witney, master of Exeter cathedral, and possibly completed by William Joy after 1326. The retrochoir would have been intended as a processional route to a saint's shrine, but Wells never found a saint to pass muster in Rome. Instead we are left with a Gothic chamber of great loveliness. Piers rise like giant fronds waving under water, an antechamber to Witney's Lady Chapel beyond.

This chapel is octagonal with a vault formed of two overlaid circles of differing diameters, clearly the work of a master geometer. The vault comprises a starburst of ribs forming lozenges inside stars, as if each junction were releasing a golden spark. It demands music by Bach, the most mathematical of composers.

Wells's final offering lies behind two Renaissance tombs off the north transept. Here a flight of steps leads to the Vicars' Close bridge. Midway a tributary stair curves to the right into Wells chapter house, a masterpiece by an unknown hand created between 1275 and 1310, climax of the Decorated era. The chamber vault is supported by a central palm-tree column from whose trunk radiate no fewer than thirty-two branching ribs. As they fan outwards they meet eight lesser fans rising from the side walls, joining hands in a girdle of ribs and bosses. They then appear to dance together as if round a maypole. It is the most exhilarating architectural composition in all England.

This is not all. The fifty-one stalls below are each capped by a trefoil and a gable. Their corbels form yet another Wells sculpture gallery, here of canons, some stern, some laughing, one sticking out his tongue. These are grander faces than those in the crossing and must surely be portraits of those who presided over this majestic church. Let time never erode them.

WINCHESTER

✥ ✥ ✥ ✥

Unobtrusive in the grass under the towering north wall of Winchester cathedral is the footprint of its Saxon predecessor. In comparison it looks hardly more than a chapel. For William the Conqueror, destroying England's coronation church and

→ Winchester: Europe's longest nave

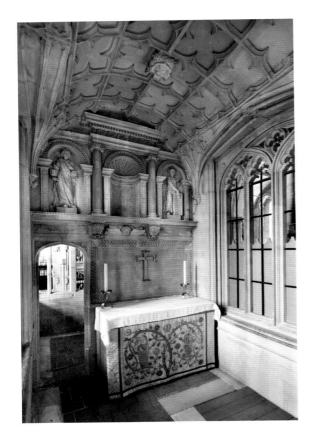

is breathtaking. Seen from the entrance an avenue of piers disappears eastwards, rising aloft to form a canopy of semi-fan vaults. By day this canopy is lit by eleven bays of clerestory. By night, it glows with electric light, drawing the eye to the crossing and chancel beyond.

A sole intrusion in the nave is the chantry chapel of Wykeham himself, built before his death allegedly on the spot where as a local boy he first witnessed the mass. It is a sumptuous work of crockets and gables bursting out of its enclosing arch. It is said the Cromwellian officer assigned to its destruction dared not touch it, having been a pupil at Wykeham's local Winchester College. Wykehamists had a higher loyalty than to civil war.

The transepts take us back three centuries, replacing the sweet music of Edward III's court with the heavy tramp of Norman Romanesque. Three tiers of rounded arches rise to a flat ceiling, lit mostly by small windows. Off the north transept lies a 12th-century Holy Sepulchre Chapel, little more than an alcove, murals discovered there among the finest of that date in England.

Also off this transept is a small door leading down to the crypt, vulnerable to Winchester's high water table and regularly flooded. It is an eerie place. The north aisle is occupied by a 1986 statue of and by the sculptor Antony Gormley, contemplating water cupped in his hands. In a corner of the retrochoir overhead stands a memorial to William Walker (d.1918), a diver who worked with a team underwater for months in the 1900s to reinforce the cathedral's crumbling foundations.

The choir stalls have the customary cast of 13th-century decorations of hazel, hawthorn, ivy, vine and humans shouting, grimacing and having a good time. The misericords below are equally enjoyable, a veiled nun cavorting in the bushes, a ridiculed bishop and green men galore. The choir is overlooked by Winchester's treasure, a Perpendicular reredos of 1450 carrying a tableau of Christian personalities down the ages. The statues were smashed

granting that status to 'French' Westminster was a matter of symbolic urgency. A new Winchester was begun in 1079 and was to be big, twice the length of the abbeys of Normandy.

William's structure remains visible in the transepts, which today have the appearance of fortress walls. The east end was enlarged from c.1202 while the nave had to wait a century and a half for William of Wykeham, Edward III's lord chancellor and bishop of Winchester (1367–1404). He employed as his architect the Perpendicular master William Wynford whose longest medieval interior in Europe of 138m now lies like a beached whale in the valley by the River Itchen.

The cathedral exterior is undistinguished. The west front is little more than a frame for an expanse of stained glass, which was smashed by Roundhead troops during the Civil War. The interior, however,

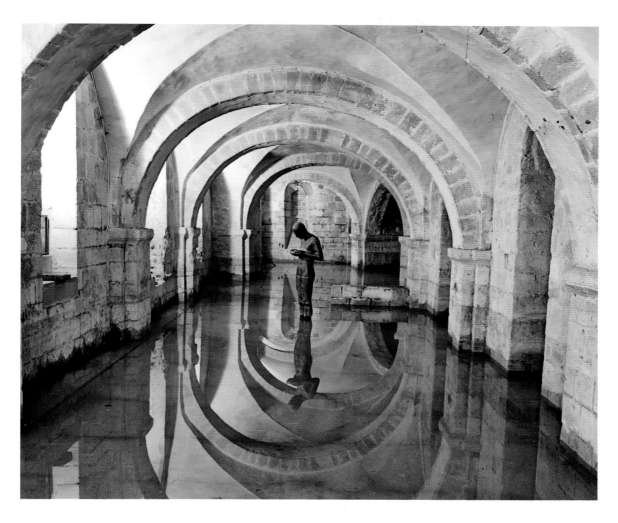

in the Reformation but restored with admirable vividness by the Victorian J. R. Sedding and others.

Behind the presbytery Winchester's large retro-choir doubles as a pilgrimage venue and display of chantry chapels. It was the earliest part of the cathedral to be rebuilt in the 13th century and much of the floor is still laid with medieval tiles. We are thankfully permitted to walk on them, though not in high heels. Broken ones are easily replaced.

The chantry chapels are Winchester's proudest monuments, moored like ships at anchor in honour of Winchester's episcopal princes. The Waynflete chantry is a thicket of pinnacles concealing an interior of delicate fan vaults. The chapel of blind

Bishop Fox was used by him for hours of daily prayer for ten years before his death in 1528. Most spectacular is that of Stephen Gardiner (r.1531–55), Cranmer's conservative opponent and champion of the Counter-Reformation of Mary I. Built during her reign in 1556, it was probably the last Gothic chapel to be constructed in the style of the old religion. Yet its designer surrounded the exterior with a Renaissance frieze, while sheltering inside is a Classical altar and reredos, a happy marriage of architectural theologies.

↖ Gardiner chantry: Gothic hides Renaissance
↑ Gormley statue in flooded crypt

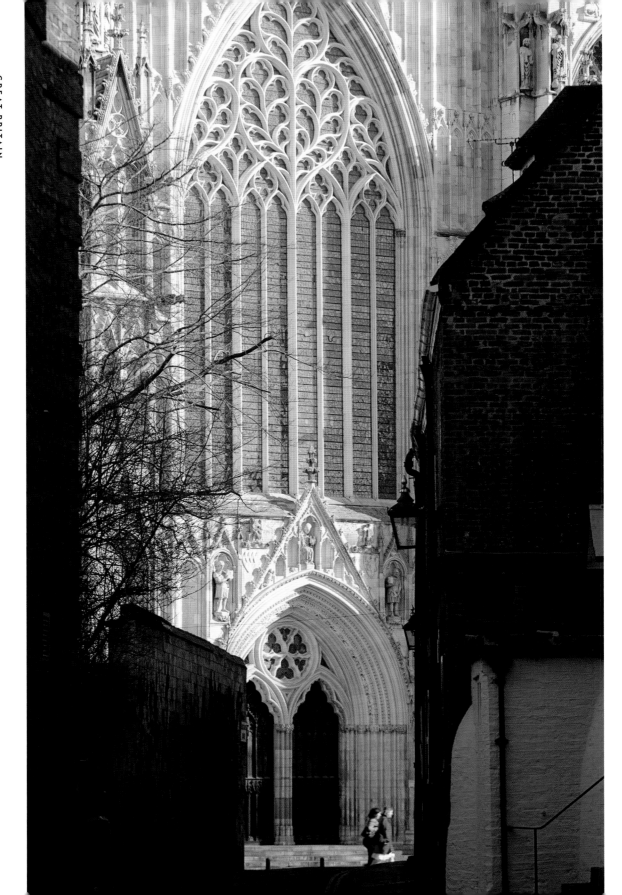

YORK MINSTER

⁜ ⁜ ⁜

Anyone visiting York minster should first view it from the city wall to see how splendidly it commands the skyline. Bede records Christians in Roman York already in AD 180 and a York bishop was at the 314 Council of Arles. A firmer history began in 627 when the pagan king Edwin of Northumbria (r.616–33) returned from wars in the south with a Christian bride, Ethelburga of Kent. She brought with her a chaplain Paulinus who converted Edwin and became first bishop of York, seat of England's second archbishop after Canterbury.

Successive minsters were built and amended before Archbishop Walter de Gray arrived in 1215 and completed a church fit to rival Canterbury.

← Heart of Yorkshire: west front
↑ Carvings in chapter house

Work progressed slowly over two centuries, resting on just 1.5 metres of sandy foundation. The Early Gothic transepts came first, followed in the 14th century by a Decorated nave and in the 15th by a Perpendicular choir and three towers. The central tower had no pinnacles for fear of the weight leading to a fall, as had happened to an earlier steeple in 1405. The precaution was sensible as excavations in 1967 revealed the tower as facing collapse and in need of immediate support.

The minster, its common title, revels in superlatives. It is England's largest medieval church in volume, with the widest vault, the biggest chapter house and the most medieval glass. York is also blessed with that rarity among English cathedrals, a noble west front. Completed in 1339, the window is

a Decorated composition without equal. Formed of contiguous ovals in the shape of a heart it is known as the Heart of Yorkshire. No engaged couple are truly Yorkshire unless photographed beneath it.

The visitors' entrance has been moved to this west front from the south transept. This is controversial as it denies the exhilaration of first catching sight of the nave from the south transept. On the other hand it delivers an immediate visual impact. Shafts rise uninterrupted from floor to vault. Triforium merges into clerestory, creating a single, vertical panel to each bay. The result is a playground of light, the rays of the sun dancing with piers and capitals. York speaks the language of space.

The scene is overlooked by the interior of the west window: its glass describes the authority of the church, with bishops below, then saints, the Bible story and the Coronation of the Virgin as Queen of Heaven. The nave roof was destroyed in a fire in 1840, as a result of which all the bosses are replicas, except that of the Virgin breast-feeding, which the sensitive Victorians updated to bottle-feeding.

York's central crossing embraces a tower vault whose roof fans float on clouds of light from side windows. Below is a 15th-century pulpitum with an off-centre door. This is a result of the early death of Henry V and the insertion of an extra statue of his successor, Henry VI. Henry's subsequent nomination for sainthood led to his statue being removed, only to be reinstated by the Victorians. Pulpitums tend to be political.

The south-transept roof was destroyed in a fire in 1984, necessitating sixty-eight new bosses. A television competition staged by the BBC's *Blue Peter* programme chose contemporary themes including an astronaut on the moon and 'saving the whale'. The north transept is dominated by the Five Sisters window of 1220, named after its five lancets, each 16 metres tall. Reputedly taken from a tapestry design by five nuns, they offer a contrast of Early Gothic simplicity with the later pyrotechnics of the west window. The glass is original, so-called grisaille, and composed

of over 100,000 tiny panes mostly grey dotted with points of colour, like carpets of semi-precious stones.

York's eastern arm is a disappointment. The Perpendicular space, though as extensive as the nave, lacks personality. The choir roof and stalls below were destroyed in a fire in 1829, and the area is best seen as the setting for York's east window, considered one of the great Gothic windows in Britain. The glazier was John Thornton of Coventry who was commissioned in 1405 to complete the task in just three years. The window has been called England's Sistine Chapel ceiling and is an illuminated manuscript in glass.

The colours form patterns of shooting rockets and falling teardrops, the subject matter the population of heaven, descending through biblical stories to the history of the city of York. The vividly portrayed faces are the medieval mind in faith, work and play. When the burghers of York saw the finished work, they made Thornton a freeman of the city on the spot. The window was magnificently restored in 2018 after ten years of repair.

York's chapter house is entered through a double doorway under a trefoil arch carrying a statue of the Virgin. Begun towards the end of the 13th century, the chamber vault and roof above are of wood rather than stone and thus free of a central support. The windows carry geometrical tracery of great subtlety, their cusps seeming to spin before our eyes.

The stone stalls and canopies of the chapter house ripple round the walls. They are framed with pendants heavy with vegetation. Monarchs, clergy, animals and birds dart in and out of the leaves, a gallery of Yorkshire faces. We see the cathedral's corporate boardroom all present and correct. In an upstairs loft survives a rare mason's workshop with the still visible outlines of window tracery on its floor. This is a great privilege. I feel we have been invited into the craftsman's mind more directly than in seeing his finished product, a fitting climax to the story of Britain's cathedrals.

→War in heaven: east window

162

ITALY AND MALTA

ASSISI, BASILICA DI SAN FRANCESCO ✢✢✢;
BOLOGNA, SAN STEFANO ✢;
FLORENCE, DUOMO ✢✢;
FLORENCE, SAN LORENZO ✢✢✢; LUCCA ✢✢;
MILAN ✢✢✢; MODENA ✢✢✢;
MONREALE, SICILY ✢✢✢✢; ORVIETO ✢✢✢✢;
PISA ✢✢✢✢; RAVENNA, SAN VITALE ✢✢✢✢;
ROME, ST JOHN LATERAN ✢✢;
ROME, ST PETER'S ✢✢✢; SIENA ✢✢✢✢;
SYRACUSE, SICILY ✢; TRANI ✢;
VENICE, ST MARK'S ✢✢✢✢✢;
VENICE, TORCELLO ✢;
VALLETTA, ST JOHN ✢✢✢

\mathfrak{M}any of Italy's cathedrals date back to the official recognition of Christianity by the emperor Constantine in 313. Perhaps as a result almost all have retained echoes of ancient Roman architecture in the style of Romanesque. Some also pay respects to Italy's old partner and rival Byzantium, notably in Venice and Ravenna.

The Italian late-Romanesque period of the 11th and 12th centuries was one of prosperity and civic confidence, notably in Lombardy and Tuscany, and saw the style evolve to a sophistication not seen elsewhere in Europe. Perhaps in consequence Italy showed little evidence of the Gothic revolution that seized France, Spain, Germany and England, adopting it largely for ornamentation rather than innovative engineering.

Visiting Italian cathedrals can therefore come as a relief after the thunder and lightning of northern Gothic. While Reims was wrestling its way towards the sky at the turn of the 14th century, Italians were crafting one of the most exquisite of all west fronts at Orvieto. Only in Milan do we find a deliberate attempt at Gothic verticality, and that was designed under French supervision. For the most part Florence was more typical, with Brunelleschi and others progressing with dignity from Romanesque into Renaissance without Gothic digression.

Italy was less torn apart than northern Europe by the Reformation and the wars of religion. Under the Counter-Reformation it even found the resources for a burst of cathedral rebuilding and refitting. This led Francis Bumpus in 1926 to write despairingly of Italian churches that the rebuilding of ancient duomos in the 17th and 18th centuries meant that 'frequently the cathedral is the least interesting church in a city.' At the same time, the period saw the most dramatic advances in ecclesiastical Baroque. Hardly a chapel or an altar was left untouched. This reached its grandest achievements in 1650s Rome in Borromini's St John Lateran and Bernini's St Peter's piazza.

Nowhere else in Europe is the cathedral so conspicuously an art gallery as in Italy. Paintings, murals and sculptures by Giotto, Cimabue, Signorelli, Michelangelo and Donatello which would in any other country be in a museum are still where intended, in a church setting. They can induce what has been called Stendhal syndrome, 'an onrush of palpitations and dizziness' caused by an excess of fine art. Jonathan Keates writes that he has only to set foot in Florence to feel 'a longing to escape this devastating perfection'. But these paintings and frescoes can bring even the dullest church to life.

Italy's cathedrals benefited like those of Spain from the relative decline in their country's urban prosperity over the 19th and early 20th centuries. The saving of Venice from canal infilling in the 19th century was a mercy. Italian towns were mostly immune to revolutions industrial and political. The centres of Florence, Siena and Bologna have retained a precious beauty, lending their cathedrals the most ideal of architectural settings.

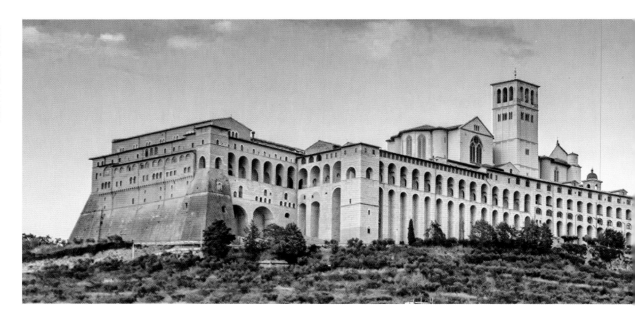

ASSISI
BASILICA DI SAN
FRANCESCO

✥ ✥ ✥

If asked to name a European landscape that comes nearest to perfection I have to answer Umbria. Green plains roll between forested hills across which oak, olive and cypress make a stately progress. Hillsides shimmer with sparkling white towns, their houses efficiently compact within ancient walls. This is how Europeans are meant to live.

No Umbrian view is more seductive than that of Assisi, its profile rising on a rocky cliff and lord of all it surveys. Here in 1209 a local playboy named Francis renounced the good life and founded an order of a dozen mendicant monks. They abjured all property and committed themselves to 'Lady Poverty', to a life of prayer, peace and good works. To qualify as an order, Francis needed the blessing of the pope, none other than the domineering Innocent III (r.1198–1216), absolute ruler of the church and scourge of the Cathars. He regarded Francis's critique of episcopal luxury as sufficiently mild to merit permission.

In today's terminology Francis's movement went viral. He returned from a hillside retreat bearing on his hands the stigmata or wounds of the cross, the first person since St Peter to be so honoured. His followers proclaimed him the second Christ. One named Clare founded a sister order of nuns, the Poor Clares. On Francis's death in 1226 he was instantly canonized, and a basilica and monastery rose over Assisi. The basilica should not be confused with Assisi's cathedral of San Rufino.

The church is composed of two chambers one above the other. Given the size of its adjacent friary and the millions who must have visited it over the centuries, the building is remarkably unchanged and unpretentious. It stands on a plinth of giant arcades built in just thirty years after the saint's death. They are a masterwork of medieval engineering.

The churches were built in one programme, the lower church Romanesque and crypt-like begun in 1228 with a 19th-century lower crypt containing St Francis's tomb. Here daily mass is sung. The upper

church followed, the whole consecrated in 1253. Both are covered in frescoes by prominent artists of the 13th and 14th centuries.

The lower church is reached through a Renaissance porch of 1487 built to frame an earlier Gothic portal, offering contrasting styles in handsome union. The interior is round-arched and low-vaulted, the painted panels on the walls and ceilings set within elaborate borders. The panels depict the life of Christ on the right side and of St Francis on the left, as if to draw parallels between them. The earliest frescoes of 1260s are in the nave while the best preserved are in the chapels. The finest are in the Chapel of St Martin to the left of the entrance, with vivid scenes from the saint's life by Simone Martini (c.1284–1344). The faces are wonderfully realistic. I am sure in one of the women we can see a copy of Martini's portrait of Petrarch's Laura.

In the lower church's right transept is a fresco of the Virgin and St Francis by Cimabue (d.1302), adjacent to livelier portrayals of the childhood of Christ by Giotto (1267–1337). Off the opposite transept is a series of the Passion of Christ by Pietro Lorenzetti (1280–1348), pupil of Duccio. The guidebook hints at controversies over these attributions, in particular

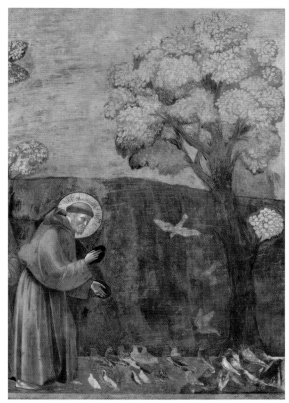

↖ Assisi: silver city on a hill
↗ *The Sermon to the Birds* by Giotto
→ Murals in upper chapel

ITALY AND MALTA

169

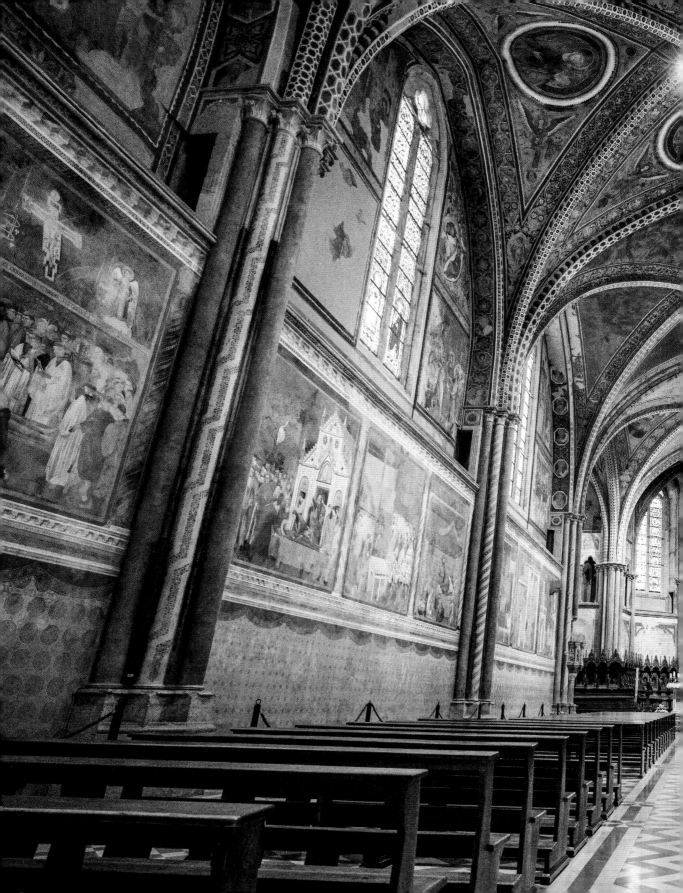

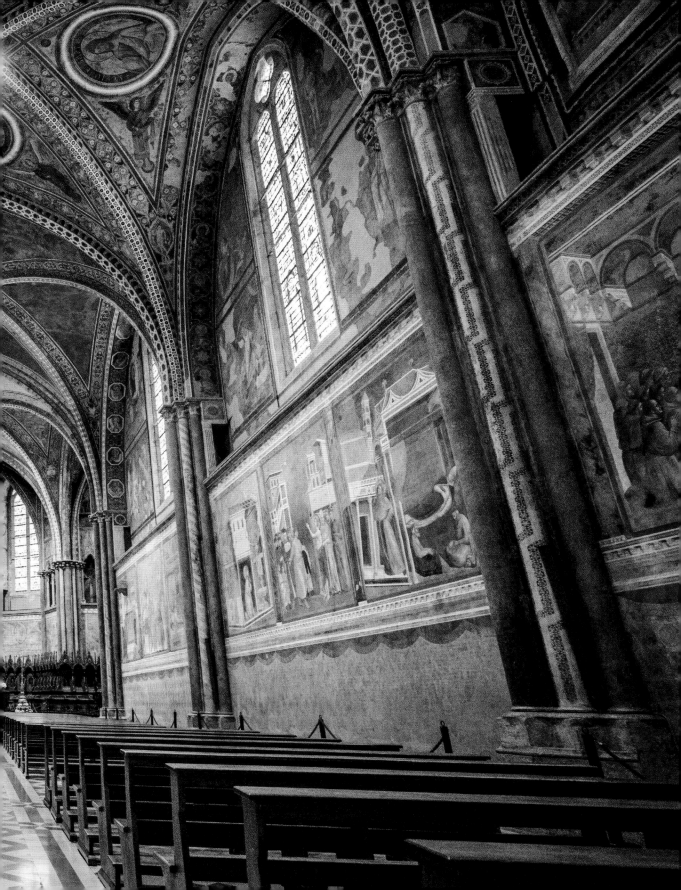

over how much is by or influenced by Giotto and his workshop. It is best just to admire the chamber as a whole, a kaleidoscope of faded colour.

The upper church is reached from the upper piazza and repeats the lower chapel but on an altogether grander scale. The interior is painted from floor to ceiling and is a rare reminder of how these churches were intended to look, not as today's bare and gloomy halls but alive with visual diversion, the picture books of their day. The church is effectively a gallery of twenty-eight murals of the life of St Francis by unknown, possibly Roman, artists. They include the famous Sermon to the Birds. When I first visited in the 1980s I recall the impact of moving from the mysterious darkness of the lower church to the dazzle of the upper one with its vault of blue sky studded with stars.

Since then, in 1997, not the least of Franciscan miracles was the basilica's survival of an earthquake that shattered much of its plaster and also brought down the upper-church vaults of the entrance bay and crossing. Film of the earthquake shows the vault actually falling. The disaster led to a familiar debate on how far to restore the damaged frescoes. Some have been brightly restored, some left faded or damaged and some areas left as grey plaster. Much still looks magnificent but the usual academic dispute has left a clash in appearance. A different case is the Cimabue Crucifixion (c.1280) in the left transept, its colours blackened by chemical reaction, leaving a photographic negative of the original. It is more a ruin than a painting.

This does not detract from the glory of one of Italy's most spectacular churches. Outside the lower church is an extensive piazza lined with covered arcades to shelter pilgrims. Its irregular shape and gliding stairs display the Italian genius for informal spaces. From its walls we can watch the Umbrian plain rolling peacefully into the distance.

↗ Bologna: ancient basilica of San Stefano

BOLOGNA
SAN STEFANO
❖

Nowhere better evokes the spirit of early Christianity than Bologna's San Stefano enclave. The city is urban Italy at its most handsome, shielding its citizens from sun and rain under miles of arcaded streets. The central piazza boasts a medieval basilica, that of San Petronio, and a town hall surrounded by palaces and tenements. But Bologna's most treasured relic lies down a backstreet devoid of ostentation. Here a group of eight religious buildings grew up round what had been a Roman spring and shrine to the goddess Isis. The enclave conveys an intimacy and mysticism that drew Bolognese to this spot long before the birth of Christ.

The priests of Isis honoured their spring with a circle of black stone columns, reputedly blessing it with water brought from the Nile. Some of these columns still stand, as does the spring. The temple was later converted to Christian worship with new brick columns bringing the circle to twelve and forming what was presumably a baptistery. In the 11th century a group of monks erected over the spring a replica of the conjectured Holy Sepulchre in Jerusalem. It has been much altered and the later pulpit, gallery and steps are confusing additions. Its curiosity value is largely archaeological.

To the left of the sepulchre stands a church that may have been the original cathedral of Bologna's St Petronius (d.450). It is dedicated to the local saints Vitale and Agricola martyred in 304. In the 15th century a rumour that St Peter was buried here attracted such a crowd of pilgrims that the then pope, furious at the implied demotion of his own church, had the building briefly filled with earth.

Of all the churches in this book, that of San Vitale and San Agricola most evoke the atmosphere of ancient Christian worship. It appears undated

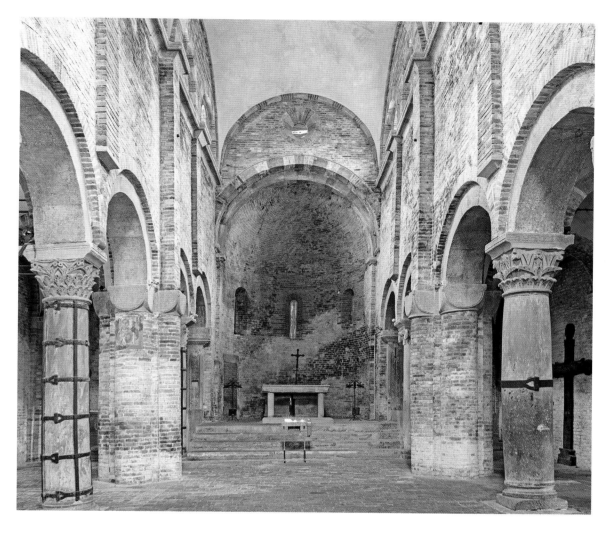

and its bare, barnlike walls suggest the beginning of built time. They encompass a simple nave and aisles divided by an arcade of crumbling arches. Most have brick columns while a few have stone ones held together by iron bands. Crowning these columns is a job lot of capitals, some cushion, some Byzantine, some Ionic. Light is supplied by a plain clerestory above.

The character of this ancient building lies in the absence of a restorer's hand, much repaired though it must be. Apart from the capitals the only adornment is offered by ghostly wall paintings and two sarcophagi with reliefs of a peacock, lion and deer. A black metal cross pinned to the south wall carries more emotional power than any Baroque extravaganza.

On the other side of the San Stefano sepulchre from San Vitale and San Agricola is another early church, that of the Holy Crucifixion. Behind them both is a small yard named Pilate's Court from where we can admire the decorative brickwork on the sepulchre's exterior. Set into a wall in the court is a 14th-century stone cock representing the one which 'crowed twice' to mark Peter's denial of Christ. It is lovely in its farmyard simplicity. I longed for it to crow.

FLORENCE
DUOMO

✥ ✥

I am not at ease in Florence. I sense I am being judged every hour of my visit, as if for preferring an espresso to a Donatello. Nowhere is this sense stronger than in the few hundred metres from the Piazza Signoria to the Piazza del Duomo. Yet the route is exhilarating, from the dignified openness of the Signoria to the jazzy, noisy spaces that surround the Duomo.

The Piazza del Duomo began life with the Baptistery, scene of the earliest of Christian rituals. Here was possibly a Roman temple to Mars, then a basilica, a cathedral and the present Romanesque octagon of green and white marble completed in 1128. The interior is plain but with a mosaic ceiling said to be by Cimabue and others. Below lies the tomb of the 'anti-pope' John XXIII (r.1410–15), according to Edward Gibbon a pirate, murderer and 'rapist of two hundred nuns'. This being Florence he died in his bed and with a tomb designed by Donatello (c.1386–1466).

The Baptistery's principal glory are the three sets of entrance doors carrying bronze sculpted reliefs. On the south door they depict the life of John the Baptist by Andrea Pisano (d.1348), completed in 1336. They display the same delicacy as his work in Pisa, witness the bas-relief of the baptizing of the disciples. The north doors were installed in 1424 and are by Lorenzo Ghiberti (1378–1455), depicting the life of Christ in a series of framed cameos. He won the competition to design them at the age of just twenty-one.

Four years after their completion Ghiberti was commissioned to provide another set of east doors depicting scenes from the Old Testament, completed in 1452. In place of cameos Ghiberti now disposed his figures in Classical buildings and lush countryside. The contrast in style between his two sets of doors has led art historians to proclaim them

as a bridge from the Middle Ages to the Renaissance. To Michelangelo they were 'the gates of paradise', to Giorgio Vasari 'the finest masterpiece ever created'. Though the present doors are copies – the originals are in the Duomo museum – their particular joy is that they can be seen day and night from the street.

The Duomo itself was projected at the end of the 13th century by a city eager to boast its emerging prominence. Florence was to follow Constantinople and Aachen in calling itself the new Rome, its cathedral

↑ Florence: Giotto campanile with Brunelleschi dome

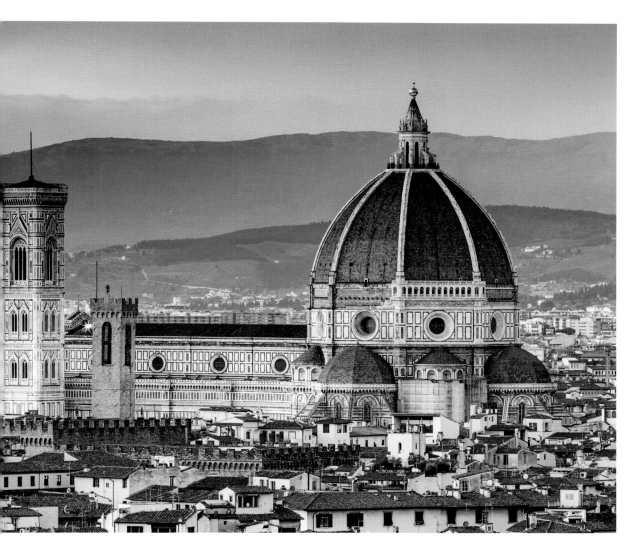

rivalling St Peter's in size. Designs were duly prepared by Arnolfo de Cambio and work began in 1296 with walls of multi-coloured, multi-patterned marble in the Pisan style. Arnolfo died in 1310 and progress was slow until a now ageing Giotto arrived in 1334.

Giotto's priority was less for the cathedral than for a new campanile, again with panels of marble, but this had progressed only two stages when he too died in 1337. His project was completed by Andrea Pisano with decorative flourishes in a Gothic style. Lozenge-shaped panels include heroes of the new learning: dialectic, harmony, grammar, logic, music and poetry, joined by the virtues of prudence, faith, hope, temperance and fortitude. Campaniles were customarily built detached from the main building in case the weight of the bells collapsed them, to avoid damaging the church. That of Florence was also a catalogue of intellectual symbolism illustrated with lightness and grace.

After the hiatus of the Black Death in 1348 work finally began on the cathedral proper, starting with its eastern apse and chapels. The exterior continued the same green, pink and white marble panelling as had been applied to the baptistery and campanile.

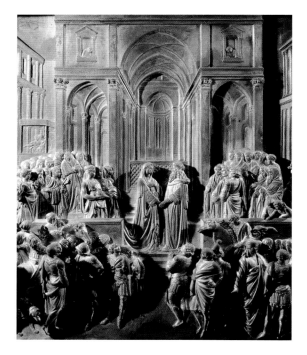

↑ Gothic to Renaissance: the Ghiberti doors in comparison
↗ San Lorenzo: Classical decorum

Then in 1418 came the challenge of crowning the huge space left empty at the crossing with what would need to be the biggest dome on earth.

The space was considered too wide for scaffolding while schemes to fill it with a giant column or even a mountain of earth were thought impracticable. Eventually a competition was won by Filippo Brunelleschi (1377–1446) with a plan for a two-skin dome which, after years of scepticism and argument, was finally completed in 1436. The so-called helmet dome came with red tiles and a white lantern reputedly designed by the young Leonardo da Vinci. It has been the signature of the Florentine Renaissance ever since.

Meanwhile the west front remained uncompleted and stayed that way. Not until 1887 was a design chosen from Emilio de Fabris reflecting the style of the existing building but clearly heavier and fussier – the English would call it Victorian. We should consider it, like Milan and Cologne, an example of 19th-century medievalism.

The interior of Florence's Duomo is famously disappointing. John Ruskin was characteristically harsh, declaring no building of such size could 'more completely hide its extent and throw away every advantage of its magnitude'. Arches are pointed and vaults ribbed. The space is gloomy. A plain pointed arch marks the crossing, with the interior of Brunelleschi's dome painted by Vasari and Zuccari overhead. It is a hard interior to love.

There are modest delights. A 24-hour clock painted by Paolo Uccello in 1443 backs on to the west façade, with four mysterious faces, one in each corner. In the north aisle is a fine equestrian fresco of the Anglo-Italian mercenary Sir John Hawkwood (1320–94), also by Uccello. Otherwise only the elaborate marble floor, some stained glass by Donatello and the view up into Vasari's dome merit the queue for entry. We do better to visit the Duomo museum to which many of the cathedral's treasures have been removed, including a *pietà* by Michelangelo and a charming organ loft by Donatello.

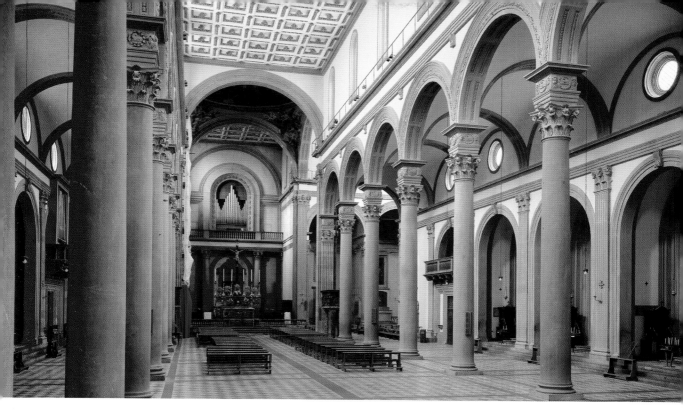

FLORENCE
SAN LORENZO

✢ ✢ ✢

The comparison between Florence's Duomo and its former cathedral of San Lorenzo parallels that of Ghiberti's early and late baptistery doors. Each is a demonstration of the city's passage into the Renaissance in the 15th century. In this case the comparison is again in the hands of one man, Filippo Brunelleschi. At the Duomo he was constrained by the plan of his predecessor Arnolfo, but at San Lorenzo he was able to give full rein to the new Classicism.

In 1419 he was commissioned to replace the old cathedral with a church and mausoleum for its new patrons, the Medici. Money was presumably no object. The Medici employed first Brunelleschi and then Michelangelo (1475–1564) on this church, but by the time the latter came to design the west front in 1518 the family's distinction and wealth were on the wane. The exterior was never finished and the

visitor's first sight of the church is thus bizarre, of a bare wall of untreated rubble. Perhaps as Antoni Gaudí said of his Sagrada Família in Barcelona, 'My client is in no hurry.'

Brunelleschi's commission came at the same time as he was starting work on the Duomo. It was for a Classical chamber with two aisles, an eastern altar and transepts, all in a soft grey stone known as *pietra serena*. The geometric module for the aisle bays is a square and for the nave arcades a double square. The floor tiles are chequered grey and white, the ceiling gently coffered.

A ghost of Michelangelo's intended later west front covers the inside of the west wall in the form of an arch framing a formal balcony and three doors. The rest of the nave is empty apart from altar paintings and two glorious pulpits by Donatello. San Lorenzo leaves me feeling that the Renaissance had arrived but was not sure what to do next.

For most visitors the nave is an antechamber for the building's principal treasures, the Medici chapels. The first is off the north transept and is Brunelleschi's

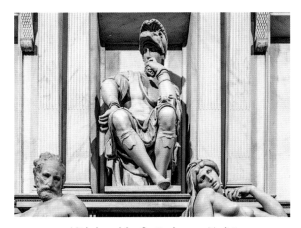

Michelangelo's reflective Lorenzo Medici

Old Sacristy, a perfect cube with white walls, arches, pilasters and spare detailing. It represents the world topped by a hemisphere representing the heavens. The altar is a sacristy in miniature, the constellations in its dome apparently dated to 6 July 1439, the moment when a signature in Florence supposedly ended the Great Schism between eastern and western Christendom. The plaques – known as tondos – hanging in the sacristy are by Donatello. The tombs are simple chests, unadorned.

The route to Michelangelo's New Sacristy and the Chapel of the Princes used to involve merely walking across the transepts. Now visitors must leave and walk round the building to a new entrance with a new ticket. A great church mutates into a museum while off the cloister is the magnificent Laurentian Library, also by Michelangelo and another visit in itself.

Michelangelo's sacristy was designed in 1520, a century after Brunelleschi's and in the Mannerist style. Pilasters are reordered and there is a sense of movement in the design, a foretaste of the Baroque. The contents are incomplete, just three tombs of lesser Medici and only two sarcophagi. Bare as it is, this is surely the most overwhelming chamber in Florence.

The figures atop the tombs were carved in the 1550s by Michelangelo at the height of his powers, though he was shortly to abandon the project and go to Rome. One tomb has Giuliano Medici as a man of action between the naked reclining figures of Day and Night. The other is of Lorenzo Medici (not the 'magnificent' one) sitting holding his head in thought, here between Dawn and Dusk. The muscular vigour of the reclining bodies contrasts with the intensity of the faces, though Lorenzo's reflective pose is most captivating, supposed inspiration for Rodin's *Thinker*. The third tomb crowned by Michelangelo's Madonna and Child is no less beautiful.

Adjacent to this chapel is the lofty Chapel of the Princes, its red-tiled dome competing with the Duomo on the Florence skyline. Here we leap forward half a century to 1602. The chamber is larger than the two sacristies, its walls and floor entirely clad in coloured marble laid as if in a jigsaw puzzle. Wall niches contain sarcophagi that were never used, the statue niches are empty. The room seems over-rich, a display of glory fading and wealth dissipated. Michelangelo has gone, his bills unpaid. Florence's great age is passing. The last of the Medici say farewell.

LUCCA

❖ ❖

Residents of Lucca have been known to plead with visitors not to publicize their lovely town lest too many people discover it. They need not worry. On my last visit its medieval towers, churches, palaces and streets looked as if someone had touched them with a wand in the 17th century, locked the gates and tiptoed away.

Proudly independent Lucca enjoyed a moment of celebrity when Napoleon was briefly king of Italy (1805–14) and declared his sister Elisa the town's 'princess' and ruler. The enlightened woman blessed it with wise government, education, art and respect for its history, benefits it boasts to this day.

→ Lucca: the Pisan west front

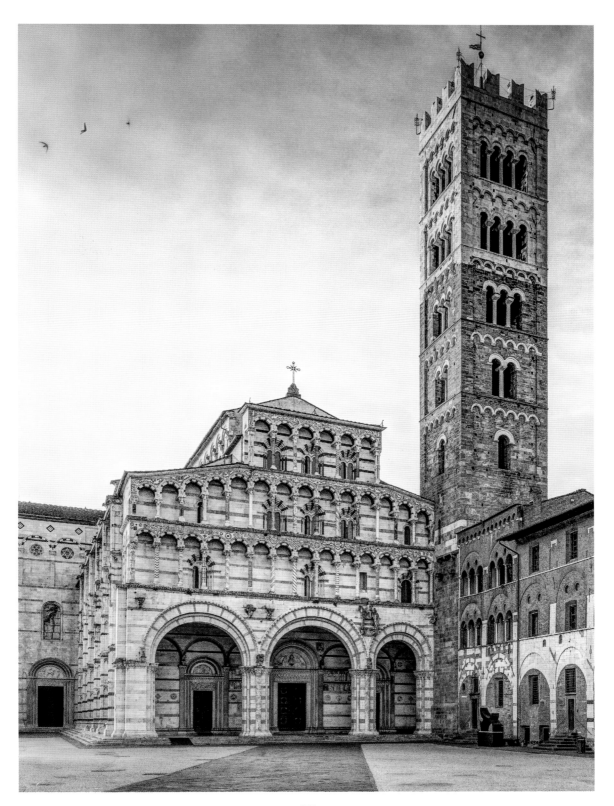

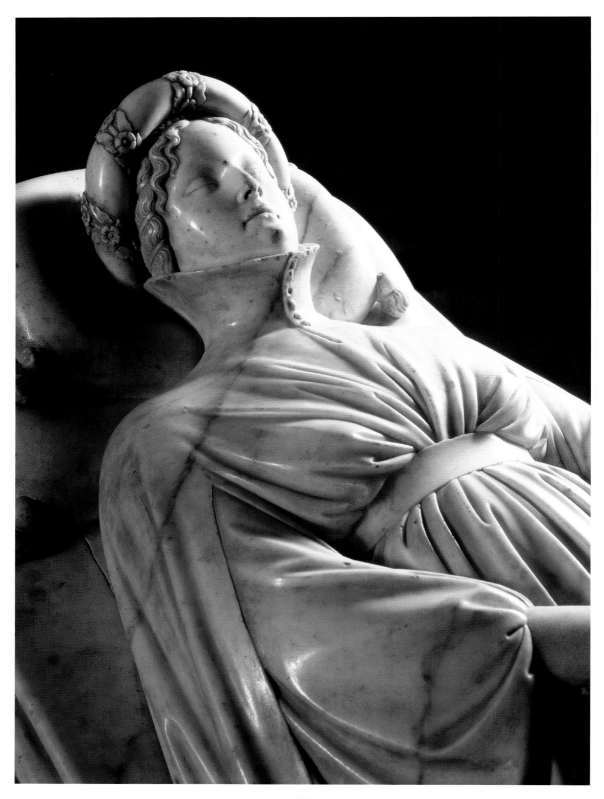

Like most of Lucca's Romanesque churches its cathedral was mostly rebuilt in bits and pieces from the 11th century onwards. The bell tower dates from 1070 and clearly pre-dates the 13th-century west front as the latter has a botched right bay. This is half the size of the other arches as it hits the tower, giving the façade an almost comical asymmetry. One of the arch piers carries a rare depiction of the Cretan labyrinth, pre-dating that at Chartres. Its inscription honours Daedalus of Crete with a reminder of the legend that all who enter perish except Theseus, 'thanks to Ariadne's thread'.

Though elements of the west façade were added throughout the Middle Ages, it is Pisan Romanesque at its most entrancing. The deep entrance atrium behind the arches was once used to shelter a spice market, while the three tiers of arcading above are alive with twisted columns. These dance delightfully across the façade, a flamboyant advance on Pisa's more austere composition. Some are carved as statues and others adorned with what look like patterns of cloth, recalling Lucca's most celebrated product, silk. A frieze below depicts the months of the year in their appropriate labours. High on the right of the façade is the patron saint of the church, St Martin blessing a beggar. The right-hand portal has Luccans 'in dispute with Arian goths'.

The interior of the cathedral comes as a shock. It was reconstructed in the 14th century after the Black Death, the old Romanesque arcades refashioned as octagonal piers. The vault was raised and the women's gallery or *matroneum* given fiddly Late Gothic arches, leaving the nave with an indeterminate age.

Pride of place goes to a golden shrine, home of Lucca's most precious icon, the *volto sancto* or holy face. Legend holds that when Christ descended from the Cross his features remained implanted on the wooden upright. This cross is supposedly an exact copy of that visage and as such is worshipped

by Luccans and carried each year round the town. The effigy looks Byzantine and dates from the end of the 8th century. The surrounding temple is by Matteo Civitale in 1484, designer also of the pulpit and sculptor of an exquisite St Sebastian at the rear of the shrine. He contributed numerous altars and screens, giving Lucca the appearance of a Renaissance cathedral in a Romanesque shell.

The chapels contain paintings and statues that would merit prominence in any gallery. Over one altar on the south side is a rowdy Last Supper by Tintoretto (c.1518–94). In a chapel to the left of the altar is a Fra Angelico (c.1395–1455) and in the sacristy a beautiful Ghirlandaio (1449–94) of the Virgin and Child. Also in the sacristy is the 1406 tomb of Ilaria del Carretto, wife of the tyrant of Lucca, Paolo Guinigi. It is the masterpiece of Jacopo della Quercia and depicts a woman serene in sleep. The message of matrimonial love is symbolized by her mastiff crouching faithfully at her feet.

MILAN

⁜ ⁜ ⁜

Milan can be an unnerving cathedral. At first sight it is breathtaking. The Gothic west front is a wedding cake confection, its white marble blazing across the city's central piazza as backdrop to every Milanese event. This front is not what it seems. The bulk of the cathedral was rebuilt from 1386 by a sequence of masons, some local but others French and German, including one of the Parler family, Heinrich. The ambition was, as earlier in Florence, to outdo St Peter's Rome, here under the sponsorship of Milan's ruling Visconti and then Sforza families.

The interior was completed slowly over the 15th century, but in 1571 the chapter decided to switch to a Renaissance style, notably for the still incomplete west front. Not until the 17th century was a start made on a Classical façade but even that was

← Lucca: Ilaria del Carretto tomb
→ Milan: wedding-cake Gothic

considered unsatisfactory and, with doors and windows already built, it was decided Gothic would, after all, be more appropriate. Then in May 1805 Napoleon was crowned king of Italy in the cathedral and ordered the work to be finished. This began in 1807. Milan's west front is thus 'Napoleonic' Gothic, and not to any medieval plan.

The resulting outline is a spectacular hotchpotch of statues, buttresses, pinnacles and pediments, part Gothic, part Classical. The composition has evoked mixed reviews. Ruskin found it 'vile . . . every style in the world and every one spoiled'. Tennyson wrote, 'O Milan, O the chanting quires / The giant windows blazon'd fires; / The height, the space, the gloom, the glory'. In 1926 the snobbish Francis Bumpus said he could see why its sumptuousness 'would always appeal to the masses', but 'to the true artist . . . with Amiens, Bourges, Chartres and Reims fresh in his mind, it must appear vulgar and unsatisfactory.' Mark Twain and Henry James loved it.

Where the critics have a point is that the 2,245 statues on the exterior are self-defeating. They break the sense of verticality so important to a Gothic façade and are too crowded to be appreciated individually. Also the façade's Classical doorways lose their order when crowned and flanked by Gothic cornices and pinnacles.

That said, when I last lunched in full view of this restored façade I could not take my eyes off it. The gabled roofline describes two sides of a giant filigree triangle. The pinnacles are almost unreal in their multiplicity, notably when viewed from the accessible roof behind them. Another good view can be had from the seventh floor of the Rinascente department store in the adjacent Corso Vittorio Emanuele II. The whole fantastical creation might have been designed as the catwalk of a Milan fashion house.

Milan's interior is no less problematic. It is colossal, second only to St Peter's in size and with an alleged capacity of 40,000 people. Here we confront a different sort of vulgarity, that of late High Gothic. Four rows of fifty-two massive piers in yellowing Lake Maggiore marble loom over the nave and aisles. As if ashamed of their nakedness the columns are clad

↑ Milan's forested arcades clad in statues

in two tiers of platforms three-quarters of the way up, breaking their vertical line with groups of statues.

The choir vault is of a height comparable with that of Beauvais, overlooked by a giant rose window. The stalls are rich with Renaissance carving, flanked by the largest organ in Italy. The whole interior is a sort of grand finale to Italy's tentative flirtation with the Gothic, already being outshone by its Baroque furnishings in a craving for ostentation.

A statue in the presbytery of St Bartholomew (1552) shows the saint in ghoulish array, standing flayed alive with his skin slung over his shoulder. The purpose of this horror escapes me. The aisles are lined with the tombs of Milanese aristocrats. By way of contrast the crypt of the cathedral displays the remains of a baptistery dating from the 4th century, one of the earliest in existence. The walls are little more than piles of rubble. Some reconstruction would give them more meaning.

MODENA

❖ ❖ ❖

Modena won me over. The city embodies the *campanilismo* – the civic pride – of the Italian city state down the ages. Within the domain of the Este family of Ferrara it spent much of its history either fighting its neighbours or rivalling them in the splendour of its buildings. Most fortunate for us today is that the city built itself a new cathedral in the 12th century but had no subsequent resources to 'modernize' it. We are thus presented with an enchanting and virtually intact work of Lombardic Romanesque. Its Ghirlandina bell tower is among the tallest in Italy and its west-front carvings, by a sculptor named Wiligelmo (fl. c.1099–c.1120), rival those of his French contemporary Gislebertus of Autun.

The cathedral was begun in 1099 by the architect Lanfranco, whose only known work this is, mostly completed by the 1120s. The exterior is most impressive from the south, where it faces the Piazza Grande and medieval town hall. From here we see the length of the nave and the apses side on, gleaming in pink-white marble. A decorative arcade runs round the entire exterior beneath the roof eaves, each bay defined by thin pilaster strips crowned by a loggia of three rounded arches. This arcading embraces three portals, the Princes' Door, Royal Door and Papal Door, lending the cathedral a compelling stylistic unity.

The west front is Romanesque perfection, dominated by a rose window inserted by the successors to Lanfranco, the Campionesi family of sculptors. Romanesque was never an ostentatious style, but its sculptors were meticulous in attention to detail. The door uprights and lintels at Modena form a gallery of accomplished abstract and figurative designs. The porches are guarded by world-weary lions, some of Roman origin, with column bases on their backs.

Fixed to the walls between the west doors are four large bas-reliefs mostly by Wiligelmo. To the historian Anne Prache they show Wiligelmo as 'without doubt one of the first great sculptors of the Romanesque epoch'. The Birth of Eve is followed by Original Sin, the Expulsion from Eden, Cain killing Abel and Noah landing his ark (see p. xvi). A curiosity of the north exterior is the Pescheria portal. While assorted monsters cavort below, Britain's King Arthur and his knights make a jousting appearance above. Hours can be spent studying Modena's exterior.

The interior is every bit a match. Here the marble of the exterior is replaced by brick but the delight lies in the purity of the design. Unadorned arcades rise to a triforium of arches, each containing three lesser arches inside. Most exciting is the survival of the original presbytery and apse, filling the east end of the cathedral on an elevated landing above a crypt. All was designed by the Campionesi in the late 12th and early 13th centuries and ranks among the most ornate works of Romanesque I have seen.

The crypt is an intimate church within a church, with the sarcophagus of Modena's patron saint St Geminianus surrounded by frescoed walls. The

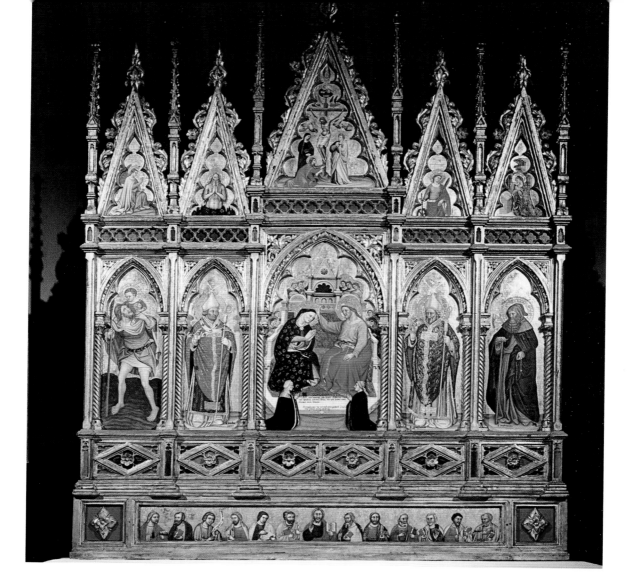

parapet fronting the presbytery above is a sculptural masterpiece. It consists of marble columns on yet more lions supporting a fascia of carved reliefs fronting the pulpit. The reliefs on the pulpit depict evangelists and scholars of the church, while the parapet itself depicts scenes from the Bible. These include a rare Washing of the Feet, a jolly Last Supper, Judas' Kiss and a Flagellation, with a child apparently joining in.

Modena shows a medieval church as a place of visual as well as verbal messages. A people whose lives were devoid of illustration found here images that today we get from galleries, photographs, films

and magazines. They could see themselves and the world round them reinterpreted in a biblical context. Thus the choir is overlooked by a sumptuous fresco of the Coronation of the Virgin in Italian countryside.

In the left apse stands a formal altarpiece of the Coronation of the Virgin by Serafino Serafini of 1385. It is the most sublime of Gothic works set in five painted panels with gilded backgrounds. It completes Modena's aesthetic harmony.

← Modena: Lombardic decorum
↑ The Serafini altarpiece

MONREALE, SICILY

✥ ✥ ✥ ✥

We do not think of Sicily as a hub of Europe, but Monreale tells us that this was once so. Its dazzling walls reflect the traces of those who have sailed its waters and walked its streets, from Greeks and Phoenicians to Romans, Byzantines, Arabs and Vikings. Its nave is reminiscent of a Roman temple, its apse of a Byzantine shrine, its towers of a Norman castle. It was founded by invaders from gloomy northern France, yet its mosaics burst with Mediterranean light.

While William of Normandy was conquering England in 1066 Roger of Normandy was conquering what might then have seemed a far greater prize, Sicily and southern Italy. His son Roger II ruled Sicily from 1130 to 1154 and in 1144 forced the pope to acknowledge him as monarch of all Italy south of Rome. This kingdom of Sicily and Naples was to last five centuries. Aided by the crusades, the warrior 'Northmen' encircled Europe from the Baltic Sea to the Aegean and crossed Russia to ally themselves to the Byzantine emperors.

Roger II's grandson William the Good (son of William the Bad) founded Monreale and its monastery outside Palermo in 1172. It was to rival the cathedral in central Palermo. The monastic cloister survives as one of the largest and loveliest in Italy, as do two towers of what were once twelve of a clearly defensive enclave. The cathedral's west end is plain, apart from an elegant entrance loggia inserted in the 16th century.

The east end is anything but plain. The exterior of the three apses is entirely coated in decorative blind arcading. The style of intersecting round arches is Romanesque but the perforations, roundels and abstract patterns are clearly Arabic. Sicilian culture was still a fusion of east and west.

The interior of Monreale is a place of splendour. The plan is that of a basilica, with arcades of grey granite hiding narrow aisles. The arches date from

the turn of the 13th century and are barely pointed. Their column capitals are Corinthian as from a Classical temple, though the apse motifs are more Romanesque. The roof is unceiled and of open woodwork. To the east the raised choir is greeted with three receding arches, all surfaced in brilliant gold mosaic.

What sets Monreale apart is that its entire wall area, nave, choir and even roof timbers are covered in painting or mosaic. The lower parts of the walls are white but decorated with arabesque patterns. So too is the inlaid marble flooring. Above the dado level is a programme of mosaic illustration, covering walls, arches and spandrels. Even the flowers on the pier capitals are painted.

← Monreale: the orient comes to Sicily
↑ Paired columns in the exotic cloister
→ Every surface an artist's canvas

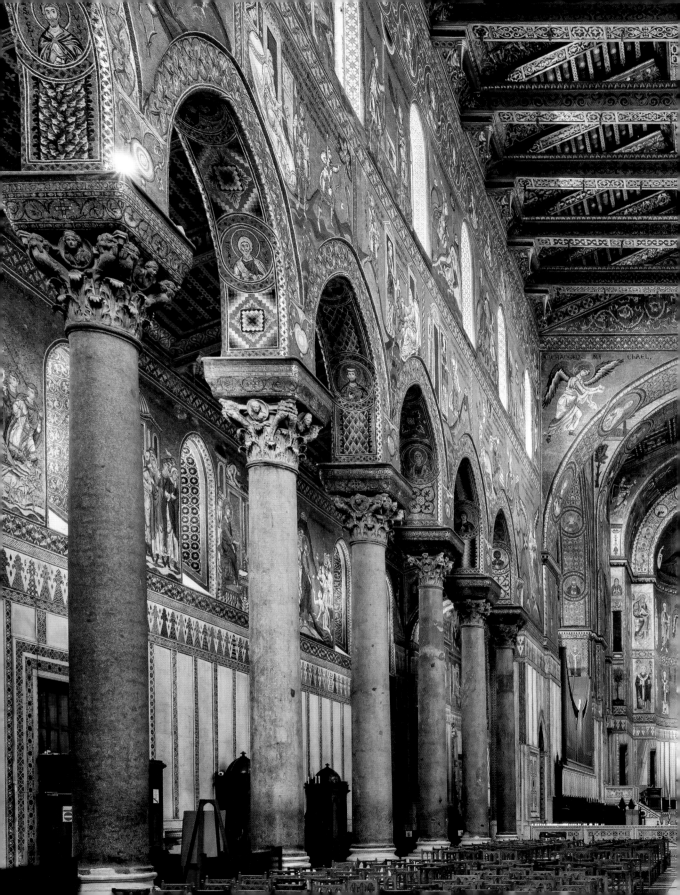

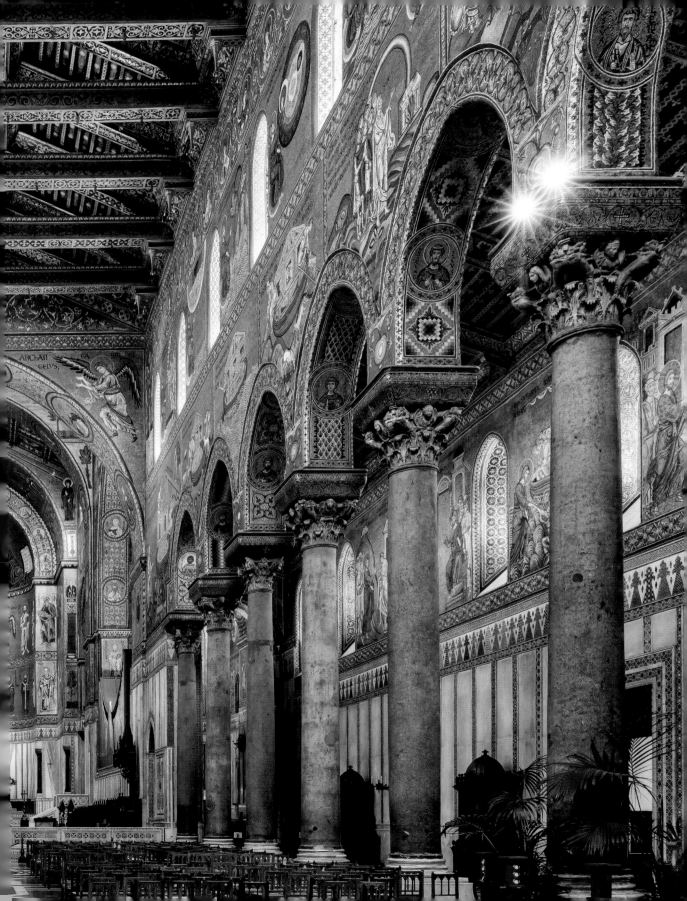

The mosaics date from the late 12th and early 13th centuries. They are of a colourful glasslike material known as tesserae, depicting biblical scenes. The ingenuity and skill are astonishing, attributed to Sicilian and Venetian craftsmen working in the Byzantine mosaic tradition. The subject matter is said to come from an illustrated manuscript, the *Menologion of Basil II* (c.1000), now in the Vatican Library.

The artists clearly felt at home. They adapted their pictures to the architecture, treating the curve of the arches as hillsides and the spandrels as seas on which to float Noah's ark. Individual scenes, such as the Last Supper and Christ washing the disciples' feet, have intense realism and detail for so early a date. The background skies are all of gold.

Indeed gold is so prevalent that the three eastern apses are like a golden wonderland. Here biblical scenes are abandoned in favour of figures of prophets, saints and bishops. In the semi-dome over the altar a giant Christ gazes down on the church below. Monreale is a complete surviving example of mural illustration, a masterpiece of medieval art.

The cloister is hardly less impressive. A low sandstone courtyard is surrounded by a quadrilateral of 216 paired columns. Their openings are formed of horseshoe arches, with diaper surrounds and

↑ Noah builds his ark
→ Orvieto: west frontal perfection

intricately carved capitals, each one different. This could be in the Levant or Córdoba. Here at the start of the 13th century and with the Great Schism already established, Christianity seems determined to retain a united Mediterranean front.

ORVIETO

✣ ✣ ✣ ✣

Orvieto's west front is as near a perfect work of art as any cathedral I have seen. It rises like a jewelled headdress on a hill overlooking the Rome–Florence highway. The cathedral was begun in 1290 on the orders of Pope Urban IV to celebrate a local miracle. A priest called Peter of Prague was visiting neighbouring Bolsena and having doubts over the doctrine of transubstantiation, which stipulated that bread and wine literally turn into Christ's body and blood during communion. Peter suddenly found his wafer dripping blood over the altar cloth. A miracle was declared, the cloth (and perhaps the wine bottle) locked away and a cathedral ordered to be built.

Building proceeded slowly until the arrival in 1309 of a Sienese architect, Lorenzo Maitani. Clearly he had features of his home cathedral in mind, not least the strong and ubiquitous black and white banding. But Siena's imperfections were here avoided. The west front has four piers framing three bays, each rising over a doorway, the central one the largest and with a rose window in a square frame above it.

The front's bottom stage is entirely composed of marble bas-reliefs of Bible stories, while the spaces within the upper-stage gables are filled with mosaics set in gilded backgrounds. Statues fill niches and blind arcades. Pinnacles and gables are covered in crockets. Not an inch is left naked, yet not an inch seems cluttered. The whole has a sense of poise and balance.

Maitani worked on this façade until his death in 1330, when his sons took over, followed by Andrea Pisano and then Andrea Orcagna (d.1368). The

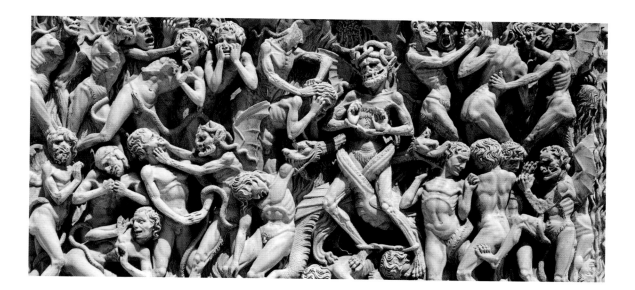

bas-reliefs tell the story of Genesis on the left through the Tree of Jesse to Mary and Jesus, with the Last Judgement on the right. The Creation of Eve has the purity of a Botticelli, while the demons of hell might be by Hieronymus Bosch, displaying what even to the modern eye seems an indecent ferocity.

Orvieto's interior is initially an anticlimax. Like Siena its visual character is dominated by black and white banding. The basilica form has single aisles with Romanesque arches, conservative for their 14th-century date. The windows are generously Gothic, some filled with strange glass of serpentine alabaster. The roof is of wood.

At the transepts, however, the interior is galvanized with decorative energy. All three arms are painted by masters of the fresco form. The apse contains the earliest, of the mid-14th century. Its depiction of the life of the Virgin is by a little-known Sienese artist, Ugolino di Prete Ilario, lit by a tall Gothic window of forty-eight panes created in the 1320s. The north transept is the Cappella del Corporale, its focus a gilded enamel reliquary containing Peter of Prague's bloodstained linen. The chapel walls carry the story of the famous miracle in vivid detail, including blood dripping from the communion wafer. The backdrop to the scene offers a detailed catalogue of late-medieval architecture.

In the south transept opposite is the Cappella Nova. Its Baroque altarpiece frames a 12th-century picture of the Madonna, credited by Orvietans with sparing their church from Allied bombing during the Second World War. The chapel's frescoes rank as national masterpieces, by Fra Angelico, Benozzo Gozzoli, Perugino and Luca Signorelli.

Those by Signorelli (1445–1523) display an awesome imagination. The subjects are the life of Christ, the history of the church and the Last Judgement. Signorelli's depiction of hell makes the west front seem tame, as does his obsession with human nakedness and with violence. The Preaching of the Antichrist is allegedly based on the downfall of Savonarola in Florence in 1498. The scenes clearly have contemporary relevance to Signorelli's day. Listening to him are Christopher Columbus, Petrarch, Raphael and Cesare Borgia. The artist also depicts himself and Fra Angelico witnessing the event, while Virgil, Dante, Homer and Ovid look on. We even have a glimpse of Bramante's design for a new St Peter's Rome. It is a grand Renaissance reunion.

← Signorelli's preaching of the Antichrist
↑ Most horrific of damnations

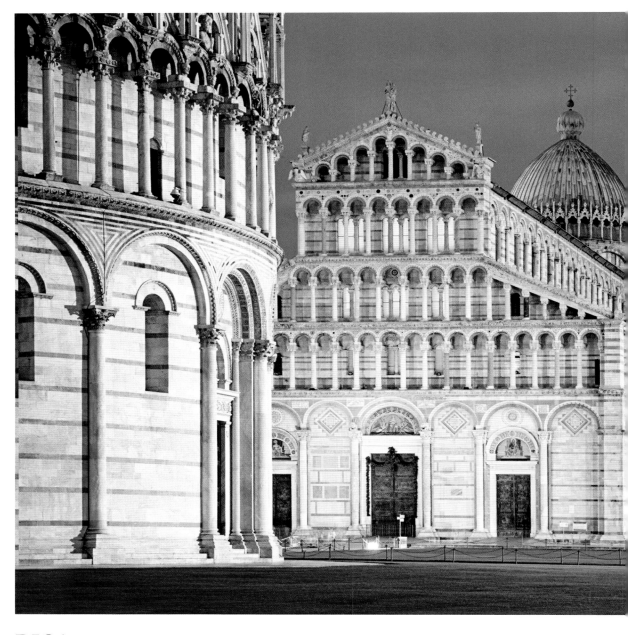

PISA

❖ ❖ ❖ ❖

Pisa's Campo dei Miracoli has one of the oddest locations on the cathedral trail. In the 11th century the city was a supreme maritime power, the equivalent in the western Mediterranean of Venice in the east. Its wealth was as great as its self-importance. In 1063 the city's elders duly set about building themselves a new cathedral in a cemetery outside their walls, incidentally showing rival cities that Pisa had no concern for its security. The Duomo was followed by a baptistery begun in 1152, a campanile in 1172 and a Camposanto or cemetery building in 1277.

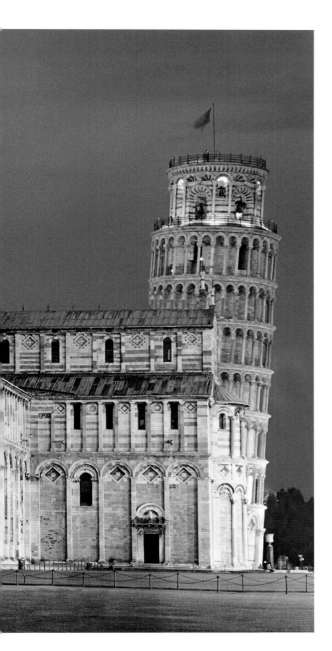

pristine on a neat lawn. Cars and coaches park in residential side streets with none of the piazzas, alleys and shady cafés that add convenience to visiting most Italian cathedrals.

The Duomo was financed from the winnings of the war against the Moors in Sicily in 1063. It is 100m long and took over a century to complete. The plan is cruciform with an apsidal chancel, all built of brilliant white marble inlaid with darker shades to create geometrical arabesques. The walls also include stones incorporated from Roman tombs – complete with inscriptions – which emphasize a link with the past.

The west front is Pisa's signature, the epitome of so-called Pisan Romanesque. The composition is four tiers of arcades – or shallow loggias – rising above three doors embedded in seven blind arches. Of the four tiers three are identical in proportion, the fourth graduated to fit the surmounting gable. Figurative carving is largely confined to column capitals, the walls otherwise decorated with majolica plates and marble inlays of abstract design. The façade has a handsome symmetry and plainness.

The cathedral suffered a devastating fire in 1595 which led to an extensive restoration with a major impact on the interior. The only older doors to survive the fire were the so-called St Ranieri portal in the southern transept. Its beautiful panels were cast in 1180 and are among the earliest Romanesque bronzes in Italy. By Bonanno Pisano, they pre-date by over a century those of his compatriot Andrea Pisano on Florence's baptistery. They are stiff and stylized but rich in palm trees and oriental pavilions. Byzantium is not far away.

Pisa's post-fire interior is both massive and colourful. Light is confined mostly to high clerestory windows, rising above the *matroneum* or gallery for women worshippers. The nave arcades might be those of a Classical basilica, the Corinthian

By the end of the 14th century Pisa's enmity with Florence and Genoa had sapped its strength while its river, the Arno, had begun to silt up. Eventually commerce collapsed and in 1406 Florence took control of its government. The cathedral enclave was left to posterity unaltered. It was always a suburb, and suburb it is to this day. The four buildings stand

↖ Pisa on parade, baptistery, Duomo and tower

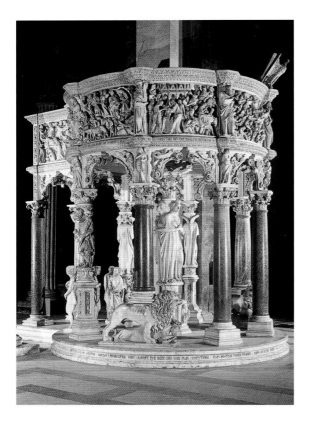

columns apparently looted from a Moorish mosque in Palermo. Arches and clerestory are prominently banded in that Tuscan favourite, black stone and white marble.

Of the interior decoration only the apse ceiling survived the fire. This is dominated by a Byzantine-style mosaic of Christ between St Mary and St John. The face of St John is documented as the last (and only) recorded work by Cimabue, dated 1302. The roof and upper stages of the interior are dominated by Baroque frescoes painted in and after the 17th century.

The cathedral's masterpiece is the High Gothic pulpit by Giovanni Pisano completed in 1310. Its panels portray nine New Testament scenes interspersed with mythical and biblical characters. Like other such creations of this era the work seems beyond any period or style. Nothing is still, no one is silent. Mary draws back Jesus' blanket, innocents are slaughtered and the horrors of the Day of

Judgement are unleashed. The liberal virtues look on. Prudence seeks unsuccessfully to cover her modesty while Hercules is stark naked. I remember seeing this work when I was still a student and being bowled over by it. I still am.

Pisa's adjacent leaning tower and baptistery are more celebrated than its cathedral. The tower's six tiers of circular loggias are famous both for staying up and for hosting Galileo's experiment in gravity, dropping balls of different weights and seeing them land at the same time. It has the same decorative simplicity as the cathedral. The tilt is closely monitored and now stabilized.

Meanwhile the baptistery begun in 1152 is the finest building of the group. It is a marble drum domed in red tiles. The exterior is decorated with blind arcading, Romanesque round the base with Gothic gables decorating the upper stages (see p. xx). The elaborate portal is flanked by two enriched Classical columns round an arch of Byzantine motifs.

The interior contains a lovely font and statue of St John but its notable furnishing is a pulpit of 1260 by Nicola Pisano, father of Giovanni. Its features hark both back to ancient Rome and forward to the Gothic, including another Hercules to compare with that in the Duomo. Its mid-13th-century date has it often referred to as the 'spark that lit the Italian Renaissance', though it seems rather early for that credit.

Although Pisa's cathedral enclave may seem eccentric in its location, the group as a whole forms one of the great compositions of European architecture. Even in the city's years of decline at the turn of the 15th century it continued to dazzle Europe, defying all Italy to do better.

↖ Duomo pulpit by Pisano
↗ Ravenna: Hagia Sophia comes west
→ Byzantine fashions: Theodora's court

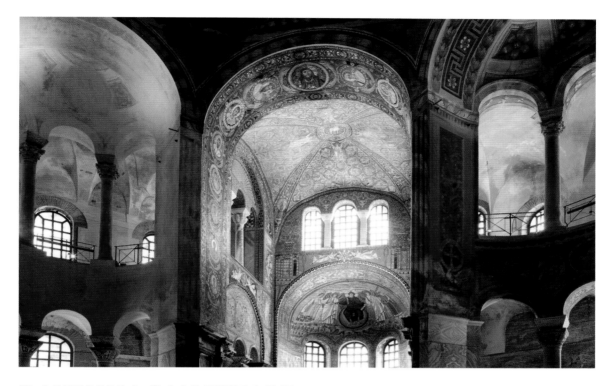

RAVENNA SAN VITALE

✣ ✣ ✣ ✣

Ravenna is a town in which a glorious past must be disinterred from a modest present. Across its rooftops march the campaniles of some of the oldest churches in Christendom. Yet they are not churches in a style familiar to most west Europeans, for most derive from ancient Byzantium.

As the Roman Empire fell to invading Huns and Goths in the 5th century its rulers fled northwards from Rome, making Milan and then Ravenna their capital. Ravenna was Italy's largest naval base, commanding much of the eastern Mediterranean prior to the rise of Venice. When it too fell to the invaders it was occupied by the Ostrogoth king Odoacer and his successor the Arian Christian Theodoric the Great (r.493–526). Theodoric beautified Ravenna, restored its Roman water supply and even offered allegiance to Constantinople. Churches in the city were built to both Arian and Roman faiths.

Theodoric's death in 526 stirred in the Byzantine emperor Justinian a bid to re-establish the old Roman empire from the east, eventually conquering Ravenna in 540. It survived in effect as a Byzantine colony until falling to Lombard invaders in 751. Its port silted up, the city declined and its churches went to sleep, preserved from subsequent rebuilding. They soon became a source of nostalgia for a lost east–west concord, not least to Charlemagne, who built a copy of San Vitale at Aachen in the 790s (see p. 63).

Where to start with Ravenna's churches is a problem. There are eight major sites dotted about the town. St Apollinaire Nuovo and Apollinaire in Classe are fine examples of Byzantine churches, while Galla Placidia's mausoleum contains perhaps the finest mosaics. Pre-eminent, however, is the Basilica of San Vitale, begun in 526 and completed

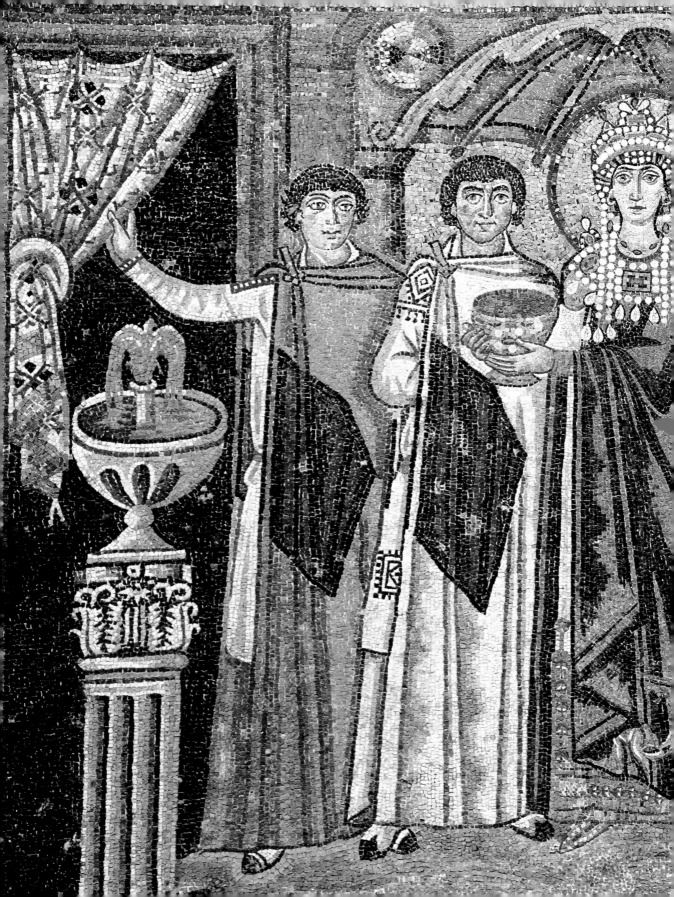

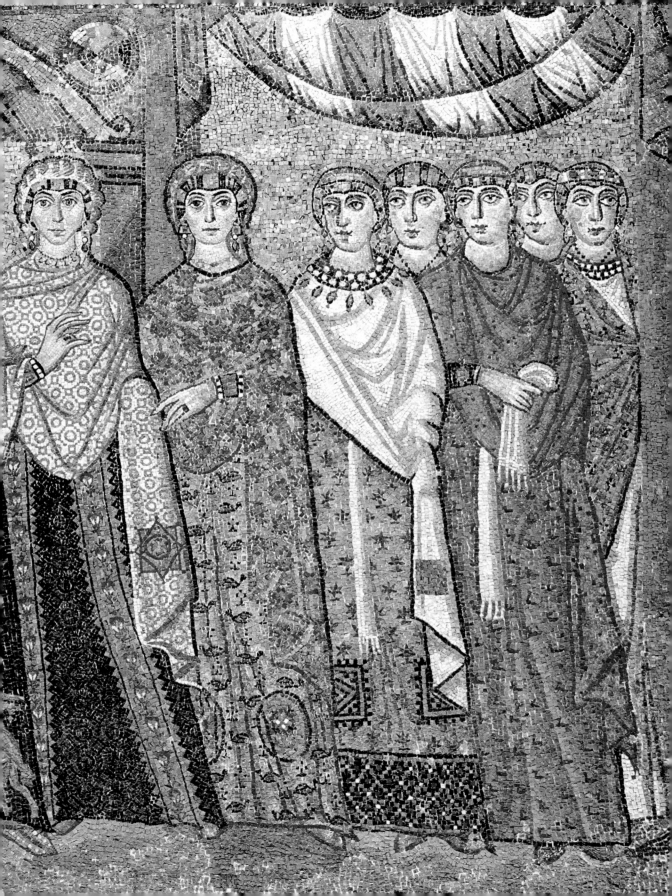

in 547. It straddled eastern and western Christianity at a crucial juncture in European history.

San Vitale was thus a contemporary of Justinian's Hagia Sophia completed in 537. It is octagonal in shape round a central cupola, with an eastern presbytery with protruding chapels. In this it is quite unlike the two St Apollinaires, which are in the form of rectangular halls. The heavily restored exterior is of no particular distinction apart from the appearance of what may be primitive early flying buttresses.

The interior is a feast of decorative colour. Lavish in mosaics and frescoes, its Greek cross plan has a large central space surrounded by a lower ambulatory and upper *matroneum*, giving the interior a sense of depth. Doors, dados and columns are of coloured marble, the capitals with elaborate arabesques and other oriental designs. The impression is exuberant and rich. While some of San Vitale's vaults including the dome were painted in the 18th century, the principal surfaces retain the mosaics of the 6th century and are among the most impressive in Europe.

These mosaics depict Bible scenes interspersed with symbols, animals, vegetation and general fruitfulness. They abound in fields and landscapes, unlike the icons of most eastern churches. In the apse Christ is depicted in a meadow attended by St Vitale and the founder of the church, Bishop Ecclesio (r.522–32), with two angels. On the left and right walls are matching depictions, with Justinian and his court on one side and his empress Theodora with hers on the other. Her clothes are of great richness, including a headdress laden with pearls. The two monarchs are clearly presented as of equal status. In the case of Justinian's officials the faces appear realistic, some bearded, some not. Bishop Maximian, two to the right of the emperor, looks like a portrait – might it be the first?

The apse and cupola mosaics are enveloped in vegetation with tendrils, garlands, birds and fruit. There are even two castles representing Jerusalem and Bethlehem. Heaven seems a happy, relaxed, almost childlike place, unlike the judgemental compositions

of western imagery. The apse is framed by a triumphal arch peopled by medallions of apostles and saints.

Two landscapes dominate the walls on either side of the central presbytery. One is of Abraham serving three pilgrims and about to kill Isaac, the other of Moses on Sinai and with the burning bush. On other panels we see the four evangelists set in rocky terrain attended by their symbols, St Mark by a fierce lion, St Luke by a gentle ox. Birds and fruit seem to fill every arch and cornice. The artists were clearly entranced by nature and landscape, expressed in thousands of tiny coloured stones. This is a naturalism reminiscent of the floors of Roman villas.

The decoration of this church seems far from the formal visages of most Byzantine icons. It is as if their creators were liberated from ecclesiastical formality and permitted to represent the everyday world about them. Most western depictions of Moses and his Ten Commandments have him surrounded by thunder, fire and lightning. At San Vitale he is gently stroking the nose of an adjacent sheep.

ROME
ST JOHN LATERAN

✢ ✢

Tucked away from tourists south of Rome's historic centre stands the original headquarters of the Catholic papacy, the cathedral of St John Lateran. The Christian associations of the site go back to the emperor Constantine, who gave the Lateran palace as residence to the then pope shortly after 313. A basilica was built next door in 324, officially the earliest 'proper' church in existence. Pilgrim legend held that the cathedral's relics included fragments of

the biblical loaves and fishes, milk 'from the Virgin's paps' and even Jesus' foreskin. There seemed no limit to antiquity's inventiveness.

When the papacy returned to Rome after the Avignon schism in 1376, St John Lateran was considered uninhabitable. In 1377 the pope formally declared the Vatican to be his new residence. But St John remained his cathedral as bishop of Rome and continues as such to this day. The pope alone (or his representative) may say mass at the high altar.

In 1646 with the cathedral close to collapse, Innocent X commissioned the Baroque master

↑ Rome, St John Lateran: Borromini Baroque

↖ Ravenna: Moses stroking the sheep

blue and gilded mosaics above. The bust of Christ is said to date from the 5th or even 4th century, proclaimed as one of the earliest such depictions.

The cloister is early 13th century. Its columns, some plain, some twisted, are slender and beautifully proportioned, rising over yet more Cosmati panels. Attached to the church's north front is a charming double loggia built in 1586 by Bernini's assistant Carlo Fontana (1634–1714). It was from here that the pope would bless the crowd, *urbi et orbi*, as he now does from the Vatican. Nearby are the Holy Stairs, claimed to be those up which Christ climbed to his trial by Pontius Pilate. As a result people go up them only on their knees.

In front of St John Lateran is the largest of Rome's many obelisks, the looting of which was said to be the Roman Empire's act of deference to the ancient Egyptians. This monolith from the second millennium BC is 32 metres high and was somehow shipped to Rome in the 4th century AD. The ship must have been massive.

Francesco Borromini (1599–1667) to refurbish its interior. Sadly the commission did not extend to a new façade, which did not appear until 1735, the work of the little-known Alessandro Galilei. This is a hesitant composition saved by a flourish of 'doctors of the church' lined up along the skyline as at the Vatican. Beneath the portico is an atrium with marble paving overlooked by an excavated Roman statue of the church's original sponsor, Constantine. It might be the entrance to a Roman aristocrat's palace.

Borromini's interior is palatial, like a grand hall leading to something grander beyond. He was constrained by the dimensions of the old basilica and lined the nave with arcades of fluted Classical pilasters, flanking large niches. These niches were filled in the 18th century by larger-than-life statues of the twelve apostles gesticulating under heavy Baroque pediments. The nave floor is elaborately decorated by the Cosmati family of medieval tilers and survives from the earlier cathedral. The ceiling is richly coffered.

St John's interior rises to a climax in a baldachin dated from 1369 and also surviving from the old church. Fragments of the interior altar are said to date from that at which St Peter himself would have prayed. Above it hangs a chest alleged to contain the skulls of St Peter and St Paul, though even the guidebook admits this is improbable. Behind the altar the pre-Borromini apse is ablaze with more Cosmati work covering the floor and lower walls and with

ROME
ST PETER'S
❖ ❖ ❖

St Peter's is Christendom's most spectacular creation. This is due in large part to one man, Gian Lorenzo Bernini (1598–1680), who described the Baroque style of which he was master as 'magic art by whose means you deceive the eye and make your audience gaze in wonder'. In 1656 he was commissioned by Pope Alexander VII to clear the neighbourhood in front of the half-finished Basilica of St Peter's so as to present the façade as 'stretching out its arms maternally . . . to confirm Catholics in their faith, heretics to reunite

↖ Rome, St John Lateran: Romanesque cloister
→ Rome, St Peter's: Bernini crossing with baldachin and Cathedra Petri

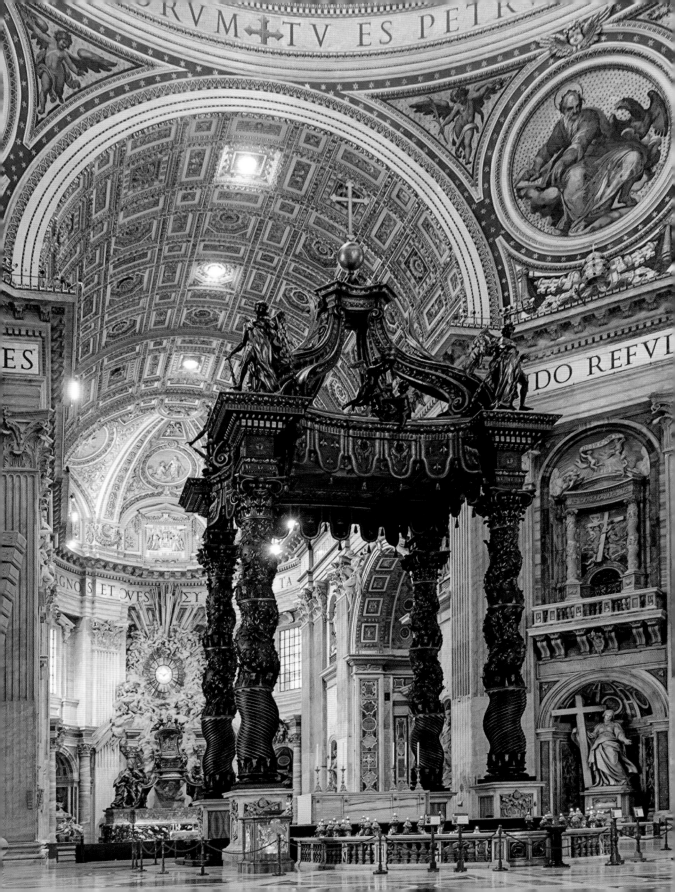

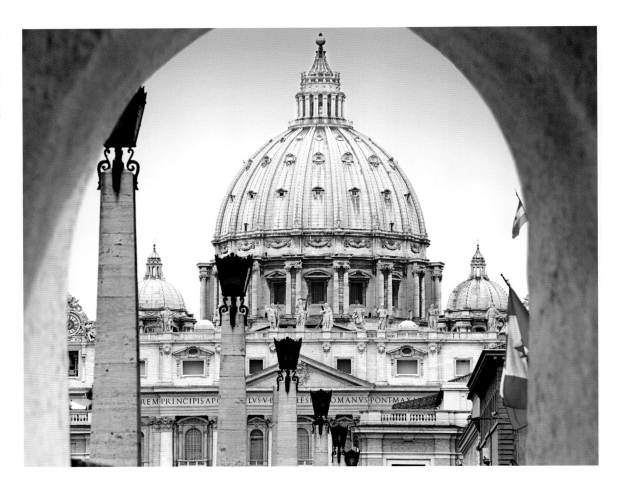

them to the church and infidels to enlighten them'. The oval of Bernini's Doric colonnade overwhelms the church's façade. Soon afterwards in London Sir Christopher Wren offered Charles II a similar layout for his new post-fire St Paul's cathedral. The Protestant City fathers would have none of it.

The balance between Bernini's colonnades, St Peter's basilica and the adjacent Vatican was dramatically altered in 1936 when Mussolini ordered the demolition of the entire medieval quarter between the Vatican and the Castel Sant'Angelo on the Tiber. He then built a ceremonial boulevard to link the two, the Via della Conciliazione. This turned what had been a visually enclosed piazza into the climax of a line of authority leading from castle to church. What had been an open auditorium focused on St Peter's became

something quite different, a martial triumphal way.

As for the basilica itself – St Peter's is not Rome's cathedral, which is St John Lateran (p. 203) – it remains a church in which grandeur takes precedence over beauty. It is so gigantic and so surrounded by myth, legend and tradition that its biographer James Lees-Milne complained he had names and dates 'swarming round me like a cloud of gnats: the more I swatted them the more persistently they made themselves felt.' The original church was supposedly the site of Peter's martyrdom as first *papa* or father of the church and also of his tomb, attested by 2nd-century inscriptions. There is no contemporary or archaeological evidence of any

↑ Rome, St Peter's, with help from Bernini

of this, indeed of St Peter as ever being in Rome. All that we do know is that Constantine chose here to erect what became, with Hagia Sophia, one of Christianity's two premier citadels.

St Peter's survived through war, siege and dereliction until in 1505 Pope Julius II proposed to demolish the old church and rebuild on the grandest possible scale. It would rise round his own tomb by Michelangelo. The initial building was designed by Donato Bramante (1444–1514) as a Greek cross, begun in 1506. This was little advanced when in 1513 Julius died and was succeeded by the Medici pope Leo X, who was not even a priest on his selection. The cost of the project had now become astronomical and was met by the marketing of indulgences – or pardons in the afterlife – which in northern Europe was the spark for Luther's Reformation. St Peter's has much to answer for.

Building proceeded in fits and starts as and when money was available. Bramante's Renaissance design was adapted successively by Raphael, Peruzzi, Sangallo and, in 1547, by Michelangelo, who contributed the dome and parts of the interior behind the altar. He took as his inspiration Brunelleschi's Duomo in Florence, a dome resting on a drum (see p. 175). Michelangelo was followed in turn by Vignola, Fontana and finally Carlo Maderno. It was Maderno who in 1606 extended the nave westwards and built the front portico. Bramante's original plan for two towers over the portico was abandoned but the dome was now invisible from the piazza. The Maderno façade is dull save for the row of saints along its parapet, but looks better from a distance when seen as the base for Michelangelo's dome.

St Peter's interior has always been overwhelmed by the crush of humanity as much as by its architecture. By volume it is the biggest church and probably the highest dome in Europe. Its Classicism appears a discipline rather than an inspiration. There is none of Seville's soaring uplift or Winchester's disappearing perspective. The interior is characterized by massive piers carrying Corinthian pilasters. The vaults and dome interior are richly painted and the walls lined with larger-than-life statues of popes. Everywhere is what can easily seem visual clutter, covering floor, walls, ceilings, altars and side chapels.

The principal attraction of the interior is as a gallery of art, notably that of Bernini. Most eye-catching is his baldachin which unites the components of the crossing under the dome. The canopy rests on four barley-sugar columns in what is the largest work of solid bronze in the world. Bernini was also responsible for the Cathedra Petri, St Peter's supposed chair set in the apse amid an explosion of Baroque energy. Four church fathers in tortuous poses raise the chair up into a burst of light round the dove of the Holy Spirit.

Also by Bernini is the Chapel of the Blessed Sacrament, reserved for private prayer. The focus is an altar in a Classical alcove, a miniature of architectural perfection. The sacrament is housed in a model of a tabernacle by Bramante, flanked by two bronze angels apparently in flight. Behind rises a painted backdrop by Pietro da Cortona (1596–1669), framed in an arch and fluted pilasters. The composition is more Renaissance than Baroque, as if Bernini was looking back to the style of Bramante, supremely measured and calm. It is for me the loveliest corner in St Peter's.

Equally serene is Michelangelo's *Pietà*, standing in the north aisle of the nave, though its extravagant Baroque chapel is a distraction. The statue itself portrays Christ looking if anything older than his youthful mother. It is said that the sculptor wanted her to be an idealized vision of purity and virginity, as much Christ's daughter as mother. The plinth is nowadays set well away from the crowds and the detail can only be appreciated, dare I say it, from photographs.

Those seeking relief from the interior can retreat upstairs and find their way to the dome and out on to the roof. Here is a different more peaceful St Peter's. Stairwells, attics and cupolas appear like cottages in an Italian village. The view is the best in Rome, shared with Maderno's apostles in the foreground.

SIENA

❖ ❖ ❖ ❖

Siena was my first and favourite Italian city. The antiquity of its streets and buildings, the coherence of its architectural language and the raucous *palio* festival testified to a city at peace with its turbulent past. This was once a place of wealth and confidence whose long guardianship of its greatest asset, the beauty of its townscape, must have secured its future for all time. Life revolves round the hub of the Piazza del Campo and its Palazzo Pubblico, scene of the biannual *palio*.

The cathedral stands uphill from the *campo* and was begun in around 1220, which makes it contemporary with France's Amiens and England's Salisbury. The west front dates from 1284 onwards to designs by the Pisan masters, Nicola Pisano and his son Giovanni. Theirs is the lower half of the front and the three grand doorways. The upper portion of the front came later in the 1360s after the Black Death, and appears almost an afterthought. The style here is Gothic, like a quick facelift from a passing Frenchman. The side turrets are a flurry of Gothic motifs. The central rose window is devoid of tracery and has been left blank. Every bit of space is filled with blind arches, gables, statues and rows of faces. We can only imagine the Pisanos looking at the result appalled: 'What have you done to our façade?'

Further confusion is revealed as we circle the exterior. Siena is an extreme example of the Pisan affection for building horizontal stripes of black and white stone. It has been compared to a stockade of zebras or perhaps Siena's football-team strip. To the east of the cathedral in a car park is a high wall erected as the first phase of a new nave that was never built.

Siena's interior is so rich in decoration as to overwhelm its architecture. It thankfully escaped the stripping, vandalizing and 'purifying' of later generations and is a museum of works of church art from Romanesque to Renaissance. The dome is a *trompe l'oeil* of soaring panels and murals of church elders. The cornice line below, extending round the entire church, presents busts of 172 popes and 36 Roman emperors, all too small to be identifiable even if one knew one's popes and emperors. On the walls murals also embrace nave, sanctuary and apse. The transept side chapels disappear into their own depths, flashing gold and silver as they go.

The masterpiece of the Siena nave is that Tuscan speciality, the pulpit, here from the master hand of Nicola Pisano in 1265. While the pulpit's frame is Gothic, the panel composition and facial expressions clearly look forward to the Renaissance. The work is octagonal with panels portraying a Last Supper, a Crucifixion and a Day of Judgement. The pulpit rests on Gothic trefoil arches, separated by statues representing philosophy and the liberal arts. Grammar is represented by a boy studiously reading a book.

The cathedral is lined with sculptures by Donatello (c.1386–1466) and Bernini, and there are four by Michelangelo on the earlier Piccolomini altarpiece of 1485. The St John the Baptist Chapel is decorated by Pinturicchio (c.1454–1513). The Chigi Chapel, commissioned in 1659, was designed by Bernini with two sculptures by him. Duccio's Maestà altarpiece of 1308 has sadly been moved to the adjacent Duomo museum.

The exquisite Piccolomini Library off the north transept was commissioned by Pius II (r.1458–64). One of the more intriguing popes, he was a diarist and former erotic poet who also commissioned a new town, that of Pienza in Tuscany named after him. The library is adorned with ten frescoes of his life and achievements, possibly designed by the young Raphael and painted by Pinturicchio. There also stands a Roman statue of the celebrated Three Graces.

Finally there is Siena's greatest treasure, the floor of its nave, to Vasari 'the most beautiful, largest and most magnificent ever made'. It dates from the 15th century to the 19th. Some is in graffito, a sort

→ Siena: the two-stage west front

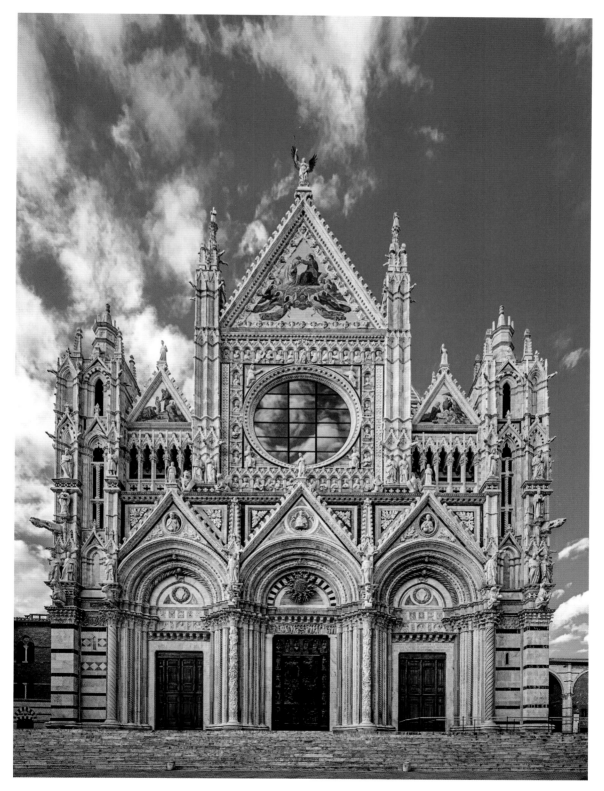

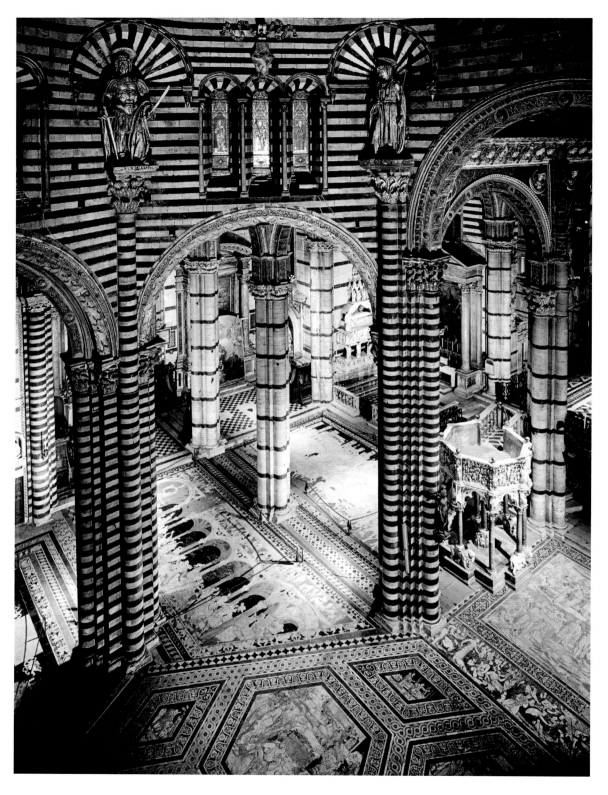

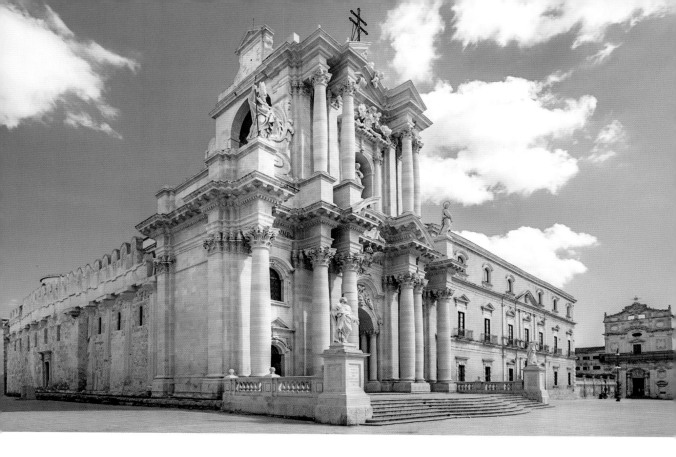

of incised etching, some in mosaic intarsia, some polychromy and some silhouette. There are fifty-six panels, most of them by Sienese artists. The overall theme is the new Renaissance wisdom, celebrated by Pinturicchio in his section the *Mount of Wisdom* created in 1505, where we encounter Hermes, Socrates, Fortune, Virtue and Wealth. Closer to the altar we reach the Old Testament and then the Massacre of the Innocents. Here some of the panels are framed, some circular, some vignettes, like playing cards laid out on the floor. The tiles are considered so valuable as to be revealed only on pre-bookable occasions and for a few weeks a year. For the casual visitor it is a case of hoping to strike lucky.

← Siena: banded nave with floor pavement
↑ Syracuse: the Baroque façade
→ Romanesque arcade with Greek columns behind

SYRACUSE, SICILY

❖

No building so vividly conveys the continuity of Europe's history as Syracuse cathedral. Here on one site stands a Greek temple, Byzantine church, and Norman and Sicilian Baroque cathedral that even saw an interlude as a mosque. Its stone dazzles white in the sun here in the centre of what was once the capital of Greece's Mediterranean diaspora.

The plan of the cathedral is that of a Doric temple of Athena built c.480 BC. A temple of fourteen columns by six survives as the stone frame inside which was constructed a church in the 6th century AD. It is on a basilican plan of a nave and two aisles, divided by an arcade of seven unadorned arches. This became a mosque during the Saracen occupation in the 9th century but reverted to a church on the arrival of the Normans in Sicily in 1085. An

earthquake in 1693 collapsed the west façade, which was replaced by one in Sicilian Baroque by a local architect Andrea Palma after 1725.

This west front is the cathedral's face to the world, though ghostly fragments of the old temple and church walls can be seen down the side streets behind. The façade's composition is worthy of the most accomplished Baroque masters, offsetting the bishop's palace next door. It is of two stages, both formed of paired Corinthian columns and curving pediment fragments, the whole studded with statues of saints and wonderfully ornate.

The interior is a total contrast. Our eyes must adjust to the darkness as we see looming out of the walls the same Classicism we saw in the façade columns, but here 2,000 years older, massive and with stern Doric capitals. The columns are like giants from another age, as if embracing the lesser arcades forming the aisle arcades. Two of the columns flank the interior of the west door like a triumphal arch. It is hard to imagine what was in the mind of the early church builders, as the retained columns appear to have no structural value and some are merely left as part of the wall.

The cathedral interior is simple. The right aisle contain chapels with bronze gates. Fine iron candelabra hang from each arcade arch, while handsome 15th-century tiles line the floor. In the aisles stand statues of saints looking from a distance like Roman emperors. At the east end, two Renaissance pulpits flank the arch to the Baroque choir, which again is kept simple. Only the silver-plated altar echoes the grandeur of the west front.

The left aisle retains its Byzantine apse with a lovely statue of the Madonna of the Snow (1512). Her attribute reflects her reputed capacity to 'weep' on the rare occasions that snow flurries ever occur in this latitude, which is south of parts of Africa.

→ Trani: alone with the sea

TRANI

Trani cathedral seems at the end of the world. Its blaze of pink-white stone perches on a promontory overlooking the Mediterranean at the heel of Italy. The site dates back to a church in the 4th century and must have seen half Europe's history sail its coastline. The Romanesque basilica rests a few paces from the sea shore.

The present structure owes its foundation to an eighteen-year-old Greek, St Nicholas the Pilgrim, who died here when already a celebrity. He was a so-called 'fool for Christ', an eccentric mendicant whose particular habit was incessantly to incant *kyrie eleison*. The bulk of the church, later cathedral, erected in his honour was built over the next century.

The church has four distinct façades. The north side faces the sea with bare stone walls, as if fearing attack. The east is also citadel-like, with three turret-like chapel apses, and the south is clad in various forms of blind arcading on both the nave wall and the bell tower. This tower rises elegantly above a 13th-century arched passage. Its summit offers a view of Trani's surroundings and sea and must have been of maritime utility. The transepts are in the form of a curious gabled shed running north–south, terminating in a rose window whose tracery is in the form of miniature Romanesque arches. The whole composition looks charmingly amateur.

Trani's west front has a doorway reached from a gallery up a double staircase. The doorway and surrounding windows carry carvings of flowers and mythical beasts as well as abstract devices identified as Islamic in origin. The gallery conceals an external entrance to the cathedral's extensive crypt.

This crypt is impressive, covering the footprint of the church nave and dating from an earlier church of the 7th century. It is high enough off the ground to have its own windows and comprises two chambers of Romanesque arches, one with the relics of

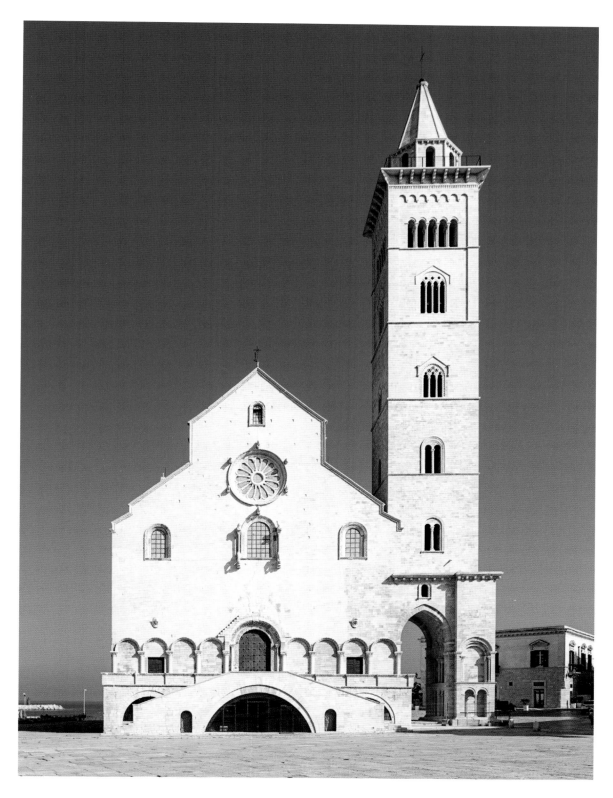

cathedral's original bronze door, dating from 1175. Otherwise Trani offers only a timeless peace, its echoes those of the sea outside its walls.

VENICE
ST MARK'S

✣ ✣ ✣ ✣ ✣

St Mark's is Venice's heart, pulsating, radiating, glowing, inspiring. It is the city's most celebrated building yet also its enigma. In the eternal European conversations of north and south, Gothic and Classical, east and west, this building might serve as the fulcrum, the arbiter. Yet like St Basil's in Moscow it can also seem from another place and another time. What is it doing here?

St Mark's is not Italian but Venetian. The earliest settlement of the lagoon was by refugees fleeing incoming Visigoths, Huns and Lombards. At first it was subordinate to Torcello (see below) but by 697 it was electing its first doge and its navy was already growing in power. The city's loyalty was initially to Constantinople, which rewarded it with trading monopolies across the eastern Mediterranean.

On its high bank (or *rialto*) in the disease-ridden marshes, Venice was near impregnable, with a lagoon that was like a vast moat against land and sea. Charlemagne failed to conquer it and successive Holy Roman emperors respected its autonomy. Venice declined to join the various confederacies of Italian city states before unification in the 19th century.

In 828 the remains of St Mark were looted from Alexandria in a barrel of pork fat and a chapel was built next to the doge's palace to house them. Various churches followed and in the 1060s the present brick building was begun. Venice at the time looked

St Nicholas. Below the crypt is an undercrypt dedicated to another saint, St Leucius, its walls showing traces of faded murals.

The cathedral's interior is entirely Romanesque, its white stone arcades and uncluttered east end forming a stylistic unity. The aisles are narrow and little more than a backdrop to the doubled columns of the arcade piers. These columns, which look as if they might come from a Roman temple, have severely eroded capitals, some of which retain Byzantine carvings. The triforium has an attractive tribune gallery with triple-arched openings. As so often in a Mediterranean cathedral this all has a sense of an aesthetic more in touch with eastern shores than with Europe to the north. There is not a ghost of Gothic to Trani.

The cathedral was largely stripped of its contents in a restoration of the 1960s. I find the resulting bareness, coupled with the lightness of its stone, strangely pleasing. The east end has an almost Protestant simplicity. The clear glass of the apse window illumines a plain altar table covered in a white cloth. On the floor are mosaic fragments depicting Adam and Eve with a lively serpent and a rare image of Alexander the Great. He surveys his empire both from beneath the sea and from the skies overhead, guided by helpful monsters.

There are no surviving chapels and no furnishings apart from dark-wood confessionals and the

↖ Trani: Romanesque interior
→ Venice: Byzantine exotic
↓ Venice nave: a cavern of gold

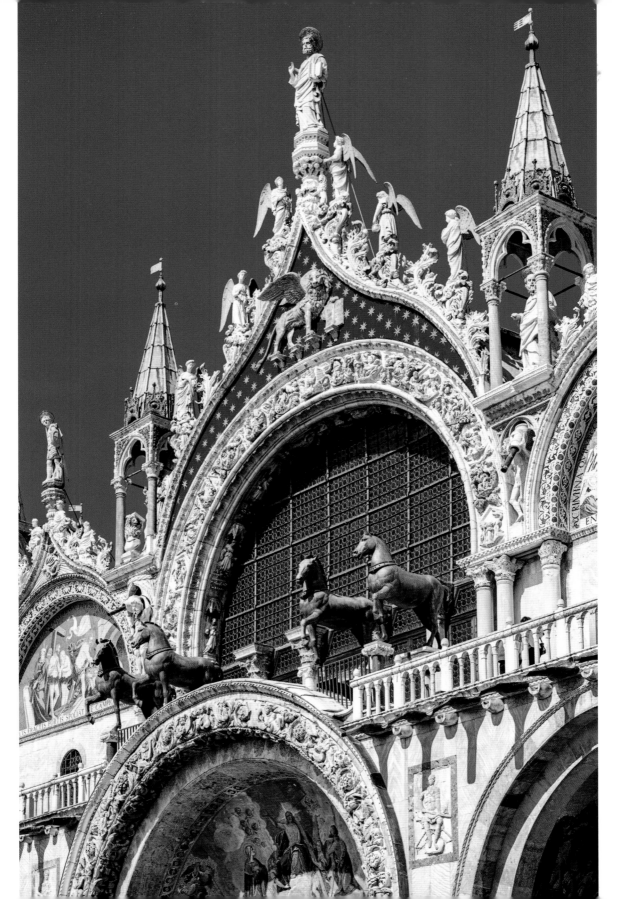

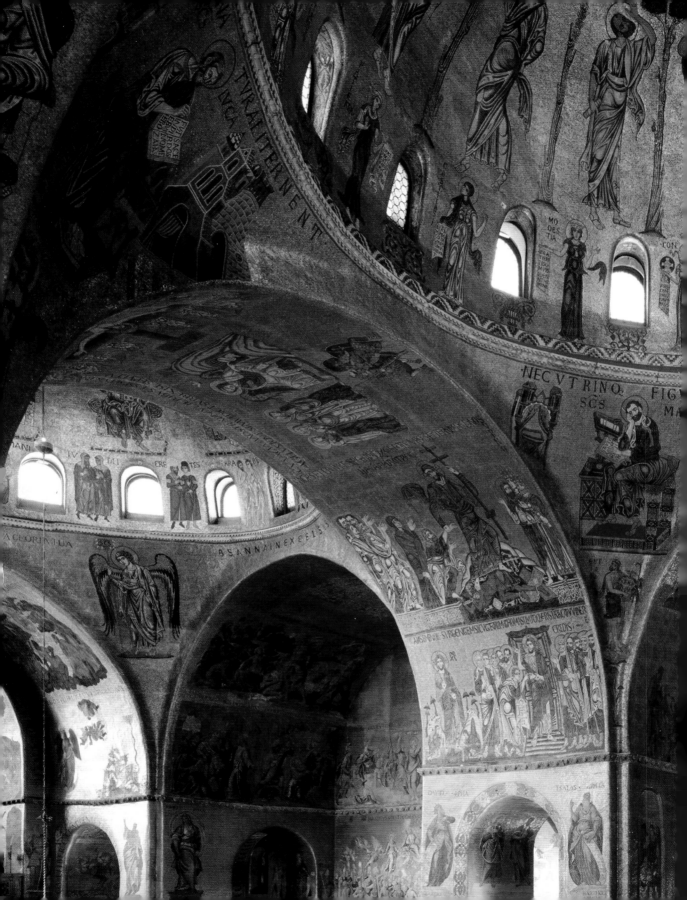

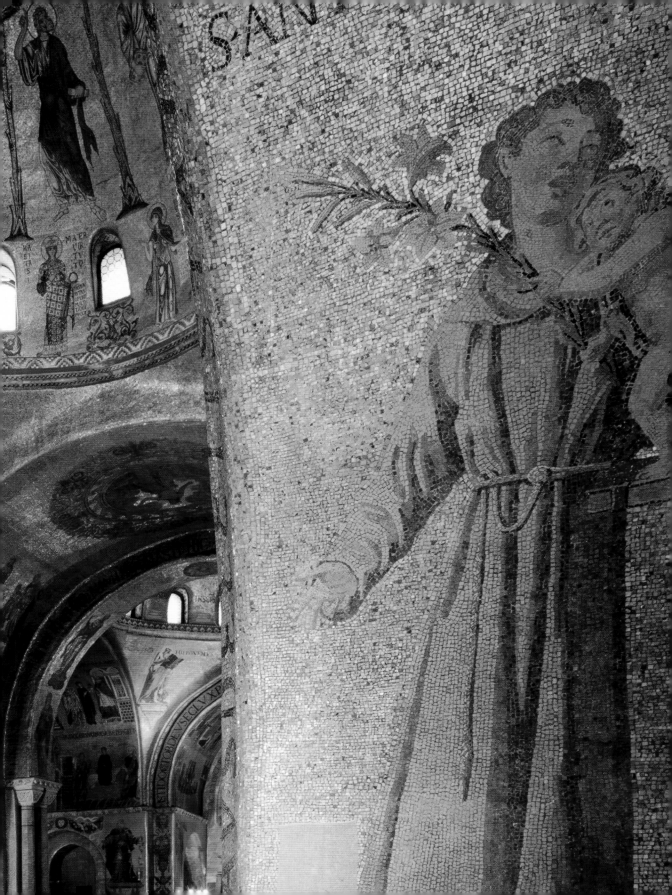

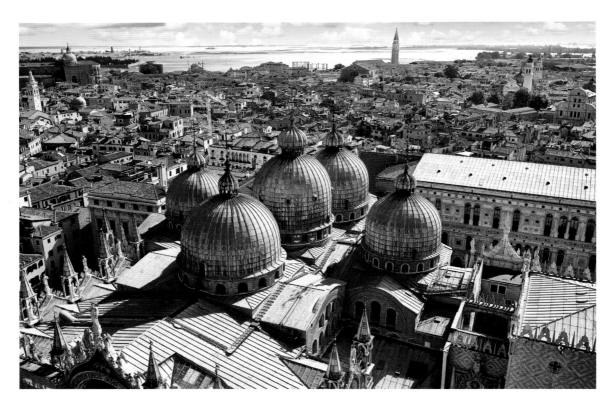

east not west and the natural style to choose was Byzantine, here with a central dome and four domed arms. The west front had five arched entrances with a gallery of five arches above. These walls and domes were adorned from the start with mosaics from the adjacent island of Murano, in line with Hagia Sophia in Constantinople and the churches of the former Byzantine colony of Ravenna.

By the 13th century Venice had become the leading maritime power of the day. Yet in 1204 it could perpetrate one of Christendom's greatest acts of treachery. Its merchants bribed the fourth crusade to divert from its journey to Jerusalem and capture, sack and loot Constantinople in what amounted to a mercenary contract to a pretender to the Byzantine throne. The venture was not authorized by Rome and appalled the pope, Innocent III. Venice carried off treasures galore, including icons, statues and

↑ St Mark's with adjacent Doge's palace

four magnificent bronze Hellenistic horses.

St Mark's west front was now transformed. It had a new narthex and façade, much of it adorned with the spoils of the crusade. Five arches became seven, resting on two tiers of clustered Roman columns. Spandrels and tympanums over the doors, which elsewhere in Europe would normally have stone carvings, here shine with mosaics. Those in the northernmost arch depict the arrival of St Mark's remains. Another humorously shows the building of the Tower of Babel, with masons quarrelling incomprehensibly. In pride of place on the terrace above were the Byzantine horses.

At the same time new features rose above the first-floor gallery. These are exceptional, a façade enriched with mosaics and crowned with the most seductive – and oriental – of Gothic forms, giant ogee gables. These became the visual footings to new domes behind, which were heightened and given onion-shaped cupolas. Since the gables were

fringed in frothy scrolls they look as if the domes are dancing on fire. The central gable embraces a mosaic of St Mark's emblem, a winged lion.

To the Venice historian J. G. Links the new west front of St Mark's merited the title of 'a thieves' den'. Sailors and merchants brought back works of art to be inserted among the façade's niches and pinnacles, until there was no room for more. The façade is unlike anything in European architecture, the more exotic for the Gothic purity of the Doge's palace next door. In front of it rise three giant flagpoles, representing Venice's colonial territories of Crete, Cyprus and the Peloponnese.

Few visitors to St Mark's now enjoy the pleasure of moving easily from exterior to interior. The crowds are pressing and the queues long. But the interior is as spectacular as the west front suggests. It is not big or even particularly grand. The plan is basically that of the 11th-century church round a central domed space. Its impact lies in the capacity of gilding to inspire awe. The walls and vaults constitute a great enveloping cavern of gold.

The mosaics date from the 11th century in the apse to the 14th century elsewhere and have been copiously restored. Since each generation of mosaicists sought to copy the previous one, it is almost impossible to tell the ages apart. Nor did St Mark's switch to painted frescoes as did most churches in the Middle Ages. The Murano glaziers kept their monopoly intact and St Mark's stayed true to its past. Another feature of the interior is the marble paving of the floors and lower walls, much of it brought from the east. Stones were cut from the same slab such that each could be laid to mirror the adjacent one. This lends a shimmering sense of illusion to the surface.

The interior is not rich in furnishings, the finest objects being consigned to the treasury. This is an extraordinary chamber crammed with religious and other bejewelled relics of Venice's more piratical days, including the treasures seized from the rape of Constantinople. In 1797 Venice suffered a taste of its own medicine when it was comprehensively looted

by Napoleon. He even took the four horses to Paris. They at least came back, to rest in the museum – so those now on the façade are replicas. Pride of place goes to the *pala d'oro* in front of the altar. As if St Mark's was not gilded enough already, this is of solid gold. It contains eighty Byzantine enamels dating from the 10th century, carrying an alleged 2,500 precious stones radiating from their golden settings.

I come away from most of my cathedrals wishing for something to be a little different. Not so St Mark's. To see it in an evening sun from the piazza outside Florian's is the nearest my journey brought me to perfection.

VENICE
TORCELLO
❖

To those overwhelmed by the crowds of modern Venice there is only one cure. Collapse into a vaporetto from the Cannaregio and snooze gently across the lagoon. We soon enter a different world. Light softens. Mists appear. Waterside shacks come and go. Reed banks nod at the boat's wake. Eventually a wooden landing stage is reached beyond which a muddy path leads through fields besides a canal. At the end is an ancient brick campanile in a clearing surrounded by houses and churches. All is very quiet.

Without visiting Torcello, said Henry James, 'we cannot know Venice.' She was its mother city and now lies 'a mere mouldering vestige, like a group of weather-bleached parental bones left impiously unburied'. Refugees from invading Goths settled here in the 7th century and built a place of palaces and churches, paved streets and canals. The cathedral was founded in 639. By 1500 the settlement was thought to have over 3,000 citizens. Then mud, malaria and the more convenient Rialto islands took precedence. Torcello's buildings were ransacked for

+HANAC:

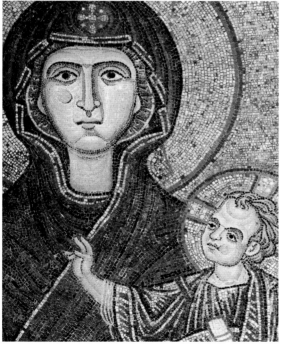

Venice's stone and it dwindled until barely a hundred farmers remained, just a few dozen now. All else simply vanished. To Jan Morris, Torcello lies in an 'ecstasy of melancholia'.

The cathedral has always been simple. It has the form of a basilica, rebuilt in 1008 when Venice still hovered between eastern and western influences. The church of Santa Fosca next door is clearly Byzantine. Outside are the remains of an earlier church and baptistery in a clutter of fragments. Inside, the nave arcades have Roman capitals below a clerestory of slit windows but only on the south side. Marble panels carved with animals and foliage mark a raised sanctuary beneath a gilded iconostasis. The sanctuary is unusual in being built as a semi-circular upper auditorium with steps in the centre leading up to a bishop's *cathedra*.

The cathedral's principal treasures are two magnificent mosaics filling its east and west ends. The west wall is covered by a vividly colourful 11th-century Crucifixion, Resurrection and Day of Judgement. The saved and damned are in formalized Romanesque poses rather than the more familiar horrors, with sins personified and Christ dragging the saved up to heaven by their wrists.

The eastern apse contains a gilded mosaic of the Madonna Hodegetria or Mary the God-bearer. She was created possibly by Greek artists in the 13th century and rises over a frieze of apostles. To Morris hers is a gaze of timeless reproach, 'cherishing the Child in her arms as though she has foreseen all the years that are to come and holds each one of us responsible'. The face is of great refinement, a falling tear seeming to embody Torcello's fate as its rolls down the centuries.

Outside rises the 11th-century campanile from which it is possible on a clear day to see over the lagoon to distant Venice. I prefer to avert my eyes. I love humble Torcello, a place apart, a yellowed and dog-eared page torn from the book of history.

← Torcello's page from the book of history
↑ Venice's deserted precursor
↑ Mary the God-bearer

VALLETTA ST JOHN

✢ ✢ ✢

Suleiman the Magnificent (r.1520–66) ruled an Ottoman empire that stretched from Persia in the east to Morocco in the west and from the Crimea to the gates of Vienna. In 1522 he evicted the ancient crusader order of the Knights Hospitallers from their base on Rhodes and eight years later they found refuge on Malta courtesy of Spain's Charles V. They paid him an annual rent of a single Maltese falcon. They then fought off an Ottoman siege in 1565 and remained in command of the island until evicted by Napoleon in 1798. The order continues today but in highly fragmented form, the British branch being chiefly devoted to ambulances in the name of the Order's patron, St John.

With an economy based on charity, extortion and piracy, the 16th-century knights proceeded to build the lavish city of Valletta under the direction of a Maltese architect, Girolamo Cassar (c.1520–92). Symbol of their status was a Baroque church, since 1816 Malta's co-cathedral with Mdina, dedicated to St John. Begun in 1572 and built in just five years, it was intended to rival any in Rome. After being badly damaged during the Second World War, its restoration was completed in 2014.

The cathedral's exterior is austere, more Classical than Baroque, flanked by what appears to be a defensive wall of the old conventual buildings. It has a balcony from which the grand master would address the Valletta citizenry. The interior is a total contrast, its Baroque style more luxuriant than its Italian contemporaries and more coherent than its Spanish ones. The knights were clearly out to make a point, and that point was triumphant Counter-Reformation. The cathedral was begun the year after Christianity's victory over the Ottomans – as it was seen – at the Battle of Lepanto in 1571 and seven years after the rebuffed siege of Malta. It was also a gesture of defiance at the defection of the northern knights to Protestantism.

The result is among the most lavish churches in Christendom. It is essentially a hall of six bays under six golden arches leading the eye to a sculpted reredos of the baptism of Christ by St John. The side aisles take the form of colonnades linking nine side chapels dedicated to the national divisions or *langues* of the Order, including those of Aragon, Auvergne and Castile as well as Germany, France, Italy and, obscurely, Anglo-Bavaria.

No inch of surface is spared a painting, a statue or a motif. The style is the highest Baroque and while it may be indigestibly rich to some, its consistency and panache are undeniably impressive. The decoration is chiefly by a Calabrian artist-knight, Mattia Preti (1613–99), who reputedly worked not from his studio but from scaffolding on site.

The chapels so tumble over each other as to be hard to distinguish. Golden panels on the pilasters and soffits of the main arches are of Baroque scrolls, leaves and figures in deep relief. The ceiling has frescoes of scenes from the life of St John, where some of the figures are so painted as to give an illusion that they are three-dimensional carvings. The floor is an inlaid marble carpet of the coats of arms of some four hundred senior knights, bursting with pride and colour.

The richest work is in the *langue* chapels. Altars are to patron saints often adjacent to tombs of grand masters, crowded with elaborate sarcophagi, twisted columns, ecstatic saints and cavorting putti. The chapel of the Italian *langue* is perhaps the most flamboyant. The funerary monument to its grand master, Marc'Antonio Zandadari (d.1722), was so huge it could not fit into its chapel and had to be located against the west wall of the cathedral where it now towers over arriving visitors.

Relief from this splendour is in the simple crypt, albeit with more grand-master monuments.

→ Malta bids to outshine Rome

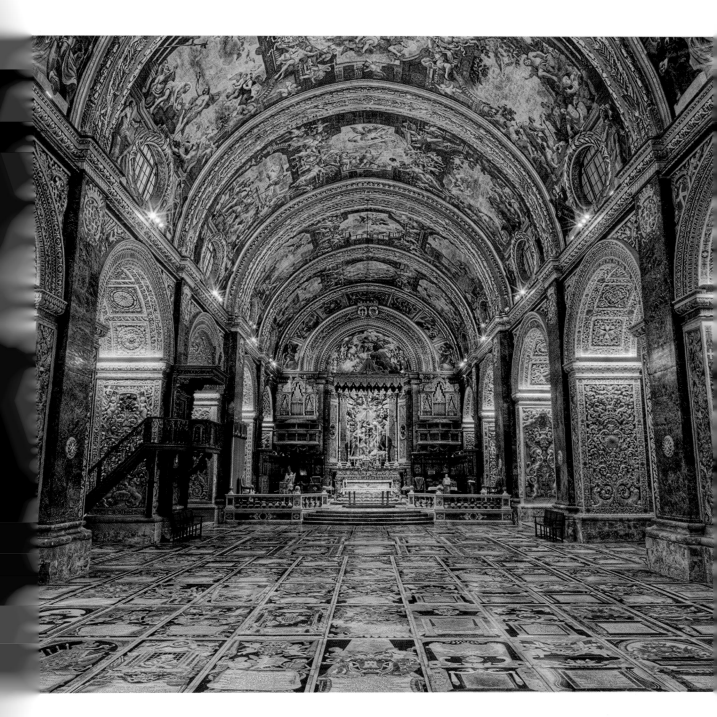

Caravaggio's most celebrated and largest canvas, *The Beheading of St John the Baptist*, hangs in the cathedral oratory. It was painted in 1608 to thank the knights for offering him refuge when fleeing a charge of murder in Rome. Why he chose this particularly bloodthirsty depiction of the patron saint is not known. Also in the Oratory is his more peaceful *St Jerome Writing*.

RUSSIA AND
EASTERN EUROPE

ISTANBUL, HAGIA SOPHIA ✦✦✦;
KRAKÓW, WAWEL ✦; MOSCOW, ST BASIL'S ✦✦✦;
MOSCOW, DORMITION ✦✦;
PRAGUE, ST VITUS ✦✦✦; WROCŁAW ✦

In the year AD 330 the Roman emperor Constantine decided to build his imperial capital on the Bosphorus at the mouth of the Black Sea. What became Constantinople not only signalled the end of Rome as political capital of what remained of the Roman Empire, it also established what became for half a millennium the most prominent city of the Christian church. Until the rise of Islam, the focus of its faith was where it was born, at the eastern end of the Mediterranean. The overwhelming majority of bishops attending the early councils that formulated the Nicene and other Christian creeds came from what is now Asia and Africa. Their business was conducted in Greek. There was no more lasting symbol of this geographical focus than the emperor Justinian's great church of Hagia Sophia in Constantinople, completed in 537.

The death of Mohammed in 632 and the advance of Islam over eastern Christendom in the succeeding century stripped Constantinople of its hinterland, while at the same time the Gothic and other tribes of northern Europe were steadily converting to Roman Christianity. The rise of Charlemagne and the formation of the Holy Roman Empire in 800 marked a return of authority to the Roman episcopy, resulting in the Great Schism between the Catholic and Orthodox rites in 1054. Relations plummeted, culminating in the sacking of Constantinople in the course of the fourth crusade in 1204 and the city's brief submission to Rome (1204–61). Later spasmodic attempts at reconciliation failed to achieve lasting results and in 1453 came the capture of Constantinople itself by the Ottoman sultan, Mehmed II (r.1451–81). By now Christendom had lost an estimated half of its former population. Hagia Sophia became a mosque and was never again a church.

Meanwhile eastern Europe north of the Balkans found itself faced with a choice between western Roman and Eastern Orthodox Christianity, the outcome largely dependent on the faith of individual rulers, though also reflecting geography. Scandinavia, the Baltics, Poland and Hungary went for Catholicism.

Legend holds that in 987 Vladimir the Great (r.980–1015) of Kievan Rus', modern Russia and Ukraine, sent envoys to research the most suitable religion for his emergent empire. They reported that the faith of Islam 'had no gladness, only sorrow and a great stench' and banned alcohol. Judaism had lost Jerusalem and so been rejected by its God, while the German church 'has no beauty'. But Constantinople, then still Christian, was so glorious the envoys declared 'we no longer knew if we were in heaven or on earth.' Russia opted for Orthodoxy.

Ten years after the fall of Byzantium, Vladimir's descendant Ivan the Great (r.1462–1505) longed to see a modernized Russia as successor to the crown of Rome. He married a Byzantine princess and imported Italian architects. But when he and his grandson Ivan the Terrible came to build churches it was to ancient Russia and Byzantium that they looked for inspiration.

Orthodoxy produced lovely buildings but few great cathedrals. Its liturgy was introverted, with an architecture that emphasized the role of a clergy hidden behind icon-laden screens through which the laity would listen and murmur prayers. Interiors were intimate rather than awesome, their mostly windowless walls coated in mosaics, sadly to be the victims of iconoclasts in the 8th and 9th centuries. Unlike western Christianity, eastern Orthodoxy did not undergo a theological or architectural Reformation or Renaissance with the end of the Middle Ages.

By the dawn of the modern era, Orthodoxy was largely confined to the Balkans and the Russian sphere of influence, remaining deeply conservative throughout. Though wars of religion were to take a terrible toll on churches of all Christian persuasions, those in the east on the whole retained a constant loyalty. Only with the rise of communism did they suffer widespread losses. Since

communism's decline, the restoration of churches and of other historic buildings has mostly been successful. I sense these churches of the east are now safe for all time. In what was termed eastern Europe, the churches of Poland and former Bohemia were always Roman Catholic. The evolution of their architecture is similar to that of churches of the western Gothic tradition.

ISTANBUL
HAGIA SOPHIA

✣ ✣ ✣

I am in favour of holy wisdom. To a classicist the idea of a church dedicated not to a supernatural spirit or Trinity but to wisdom is appealing. Indeed *hagia sophia* was sometimes translated not as 'holy wisdom' but as 'sublime explanation'. As such it was an attempt at an intellectual bridge to Christian theology from the Greek philosophy of Plato and Aristotle, uniting the two great streams of European thought and perhaps appealing to those of a more agnostic persuasion.

Whether the emperor Constantine (r.306–37) himself built a first church on the site of Hagia Sophia is unknown but is thought probable. The present building was begun two centuries later in 537 by the emperor Justinian (r.527–65). Since then it has survived earthquakes, rebellions, sieges, partial collapse and conversion to a mosque and museum. Today it is again a mosque.

Despite its name, Hagia Sophia's early relics had little to do with wisdom. They were mostly an assortment of souvenirs brought back from Palestine by Constantine's enterprising mother Helen, though which bits of the True Cross, Noah's axe and the dish that fed the 5,000 came here rather than to Helen's

→ Hagia Sophia: wisdom in a church, mosque, museum

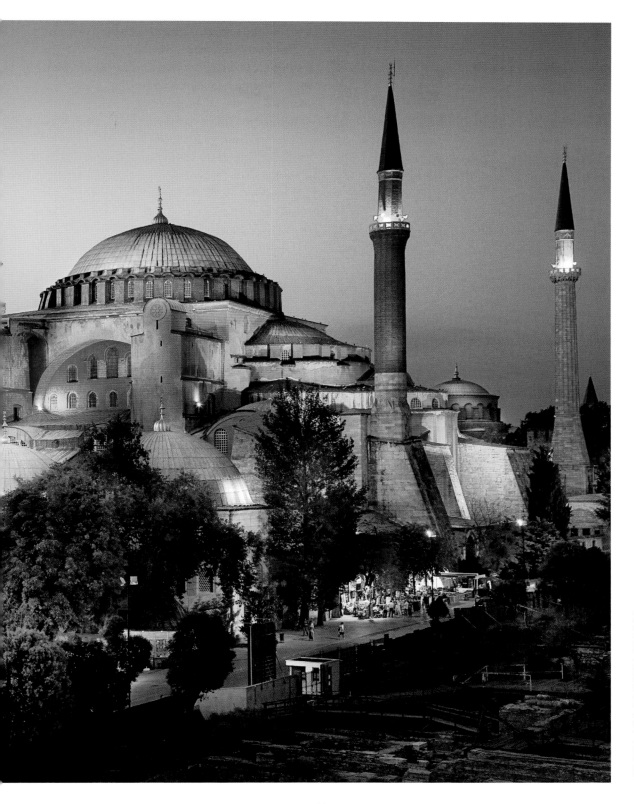

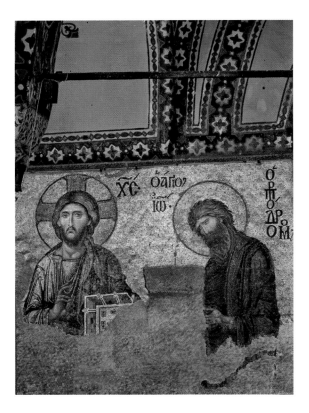

that it would revert to being a mosque.

Justinian's church was erected in great haste over five years. The architect was Isidore of Miletus, a renowned mathematician and engineer. It was said that two armies of builders, each 5,000 strong, competed to complete the north and south elevations. It was not an ideal construction technique, producing botched joins that now fascinate archaeologists. When Justinian saw it finished he declared, 'O Solomon, I have surpassed thee' – a reference to Jerusalem – and thanked God 'who has found me worthy of such a work'.

Today I find it hard to regard Hagia Sophia's exterior as beautiful. It is like a great turtle overlooking the Bosphorus. The building's interior, however, is magnificent, in the form of a rectangular hall with a large dome over the nave. Entry is through two western narthexes framing the great door, used only by the emperor. The empress and her retinue were accommodated in the extensive galleries above.

The nave is unlike any other. Devoid of aisles it conveys a sense of a vast space waiting for something to happen, part Colosseum, part Grand Central station. The light from multitudinous small windows – there are forty round the dome alone – is dazzling. On all sides are leaping arcades, galleries, chandeliers, apses and alcoves, such that the eye drifts restlessly from one vista to another.

As the main dome over the nave is shallow, its engineering is baffling. Weight is distributed on to four subsidiary arches, on two sides, each embracing a tympanum above a triforium above an arcade. This rests in turn on massive columns of marble rising to beautiful capitals. Formed like bowls, these capitals depict traditional Greek acanthus and palm leaves, deeply undercut and each one different. The walls are of exotic marble gathered from across the eastern empire and set in matching patterns such that each panel mirrors its neighbour.

To the east the nave merges into what is a hemispherical apse flanked by aisles and colonnades. Where once stood a 15m screen and iconostasis

palace at Trier must be moot. During the fourth crusade in 1204 Venetian mercenaries sacked Constantinople and carried off the cathedral's incalculable wealth of treasures. The church was even brought under papal authority for half a century until 1261.

Even as they looted, the crusaders were said to have gasped at the city's beauty. One Frenchman admitted he 'could not imagine a finer place in all the world . . . no man was so brave his flesh did not shudder.' But Hagia Sophia's fate was finally sealed in 1453 when the Ottomans invaded and converted it into a mosque. Four minarets and various outbuildings were added to its perimeter.

The secularizing reforms of Turkey's Kemal Atatürk in 1931 saw Hagia Sophia become a museum and it was in this form that I first visited it in the 1970s. It was vast, bleak and uninspiring, but it was subsequently restored and still stands as Byzantium's most splendid memorial. In 2020 the Turkish government of Recep Tayyip Erdoğan announced controversially

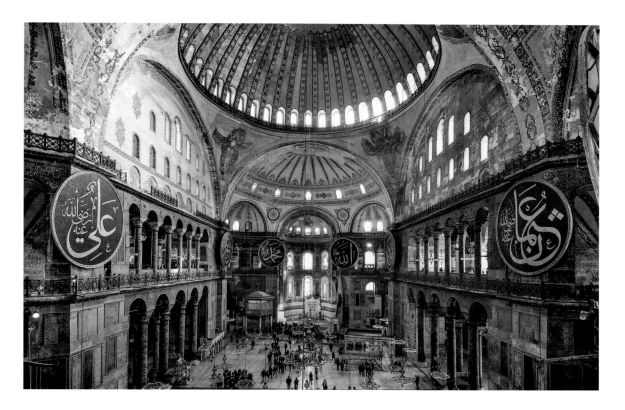

are now the furnishings of a mosque. The roofs are painted gold with mauve trimmings. For the most part there is no figurative art and the calligraphy is Arabic. Large wooden plaques are positioned round the interior inscribed with the sacred names of Islam. Against the eastern wall stands a *mihrab* or alcove pointing to Mecca. Next to it is a *minbar* (pulpit) and a charming 1850s sultan's pavilion, a private pew that might be the howdah of an imperial elephant.

The interior has been well restored. During its time as a museum considerable effort went into discovering and revealing early Christian decoration, notably murals and mosaics that managed to survive centuries of iconoclasm and vandalism. Archaeologists have had to agonize over whether to remove later treasures to reveal earlier paintings underneath.

Most of the finest works are in the entrance and the nave galleries. Over the narthex door is a remarkable 10th-century mosaic of the Virgin flanked by Constantine and Justinian presenting her with

models of the city and cathedral respectively. A 9th-century Christ in majesty over the imperial door shows the emperor grovelling in supplication. The gallery also displays pictures of Mary and various emperors and empresses, male and female noticeably enjoying equal status. At the end of the south gallery is the cathedral's greatest treasure, the Deisis mosaic of the 1260s rediscovered in 1932 and showing Christ flanked by Mary and John the Baptist. Its soft and lifelike features dating from the end of the cathedral's 13th-century Catholic interlude are considered more Italian than Byzantine.

Hagia Sophia is clearly an outlier in the story of the European cathedral, but it was long the most famous of all, the capital church of half of Christendom. That it has served as a Christian, Muslim and secular temple honours the centrality of these buildings to Europe's ongoing history.

↖ Fragment of Deisis mural
↑ Mosque interior looking east

KRAKÓW
WAWEL

∻

Kraków is a jewel of a city surrounded by the dreariest of suburbs. The Wawel citadel and cathedral lie on a hill outside the centre, under a perpetual tourist siege. It was Poland's chapel royal and is the national shrine of monarchs and bishops. Like Venice it is today a victim of its own beauty.

Once we are inside the citadel, we find the cathedral itself almost lost amid the castle roofs, surrounded by a cluster of chapels with distinctive towers and roofs. The Vasa Tower, the Sigismund Chapel and a bell tower rise above a burst of Classical portals, gables, turrets, domes and cupolas, almost as if the masons were trying out everything they could find in their pattern books. The group admirably offsets the austere façades of the surrounding castle, as St Basil's does the walls of Moscow's Kremlin.

Entry through the west front is squeezed between two protruding Gothic roofs. The atmosphere inside is more mausoleum than place of worship, so intimate that the distinguished occupants might almost be waiting to move somewhere grander. In the centre of the small nave is a Baroque baldachin sheltering the tomb of Poland's patron saint, the 11th-century Bishop Stanisław. It is in the form of a silver casket attended by cherubs beneath a gilded dome. Beyond lie the choir and bishop's throne, lined with portrayals of Polish landscapes. This leads to the sanctuary and a large main altar that has been 'Baroqued' to an extreme, as if frantic to outdo the Gothic apse behind.

Round the interior is an ambulatory almost as crowded as that of London's Westminster Abbey. Some celebrities get plaques, some portraits, some memorials, while the grandest get entire chapels. On the south side a screen runs the length of the ambulatory guarding each chapel like a corridor of cubicles. The Sigismund Chapel is a handsome Renaissance chamber lined with alabaster statues and tableaux. The Vasa Chapel takes the form of a sumptuous mausoleum, its black-painted walls lined with golden images.

Elsewhere the tomb of Casimir the Great (d.1370) is a Gothic tabernacle of polished marble while that of King Casimir IV (d.1492) lies under a canopy of red marble with interlocking ogees. When the latter's coffin was opened in 1973 a 'mummy's curse' rumour followed after a catastrophic fungal infection in the wood killed fifteen people who had been in contact with it.

Poland's modern pope Karol Wojtyła, John Paul II (r.1978–2005), is honoured with a special shrine in the crypt, though his body was buried as with most popes in Rome. Many of these figures may mean nothing to foreign visitors, yet Wawel conveys a vivid sense of a national family assembled in communal memory.

↖ Wawel's eclectic roofscape
→ St Basil's jesting with power

MOSCOW
ST BASIL'S
✥ ✥ ✥

My first experience of Moscow was on a freezing evening at the height of the Soviet era when I strayed from my hotel to see Red Square at night. As I walked up the incline the Kremlin's blood-coloured walls towered over me, the architectural embodiment of power. Then, over the brow of the hill, emerged a mirage, a fantasy of floodlit onion domes, swirling like plumes of flame into the black sky. Here at the heart of global communism was a gesture of wild anarchy, a jester dancing, almost jeering at the Kremlin opposite.

The metaphor is not far from the truth. St Basil's cathedral is unlike any other in the world. It is not a masterpiece of engineering or of sculpture but rather a conceit of the visual imagination. Since its creation in the 16th century by Ivan the Terrible (r. 1547–84) visitors have been puzzled that St Basil's should be a place of Christian worship at all. The French poet Théophile Gautier called it a 'stalactite grotto turned upside down, that might be taken for a Hindoo, Chinese or Tibetan pagoda . . . a will-o'-the-wisp formed of clouds fantastically coloured by the sun'. Both Napoleon who thought it a mosque and Stalin who thought it obstructed his parades wanted it gone. The church became a museum in 1923 but was persistently threatened with demolition by Moscow planners. In 1933 a Moscow conservationist, Pyotr Baranovksy, was sent to the Gulag for demanding its protection, but Stalin never quite had the nerve to proceed. Regular church services resumed in 1997.

The cathedral, formally 'of the Intercession', was built by Ivan to celebrate his victory over the Tartars at Kazan in 1552. It was on the site of a church of the Trinity in what was then a market

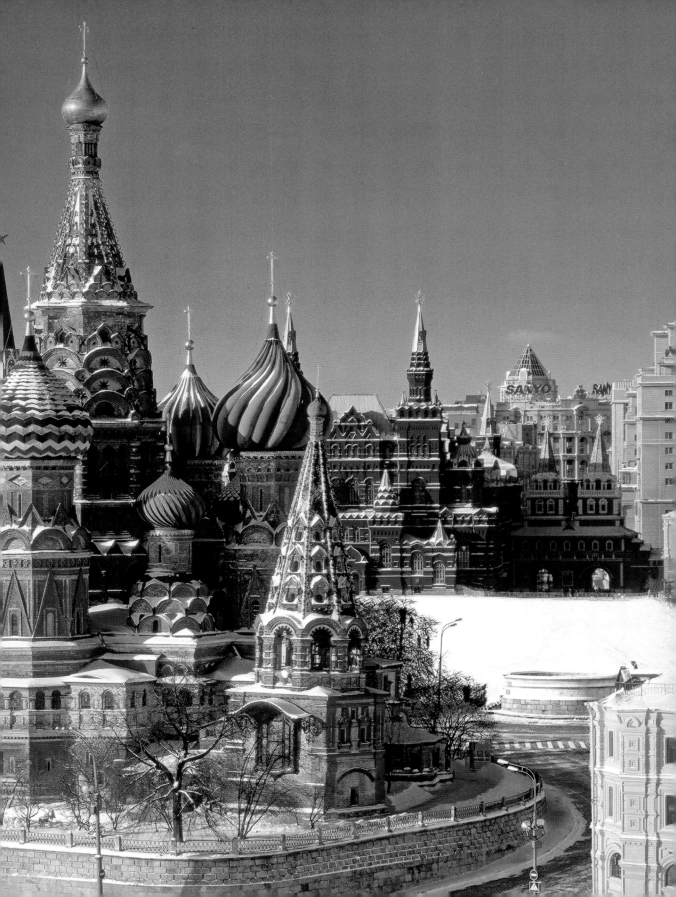

outside the Kremlin wall, so located because Ivan hated the Kremlin as the residence of boyars who had schemed against him when young. As his reign degenerated into autarchy and cruelty he began to fear retribution in the afterlife. Building the church was supposedly an act of atonement.

We now return to the jester. Ivan's church was to bear the name of the only courtier said to have a hold over him, his fool Vasily (or Basil). The role of fools in medieval courts was, as in Shakespeare's *King Lear*, an intriguing one. A so-called 'idiot for Christ', Vasily was said to work miracles as well as tell jokes and know the future. The saying was that 'the angel of mirth stands closest to the throne of God.' Ivan idolized Vasily and his shrine stands prominent in the church that bears his name.

The cathedral was completed in 1561 as the work of a Russian architect Postnik Yakovlev. The core construct was a giant wooden frame on which was built a pyramid of octagonal boxes of diminishing size, inspired by the tent-shaped wooden churches of the time. The actual model was reputedly the church of Kolomenskoye outside Moscow. France's 19th-century architect Viollet-le-Duc considered it Asian and some have seen Tartar patterns in the domes, perhaps related to the Kazan victory. To others, the twisted cupolas are merely variants on a Byzantine theme.

St Basil's is actually a cluster of churches. Despite appearances it is symmetrical, with a central chamber and four lesser chambers at each point of the compass. Four more chapels were then built into the angles of these chambers, each with its own turret and cupola. Two additional chapels were then affixed, confusing the symmetry. They were dedicated specifically to Vasily and to a later 'holy fool', John.

These eight churches plus two chapels and two porches are linked by a narrow gallery running round the outside of the building. The walls are decorated with geometrical patterns, triangles, arches and rectangles, picked out in red and white. The vivid and much celebrated colouring of the cupolas is later, dating from the 17th and 18th

centuries. The lower part of the exterior is decorated with flowers honouring Yakovlev's vision of St Basil's as a 'heavenly garden'. It is best seen on a sunny day, shimmering against a blue sky with snow on the ground, though I still revel in its nocturnal impact.

The cathedral interior is a maze of corridors, galleries and passages linking the various churches and chapels springing out of the gloom. The ground floor has a series of undercrofts while the formal churches are on the first floor. They are all small with only the central Church of the Intercession rising to the full height of its dome. As in most Orthodox churches, space for lay worshippers is limited and what passes for a nave is more an atrium with a large iconostasis screen separating it from the clergy behind.

Virtually every wall of St Basil's is painted with religious scenes and themes, mostly created in the 18th and 19th centuries and much restored. In between the paintings is decorative foliage or just a wall painted to look like brickwork. The style is universally medieval, though 19th-century restoration has given some of the painting an Art Nouveau feel. I find it reminiscent of William Burges's interiors in Wales's Cardiff Castle.

On my first visit I did not take St Basil's seriously, but it has grown on me. It lacks the drama and awe of a western cathedral. But its intimacy is intense. Twisted cupolas, eerie chambers and hundreds of silent stylized icons seem lost between Europe and Asia, between worlds medieval and modern. Nor can I rid my mind of my first impression, of an 'idiot for God' laughing on the doorstep of authoritarian power.

MOSCOW USPENSKY CATHEDRAL OF THE ASSUMPTION, THE DORMITION

✣ ✣

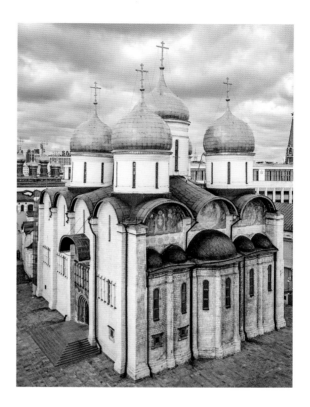

We so think of the Kremlin as a secular citadel that it is a surprise to find at its heart a cluster of buildings called Cathedrals Square. Here Ivan the Great, grandfather of Ivan the Terrible, reigned over a newly consolidated Russian state from 1462 to 1505. His reign followed the collapse of the Byzantine Empire in 1453 and he yearned to see his modernized Russia as the new Byzantium, Moscow as the new Rome. The Kremlin was his Renaissance palace. Ivan even married Sophia Paleologue, niece of the last Byzantine emperor, and recruited an Italian architect Aristotele Fioravanti to beautify his new capital. In the Kremlin was to be a new Cathedral of the Assumption, built in 1475. But Fioravanti was no Brunelleschi and the church bears a strong likeness to the earlier cathedral in Vladimir, the old Russian capital 185 kilometres east of Moscow. The only Italian parallel is perhaps with St Mark's Venice.

The cathedral became the coronation church of the tsars, as well as headquarters and burial place of Russian patriarchs. It hosts the patriarchal throne as well as the throne carved for Ivan the Terrible in 1551. After the Revolution in 1917 the church became a museum, but occasional services were restored in 1991. The cathedral requires a ticket of admission to the Kremlin for access. It is popularly known as the Dormition, its dedication to the falling asleep of Mary on her death.

The exterior is virtually a copy of its Vladimir predecessor, a fine cathedral in its own right. The plan is four bays by three, each divided by thin pilasters and with tiny slit windows. The chief decorative device is a band of blind arcading halfway up the walls. The western entrance is adorned with receding Neo-Romanesque arches with a Madonna fresco in the tympanum above. The arches on the apse exterior also carry mural paintings. The roof is crowned with five bulbous golden cupolas on drum towers, imitating most of the churches in the square.

The charm of the Dormition lies inside. It is entered through a Renaissance portal framed by Corinthian columns flanking two copper doors. These are panelled with reliefs depicting the Annunciation, saints and philosophers. Unlike at St Basil's, worshippers were accommodated in an airy chamber, surrounded by ambulatory galleries. These are crowded with icons and frescoes, tier upon tier, occupying virtually the entire surface area as well as four columns in the centre of the chamber.

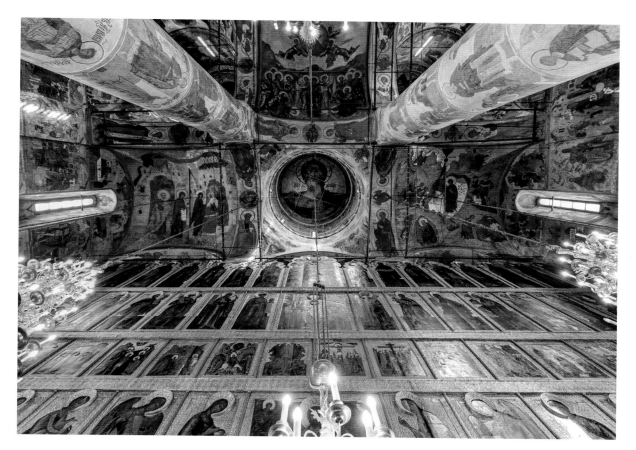

Over this central space towers a five-tiered iconostasis, one of the oldest and surely the most precious in Russia. It displays nearly a hundred icons dating from the 14th to the 17th centuries, most of them painted after a fire in 1547. There is an excellent guide to the individual icons, though it is hard to appreciate any one in particular as they are all crammed next to each other. I would single out a Mother of God 'Hodegetria' of the 11th century and a 16th-century icon of St Simeon Stylites, which shows him settled comfortably in a tower rather than on his usual column.

The cathedral is brightly lit, but some idea of how it must have seemed during worship is gained by visitors' accounts of Easter services. The diplomat Maurice Baring described Maundy Thursday in 1906: 'The church is crowded to suffocation.

↖ Moscow, Uspensky: Dormition exterior
← Gilded columns in the nave
↑ Towering iconostasis and vault

Everybody is standing up as there is no room to kneel. The church is lit with countless small wax tapers. The singing of the noblest plainchant, without any accompaniment, ebbs and flows in perfectly disciplined cadences. The bass voices are unequalled in the world . . . There is a strong smell of poor people, without which a church is not a church.'

Another diplomat, Sir Samuel Hoare, wrote of the 'intimacy, mystery and splendour of these ceremonies . . . the frescoes of Byzantine figures against a background of gold, their screens a blaze of precious stones and metals, the only lights the candles before icons or in the hands of the faithful, the only music the bass of the deacon and the baritone of the bishop'. Services would last far into the night, yet 'such was their dramatic hold, their wealth of picturesque detail, that we would cheerfully stand, hour after hour, and return after a brief rest.' Outsiders were amazed at the stamina of clergy and worshippers alike.

PRAGUE
ST VITUS

✣ ✣ ✣

Over no European capital does a cathedral soar as does St Vitus over Prague. Erected as the shrine of Wenceslas, 10th-century Duke of Bohemia, the cathedral was mostly the creation of Charles IV, king from 1346 to 1378 and Holy Roman Emperor from 1355. France at the time was in decline and wrestling with the Hundred Years War with England. Charles's ambition was to make Bohemia a second France and Prague a second Paris. It would be friend to German civic autonomy and champion of a reformed Catholic church.

Charles's Golden Bull of 1356 was a constitutional charter for the election of Holy Roman emperors by Germany's many states that held until the Thirty Years War in the 17th century. He founded the University of Prague and sowed the seeds that erupted in the proto-Reformation of Jan Hus (1372–1415). Charles's dream was extinguished by the wars of religion; Eastern Europe saw no new Rome.

The church begun in 1344 on the hill overlooking the Vltava river expressed Charles's ambition in architecture. He took the Île-de-France as his model and commissioned a design from the master mason Matthias of Avignon. Matthias lived only to complete much of the east end, to be followed by the Late Gothic master Peter Parler of Germany. Other Parlers followed.

The project was blighted by politics and expense. Building was halted by the Hussite wars at the turn of the 15th century and by Bohemia's devastation in the 17th. The south tower was not capped until the 18th century and not until 1844 was a society formed 'for the completion of St Vitus'. The nave and west front are thus 19th-century Gothic.

The west front is not a success. The buttresses are intrusive and the rose window is inserted awkwardly into a Gothic arch. There is an uncomfortable plethora of ballflower decoration. The cathedral is best approached from Parler's south front, where a golden mosaic of the Last Judgement dates from 1400. Charles IV and his wife are shown in the tympanum. Matthew's east end is pure French, with a squadron of flying buttresses diving and swooping round the chevet. The silhouette of St Vitus's pinnacles rising above the lozenge-patterned roof tiles is Prague's architectural signature.

The character of the interior is dominated by Parler. Rhythmic arcading leads to a crossing and eastern apse dominated by three tall windows. Overhead is Parler's great choir vault, a maze of ribs leaping in all directions in clusters of fours and sixes. They describe a network of aerial patterns almost as frenzied as the 'crazy' vault of England's Lincoln. It lends a welcome touch of levity to an otherwise solemn spectacle.

The prize of the cathedral is the Wenceslas Chapel designed by Parler in 1362 and completed by his nephew. Wenceslas was Duke of Bohemia from 921 to 935 until he was murdered by his brother, a fate that had him posthumously created both king and saint – the Good King of the children's song. Legend depicted him as the epitome of the kindly ruler with a Christmas carol in his honour. The chapel marks his original burial place and became the focus of Bohemian coronations.

This chapel is a dazzling work of Late Gothic. The walls are covered in murals dating from 1509, depicting the lives of Wenceslas and of Christ. Charles IV is shown at the foot of the Cross. Thirteen hundred semi-precious stones are said to decorate the walls, including jasper and amethyst set in gilded plaster. A stairway at one corner leads to a treasury of the Czech crown jewels. The door has seven locks.

Other chapels include three decorated by the Czech Art Nouveau artist Alfons Mucha

→ St Vitus, the pride of Prague

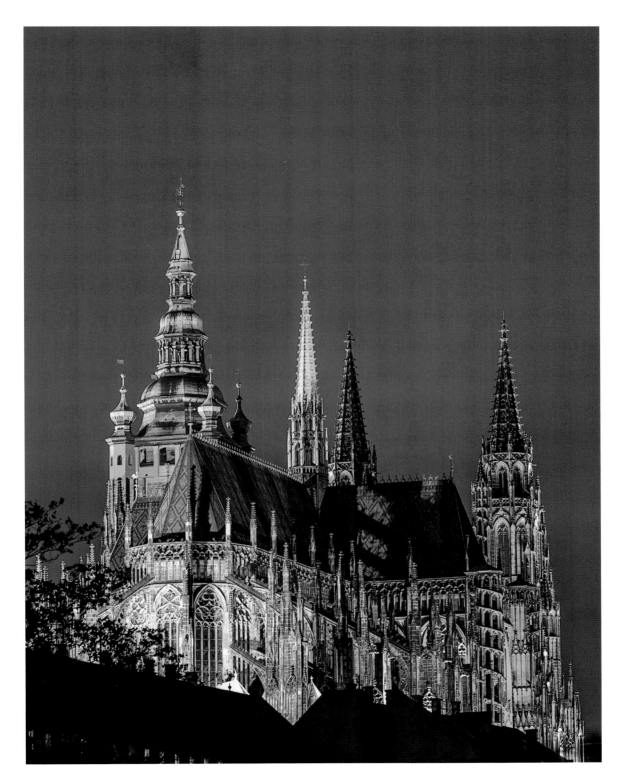

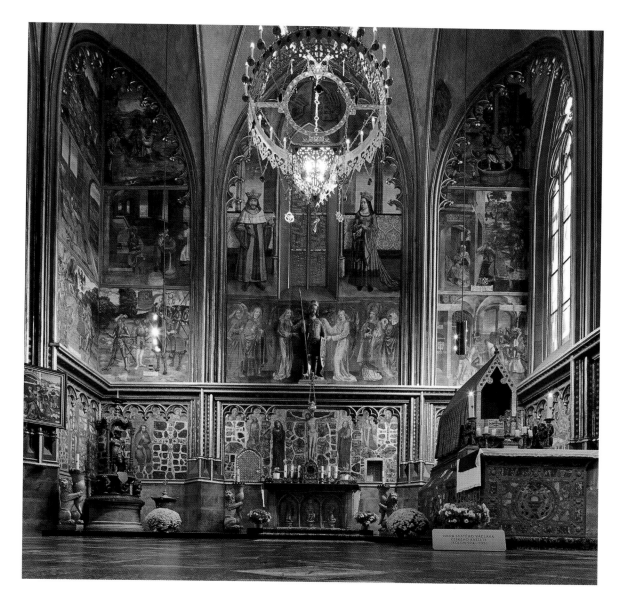

(1860–1939). The centre of the choir is dominated by a single tomb of a Bohemian martyr, St John of Nepomuk, a bishop killed in 1393 by a later King Wenceslas. He became the patron saint of the confessional, reputedly for refusing to reveal secrets of the love life of the king's wife. The tomb by the Austrian master Fischer von Erlach in 1736 is made of 2 tonnes of solid silver, a work of Baroque exuberance.

St Vitus guards the entrance to Prague castle. Its warren of palaces, back streets, stables and workshops is one of Europe's most precious medieval enclaves, presided over as if in benediction by its majestic cathedral.

↑ Wenceslas Chapel
← Alfons Mucha window

WROCŁAW

This cathedral was for me an experience as much as a building. I had been driving on a winter Sunday evening round the depressing snow-bound suburbs of modern Wrocław wondering if I would ever find the old town and its corner of history. Suddenly through the cold air I saw the soaring spires of the cathedral by the Oder river. As if in a vision, the ghosts of Silesia beckoned me in.

Wrocław – Breslau to the Germans who ruled it for part of its history – has had a church on this site since the 10th century. Various buildings rose and fell, including one destroyed in the Mongol invasion of the 1220s. The building of the present one began in 1244, with the nave and western towers completed in 1341. A serious fire in 1759 led to a comprehensive Neo-Gothic rebuilding in the 1870s, including the west front and towers. Almost 70 per cent of the structure was then devastated by Russian bombs in the Second World War, though most of the fittings had been removed. From the 1950s onwards, local citizens determined to repair what was lost and restore their pride, however long it took and whatever the cost. Work on the towers was not completed until 1991.

The towers are now stars of the Wrocław skyline. Like most of the cathedral they are built of brick on stone footings, rising like two elongated telescopes. Seven diminishing stages with corner buttresses culminate in thin spires to a height of 98 metres. The portal beneath is robust rather than beautiful, somewhat reminiscent of London's St Pancras station. The much-restored east end is a delightful cluster of chapels, redbrick walls, pink plasterwork and green copper roofs.

The cathedral interior maintains, or contrives to recreate, the atmosphere of a great medieval church. The mood is dark and mysterious in flickering candlelight. Baroque statues loom out of Gothic corners. Long-departed princes and prelates swim into view. We hear the sound of murmured prayers and see old ladies in black kneeling before chapel altars. Wrocław was one of the few modern cathedrals in which I sensed a full complement of priests and casual worshippers. Catholic Poland seemed alive and worshipping.

The nave arcades are simple and unadorned Early Gothic beneath a graceful six-part vault. The aisles form an ambulatory round the entire interior. The cathedral's centrepiece is its magnificent choir. Entered between two gilded statues, the stalls are each crowned by a life-sized wooden effigy of what appears to be a civic dignitary, flanking panels of relief carvings of local scenes. These are said to date from the 1660s. The effect is of a luxurious drawing room. The altar beyond is modest, separated from its tall east window by an expanse of bare brick wall as if mourning a long-lost reredos.

The cathedral has a complement of twenty-one chapels which almost fill the aisles and ambulatory. Most are insertions of the 17th and 18th centuries. Behind the altar, however, are three of the first rank. The Elector's Chapel of Corpus Christi of 1716 on the north side of the apse is by the Viennese architect Johann Fischer von Erlach. It is balanced by the Chapel of St Elizabeth (1682) on the south side in Italian Baroque, with a dome depicting the saint's miraculous life and death and designed by pupils of Bernini. The third, the Marian Chapel, is Gothic of the 14th century. Its 19th-century statue of Mary famously stood untouched by flames as bombs consumed the chapel around it in the Second World War. Considering what it has suffered, the survival of Wrocław cathedral at all is a miracle.

→ The stars of the Wrocław skyline

SCANDINAVIA AND THE LOW COUNTRIES

ANTWERP ❖❖; ROSKILDE ❖❖❖;
'S-HERTOGENBOSCH ❖❖; STOCKHOLM ❖;
TRONDHEIM ❖❖

Scandinavia was untouched by the Roman Empire's conversion to Christianity. Its route from paganism came later, over the 10th century and was largely the decision of individual rulers and the outcome of the turbulent politics of the region. Undoubtedly a crucial influence was Viking expansionism and contact with Christian communities along the coast of Europe. Even captured slaves became unofficial missionaries, no less than warrior kings eager to be thought in tune with the times. King Cnut (r.1018–35), effective ruler of an empire from the Atlantic to the Arctic, signified Scandinavia's conversion by attending the coronation of a Holy Roman emperor, Conrad II, in Rome in 1027. Most of the region's cathedrals and dioceses were established by the 12th century.

The three principal cathedrals were founded in this period, although they have all since been altered and modernized. All are basically northern European Gothic, Trondheim austerely so, Roskilde in a more light-hearted vein. The statue of St George in Stockholm is a glorious medieval work. Scandinavia was swept by the Lutheran Reformation in the 1530s and chancels now tended to be ascetic. This did not stop the Swedish and Danish royal houses filling their churches with flamboyant Baroque tombs and memorials worthy of Bourbon princes.

The Belgian and Dutch churches are firmly in the Late Gothic tradition of northern Europe. Den Bosch has the added delight of a sense of humour: its modern rooftop sculpture of an angel on her mobile phone.

ANTWERP

✢ ✢

Antwerp in the Flanders region of Belgium was a fragmentary relic of Charlemagne's empire in the no man's land of Lotharingia between what became France and Germany. Variously Frankish, Flemish, Burgundian, Spanish, Dutch and French, Antwerp benefited from not belonging to anyone, until that benefit became a curse.

By the first half of the 16th century the city had grown to become the largest port in northern Europe. It was estimated to control 40 per cent of all global trade, specializing in sugar, spices, diamonds and English wool cloth. The population was second in northern Europe only to that of Paris. The marriage in 1477 of Mary of Burgundy to the Habsburg Maximilian I brought Antwerp into the Holy Roman Empire under the Spanish crown. Over the course of the 16th century, rebellion and Protestantism meant oppression, the Spanish Inquisition and disaster. The city's prosperity soared and crashed. By the end of the Thirty Years War in 1648, Amsterdam and London had relegated Antwerp to history.

An earlier Romanesque church was rebuilt from 1352 and grew with the prosperity of the city. The choir and nave followed in the 15th century and the Flamboyant Gothic tower was completed in 1518. A proposal to create a grand double ambulatory, Spanish-style, was not executed. As Lutheranism took hold of the Low Countries, a planned second tower was also never built and remains a stump. A sculpture at its base shows workmen still busying themselves in preparation. The cathedral was comprehensively sacked and looted by Protestant iconoclasts in 1566, a visiting Welsh merchant witnessing scenes 'looking like hell, such a noise as if heaven and earth had got together, with falling of images and beating down of costly works'. Though declared a cathedral, it was Lutheran from 1581 to 1588, reverted to Catholicism and was then plundered by French revolutionary troops in 1794.

Through these vicissitudes, the cathedral and its 123m tower survived as an Antwerp landmark. The tower is the tallest in the Low Countries, its pinnacles and lattice openwork a mix of French and German styles and containing no fewer than forty-nine bells. The emperor Charles V allegedly declared it so fine it should be kept under glass, while its latticework reminded Napoleon of Flemish lace.

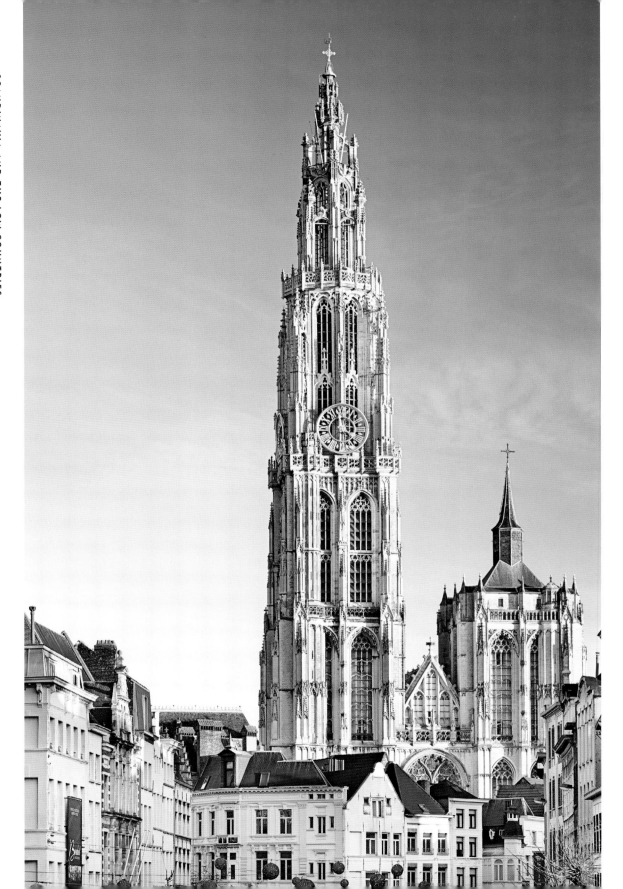

Antwerp's Gothic interior is a hall of light, an example of the late-medieval trend towards giving lay worshippers more space at the expense of clergy and choir. The seven-aisled nave can reputedly hold a congregation of 25,000, though this is hard to believe. Either way it must have seemed alarmingly 'democratic' to Antwerp's Spanish rulers.

The arcades rise to gracefully undulating arches, naked of capitals. The tall clerestory, almost a nave piled on a nave, makes the upper stages seem like a greenhouse, its lightness enhanced by being partly whitewashed. The walls are of flat panelled tracery, reminiscent of the Perpendicular of England's Gloucester cathedral. The design is consistent throughout, remarkable given that the cathedral took almost two centuries to complete.

The cathedral is a gallery of works by the city's distinguished son Peter Paul Rubens (1577–1640) and his contemporaries. They were mostly donations by the city's guilds following the re-establishment of Catholicism. Though the paintings were stolen by Napoleon in 1803 they were later returned, and are distributed above altars and against piers. Three are by Rubens under the influence of Caravaggio, including *The Raising of the Cross*, *The Descent from the Cross* and a triptych of the Resurrection.

Other works include *The Lamentation* by Quentin Massys, painted for the carpenters' guild a century before Rubens in 1511. Here the body of Christ is mourned by well-dressed burghers of Antwerp in what became a historical record of 16th-century costume design. The painting was so celebrated that both Philip of Spain and Elizabeth of England tried to buy it. Antwerp kept it for itself.

An exquisite carving of the Madonna and Child stands in the north aisle. The Baroque pulpit dates from 1713, standing on four figures of the four continents in the form of a tree with thick branches. A cohort of chanting cherubs hides under a swirling canopy of leaves. Of the same period along the north-nave aisle is a row of confessional statues of apostles and virtues, confessions then being heard in the open – though we assume not overheard.

ROSKILDE

✣ ✣ ✣

Those sated on Catholic church imagery have an easy remedy. They can hasten to the ambulatory of Roskilde cathedral on the outskirts of Copenhagen in Denmark. Once it might well have been crowded with crucified Christs, Blessed Virgins and tortured saints. But since the Reformation came to Denmark in 1536 the walls have become home to pictures of identical Lutheran divines in black gowns and white ruffs, as if from the hands of Frans Hals. Yet for all its Protestant sobriety Roskilde cannot quite shake off the glamour of being a royal mausoleum, with painted chapels and thirty-nine statues.

The cathedral dates back to the 12th century when Roskilde was capital of an emergent Danish empire in the reigns of Sweyn Forkbeard (r.986–1014) and Cnut the Great (r.1018–35). An old Romanesque structure was rebuilt in a Transitional Gothic style following the arrival of kiln-fired bricks in 1160, replacing the stone that was by then in short supply round the Baltic Sea. The present much restored building may look uncomfortably new but it was mostly completed by 1275, with the towers finished in 1405 and the spires added by 1636.

← Antwerp's tower, symbol of departed glory
↑ Roskilde's Chapel of the Magi

In 1413, the body of Europe's most formidable female ruler of the Middle Ages, Queen Margrethe I (r.1387–1412) of Denmark, Norway and Sweden, was transferred to Roskilde in a three-day ceremony of epic splendour. The nation's bishops and aristocrats laid donations on the church's reputed fifty altars with eternal masses to be said for her soul. In 1423 her beautifully carved effigy and sarcophagus were placed behind the high altar, while succeeding monarchs had chapels and altars of their own.

The redbrick exterior of Roskilde is dull. It is distinguished by a touch of eccentricity from the walls of the 17th-century Dutch Renaissance chapel of Christian IV and by the 20th-century Neo-Byzantine chapel of Christian IX. The cathedral's interior has Gothic arcades with a generous triforium gallery running round the entire church. White plaster walls are picked out with redbrick piers and ribs. While every restored inch looks new, it is a Gothic of unusual warmth decorated with painted bosses, ribbons and garlands. The piers run from floor to vault, giving height and dignity to the walls.

The nave benefits from an ornate Baroque pulpit and organ case donated by King Christian IV in 1610, and by the survival of the original medieval choir stalls. The original seats of these stalls were removed in the Reformation but not the canopies overhead. These depict devotional, royal and domestic scenes with delightful humanity. Otherwise the nave is animated only by a golden altar reredos and by glimpses of sculptural riches in the side aisles and chapels.

These memorials to Danish royalty are a catalogue of sculptural taste down the ages. Margrethe's sarcophagus of 1423 lies directly behind the altar, a Gothic chest with saintly statues round its plinth. It is one of the few sober tombs in the cathedral. Behind her loom four extravagant sarcophagi, of Christian V (d.1699) and Frederick IV (d.1730) and their wives, each seemingly determined to outdazzle the others.

The Chapel of the Magi contains the tombs of Christian III and Frederick II, both on chests and under lavish Baroque canopies set in a chamber whose walls are covered in floral motifs of c.1460. The entire chamber is as if papered by an illuminated medieval manuscript. Frederick V's chapel dating from 1774 is coolly Classical, with no effigy, just two weeping maidens. The interior of Christian IX's chapel is similarly austere, though he gets three maidens.

Most spectacular is Christian IV's chapel, begun in 1614 long before his death in 1648. It is fit for a Versailles, the Baroque exceptionally rich, with sarcophagi of the king and his queen in the centre. Despite its early start, such were the delays in completion that the chapel was not finished until 1866. The result is an enjoyable confusion of 17th-century Baroque with 19th-century Baroque Revival. The chapel is screened by intricate latticework of the most delicate wrought iron.

Like the similar cathedral in Stockholm (see below), the chapel gives the visitor a counter-intuitive impression of Scandinavian monarchy. The church may be a demure redbrick Protestant temple, but it offers an image of rulers straining every nerve to outshine Louis XIV. Unlike the French monarchs, the Scandinavians are still on their thrones.

'S-HERTOGENBOSCH
❖ ❖

Den Bosch, as it is usually and helpfully called, is a relaxed canal-side city in the Netherlands that was once the citadel of a duke, Hertogen, after whose wood (*bosch*) it takes its name. Though the citadel walls survive, it has more the feel of an English garden suburb. Even the city centre, with houses no higher than three storeys, is unobtrusive. Nowhere would be a more implausible birthplace for the late-medieval artist Hieronymus Bosch (c.1450–1516) – were it not for its Gothic cathedral. It is the star of Dutch churches, but it might be from another planet.

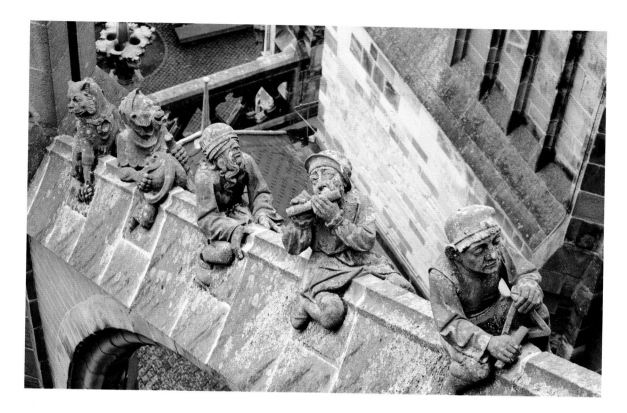

The cathedral has a French appearance, though it is more in the Flamboyant Low Countries style known as Brabantine Gothic. The west tower is Late Romanesque of c.1220, in brick with plain round-arched openings and with a later Baroque onion dome. The rest of the church was rebuilt after 1380, in riotous Brabantine. Its exterior ledges, niches and pinnacles are laden with filigree stonework, while a reputed 600 medieval carvings of angels, priests, animals, monsters and townsfolk cling to every spare inch. All Den Bosch is on the roof, peering, grimacing, laughing, playing music or just crawling up buttresses. Ghouls clamber across tiles and spout water from gargoyles.

We can only imagine the ingenuity and fun that must have gone into this public circus. The architect of this final stage of the cathedral was named Alaert du Hamel (c.1450–1506), also a sculptor and artist. As a fellow member of the local artists' guild he would have known Hieronymus Bosch. Some prints by du Hamel survive that are remarkably similar to Bosch's more fantastical works.

In the course of a restoration begun in 1998, a local sculptor Ton Mooy replaced forty of the more eroded statues, including fourteen angels. One of Mooy's angels fixed to the south transept is clad in wings, jeans and a sweatshirt and talking on a mobile phone. The phone is said to have just one button, 'to God'. A number subsequently posted in a town window purported to be that of the phone and had a lady answering callers as 'the angel'. She offered therapeutic advice and was getting thirty calls a day. This soon got out of hand and another number, promoted by the cathedral, also purported to be the angel, in a bid to raise funds. The church became Protestant after a burst of iconoclasm in 1629 but reverted to Catholicism under Napoleon in 1810, gaining cathedral status in 1853. Its interior is that of

a Late Gothic hall church with double aisles lit from triforium and clerestory. The furnishings reflect the Catholic restoration. Arcade piers all carry statues and aisle windows are filled with stained glass. The crossing might be that of a banqueting chamber, the roof alive with decorative frescoes. One of the crossing statues has its canopy twisted into a swirl, apparently by the architect du Hamel as proof of his innovative talent. He is also credited with the Holy Sacrament Chapel to the left of the apse.

Den Bosch demonstrates the visual compatibility of Late Gothic and Baroque. We see it in the pulpit canopy of 1560 and the organ case of 1620. The choir apse is almost another Beauvais, a semicircle of narrow arches soaring upwards from a Baroque altar to a close-ribbed vault. The choir frescoes are of Rococo angels with musical instruments.

Two paintings thought to be by Hieronymus Bosch hang in the north transept. Of all the Dutch church interiors painted by the master of the genre, Pieter Saenredam (1597–1665), that of Den Bosch choir is regarded as his finest, a harmony of Gothic light illuminating a Baroque altar. It is now in Washington's National Gallery, but oh to have it back here in the cathedral.

STOCKHOLM

⁜

I first visited Stockholm's old town, Gamla Stan, on a snowy evening before Christmas. Every window on the island was lit as if with a single candle and the scene was enchanting. The ancient façades seemed to float across the lagoon as if in Venice. In their centre was the façade of Stockholm's cathedral, the Storkyrkan or Great Church.

This was the original parish church and royal chapel of Stockholm, not elevated to cathedral until 1942. The early church was rebuilt in the 13th century and completed in 1496 as a Late Gothic hall church. None of this appears outside as the exterior was given a complete Baroque facelift in 1745. This was so as to conform to the Classical style of Gamla Stan in general and of the new royal palace next door. The façade is modest and elegant rather than imposing.

The cathedral interior is quite different. Here conflicting styles jostle for attention. Redbrick piers and vaults on white plaster walls affirm the church's Gothic origins. But while almost all the thirty chapels and altars added by the early 15th century have disappeared, every corner is alive with Baroque furnishings. The Storkyrkan may be a Lutheran cathedral, but it would surely have given Luther a fit.

The dominant feature of the nave is the presence of red brick. The piers are clusters of brick shafts, rising to a vault of thin brick ribs on white plaster. This brings to the ceiling a colour and warmth unusual in a Gothic interior. The windows are clear and the sun shining on brick creates a most pleasing effect.

The furnishings are exceptional. The nave is overwhelmed by three oversized intrusions, a pulpit and two monumental pews, in effect royal thrones, in the most ostentatious Baroque. They were designed by Nicodemus Tessin the Younger (1654–1728), who as

← Den Bosch: angel on mobile
→ Stockholm: St George and the Dragon

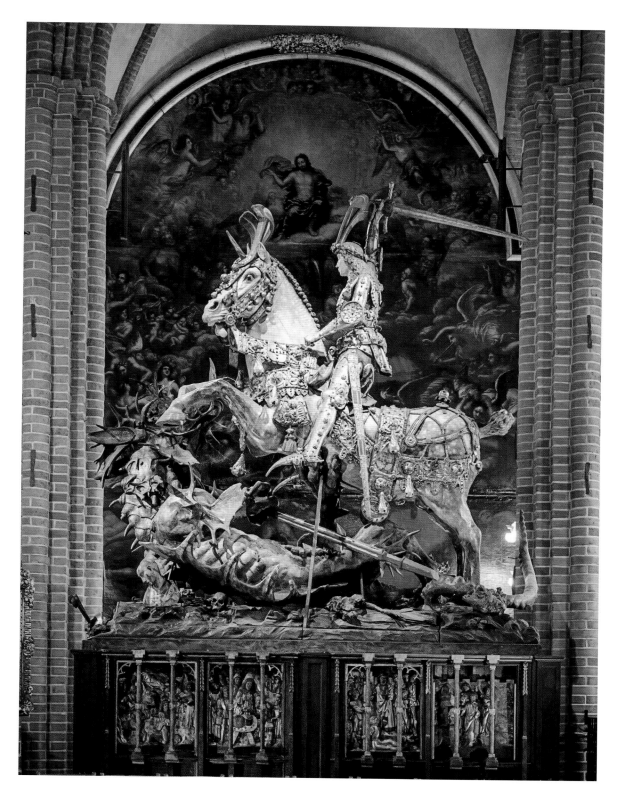

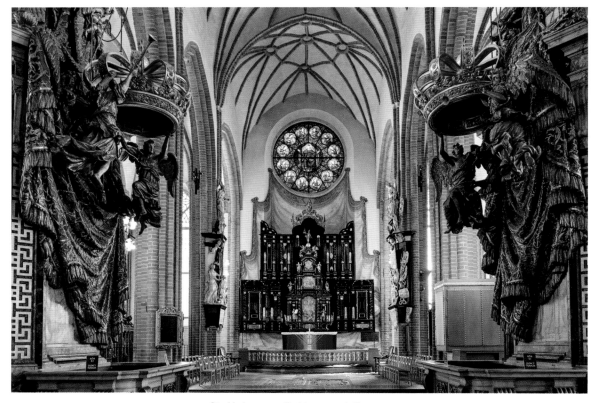

Stockholm: warm Gothic, eccentric Baroque

a young man had studied in Rome under Fontana and Bernini and returned to serve as a court architect, clearly with ambitions of similar grandeur. His work in the cathedral might be more suited to St Peter's.

While the pulpit is a conventional design, albeit gilded to the hilt, the two royal pews are extraordinary. They have canopies of giant gold crowns above curtains drawn back by naked youths as if revealing the royal occupants only to the altar and God. They would once have contained a throne each. The altarpiece is altogether quieter, a restrained Baroque work of 1652 made of black ebony framing silver statues and plaques. It rises to a vividly colourful rose window which, from a distance, looks designed for target practice.

Immediately to the left of the altar is Stockholm's treasure dating from the 15th century. This is the statue of St George and the Dragon commissioned by Sweden's then regent, Sten Sture (r.1470–1503) to celebrate his military victory over the Danes in 1471. The work is attributed to Bernt Notke (1440–1509), a little-known Estonian sculptor but clearly among the first rank of late-medieval artists. A young St George rises on a magnificent horse to smite a dragon which appears to have deer's antlers. Round the plinth are scenes from the saint's life and that of his adoring princess.

Overlooking the statue are the cathedral's two monumental paintings by David Ehrenstrahl (1628–98) depicting the Crucifixion and Last Judgement. The remainder of the interior is a gallery of mostly Baroque memorial sculpture honouring Sweden's royal family and aristocracy. The cathedral was much used for royal coronations and weddings, though less so of late. As with Denmark's Roskilde, it presents a curiously unScandinavian evocation of royalty.

TRONDHEIM

✣ ✣

Medieval heroes are necessary to the history of states. Whether St Olaf II, ruler of Norway from 1015 to 1028, was a hero, a saint or even a devout Christian is debated. He may have saved London from its shared enemy, the Danes, in 1014 supposedly by destroying London Bridge and thus originating the rhyme 'London Bridge is Falling Down'. London is certainly dotted with St Olaf churches. But he was eventually defeated by Cnut and the Danes and died in battle in 1030. His memory inspired Norway to grant him a shrine in his old capital of Trondheim, then Nidaros, which went on to become the grandest church in Scandinavia.

Nidaros cathedral stands heavy and massive in the centre of Norway's third city. It could hardly be further removed from the wooden stave churches of the country's medieval tradition, which sadly left us no cathedral. A Romanesque church of the early 12th century – surviving in the present transepts and choir – was extended in the Late Gothic era and survived until Norway's conversion to Lutheranism in 1537. There followed a swift descent into dereliction, a severe fire in 1708 and a comprehensive 19th-century restoration. A sizeable portion of Trondheim's western arm is Neo-Gothic.

The exterior is heavy and big-boned. The 19th-century roof is crowned with two west towers and a tall crossing tower, all with modern conical spires visible across the city. The stone is a hard grey-black, much improved by a dusting of winter snow.

The cathedral's best-known feature is its largely 19th-century Neo-Gothic west front, with a Flamboyant rose window inserted in 1930. It comprises a sculpture gallery in the manner of England's Wells and Exeter. This has three tiers of statues, each bigger than the one below to aid visibility. Just five of the original statues survive – now in the cathedral museum – and the current angels, disciples and

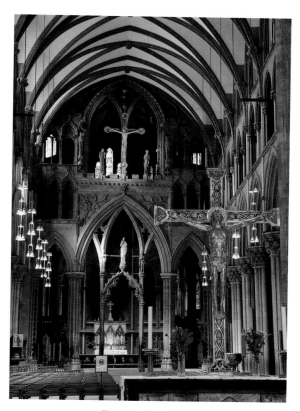

The nave looking east

saints were all recarved in the 20th century. They are supremely expressive, as if each was eager to step from its niche to tell its tale.

The interior of Trondheim is familiar Late Gothic. The nave arcades have multiple-shafted piers and an elaborate vaulted ceiling. The building comes alive at the crossing, where the walls are still largely those of the 12th-century church, notably in the Romanesque south transept. Its elaborate doorway has an external surround of multiple zigzag arches. Inside is a charming small chapel of St John.

Links between medieval Norway and the British Isles were strong. Critical to Trondheim's design is thought to have been a bishop who returned from three years of exile in England in 1183, bringing with him a team of Anglo-French masons. The result are a number of features said to imitate those in England. The long choir, now an extension of the

nave, is strongly reminiscent of Lincoln cathedral's St Hugh's Choir, while the beautiful Gothic screen between the choir and apse octagon are similar to that at Wells. That said, almost all these features are earlier than their English equivalents — and might reasonably claim to be their precursors.

The screen dominates the cathedral's eastern arm. It consists of three open arches, the central one higher and framing a statue of Christ the Teacher. Behind are views of the ambulatory, a dark passage of cusped and intersecting arches with openings into the altar sanctuary. Beyond is an octagonal chapel.

The interior of the nave's west wall is dramatically filled by a large Steinmeyer organ designed in 1930 and restored in 2014. Its swooping modernist outline mirrors the contour of the vault overhead. In contrast is a second organ in the north transept, its case a handsome Baroque of 1738. The pipes and Rococo cherubs are so beautifully arrayed they look as if they could play this keyboard unaided.

The west wall lancets and rose windows above the organ are a tremendous burst of blue and red stained glass created mostly between the wars by a Trondheim artist, Gabriel Kielland (1871–1960). He was also responsible for virtually all the cathedral's stained glass, showing how successful such a programme can be when planned as a coherent whole. On dark winter evenings when the glass is invisible, the interior is superbly lit, converting a work of architecture into a visual drama.

The crypt, unusually for a cathedral, contains a collection of tombstones, some dating back to the 12th century. Norway's crown jewels are kept in the adjacent museum, though the country's kings have not been crowned here since 1908. However, Trondheim has restored its medieval status by becoming a destination for Europe's burgeoning pilgrimage movement. Getting there involves a spectacular 490km trek from Oslo to this northernmost episcopal outpost of European Christianity.

→ Trondheim: the faith of the Norse

SPAIN AND PORTUGAL

BARCELONA, SAGRADA FAMÍLIA ✦✦✦;
BURGOS ✦✦✦✦; CÓRDOBA ✦✦✦✦;
GERONA ✦✦; LEÓN ✦✦✦;
PALMA, MAJORCA ✦✦; SALAMANCA ✦✦✦✦;
SANTIAGO DE COMPOSTELA ✦✦✦;
SEGOVIA ✦✦✦; SEVILLE ✦✦✦✦✦;
TOLEDO ✦✦✦✦✦; ZARAGOZA, LA SEO ✦✦;
COIMBRA ✦

came late to the cathedrals of Spain. I was initially a reluctant admirer, unattracted to their Baroque extravagances and the aura of ancient intolerance. In time familiarity changed my mind as these great churches wove their spell of self-confidence and architectural splendour.

Spain had been a Roman province that was then occupied by Christian Visigoths for three centuries. In 711 a Muslim Umayyad army crossed the Strait of Gibraltar from North Africa and by 718 had conquered all of Iberia apart from the northern enclave of Asturias. The invaders were Arabs, Syrians, Egyptians and Berbers, tribes sharing little beyond their Islamic faith.

Though ignored as barbarians in Christian history, the so-called Moors gradually brought the science, culture and sophistication of the Middle East to what became for more than three hundred years a civilized outpost of Islam in western Europe. Granada and Córdoba were great cities, the latter a centre not just of Muslim but also of Jewish culture. It was tolerant of Visigoth Christianity, known as Mozarabic. By the 11th century Córdoba was the most populous city in Europe after Constantinople, ahead of Paris.

Moorish Spain had one overriding weakness. As was said of ancient Athens, it mastered all the arts but that of politics. By the 12th century it was disintegrating from within, falling easy prey to Christian *reconquista*. Already in 813 the 'discovery' of the bones of the apostle St James at Santiago in Galicia had opened up northern Spain to pilgrimage, mostly from France. The reign of Alfonso VIII of Castile (1158–1214) saw the uniting of the north under Castile and the recapture of Toledo. In the 13th century Ferdinand III of Castile (r.1217–52) presided over the conquest of most of the south, taking Córdoba in 1236 and Seville in 1248.

None the less Iberia remained fragmented into sovereign territories such as Portugal, Galicia, León, Castile and Aragon. Not until the marital alliance of Isabella of Castile (d.1504) and Ferdinand of Aragon (d.1516) in 1479 was most of Spain united in a new and potentially powerful state. The final Moorish outpost, the emirate of Granada, fell to Ferdinand in 1492, an *annus mirabilis* that also saw the opening up of the Americas by Columbus in Spain's name. Muslim Iberia was reduced to minarets, horseshoe arches, gilded mosaics and castanets, though a few craftsmen continued to practise a style of decoration known as *mudéjar* (Arab for staying behind), adorning some cathedral buildings.

A new and confident Spain now blazed across the sky of European history. American and Flemish wealth funded a burst of 16th-century energy under the Habsburg Holy Roman emperors. Pledges of religious freedom in Spain for Muslims, Jews and non-Catholics were broken. For a brief period from the mid-16th to the mid-17th centuries the dynastic union of the royal houses of Spain and Austria led Charles I of Spain to become Charles V (r.1516–56) of what was Europe's greatest political union since the fall of Rome.

Charles and his son Philip II (r.1556–98) treated empire as a tool of religious uniformity. The Madrid regime degenerated into a fanatical piety, inbreeding and the horrors of the Thirty Years War (1618–48) and the War of the Spanish Succession (1701–14). The decline was satirized in the gloomy drama of *Don Quixote* by Cervantes (1547–1616), a writer said to have 'killed a nation'. The persecution and eviction of Jews and Protestants drove out enterprise, leaving Spain with a legacy of conservatism and isolation which held it aloof from the enlightenment that was to be the making, if sometimes the breaking, of northern Europe.

Many of the early Spanish cathedrals were built to receive travellers to Santiago. From the Romanesque vastness of Santiago itself to the High Gothic effusions of Burgos and León, the inspiration for these buildings was overwhelmingly French. Monastic orders, notably France's Cluniacs, founded hostelries along the route. Spanish bishops visited Bourges and Chartres, bringing back masons and craftsmen to be joined by artists from Germany, Flanders and Italy.

By the 16th century, Reformation and schism were threatening most of Catholic Europe, but Spain's suppression of dissent maintained loyalty to Rome. The Habsburgs oversaw a cathedral embellishment that was without parallel elsewhere in Europe. Burgos, Toledo, Salamanca and Seville outshone the rest of Europe in decorative exuberance. This golden age even evolved a distinctive style of relief carving, Plateresque, in the transition from Gothic to Renaissance.

By the 17th century Spanish cathedral design had given way to fully fledged Baroque. American gold enriched sanctuaries, chapels and altars. This was to reach its apotheosis in Toledo's Transparente, Seville's altarpieces and the elaborate woodwork of choir stalls, now usually located behind high screens in cathedral naves. Jan Morris describes such a choir as 'less a sanctuary than a library … where we can sniff its bookish atmosphere and inspect the choir stalls in the gloom'. I find them magical places.

When I first visited these cathedrals in the 1970s they were like Miss Havisham's wedding banquet, a gilded promise frozen in time. Bloodstained crucifixes and sobbing Madonnas loomed out of the darkness coated in dust. There seemed something pagan in the obsession of Spanish churches with sacrificial violence. But judgemental history is senseless. These are historic buildings and we must accept them for their time and place. Spain's cathedrals have undergone the most comprehensive restoration of any in Europe, enabling them to emerge resplendent into the present. They are spectacular buildings especially when floodlit at night.

Meanwhile the care with which Spanish cities and towns have guarded the settings of their cathedrals is admirable. Centuries of poverty may have spared Spain intrusive urban renewal but that has become a blessing. Seville, Córdoba, Toledo and Salamanca rank among the most treasured cities in Europe, and attract visitors accordingly. In this sense Spain's golden age is thankfully still with us.

BARCELONA
SAGRADA FAMÍLIA
⁂ ⁂ ⁂

When I first visited the Sagrada Família it was a cluster of see-through spires rising amid what seemed derelict scaffolding. Designed by Antoni Gaudí (1852–1926) in 1883, it was a deserted building site. There seemed little hope of realizing Gaudí's bizarre vision of Spanish Art Nouveau. Visitors to Barcelona had to rest content with the city's official cathedral in its Gothic quarter, a fine Gothic building if not of the first rank.

Today the Sagrada Família is almost complete, having been consecrated as a basilica in 2010. The interior is finished and of the exterior only the central towers round the giant Jesus tower are awaited. Builders with robotic fabricators and computer printers work to meet a deadline of 2026, fuelled by the revenue of one of Europe's most visited churches. Now time-ticketed, it earns $25m a year towards its completion.

The church was an 'expiatory temple' proposed in 1866 by an eccentric Catalan publisher, Josep Bocabella. He began in 1882 with a conventional Neo-Gothic design but a year later met the young and deeply pious Gaudí and immediately recruited him. The architect saw the project as an assertion of traditional Catholicism against modernism and democracy. Work continued slowly until 1926 when, with his building only just begun, Gaudí was run over and killed by a Barcelona tramcar. Ten years later in the Spanish Civil War revolutionaries destroyed many of Gaudí's plans and models. Progress now depended on charity.

Gaudí believed that natural forms should hold the key to human design. Nature, he wrote, 'was

→ Sagrada Família: Gothic refashioned, reborn

the Great Book, always open, that we should force ourselves to read'. The church was to be his Bible, a visual narrative of his faith. It was no romantic conceit but a full-blown reinterpretation of the Gothic imagination. The exterior has at first sight an excess of folksy romance, as if by Disney out of Tolkien, though to me it is none the worse for that. The interior is a different matter. It has the soaring sensationalism of an Amiens or Beauvais. Whether we call it late Gothic or Catalan Art Nouveau does not matter. It is Gaudí.

In honour of nature the exterior displays no right angles and few straight lines. There are eventually to be eighteen towers, representing the twelve apostles, the four evangelists, Mary and Jesus. The towers will contain bells supposedly rung by the passage of the wind. The Jesus tower of 172m, when complete, will be the tallest church tower in the world.

The portal façades followed the traditional iconography of Christian cathedrals and are masterpieces of decorative imagination. The Nativity façade is a menagerie concealed in a grotto. The pillars separating the three doors are based on a turtle and a tortoise representing sea and land, while the surrounding stonework seems carved out of a cliff rather than built by hand. Gaudí chloroformed animals and birds to cast them in plaster, and even obtained aborted foetuses as models for babies 'because they lie still'.

The Passion façade was not begun until the 1950s, twenty-four years after Gaudí's death. It is like the jaws of a giant shark, gaunt with sculpted figures depicting Christ's torments. The doorway is topped by a palisade of what look like bones picked dry. The unfinished Glory façade will complete the ensemble, embracing heaven, hell, damnation and redemption.

To the enthusiast for Gothic interiors, the interior of the Sagrada Família is a radical departure. The plan is conventional, of nave, double aisles, transepts, sanctuary and ambulatory. Conventional too are such Gothic features as piers and shafts, arches and vaults, windows and stained glass. There ends

convention. Columns soar and dive like eagles in flight, swelling, narrowing and twisting. Nothing seems symmetrical yet there is visual coherence to the whole. To lie on a bench and look upwards as most visitors do is to watch a starburst of ribs and vaults erupting overhead. The south-nave glass at sunset turns the interior aflame. Galleries and staircases stacked round the crossing are like boxes in an opera house.

Like any artistic novelty, the Sagrada Família has attracted mixed responses. Visiting it during the Spanish Civil War, George Orwell called it 'one of the most hideous buildings in the world' and thought 'the Anarchists showed bad taste in not blowing it up'. Yet to Walter Gropius it was 'spirit symbolised in stone'. What to the critic Robert Hughes was 'melted candle-wax and chicken guts' was to Nikolaus Pevsner 'sugar loaves and anthills … handled with vitality and ruthless audacity'. Some of the exterior sculpture looks slapdash and the quality of much of the detail is sacrificed for overall effect, applied long after Gaudí's death. But that effect is sensational.

The Sagrada Família offers intriguing comparison with its English contemporary, Giles Gilbert Scott's Liverpool cathedral. Scott's church accepted the disciplines of the Gothic canon, while Gaudí uses that canon as a theme on which to play endless variations. He shows the self-confidence of an artist for whom style is merely a point of departure. The church dates from a time when architecture was losing faith in the decorative tradition and becoming slave to engineering rather than its master. Gaudí has none of that.

← Sagrada Família: carved as from a cliff
→ Gaudi's nave: Gothic reinterpreted

BURGOS

✣ ✣ ✣ ✣

Burgos cathedral in its busy city north of Madrid is magnificent, but for me it comes with a health warning. It is heavy with the clutter of centuries of Catholic worship and can seem indigestible to those of a sensitive disposition. After hours of bloodshed, damnation, crucifixion and torture, I retreated to the Plaza Rey San Fernando for a stiff Protestant drink. Yet it ranks among the great cathedrals of Europe, believed to have been built by masons influenced by France's Bourges.

Burgos began soberly enough. A former pilgrimage shrine to the Virgin was rebuilt from 1221 by Ferdinand III of Castile (r.1217–52), a monarch eager to bring to his country something of France's – or at least Paris's – emerging panache. The design was by the French master Enrique who worked also on León. The cruciform plan is austere, with unadorned double buttresses and plain window tracery. In the

15th century the design was transformed by a family of masons, the Colonias from Cologne, who created an eruption of Flamboyant Late Gothic.

Juan de Colonia's towers define Burgos from a distance. The two western ones are topped by pyramid spires composed of openwork tracery in the German style, similar to those intended (and later built) for Cologne. The crossing tower was replaced after its collapse in 1539 in Transitional Gothic–Renaissance Plateresque. It is formed of an astonishing mixture of tracery, pinnacles, balconies and niches. Never was architecture so needlessly busy.

Since the cathedral sits on a slope, each side offers a different impression of the whole. To the south an open square leads up steps past the site

↑ Interior crossing coated in Plateresque
→ Burgos: towers fussy with encrustation

of the old bishop's palace. At the top is the lovely Sarmental portal into the south transept. The tympanum depicts Christ surrounded by the evangelists scribbling their gospels at their desks. Below in the archivolts are apostles, angels, musicians, scholars and kings, a congregation of medieval theology. Matching this portal on the north transept is the Coronería one. Here Christ is shown as a judge presiding over St Michael weighing souls and dividing them into saved and damned.

The interior of Burgos might be termed Gothic's last stand. The massive arcades would seem heavy were they not so soaringly high. The triforium is the most elaborately traceried anywhere. The view at the crossing upwards into the lantern is into a fairy-tale gazebo beneath a vault of windows. Faces and fronds erupt from every inch of stone.

The view below down the nave is broken by the Spanish arrangement of choir and sanctuary. The late 16th-century choir positioned in the nave is a gallery of Renaissance carving, each stall carrying reliefs of biblical scenes carved by the Burgundian master Felipe Vigarny. East of the crossing the sanctuary is dominated by the high altar and reredos completed in 1585. This is arranged like a four-storey doll's house, its interior rooms open to view. Again it portrays biblical scenes overrun by putti as if by golden mice.

Burgos's chapels are hard to take at one sitting.

St Thecla's Chapel in the north-west corner was designed in part by the ultra-Baroque Alberto Churriguera in the 1730s. It is a fantasy of white columns rising to a ceiling of abstract decoration. The reredos is a near-demented composition of columns and cornices dripping gold and cherubs. Two workmen cheerfully build a pyre under a prospective martyr, fashionably dressed and looking more than ready for his ordeal.

The Chapel of St Catherine is entirely walled by wood panels on which hang episcopal portraits. The sacristy's Rococo ceiling shows Christ orchestrating what might be a vast bank holiday outing in a celestial paradise. In the Corpus Christi Chapel is the chest of El Cid, Burgos's 11th-century hero, reputedly sold by him as full of gold when it was really full of sand.

East of the ambulatory stands the Chapel of the Constable. Begun in 1482 by Simón de Colonia it is a climactic work of Late Gothic. Arches outlined in filigree rise to tiers of windows and a starburst vault. The support shafts are so delicate they might be suspended from above. Even the tilting shields in the wall medallions draw the eye upwards. The altarpiece, mostly by Vigarny and completed in the 1520s, faces a beautiful Plateresque doorway, Gothic declining gently into the advancing Renaissance. The 1490s reredos of the St Anne altar is by the Flemish-born master Gil de Siloé. This is Spain at the height of its European eminence. Strip away the pious poses and we see fashionable ladies of medieval Burgos on self-conscious parade.

Burgos's 13th-century cloisters are lavish, rising two storeys. The portal to the upper cloister retains its original colouring, depicting Jesus entering Jerusalem. The chapel dedicated to my favourite saint, the scholarly Jerome, has a reredos depicting his comforts and his torments.

↖ Sarmental portal: evangelists hard at work
↑ The sacristy's orchestration of delights

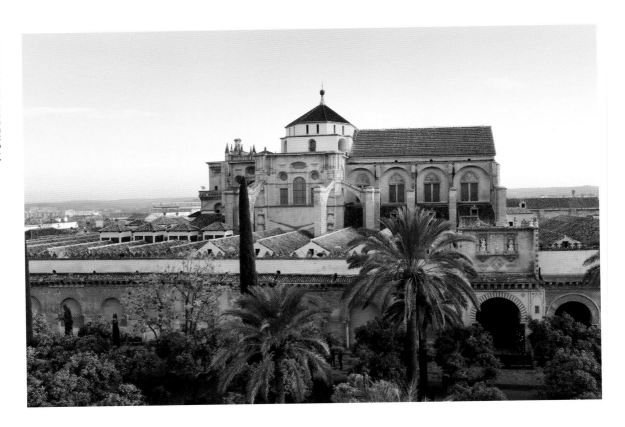

CÓRDOBA

✣ ✣ ✣ ✣

For centuries Córdoba was the unsung city of medieval Europe, unsung because it was not Christian. In its 11th-century heyday it rivalled Baghdad as a capital of Islam and Constantinople as a European metropolis. Its caliphate, wrote Jan Morris, was 'so cultured, sophisticated, broad-minded and fastidious that, for a century, southern Spain was the lodestar of Europe. Religious diversity was tolerated, universities and learning were encouraged and poets abounded.' It could be said that Córdoba was the only European city that matched ancient Rome in civilized living. It even had a domestic water supply and street lighting.

The life was often sybaritic. One caliph would drift between his magnificent library and his male and female harems. Perhaps inevitably such a culture was not proof against political decay. In 1236, Córdoba was seized by Ferdinand III of Castile (r.1217–52). But when the incoming Christians proposed destroying the mosque and replacing it with a church, local Christians, Jews and Muslims combined to condemn such vandalism, declaring that the mosque 'could never be replaced by anything of such perfection'. The result is the most unusual building in Spain if not in all Europe, a mosque into which has been dropped a Gothic church like some architectural joke – or perhaps insult.

The mosque is unquestionably dominant. It was begun in 785 by the Moorish leader Abd al-Rahman I on the site of a Roman temple turned Visigoth basilica. Fragments of this are on display inside. The exterior can be baffling. There is no orientation, no grand entrance and no striking profile or skyline. There is certainly no outward evidence of Christian faith.

The site is surrounded by what amounts to

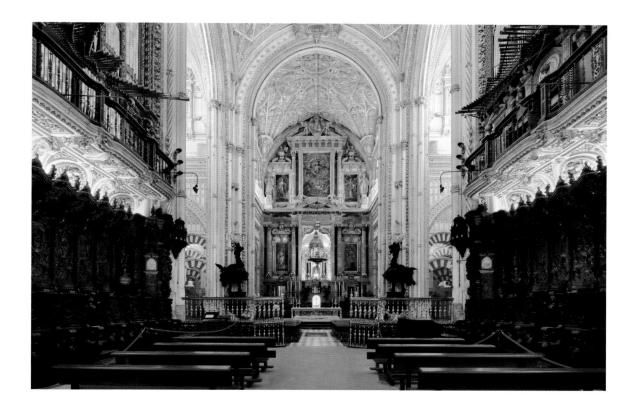

a battlemented wall pierced by a dozen door-ways. Some are Moorish, some Gothic, some Renaissance. Over the main entrance rises a minaret much altered over the centuries. Entry is through a gate, the Puerta del Perdón or forgive-ness, a virtue of which 16th-century Spain had much need. This gives on to a traditional Islamic Patio de los Naranjos (oranges), its trees imitating the orderly columns of the mosque interior.

On entering we still see no sign that this is a church. The original mosque's prayer hall was extended at least four times and is vast, comprising nineteen transepts and thirty-six aisles. These do not soar, but rather form an intimate forest of columns rising to gently undulating horseshoe arches. Many of the columns date from Roman and Visigoth pre-decessors, some with intriguing capitals. It is as if the Moorish masons were half remembering the motifs of ancient Corinth.

The striped red and white stone of the arches reminded the traveller H. V. Morton of a herd of zebras lost in a maze of mirrors. The effect is enhanced when the uplighters are turned on and the hall becomes a giant tent. Unfamiliar visitors wander these arcades lost in their seemingly end-less replication.

On the east side furthest from the entrance stands the surviving focus of the old mosque, the *mihrab*. This is an octagonal alcove framed by a horseshoe doorway with arabesque designs. It is the loveliest of portals through which can be seen the empty niche indicating the direction of Mecca. Outside is the *maqsura* or reserved space where the caliph and his courtiers would pray. Its cupola is composed of shimmering gold mosaics dating from the 10th

↖ Córdoba's Christian cuckoo in Muslim nest
↑ Renaissance choir and sanctuary
→ An undulation of arches

277

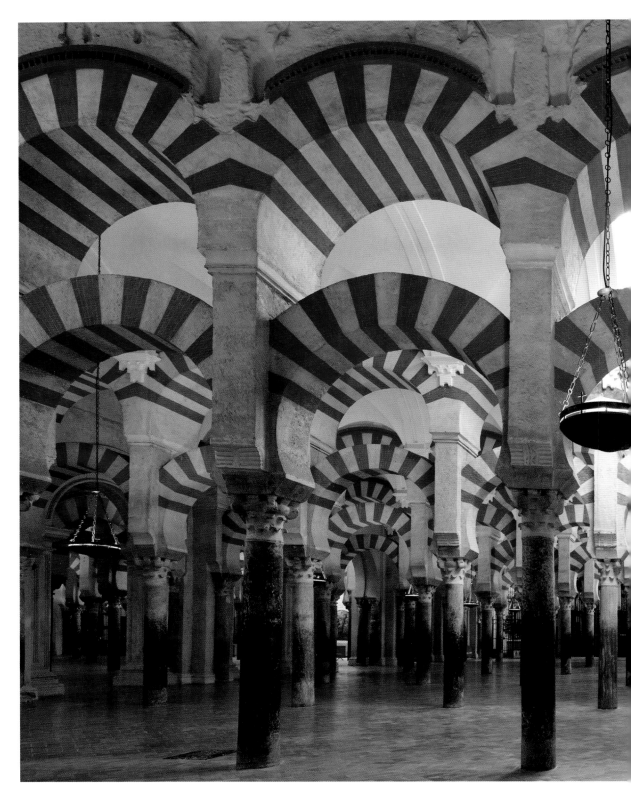

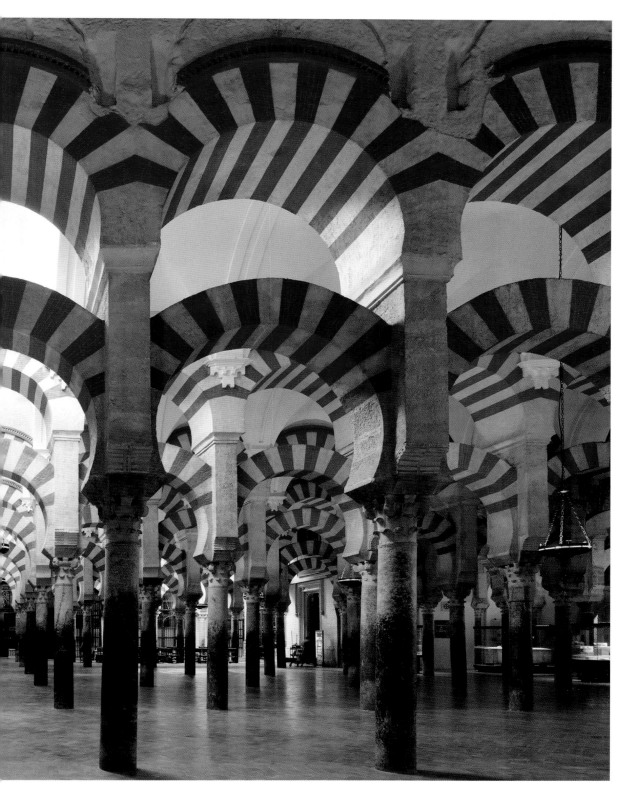

century. Scholars have traced its patterns to the great mosque in Damascus.

When Ferdinand's Christians arrived in the 13th century and demolition was forestalled, the mosque was initially divided and shared by the two faiths. A century later in 1371 it was decided to convert some of the bays facing the *mihrab* into a royal chapel, still displaying Moorish characteristics in its *mudéjar* designs, including a Flamboyant 'polylobed' arch. Another century later and a chapel named the Villaviciosa was inserted next door. Here the 'nave' is described as Gothic, though the arcades rise to double-tier horseshoe arches in red and white stone, still with a Moorish flavour. Nowhere in Europe is the aesthetic fusion of east and west better illustrated.

At this stage the building was still in essence a mosque. But, come the 16th century, Charles V found this intolerable. His bishop Alonso de Manrique decided to erect on the site a proper cathedral in the Renaissance style. As before, the proposal was bitterly opposed by Córdobans and by their local council, which threatened with death anyone who progressed the plan. The emperor eventually overruled the council and in 1523 building commenced, but went only as far as a choir, sanctuary and crossing inserted into the central bays of the mosque. It is said that when Charles saw what he had initiated he regretted his decision, remarking, 'You have destroyed something unique to build something commonplace.'

As so often in these battles, time softens the shock of the new. Today the high altar, the crossing cupola and the enclosed choir are part of the eccentric character of Córdoba. Starting with the choir, the designers were successively Hernán Ruiz the Elder (d.1547), his son (d.1569) and his grandson (d.1606). Their work reflects the 16th-century transition from Late Gothic to Plateresque, with the roof a full-blown Spanish Baroque. The high altar came in the 17th century, the choir stalls and grand bishop's throne in the 18th. The stalls tell the Bible story in West Indies mahogany and are among the finest in Spain.

Other insertions came later, as some thirty Christian chapels were situated round the mosque perimeter wall. The charming Chapel of St Theresa is delicately Rococo, containing an elaborate monstrance made in 1518 and encrusted with American gold. The Chapel of Our Lady of the Conception is chocolate-box Catholic Mannerist. These insertions offer a noisy contrast with the quiet dignity of Moorish arcades and the *mihrab* closet.

In 2004 a request by local Muslims to resume worship in part of what had been their building was refused by the Vatican. We duly leave Córdoba with a touch of irony, through the gate marked forgiveness.

GERONA
✤ ✤

The cathedral in the ancient Catalan capital is not so much a thing of beauty, more a sensation. It sits like a giant biscuit tin of stone on a hill reached by ninety-six steps. The church dates back to Charlemagne's recapture of Catalonia from the Moors in the 8th century, during which period an earlier building sometimes served as a mosque. This gave way to a Romanesque structure begun in 1038, of which only the old bell tower and cloister survive. The present choir was completed in 1347 with a dividing wall and nave added by a builder named Guillem Bofill in 1417. Like its near contemporaries Palma and Albi, it dispensed with aisles and went full tilt for spatial effect. There is no truck with French flying buttresses to support the vault, just wings of solid stone.

The original exterior must have seemed a grim citadel looming over the city. It was softened by an octagonal bell tower begun in 1590 in a graceful Classical style. Then in 1606 a Baroque west front was attached to the façade. It is of three tiers of porticoes rising to a rose window coated in swags. The

→ Gothic grandiosity at Gerona

terrace below is reached by a spectacular flight of steps, much adorned with flowers on festival days. The surviving Romanesque tower, named after Charlemagne, can be seen embedded in the cathedral's north-east corner. It is a six-storey structure of double-arched openings looking like a visitor from an Italian hill town.

The impression of the interior of Gerona is dominated by the dividing wall between the nave and the apsidal choir beyond. It is like a triumphal entrance, Gothic at its most aggressive and in-your-face, demonstrating the thesis that the defining quality of a Spanish cathedral is not architecture but engineering, 'like medieval forerunners of Victorian railway stations'. The central arch is topped by a rose window and flanked by two side arches with lesser windows above. The wall is unadorned and of bare stone, its dramatic presence enhanced by the stained glass. It is matched by the nave's west wall, which is almost as overpowering. The vault overhead is said to be the widest Gothic vault in Europe, albeit somewhat austere.

The nave is lit by large clerestory windows and such light as can penetrate through the side chapels where would normally be aisles. The choir and apse beyond have lofty vaults and strong vertical piers, reminiscent of Beauvais and Le Mans. The curve of the ambulatory and its ten chapels is a relief from the right angles of the nave, introducing a sense of mystery. The altar dates back to the old cathedral of the 11th century.

The cloister is a contrast, a study in architectural delicacy. Its paired 11th-century columns have carved capitals of animals, people and vegetation, sadly much eroded. The cathedral museum is exceptionally rich in treasures, including a set of Gothic and Early Renaissance retables. Here too is Gerona's celebrated Tapestry of the Creation, a rare roundel of Romanesque needlework depicting various fantastical myths of how the world began. It might be considered a creationist icon.

↑ Gerona: Romanesque delicacy
↗ León: the tripartite west front

LEÓN

✣ ✣ ✣

León cathedral might be in France, as if design left an offering by French pilgrims on their way to Santiago. The two free-standing towers on either side of the west front look like male and female guards protecting a precious child. The building was begun soon after 1254 under the French master Enrique,

previously at Burgos. His inspiration was said to be Reims. The interior was not completed until the 15th century and retains most of its medieval glass. It is a serene evocation of French Gothic far from home.

The cathedral was located on a large Roman bath which caused subsidence throughout its life. What we see today is therefore much rebuilt, propped and buttressed. The west front is of three Gothic portals, their tympanums alive with sculpture. The central one

depicts the Day of Judgement, vivid with pathos and humour. An angel firmly bars the way to a naked member of the damned trying to sneak into heaven unseen.

León's interior is dubbed the House of Light thanks to its extensive clerestory and glazed apse. The view down its length from the west is obscured as in many Spanish cathedrals by an intrusive, if lovely, choir. This excuses itself by a screen in the form of a triumphal arch, a masterpiece of Early Renaissance carving by Juan de Badajoz the Younger (d.1552). Inside are choir stalls in dark walnut depicting saints in the upper tier and often satirical scenes from contemporary life below. Dating from Spain's overlordship of Flanders, they are precursors of the paintings of Jan Steen in the 17th century.

Renaissance and Gothic sit happily together in León. The crossing contains two splendid Gothic wall tombs, while the Chapel of the Virgin of the

Camino has a reredos whose pinnacles seem to clamber up the wall as if desperate to escape. The eye is led upwards to a magnificent set of medieval windows. Exhausted pilgrims must have marvelled to see the Bible story narrated across 1,800 square metres of glass, filling apse, chancel, nave and western rose. This is claimed to be the largest set surviving in any European cathedral, a claim so often made I long for a definitive league table.

León's originally Gothic cloister is a surprise. In the 15th century the younger Juan de Badajoz, designer of the choir screen, gave it what can only be called a makeover. He did not demolish the Gothic arcades and start again, but he coated them in Mannerist pilasters and dressed the vaults with pendants, bosses and corbels seemingly at random. Ancient frescoes and tomb carvings peer through this delightful stylistic assault. A charming capital in the south range depicts bakers hard at work.

The cathedral museum contains no fewer than fifty Romanesque Virgin Marys with crucifixions and martyrdoms galore. It also possesses a rich collection of early books, including a Mozarabic Bible, used by Christians during Moorish rule, and a rare codex in the ancient Leonese language. Spain's cathedrals are its British Museum, dispersed across the country to the delight of intrepid visitors.

PALMA, MAJORCA
⁂

On a prominent hill in the centre of Palma we might expect to see a luxury hotel. Instead there is a colossal sandstone cathedral sitting adjacent to the old royal palace. Palma was a base of the kings of the Aragonese confederacy which by the 15th century had become a 'thalassocracy' or maritime empire. Aragon embraced east Spain, the Balearics, Sardinia and southern Italy. It also produced the first and finest of Henry VIII's wives, Catherine of Aragon.

↑ León interior: the House of Light
→ Palma: Gaudí's Art Nouveau candelabra
↓ A palisade of buttresses

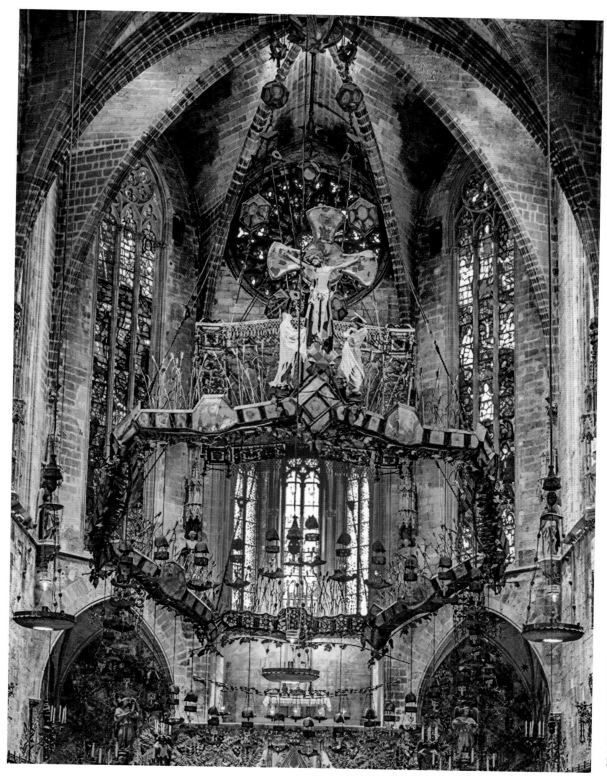

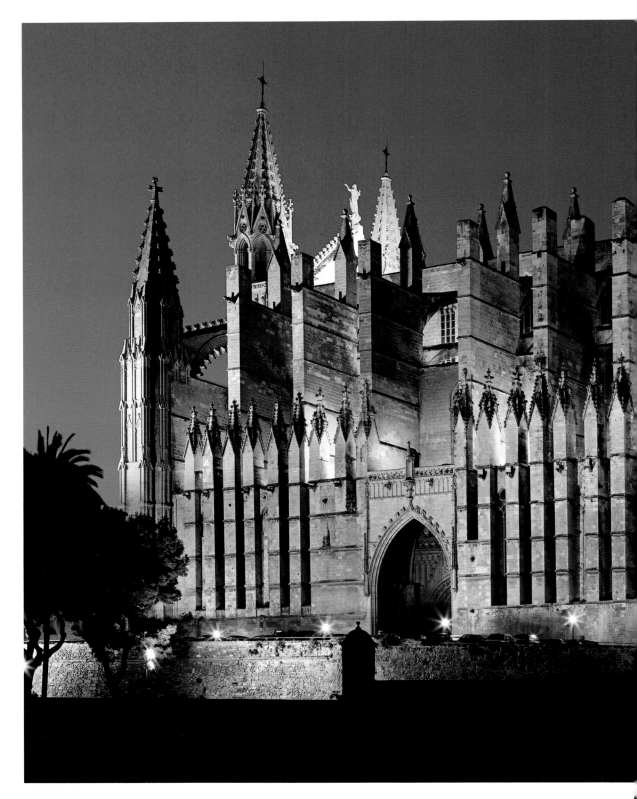

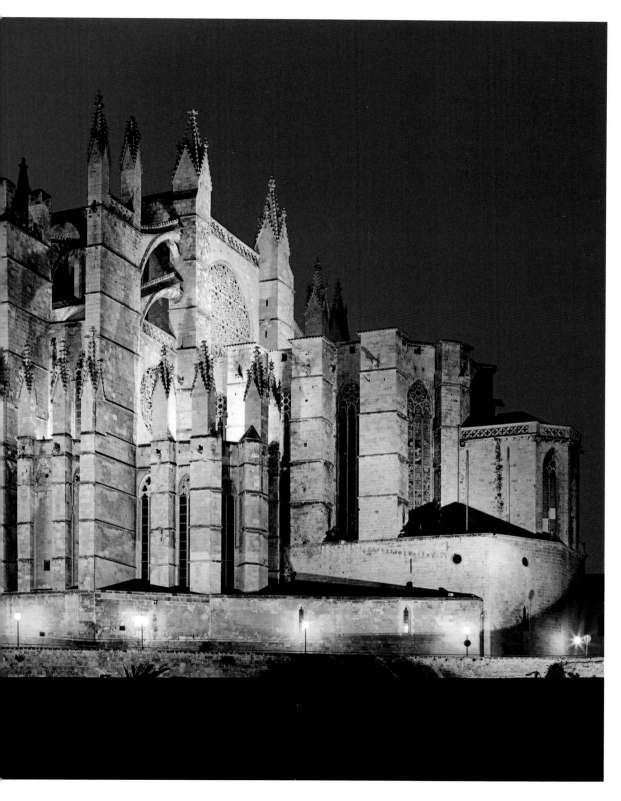

Begun in 1306 and not consecrated until 1601 the cathedral's 44m vault is higher even than those of Seville or Notre-Dame and only 4m lower than Beauvais. Its partial reordering by Antoni Gaudí in the 1900s is its principal feature, that and the view from its terrace over the port of Palma and the surrounding mountains.

The cathedral's exterior indicates a long struggle with an unstable site, leading to walls thickly encircled with almost despairing buttresses. These are solid below and flying above. Only the west front rebuilt after an earthquake in 1851 is devoid of such support. The roofline is etched in filigree stonework.

The interior presents a sensation of height. Nave and aisles are built of grey stone heavily mortared and gloomy but warmed by stained glass which, in the Mediterranean sunlight, dances over the walls. This is most effective in the rose window over the arch into the chancel, an arch charmingly called in Spanish a *cabecera* or headboard to a bed. The window is filled with abstract shapes ablaze with reds, blues and whites.

In 1899 the local bishop Pere-Joan Campins was dissatisfied with his builders and visited Barcelona, where Antoni Gaudí had started work on the Sagrada Família. He was captivated by Gaudí and commissioned the architect for a reordering of Palma. This commenced in 1903, but after ten years of increasingly stressed relations Gaudí walked off the project. By then he had moved the 16th-century choir stalls into the chancel, redesigned the bishop's throne, pulpit and candelabra and resurfaced the walls of the apse.

What we thus have is a medieval shell with an eastern arm transformed by a surreal neo-Gothic imagination. There are random tiles on the floor, coloured glass set into walls, swirling ironwork railings and chains of fairy lights. The candelabra hanging over the choir is a tilting heptagon carrying an Art Nouveau crucifix and thirty-five lamps. Much of this is made of wood and cardboard as the intended metal ones were never completed. The crests of the choir stalls and pulpit are composed of abstract shapes. The apse walls appear to be forested with giant fronds, notably round the bishop's throne. It is an extraordinary fantasy as if from a children's scrapbook.

South of the presbytery is St Peter's Chapel. Here an effusion of decorative energy depicts the parable of the loaves and fishes in a cave-like space, created by Miguel Barceló in 2006 in what might be called a homage to Gaudí. The walls are covered in cracked ceramics with sculpted fish, bread, fruit and skulls in panoramic relief.

We are left wondering what Gaudí would have made of the rest of Palma had he had time or patience. He concentrated instead on the Sagrada Família and for that too we must be thankful.

SALAMANCA

✤ ✤ ✤ ✤

The preservation of Salamanca into the 21st century is one of Europe's happiest miracles. Built of golden sandstone, the city is home to Spain's oldest university, founded in the 13th century, and to two conjoined cathedrals. The builders of the new one in the 16th century left the old 12th-century one standing to avoid any interruption of worship. Today they form a duet of Romanesque and Gothic in one compelling harmony.

A walk round the complicated exterior should start in the secluded Patio Chico. On its left is the apse of the old cathedral with its tower, the Torre del Gallo, a feast of blind arches, shafts, dogtooth and a pyramid roof covered in fish-scale tiles. Ahead across the Patio rises the south portal of the new cathedral, a fantasy of ogees beneath a scatter of Gothic motifs. Beyond is the new cathedral's central

→ Ancient Salamanca: old and new towers
↓ Nave vault soaring over choir

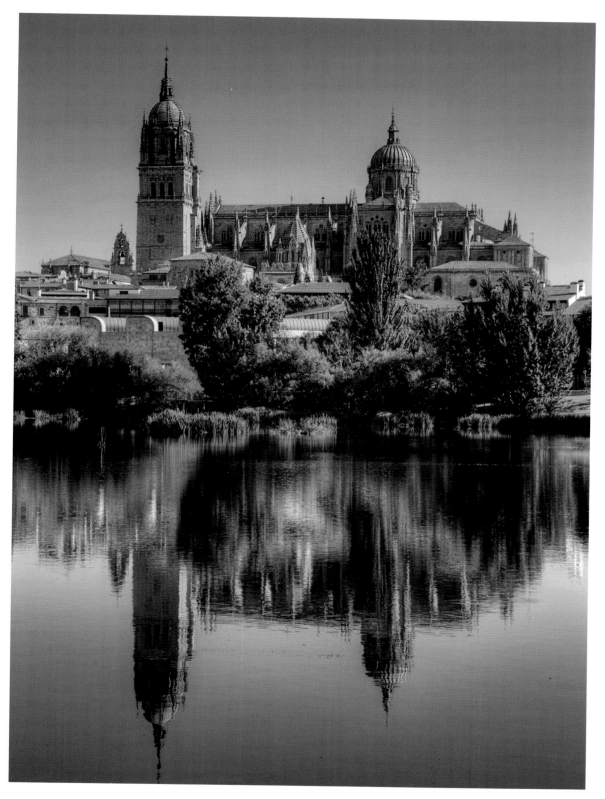

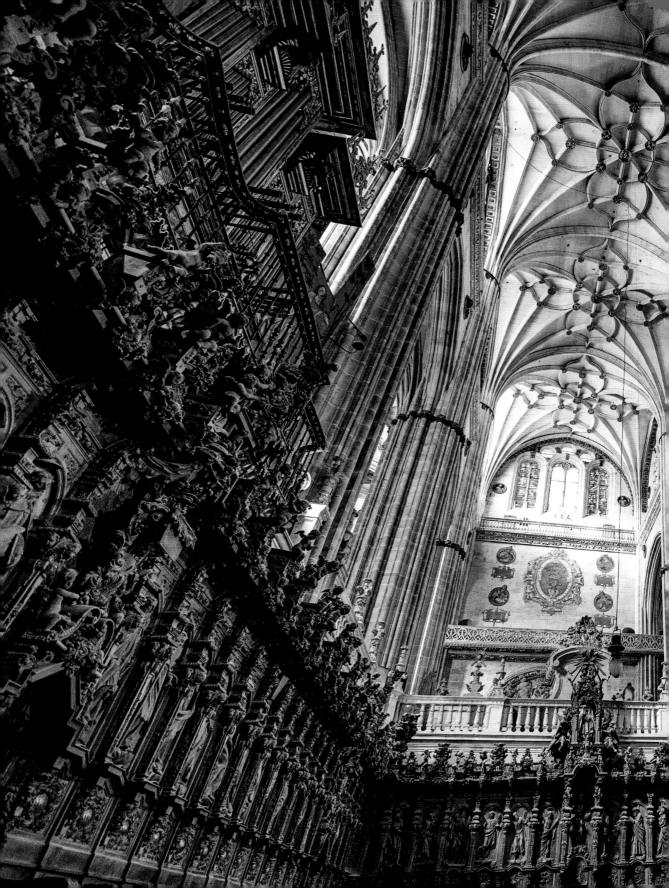

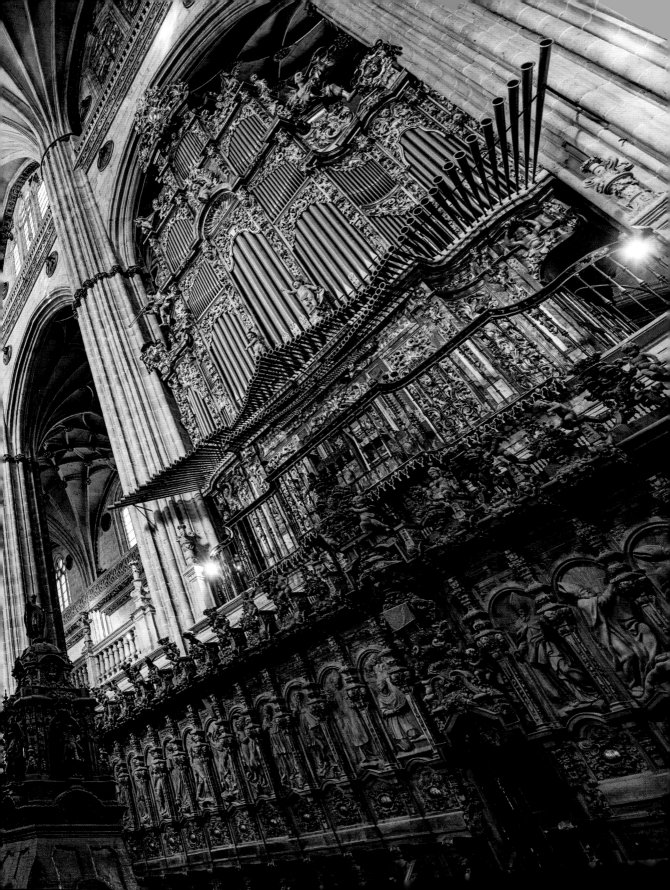

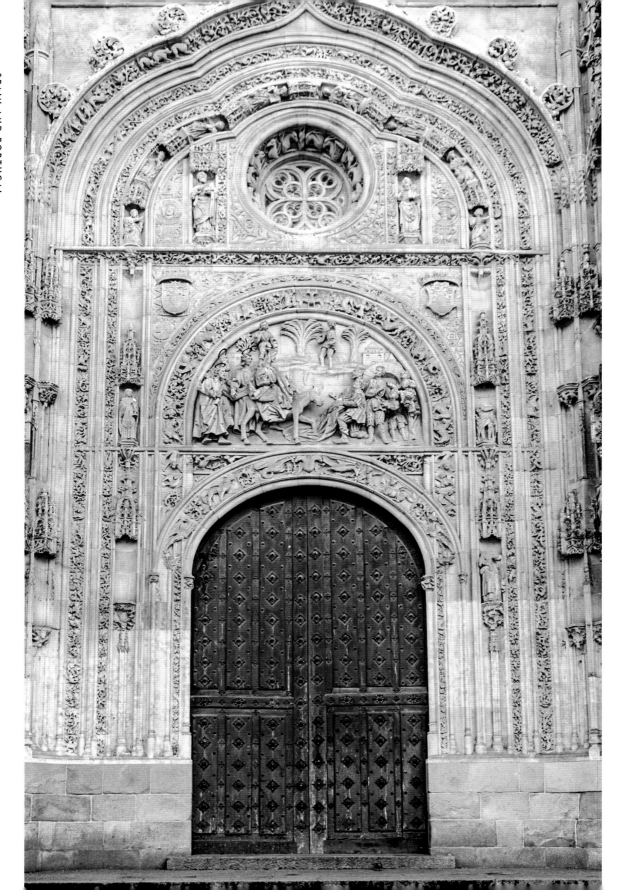

dome rebuilt in the 18th century after damage following the Lisbon earthquake of 1755, source of Voltaire's philosophical pessimism.

From here we walk clockwise round the walls of the old cathedral to reach the western bell tower of the new, with beneath it the so-called Birth Gateway. Like much of the new structure, it was designed by the masters of Spain's 16th-century revival, Juan Gil de Hontañón and his son Rodrigo, at the point when Gothic was transitioning into Renaissance. The surface is almost flat and covered in Plateresque reliefs. At the apex is a Calvary with a scenic Mount of Olives in the background. Below are two 17th-century carvings of the birth of Christ and the Adoration. The final Ramos northern portal is more restrained with an ogival arch framing a depiction of the entry into Jerusalem. Into its border an ingenious 1990s restorer inserted an astronaut and a fierce lion licking an ice-cream.

The interior is a masterpiece of stylistic transition. While it lacks the soaring quality of the de Hontañóns' work at Segovia, its Gothic columns burst upwards into a cobweb of ribs, the Renaissance evident in tiny gold capitals and spandrel medallions. The crossing dome was built in the 18th century by the Churriguera brothers in their characteristic High Baroque. The choir contains 104 seats and two organs, works of rich Rococo ornamentation, alive with cherubs.

A door at the west end of the south aisle leads from the new cathedral to the old, to a voyage backwards in time. Here the sculptors delight not in cherubs and putti but in monsters and devils. Bishops do not boast conspicuous consumption but lie in dignified repose. Over everything hovers a Florentine reredos comprising fifty-three paintings of the life of Christ set round a 13th-century statue of the Virgin. In the coving above is a Day of Judgement, the damned fewer in number than the saved. Salamanca was a goodly place.

In the cloister is St Barbara's Chapel where Salamanca's university exams were held. Students would spend the night beforehand locked in here to revise and pray. Those awarded doctorates the next day would process through the cathedral with appropriate blessing. Those who failed were tossed through a side door into the street outside.

← Salamanca: Plateresque Ramos portal
↑ Angelic spaceman

SANTIAGO DE COMPOSTELA

⁌ ⁌ ⁌

The body of Jesus' disciple James the Great was allegedly washed on to the shore of north-west Spain sometime after his death in AD 44, his tomb 'found' by an enterprising local bishop c.820. A church was built on the site in 829 but destroyed by the Moors in 997. The first visitors to the tomb arrived in the 11th century, taking away a sea shell from those allegedly covering him when he was swashed ashore. Millions have followed ever since, trekking on foot across France and northern Spain, each carrying a shell as symbol of their piety. Santiago became Catholicism's third pilgrim destination after Jerusalem and Rome.

I first visited the cathedral in the late 1960s and recall the interior as a haze of heat and incense. On my recent visit it was under heavy restoration and besieged by visitors. They arrived on foot and bicycle, by car and coach, intent on touching St James's (metal) cape behind the altar. Christian worship may be in decline but pilgrimage is not. Trekking *el camino* ('the way') is now promoted as 'walking with a purpose', be it belief, penance, gratitude, personal crisis or just exercise. The numbers doing so and receiving a certificate or *compostela* for making the last 100km on foot rose from 1,800 in 1986 to a third of a million in 2019.

The cathedral's exterior is puzzling as it is surrounded by buildings and cannot easily be perambulated. It is rather a series of façades glimpsed from surrounding streets. The main entrance originally allotted to French pilgrims is through the northern Azabachería doorway, a stern Baroque façade rebuilt in 1758. Moving clockwise from here we reach the exterior of the eastern chevet overlooked by Santiago's clock tower, beckoning pilgrims across the plain in High Baroque. Buried behind it is the so-called Platerías façade with two

tiers of ornate arches carrying 12th-century relief carvings of the Bible story. Adam and Eve do not look too mortified as God orders them from Eden. A moustachioed Christ is flagellated.

The cathedral's principal façade, the western Obradoiro, confronts the square and was designed in High Baroque by Fernando de Casas Novoa in 1738. It was intended to greet pilgrims at the climax of their journey with a burst of imagery devoted to St James. Its style is extravagant and in your face. No line moves an inch without breaking into a scroll, swirl or finial.

The Obradoiro may be coated in exuberant clutter but this renders only the more exciting what lurks behind it, a former entrance that the 18th-century architects clearly dared not destroy. This is the Pórtico de la Gloria, a work of Romanesque sculpture preserved by being indoors. Visitors thus pass into the nave through a chamber of figures drawn from the Old and New Testaments. Columns, bases and capitals are filled with all of human and animal life. The central tympanum features Christ in Glory as saviour of the world. He is crowded round with evangelists, angels and the saved. In the arch above are the elders of the Apocalypse playing musical instruments. The faces have a human intensity that transcends their age or style. Enthroned on a column is St James himself as if personally welcoming the pilgrims to his house.

We know the artist of this work only as Master Mateo, who was awarded a lifetime pension in 1168 by King Ferdinand II of León to ensure that he finished the job. This he did in 1188, the year of Ferdinand's death. The portico fascinated the Victorian architect G. E. Street, who called it 'one of the greatest glories of Christian art' and lobbied to have a cast made of it for London. This was duly done in 1866 and is now on display in the Victoria and Albert Museum. After a restoration in 2018

→ Santiago de Compostela: Pórtico de la Gloria apostles newly tinted

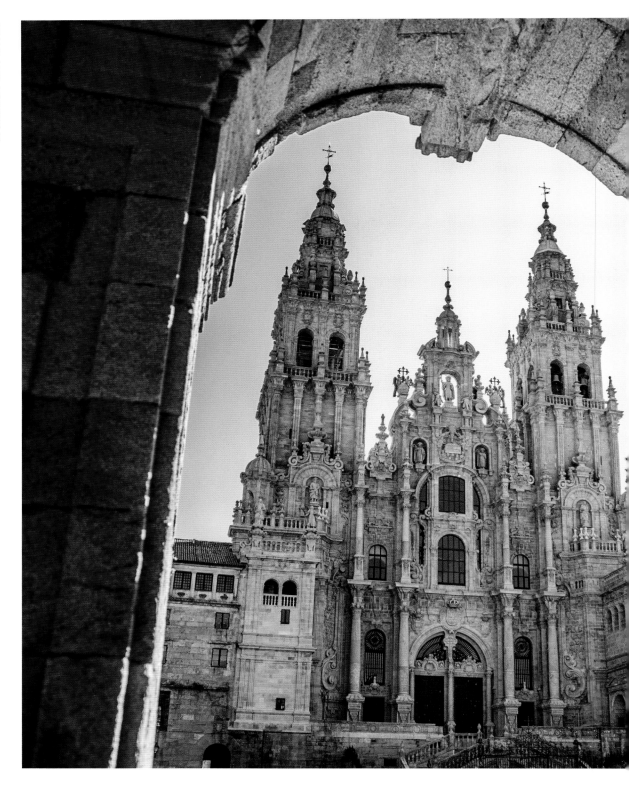

the original portico figures have had much of their colouring reinstated, bringing them gently to life.

The entry into the nave from the portico is theatrical. Pilgrims process as if through the gates of heaven, their eyes peering from the gloom to a surging focus at the crossing and sanctuary beyond. The dome over the crossing holds the brackets for the famous Botafumeiro, a giant censer (technically a thurible) invented in the 16th century, though the present one dates from 1851. It swings from transept to transept in a terrifying arc emitting a cloud of incense over the congregation. It takes seven men to wield it and is operated only on special occasions.

The Capilla Mayor choir beyond is arranged with the high altar and baldachin, signalled by the jutting pipes of the two organs and attended by scores of near-naked angels and cherubs waving arms and legs like an early Broadway chorus line, with the seated saint as centre of attention. The saint's image bursts from every shelf and corner, including one of him on horseback fighting the infidel Moor. The tomb is reached by a long queue below the rear of the chapel.

Santiago's cloister is a blessed retreat from the crowds. It leads to a museum of Gothic and later paintings and statues. Gold sculptures jostle with altarpieces, reliefs, tapestries and sketches by Goya and Rubens. A lovely reredos was donated in 1456 by an English priest, John Goodyear from the Isle of Wight. We would love to hear his pilgrim's tale.

← Pilgrim destination: Santiago west front

SEGOVIA

✢ ✢ ✢

For those who find Burgos overpowering, Segovia is a relief. It floats on its hill in the heart – and heat – of the great Castilian plain, calm and timeless. Its old Romanesque cathedral had been located in the lower town next to the Alcázar (castle). This was seized and used as a fortress by the *comuneros* during their revolt against the young Charles I (later V) in 1520. The consequence was its virtual destruction. A decision was made to build a new cathedral on a less exposed site higher up the hill.

Despite the 16th-century date and as if to emphasize the continuity of its faith, the new cathedral was in the old Gothic style, initially with no Renaissance traces. The architects, Juan Gil de Hontañón of Salamanca and his son Rodrigo, set aside their signature Plateresque. As Raphael and Michelangelo were erecting a Classical St Peter's in Rome, Segovia was honouring the pointed arch and the crocketed pinnacle. The cathedral took a century to complete, by when it must have looked seriously out of date.

From the west the cathedral is bare, as if turning its back on the slope down to the Alcázar. The eastern exterior is quite different, its apse and chapels best glimpsed from the corner of the Plaza Mayor, especially when lit at night. From here they appear as a grove of Gothic pinnacles, tier upon tier rising to the apse roof. The windows are simple and round-arched, overlooked by a cluster of pencil-thin fir trees round the base. During construction, the scaffolding was rented out to spectators of bullfights in the plaza below.

The interior of Segovia shows how lasting was the influence of French Gothic into Spain's Middle Ages. Composed by the de Hontañóns, it is an exercise in Gothic verticality. Piers soar on slender

→ Segovia: Lierne ribs fan the ambulatory

shafts before bursting into a cobweb of rib vaults. Reminiscent of contemporary English fan vaulting, they swirl to dizzying effect, north, south, east and west, in rich sandstone. On my visit the excitement of these vaults was enhanced by the music of Albinoni filling the aisles.

The cathedral layout is anything but French. In the Spanish fashion the nave is filled by an enclosed choir and sanctuary, with the laity elbowed into the aisles. By the time these insertions were being installed, the Renaissance had claimed supremacy, although the actual choir stalls were imported from the old cathedral. The sanctuary is guarded by three handsome brass screens and is dominated by a Baroque reredos of 1768 and of Italian design.

Segovia's aisles and ambulatory encompass eighteen chapels, almost all Baroque and fronted by virtuoso brass screens. In the south aisle is an eerie Chapel of the Deposition. Scenes of the Descent from the Cross are set round an ultra-realistic carving of Christ by the Baroque sculptor Gregorio Fernández (1576–1636), naked with just a rag over the groin. Blood is depicted as gushing from every aperture with glass eyes and apparently real nails and teeth. It must terrify children. Many artists depicted the corpse, including Holbein, but few in such ghoulish detail.

A stylistic contrast is through heavy doors off the north aisle, the Chapel of the Blessed Sacrament. Its sanctuary contains a High Baroque reredos by the Spanish Baroque master José Churriguera (1665–1725). Its canopy is formed of carved curtains parting to reveal Christ in an act of blessing. He is attended by a troupe of boys cavorting in the undergrowth, naked and blowing trumpets.

Segovia's cloister is a delight. It was imported stone by stone from the old cathedral and lavishly rebuilt over two storeys, the openings filled with elegant Flamboyant tracery. Off the cloister is a chapter house with a coffered ceiling and a supreme display of Flemish tapestries, dating from a time when Flanders was still ruled by Spain.

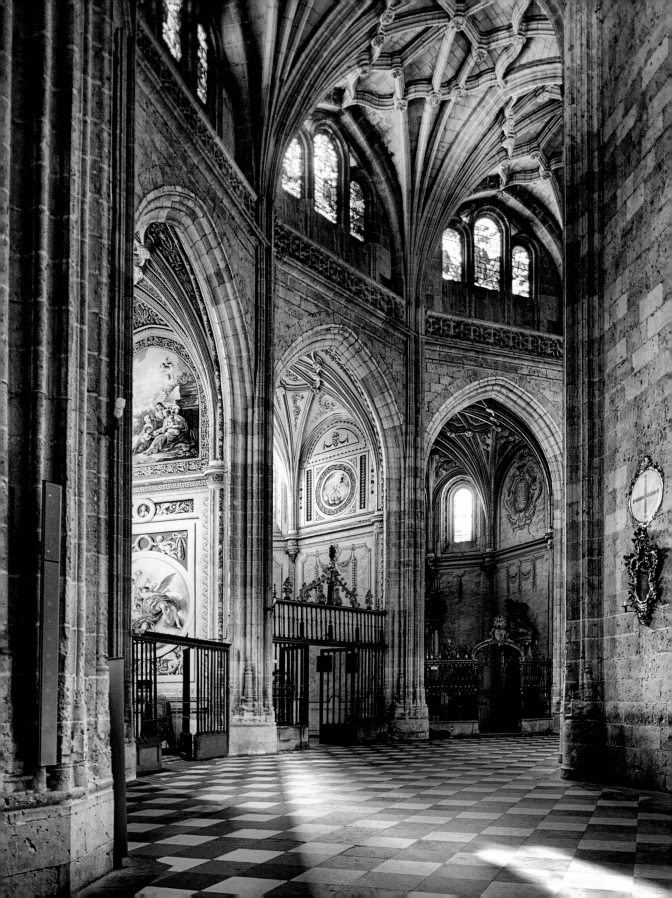

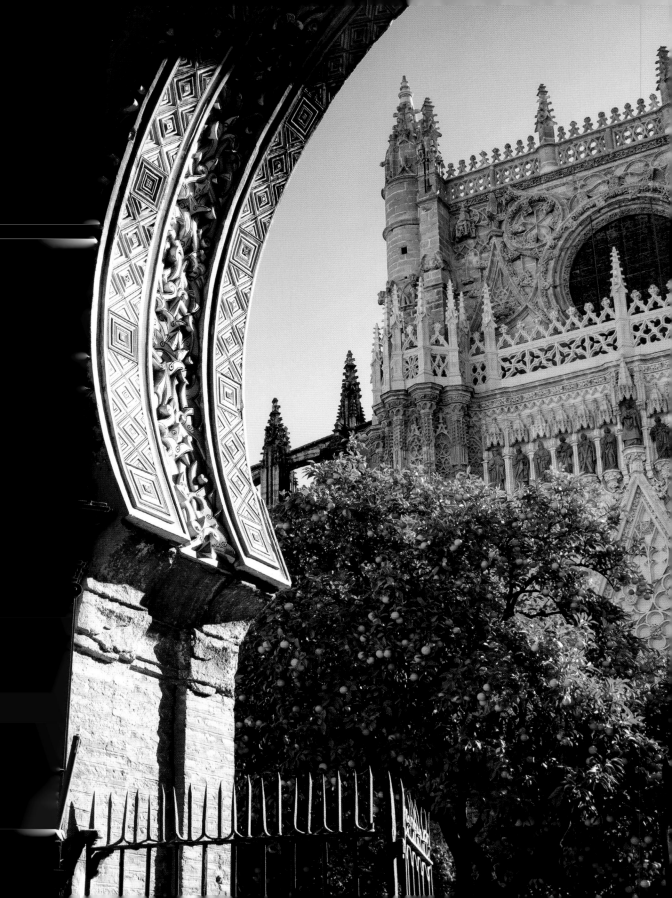

SEVILLE

✠ ✠ ✠ ✠ ✠

I last saw Seville cathedral at night from the roof terrace of an adjacent hotel. It was astonishing, floodlit against the black sky and appeared to be aflame. An aristocrat of Gothic architecture, the building displays all the great periods of Spanish history, from Moorish through Gothic to High Baroque. It towers over the capital of Andalusia, prominent in Roman times as birthplace of two great emperors, Hadrian and Trajan. After the empire's fall, a possible first church passed to the Visigoths in 441 and became a mosque sometime after the Moors invaded in 712; it was rebuilt c.1184. In 1248 came the *reconquista* and the conversion of the mosque into a cathedral.

In 1401 the dignity of the city was thought to merit not a merely converted mosque–cathedral as at Córdoba but a wholly new building. As its canons were reported to have said, 'Let us build such a church that men will think us mad.' They created what was to be the first Christian church to rival in volume Constantinople's Hagia Sophia and old St Peter's Rome. The cost was astronomical, taxing local clergy half their incomes. Building continued into the late 15th century and the reigns of Ferdinand and Isabella, just as the Renaissance was taking hold. By the 16th century, Seville was the principal port for the New World and could afford extravagance.

The cathedral was rebuilt on the floor plan of the mosque, which partly explains its exceptional width. Fragments of the mosque survive in many places, most obviously in the former minaret or Giralda. The remainder of the building is many churches in one, once reputedly including eighty distinct chapels. Here in the 1890s five hundred masses a day were said to have been sung.

Seville's exterior is hard to appreciate, each façade being a setpiece in itself. There are nine main portals

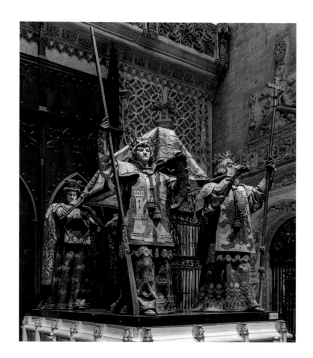

and six lesser ones. The best-known east front on to the main square is a catalogue of Spanish architecture. The Giralda tower has both Visigoth and Moorish designs below, while the five upper stages were added in 1568 in a Classical style. The Palos portal sandwiched between the Giralda and the exterior of the Capilla Real has a lovely tympanum of the Adoration of 1520. The magi look like explorers to the New World.

Continuing round the exterior we pass into the open space of the Trionfo, home to Seville's royal palace. Here the cathedral's north wall is wholly 16th century with as centrepiece the Puerta de la Lonja, a 19th-century evocation of Flamboyant Late Gothic by the architect Alberto Casanova. Continuing west we reach the main entrances devoted to Christ's baptism, assumption and nativity, with sculpted reliefs to suit.

The south side of the cathedral exterior is a wholly different story. It is partly occupied by the old mosque buildings, including the lovely Patio de los Naranjos. Into its wall is set a Moorish horseshoe arch, the Puerta del Perdón, safely guarded by statues of saints. I like to think of this patio filled with

← Seville: the Patio de los Naranjos viewed through the Moorish
 Puerta del Perdon
↗ Seville: the Christopher Columbus tomb
→ Seville's night-time profile

301

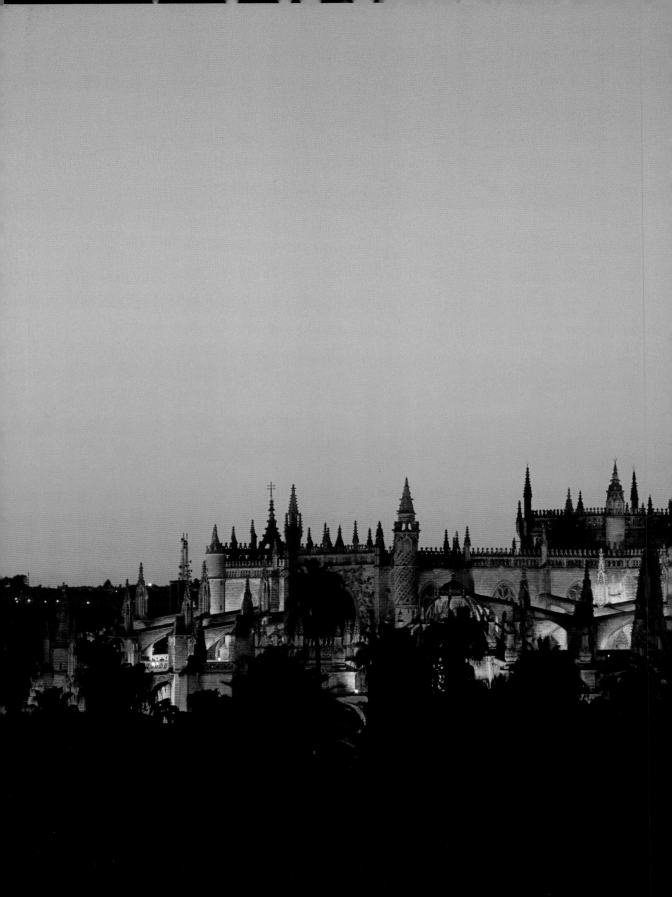

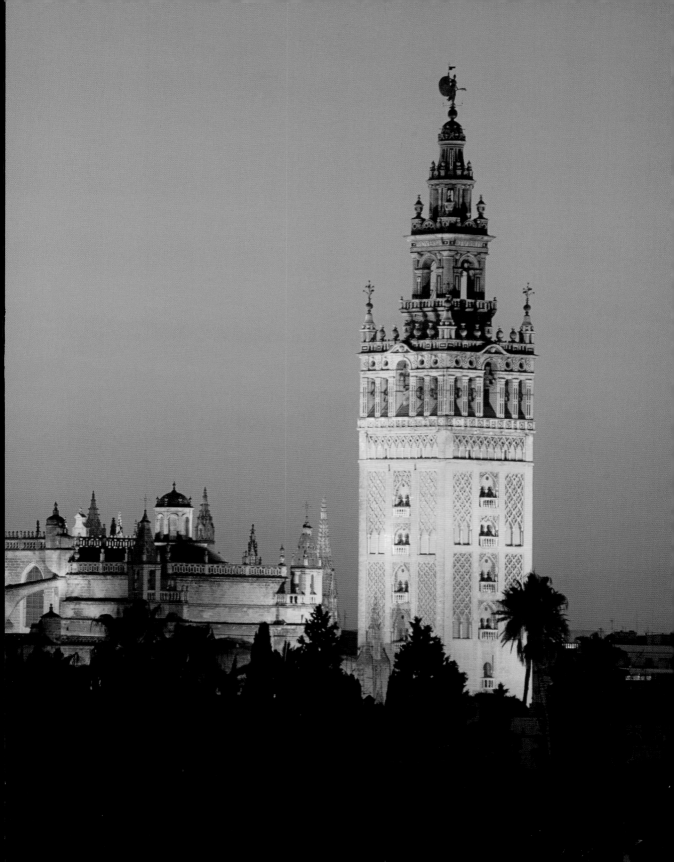

swaggering conquistadors riding up from their ships with donations of American gold to honour their blessed saint for their safe return.

The interior is overwhelming. To wander Seville's nave and four aisles – naves in themselves – is to experience the climax of the Gothic age. Clustered shafts soar to pointed arches and vaulted ceilings. Light bursts through lofty windows to flood floors and walls with colour. Candlelit altars lurk in discreet chapels. Yet this is merely a vessel, a backdrop for the lavish display of the wealth of 16th-century Spain. On every side is a gilded railing, a wall of devotional paintings, a Christ in agony, a saint in ecstasy.

The best approach for a visitor is to proceed to the space between the choir and sanctuary and then explore outwards. The grilles that separate the two chambers are fine examples of Renaissance metalwork. The choir is relatively sedate at least inside, though its two organs are spectacular works of Baroque carpentry.

The sanctuary is quite different. Dating from 1482 it contains one of Europe's most astonishing altar pieces, the masterpiece of Flemish craftsman Pierre Dancart that consumed his entire life. Thirty-six panels of 1,000 miniature sculptures depict Bible scenes in frames of gold, reputedly 3 tonnes of it in

all. Each tableau merits being taken down to be studied individually, like pages from a medieval missal.

The surrounding chapels appear endless, a giant ecclesiastical shopping mall. The best we can do is stroll past, tasting their wares, impressed or unnerved by their lavishness. The Capilla Real located east of the sanctuary is virtually a cathedral in itself. Its decoration is wild Renaissance Mannerism with motifs and figures jostling for attention from floor to dome. The centrepiece is a statue of the Virgin looking like a queen with Jesus dressed as a Spanish royal infant. The chapel houses the tomb of Ferdinand III of Castile (r.1217–52), liberator of Seville in 1248 and not to be confused with a later Ferdinand, husband of Isabella.

The remaining chapels, sacristies, treasuries and chambers together form an exhibition of Spanish design over the centuries. Altars or walls are hung with works by Murillo, Zurbarán, Goya and others. The tomb of Columbus is prominent, having been returned from Havana in the 1890s and attended by figures representing Aragon, Castile, León and Navarra. Doubts over its authenticity were laid to rest in 2003 by DNA evidence. St Anthony's Chapel has a majestic Murillo. So too does the oval-domed

↑ Seville: high altarpiece of 1,000 sculptures
→ The eternal conversation: Gothic with Baroque

Toledo: west tower stands without its twin

chapter house by Hernán Ruiz the Younger (1514–69), another master of the Spanish Renaissance. The 16th-century Sacristía Mayor has a spectacular three-ringed dome on columns encrusted with Plateresque detail. In the outer ring is hell, in the heavenly centre we imagine Seville.

TOLEDO

✤ ✤ ✤ ✤ ✤

El Greco's celebrated portrayal of Toledo in 1600 has the city rising like a ghost from the Tagus river into an angry sky. Seen from the same viewpoint today it looks remarkably similar. Ancient bridges and walls pile up the slopes while over them tower a cathedral and a castle. At night these two buildings, the only ones to be floodlit, shine out of the darkness as if floating free into the sky.

Toledo was captured from the Moors by Alfonso VI, king of León and Castile, in 1085 and its mosque was duly converted to Christian worship. This led to a dispute over whether it should adopt the Catholic rite or stay true to the Mozarabic Christians who had lived and worshipped in Toledo under Moorish rule since Visigothic times. As so often in Spain *reconquista* was not a clear-cut matter. The outcome was a compromise. In a south-east chapel, services in the Mozarabic rite are still held today.

Work on the present building replacing the mosque began in 1226 on the initiative of Bishop Rodrigo Jiménez. Masons named masters Martin and Petrus were clearly acquainted with Bourges, Paris and Le Mans but were equally at home with the Islamic style, reflected in features of the triforium and cloister. As in most Spanish cathedrals, the interior was subject to a dramatic makeover in the early 16th century when Toledo was still capital of Spain. Soon afterwards in 1560 the city was abandoned as capital in favour of Valladolid and then Madrid, 65km away. This left the cathedral buried in

a maze of medieval streets, strangely difficult to find.

My favourite approach is from the hill below where we suddenly encounter the handsome Lion doorway on a side street with its lovely Baroque statue of the Madonna. The main west front is in High Gothic with its three portals divided by buttresses to which statues are fixed as if afterthoughts. The three doors portray justice and hell on either side of forgiveness. To the left rises a tower containing an 18th-century bell, said to be larger than any outside Russia and America. The right-hand tower was never built, its base instead crowned with a 17th-century dome by El Greco's architect son Jorge Theotokopoulos. A frieze of gesticulating apostles crowns the main door. The cathedral entrance is reached down an alley on the north side through the Clock door.

Toledo's interior is an architectural wonder. The style is French Gothic with nave and chancel double-aisled but with a triforium of triple-lobed *mudéjar* arches. The nave contains screened enclosures for the choir and sanctuary, the former Renaissance, the latter Gothic. The choir is composed of two tiers of stalls backed by walnut relief panels with an alabaster frieze above. The upper stalls are by Philip of Burgundy and Alonso de Berruguete, the 'Spanish Michelangelo', with figures in gymnastic poses. The lower stalls are by a German named Roderick.

These stalls are an art gallery in themselves. The panels depict scenes from Spanish geography and history including the last ten years of *reconquista* down to the fall of Granada in 1492, an event within memory of the stalls' creation. Above the archbishop's seat is a Baroque Transfiguration of Christ by Berruguete. Overhead stand two huge organs, one Classical, the other explosively Baroque. On the altar is Toledo's marble White Virgin with a Mona Lisa smile.

Directly east of the choir is a grille of 1548 with Habsburg heraldry guarding the sanctuary and high altar. These were designed in the Gothic style in the 1490s. The reredos is like a monumental doll's house carved into a cliff by the Burgundian Philip

heaven. This was side-lit from an invisible window in the east wall. From below, the opening thus appears to depict the sky framed by amazed silhouettes. It is surrounded by carvings and paintings of curtains, clouds, angels, anything that entered the dream world of the Tomé brothers. It is a true *trompe l'oeil*.

The altar on which it falls is a gilded fantasy of a Virgin and Child, and a Last Supper looking like a civic banquet. Even the official guide admits that the Transparente is 'loved by some but hated by others'. I can only wonder at the imagination and engineering genius of its creators. The Transparente must be the apotheosis of Baroque piety.

The remainder of Toledo comprises a cluster of chapels round the ambulatory, aisles and cloisters. Along the outside screen of the choir is a wall painting of Bible stories including an apocryphal rendering of the life of Adam and his sons. A giant mural of St Christopher stands guard over the scene guaranteeing any worshipper safety for the day ahead. In the south transept the Emperor's Organ has a fascia of High Gothic relief and a Tree of Jesse in its tympanum.

Of other annexes, the Mozarabic Chapel recalls the Christians who lived and worshipped in Toledo under Moorish rule. The treasury includes a great monstrance, much of it of solid gold, which is carried round Toledo's streets on the feast of Corpus Christi. The two rooms of the chapter house mix Renaissance and Arabic styles, notably in the doorway and Plateresque ceiling. Here portraits of bishops hang beneath lively frescoes by Juan de Borgoña of 1495.

The sacristy is a minor Prado with a ceiling by the Italian Baroque master Luca Giordano (1634–1705). There are eighteen El Grecos and works by Zurbarán, Rubens, Van Dyck, Velázquez, Titian and Goya. Those seeking relief from such richness can retreat to Toledo's cloister and the tiny Chapel of St Blas. Here frescoes in their original colours date from the late 14th century, offering the tranquillity of an earlier faith.

we met in the stalls. Twenty Bible scenes are set in coloured and gilded frames stepping upwards to a Crucifixion. To add to the drama, the figures grow in size as they rise. Round them are arrayed the tombs of kings and bishops of medieval Castile, appropriate for what was intended as the royal church of a capital city. Jan Morris was overwhelmed by the reredos's 'almost physical movement upwards, through the sweet mystery of the Nativity and the splendour of the Ascension up to the very rafters of the cathedral … the very apex of Christian Spain'.

We now take a deep breath and move eastwards behind the high altar to the ambulatory and the so-called Transparente. This extraordinary space is a moment of High Baroque on a par with Bernini's *Ecstasy of St Teresa* in Rome. It was created in 1732 by Narciso Tomé and executed by him and his two brothers, all still in their twenties. Their intention was to portray celestial light bursting through the cathedral vault past a frieze of gesticulating humans and directing a shaft on to a golden altarpiece backing on to the high altar.

To achieve this Tomé cut a space between the ribs of the ambulatory vault, replacing it with a fresco of

↖ Choir stall carving of Job by Alonso de Berruguete
→ The Transparente

ZARAGOZA
LA SEO

✢ ✢

The ancient capital of Aragon, the city named after Caesar Augustus, has long had competing cathedrals, the ancient Cathedral of the Saviour (Seo) and El Pilar, the shrine of Our Lady of the Pillar. The Seo had the seniority, but the Pilar had pilgrims by the thousand in honour of the Virgin Mary's first 'apparition' to St John in AD 40. In 1676 the pope was so fed up with their feuding that he created them co-cathedrals, merged their chapters and made a single dean live half a year in each in turn. The Pilar down the road is largely an 18th-century work with multiple towers.

The Seo's exterior bears the marks of Christianity in Spain since Aragon's *reconquista* in 1118. The former mosque on the site was demolished and a Romanesque church begun in 1140. Kings of Aragon were crowned here until the 16th century. From 1318 when the cathedral became archdiocesan it was rebuilt in the Gothic–*mudéjar* style, most visible at the east end where a Romanesque ground floor erupts into entire walls of *mudéjar* decoration. Here it takes the form of an abstract pattern of softly coloured bricks and tiles round ornate windows and crenellated roofs. Such adornment continued long after the expulsion of the Moors in the 13th and 14th centuries. The west front of the cathedral was given a Classical makeover in the 17th century, balancing the Classicism of the bell tower next door.

The interior is that of a Gothic church of nave and four aisles with a vaulted ceiling and floral capitals to the piers. This is overwhelmed by the pyrotechnics of subsequent centuries. The *coro* or choir is located in the middle of the nave in the Spanish fashion, surrounded by stone screens, panels and metalwork in Spanish Renaissance. So laden with decoration are these screens that the choir is virtually a private

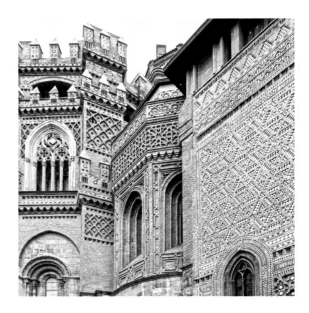

chamber within the church. Its 104 oak seats were apparently carved by monks.

Even the choir's richness is outshone by the Seo's chapels. Most notable is that of the Holy Cross located against the rear wall of the choir. Here the Crucifixion takes place under a canopy of one gigantic Baroque scroll resting on twisted black marble columns. Chapels and altars continue round the aisles and east end of the cathedral in what could be a showroom of Baroque funerary sculpture. In the centre of the apse is a dome with a brilliant *mudéjar* pattern created in 1409 by an artist called Mohammed Rami.

Zaragoza displays the confidence of Spanish piety during that country's brief prominence in Europe's affairs. It was built on the wealth of the Americas and of Flanders, commercial capital of northern Europe and subject state of Spain in the 16th century. It was from Flanders that the cathedral derived its treasure, one of the great collections of Flemish Renaissance tapestries, housed in the adjacent museum and surpassing even that of Segovia.

↑ Zaragoza's *mudéjar* exterior
→ Gothic shadows in the nave arcade

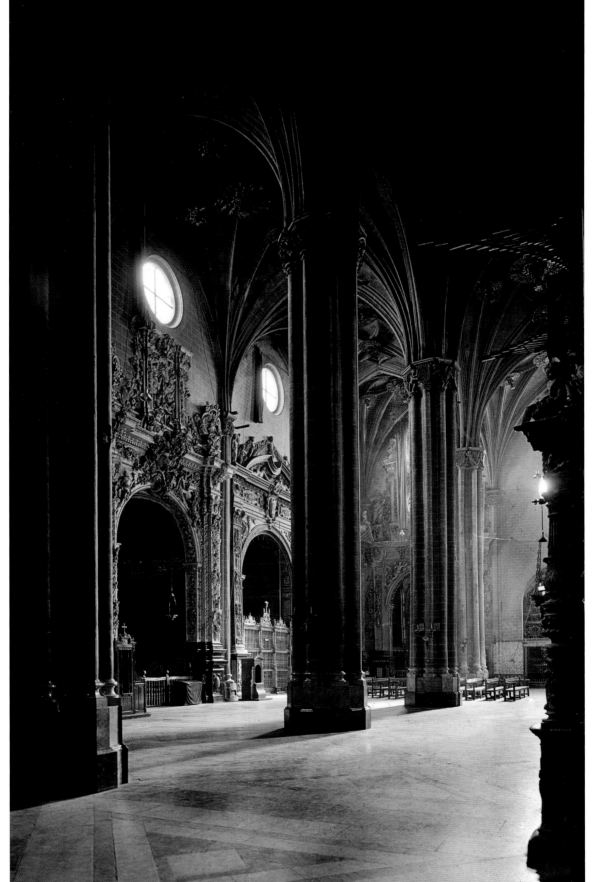

COIMBRA

✤

I have a weakness for ancient university towns, for Italy's Bologna and Perugia, Spain's Salamanca and Mexico's Guanajuato. They are places that may have lost academic pre-eminence but not dignity. Portugal's premier university was founded in Lisbon in 1290 and moved here in 1308 before returning briefly to Lisbon. Today it clings to its hillside over the River Mondego, with its Joanina Library of 1717 among the glories of Baroque decoration. Three chambers are each panelled in a different exotic wood and protected from book-eating insects by bats kept in cages and let out at night.

The old cathedral, the nearby Sé Velha, was begun by the father of Portuguese independence, Afonso Henriques, after his victory over the Moors at the Battle of Ourique in 1139. It was upgraded in the early 16th century but superseded in 1772 when the archbishop moved his seat to the grander church of the evicted Jesuits close by in an adjacent street. Coimbra's Sé Velha thus survives as a rare Romanesque cathedral from the earliest days of the *reconquista*.

The building sits alone in a charming square bearing witness to its origins. It has the appearance of a crusader fort with a jutting entrance bay and imposing doorway, tiny windows and thick crenellated walls, all in deep-ochre sandstone. The west front has a single multi-arched portal with matching window on the stage above.

The only external adornment are the beautifully carved columns flanking the door. These reflect their sculptors' Moorish tradition with no human figures or Bible scenes, rather geometrical and botanical motifs. Despite their new patrons the masons seem reluctant to break with the Mozarabic past. The only later addition to the exterior is a north Porta Especiosa (beautiful porch) in a delicate

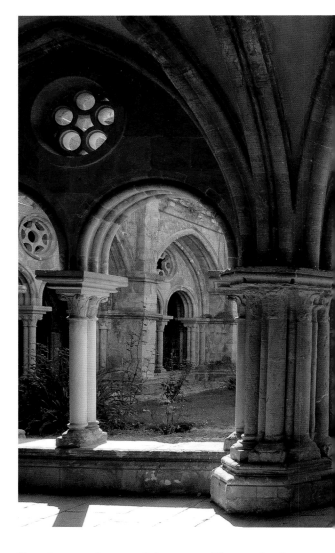

Renaissance design of the 1530s. The work of a French architect, Jean de Rouen, it adds a touch of northern sophistication to the ancient structure.

The cathedral interior is austerely 13th century, consisting simply of a short nave with aisles beneath a barrel vault. Its most distinctive Romanesque feature is a flourish of yet more Mozarabic capitals, of which Coimbra has some 380 in all. Like those in the west portal they are mostly abstract in design.

In a bay in the north aisle is the Gothic tomb of Lady Vataça Lascaris (c.1272–1336), a Byzantine princess. She was a true European, related by birth

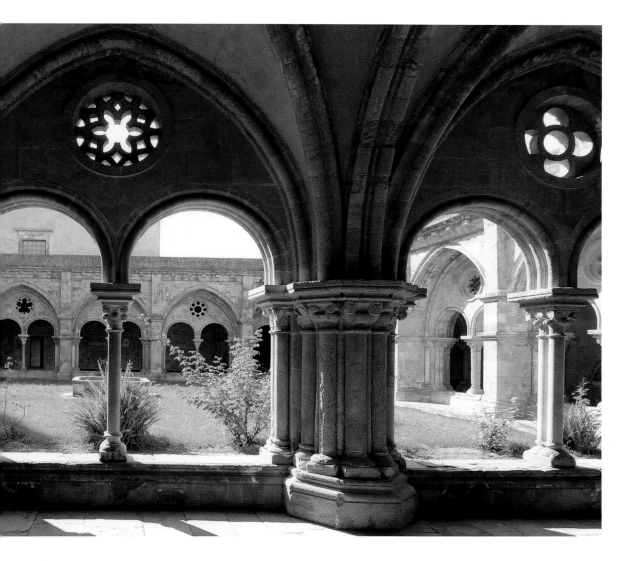

or marriage to the ruling families of Constantinople, Hungary, Sicily, Aragon, Castile and Portugal. The tomb is surrounded by Byzantine double-headed eagles to remind her of her original home.

The cathedral's 16th-century refurbishment saw the coating of the interior walls with blue and white tiling much favoured on Portuguese buildings down the centuries. To non-Portuguese it gives some chapels the aura of a bathroom. At the crossing we reach the refurbishment's most extravagant feature. The entire eastern apse is filled with an altarpiece of Flamboyant Gothic design, of gilded wood carved and painted by

two Flemish artists in 1503 and still unaltered. Adjacent to it stands a Renaissance chapel designed by the same Jean de Rouen as built the north portal. Clearly none of this was sufficient to avert the removal of the bishop to the former Jesuit church in the 18th century.

Coimbra's final delight is a cloister dating from the 1220s. Its double-arched bays with pierced roundels overlook a quiet fountain, another hint of Portugal's Moorish past. Here we can imagine scholars pondering their texts, far from the turmoil of the Spanish Inquisition that was to curtail the freedom of most Iberian universities.

↑ Coimbra cloister: hints of Moorish past

GLOSSARY

ambulatory: walkway around the east end of a church, passing behind the high altar

apse: semicircular east end of church or chapel

arcade: a row of arches supported on piers or columns

baldachin: canopy over altar

basilica: Roman public hall, sometimes arcaded; the word is also used for an important Roman Catholic church that is not the seat of a bishop

bay: a repetitive architectural unit of a building separated from the adjacent bays usually by a pilaster or a pier

boss: carving at the junction of vaulting ribs

capital: carved feature at the top of a pier or column

chancel: the part at the east end of a church where the main altar is located

chantry chapel: miniature chapel for praying for souls

chevet: French term for the exterior of the east end of a church (from the Latin *caput*, meaning head)

choir: general term for part of church used by clergy or choir

clerestory: upper row of windows lighting nave, transepts or choir

colonette: small column

corbel: carved stone projecting from a wall supporting a pilaster or a string course

crocket: carved leaf-like decoration crawling up a rib or the ridge of the roof

dormer: window projecting from sloping roof

hall church: usually Late Gothic church in which nave and aisles are of equal height

lancet: narrow window terminating in a sharply pointed arch

lantern: glazed turret above a dome or tower

lierne: short vaulting rib joining one rib to another

liturgical east: 'east' end of a church, usually choir, when not traditionally oriented east–west

misericord: an often imaginatively carved ledge, revealed when a folding seat in the choir is raised, on which monks can perch when nominally standing

narthex: enclosed entry area at west end of a nave

ogee: double convex/concave arch

pier: masonry support for an arch, rectilinear on plan (cf. a column which is circular)

pilaster: flat column or strip-like element projecting from a wall

portal: important doorway

pulpitum: built screen dividing nave and choir

putti: small naked boys in Baroque compositions

quatrefoil: panel divided by cusps in four-lobed near-circular openings

reredos, retable: carved or painted panel behind and above altar

retrochoir: area to the east of choir/altar

rose window: circular window usually containing tracery

sacristy: room to side of church for storing vestments and liturgical equipment

sedilia: three usually elaborate seats for clergy to the side of altar

shaft: main part of a column formed of a single vertical cylindrical stone, also sometimes attached to angles of a pier

sheela-na-gig: erotic fertility symbol in some British churches

spandrel: diagonal area between two arches

spire: pyramidical or conical feature on top of tower, component of steeple

stiff-leaf: formalized vegetation on capital of Gothic pier

string course: band of masonry stepped outwards from a wall

tracery: openwork pattern of ribs dividing and decorating chiefly church windows

transept: part of a church projecting to north and south of the 'crossing' (the latter often surmounted by a tower)

triforium: second stage of a Gothic church elevation between main arcade and clerestory

tympanum: normally semi-circular decorated panel between a door lintel and a surrounding arch

vault: arched ceiling inside a roof, usually of stone

BIBLIOGRAPHY

Books cited in the text:

Adams, Henry, *Mont Saint Michel and Chartres*, 1904

Bony, Jean, *French Gothic Architecture*, 1983

Bumpus, Francis, *Cathedrals of France*, 1927

——, *Cathedrals and Churches of Italy*, 1926

Cannon, Jon, *Cathedral*, 2007

Cook, Olive, *English Cathedrals*, 1998

Crook, John, *The Architectural Setting of the Cult of Saints*, 2011

Dunlop, Ian, *The Cathedrals' Crusade*, 1982

Holland, Tom, *Dominion: The Making of the Western Mind*, 2019

Jacobs, Michael, *The Road to Santiago*, 3rd edn, 2001

Jenkins, Simon, *England's Cathedrals*, 2016

MacCulloch, Diarmaid, *A History of Christianity*, 2009

——, *Reformation: Europe's House Divided*, 2003

Martin, Christopher, *Glimpses of Heaven*, 2006

Morris, Jan, *Spain*, 1964

Orme, Christopher, *The History of England's Cathedrals*, 2019

Parry, Stan, *Great Gothic Cathedrals of France*, 2017

Pevsner, Nikolaus and Priscilla Metcalf, *The Cathedrals of England*, 1985

Prasha, Anne, *Cathedrals of Europe*, 1999

Somerville, Christopher, *Ships of Heaven*, 2019

Tatton-Brown, Tim and John Crook, *The English Cathedral*, 2002

PICTURE CREDITS
(PHOTOGRAPHER NAMES IN BRACKETS)

Every effort has been made to contact all copyright holders. The publishers will be pleased to amend in future editions any errors or omissions brought to their attention.

123RF.com: 95 (Mikhail Markovskiy); 159 (SK Design), 273 (C. Viciana), 275 (Jorisvo); **4Corners Images:** ix (Olimpio Fantuz), 68, 203 (Luigi Vaccarella), 76 (Reinhard Schmid), 98–9 (Martin Brunner), 135 (Alessandro Saffo), 160 (Chris Warren), 178 (Massimo Borchi), 196–7 (Sandra Raccanello), 218–19 (Giovanni Simeone), 230–31, 233 (Anna Serrano), 236–7 (Günter Gräfenhain), 244 (Massimo Ripani), 252, 267 (Richard Taylor); **akg–images:** 223 above (Cameraphoto); **Alamy:** xiv–xv, xviii–xix, 5, 6, 7, 11, 12, 13, 17, 23, 25, 27, 29, 33 (Hemis), xvi–xvii (T. Spagone), xx left (Nikolay Vinokurov), xx right (Steve Allen), xxii (PJR Travel), xxiv above (David Bagnall), xxiv below (David Gee), xxvii (Lankowsky), xxix (ImageImage), 10, 24, 53, 56–7 (John Kellerman), 14 (David Keith Jones), 15 (NJ Photo), 19, 97 (Image Professionals GmbH), 30 (Peter Cavanagh), 36 (Culligan Photo), 39 (Capture 11/Jonathan Braid), 41 (Panther Media), 43 above left (World History Archive), 43 above right (Historic Collection), 51, 127, 258 (Ian Dagnall), 65 (Interfoto), 84 left & right (Mauritius Images GmbH), 85, 86, 260–61 (Imagebroker), 101 (McPhoto/Bilderbox), 102 (Bildarchiv Monheim), 103 (Oliver Förstner), 109, 282, 289 (Robert Harding), 111, 149 (Angelo Hornak), 113 (Mike Kipling), 121 (Lee Pengelly), 123 (Holmes Garden Photos), 128 (Andrew Wilson), 129 (Danita Delimont), 137 (Granger), 154 (Robert Proctor), 155 left & right (Nick Servian), 170–71 (Ivoha), 182–3 (Gentian Polovina), 187 (Marka), 193 (Salvo77na), 199 (Jiri Hubatka), 209 (Bailey Cooper), 212–13 (Peter Eastland), 217 (Vyacheslav Lopatin), 220 (Paul Williams), 239 (Valery Egorov), 240 (ITAR–TASS), 241 (Felix Lipov), 245 (Agefotostock), 247 (Patryk Michalski), 259 (Chris Fredriksson), 272 (Juan Carlos Marcos Martín), 274 (Olga Gajewska), 297 (Fabrizio Troiani), 298 (Victor Lacken), 300 (Bob Berry), 308, 311 (Album), 310 (D. Carreño), 312–13 (Mauricio Abreu); © **Andrew Blackmore:** 122, 151; © **Andrew Sharpe Photography:** 118–19; © **Barbara Nichtweiss/ Diocese of Mainz:** 81; **Bigstock:** 88 (C. Duschinger), 184 (Gimas), 206 (Konstick), 293 (Felipe Caparros); **Bridgeman Images:** x, 190–92 (Ghigo Roli), xi (© British Library Board. All Rights Reserved), 148 (V&A), 200–202 (De Agostini), 216 (Marco Ravenna), 222, 223 below (Mondadori Portfolio/ Archivio Magliani/Mauro Magliani & Barbara Piovan); **CanStock:** 306 (Jank1000); © **Centre des monuments nationaux:** 20–21 (Patrick Müller), 31 (Marc Chagall, *Le Paradis Terrestre*, 1959–63. © ADAGP, Paris & DACS, London, 2021. Photo Étienne Revault), 50 (Jean–Luc Paillé); **Chapter of Canterbury, reproduced by courtesy:** xxi; **David Iliff (License CC BY–SA 3.0):** 117, 126, 132–3, 143, 161; © **Dean and Chapter of Westminster:** 139–41; © **Denis Krieger:** 55; **DepositPhotos:** 189 (Angela Ravaioli), 304 (Vladj55), 305 (Bruno Coelhopt); **Dreamstime:** 8 (Boris Breytman), 83 (Anya Ivanova), 204 (Dimitarmitev), 268 (Preisler); **Dresden Frauenkirche:** 71 (Joerg Schoener); **Flickr Creative Commons:** 281 (Guillem Femenias); © **Fundación Catedral de Santiago/Fundación Barrié:** 295 (restoration carried out with the patronage of the Fundación Barrié); **Getty Images:** 26, 177 (Alinari Archives), 40, 52, 152–3 (Image Bank), 83 (A. Ivanova), 110 (Corbis), 174–5 (Julian Elliott), 176 above & below, 180, 195, 253 (De Agostini), 179 (Moment), 232 (Izzet Keribar), 243 (Peter Zelei), 270–71 (Reed Kaestner), 294–5 (E+); © **Guillaume de Laubier:** 284; **Harz-Photos:** 79 (Raymond Faure);

AUTHOR'S NOTE

This book follows my earlier book on the cathedrals of England (Little, Brown, 2016), which covered all of them. It matches previous volumes on the churches of England and of Wales. As explained in the Introduction, I have included a very few of what the Catholic church calls basilicas, where they are colloquially known as cathedrals or have special local prominence, as in the case of Vézelay and Assisi.

I have visited all of them myself at some stage in my life, almost all specifically for this book. I am indebted to individual guidebooks, many now of a high standard, and to Wikipedia's increasingly impressive academic research base. Where facts and dates differ I have tended to go with the most local source. There are many shelves of books on European cathedrals and I list in the Bibliography only a few mostly general works I found of particular usefulness.

This book is for the general reader. I include a brief survey of Christian history in general and of individual countries in the relevant sections. It is impossible to describe a Christian cathedral and its contents without assuming some familiarity with the Bible and its stories. I have tried to avoid technical and architectural terms, and have given a guide to some in the Glossary.

I cannot thank by name all the friends who nominated their 'best' cathedrals, including steering me towards the less celebrated ones. I would single out Saint-Bertrand-de-Comminges, Kirkwall and Trani in the latter category. The text was read in whole or part by James Cameron, John Crook, Peter Furtado, Richard Harries and my brother, Tom Jenkins. Jan Morris glanced at Spain before her death in 2020. Picture research was by Cecilia Mackay and design by Claire Mason. Style was corrected by Gayle Hunnicutt, details checked by Laura Mauro and the text copyedited by Peter James. Publication was overseen by an admirable team at Penguin Viking: my editor Daniel Crewe, and Connor Brown, Charlotte Faber, Ruth Killick, Francisca Monteiro and Natalie Wall.

.

INDEX

Main entries are in **bold**

INDEX